THE GREAT CHINESE REVOLUTION:
1800 – 1985

Other Books by John King Fairbank

Chinabound: A Fifty-Year Memoir, 1982

The Cambridge History of China, gen. ed. with D. Twitchett
 Vol. 10, *Late Ch'ing 1800–1911, Part 1,* ed. 1978
 Vol. 11, *Late Ch'ing 1800–1911, Part 2,* ed. with Kwang-Ching Liu, 1980
 Vol. 12, *Republican China 1912–1949, Part 1,* ed. 1982
 Vol. 13, *Republican China 1912–1949, Part 2,* ed. with Albert Feuerwerker, 1986

The I. G. in Peking: Letters of Robert Hart, Chinese Maritime Customs 1868–1907, ed. with K. Bruner and E. M. Matheson, 2 vols., 1975

Japanese Studies of Modern China Since 1953, comp. by Noriko Kamachi, ed. with C. Ichiko, 1975

Chinese-American Interactions: A Historical Summary, 1975

China Perceived: Images and Policies in Chinese-American Relations, 1974

Chinese Ways in Warfare, ed. and contrib. with F. A. Kierman, Jr., 1974

The Missionary Enterprise in China and America, ed. and introd., 1974

East Asia: Tradition and Transformation, with E. O. Reischauer and A. M. Craig, 1973

The Chinese World Order: Traditional China's Foreign Relations, ed. and contrib., 1968

China: The People's Middle Kingdom and the U.S.A., 1967

East Asia: The Modern Transformation, with E. O. Reischauer and A. M. Craig, 1965

Ch'ing Administration: Three Studies, with S. Y. Teng, 1960

East Asia: The Great Tradition, with E. O. Reischauer, 1960

Chinese Thought and Institutions, ed. and contrib., 1957

Japanese Studies of Modern China: A Bibliographical Guide to Historical and Social Science Research on the 19th and 20th Centuries, with M. Banno and S. Yamamoto, 1955, reissued 1971

China's Response to the West: A Documentary Survey 1839–1923, with Ssuyü Teng and others, 1954 (vol. 2, 1959).

Trade and Diplomacy on the China Coast: The Opening of the Treaty Ports 1842–1854, 2 vols., 1953

Ch'ing Documents: An Introductory Syllabus, 1952 (3rd rev. ed., 1970)

A Documentary History of Chinese Communism, with C. Brandt and B. I. Schwartz, 1952

Modern China: A Bibliographical Guide to Chinese Works 1898–1937, with Kwang-Ching Liu, 1952

The United States and China, 1948 (4th rev. ed., 1979), enlarged 1983

THE GREAT CHINESE REVOLUTION: 1800-1985

JOHN KING FAIRBANK

A Cornelia & Michael Bessie Book

HARPER & ROW, PUBLISHERS, New York
Cambridge, Philadelphia, San Francisco, Washington
London, Mexico City, São Paulo, Singapore, Sydney

FIRST EDITION

Designer: Sidney Feinberg
Copy Editor: Margaret Cheney
Index by Olive Holmes for Edindex
Maps by George Colbert

This book is set in 10-point ComCom Gael by The Haddon Craftsmen, Inc., ComCom Division, Allentown, Pennsylvania, and printed and bound by The Haddon Craftsmen, Inc., Scranton, Pennsylvania.

Library of Congress Cataloging-in-Publication Data

Fairbank, John King, 1907–
 The great Chinese revolution, 1800–1985.

 "A Cornelia & Michael Bessie book."
 Bibliography: p.
 Includes index.
 1. China—History—19th century. 2. China—History—
20th century. I. Title.
DS755.F29 1986 951 86-665
ISBN 0-06-039057-3

86 87 88 89 90 HC 10 9 8 7 6 5 4 3 2 1

To the contributors
to volumes 10 to 15
of
The Cambridge History of China

Contents

PART III:
THE ERA OF THE FIRST
CHINESE REPUBLIC,
1912–1949 165

PART IV:
THE CHINESE PEOPLE'S REPUBLIC,
1949–1985 271

M A P S

Foreword

Everyone says history is important for understanding the People's Republic of China but who does anything about it?

Someone should connect past and present, specifically the late imperial China of the nineteenth century with the Chinese Republic after 1911 and the People's Republic since 1949. Many books on these two centuries are now available, published mainly in the last forty years, but to be scholarly one has to specialize and leave the broad view to be cobbled together by textbook writers, popularizers, and similar types who are often least qualified to do it. What we need is an ex-professor who is not up for tenure, and who doesn't care about reputation. On that basis the integration of China's past and present can be a lot of fun. Institutions of the imperial era may reappear under new names, like the ancient *pao-chia* system of mutual surveillance turning up as today's street committees, or the lower gentry of pre-1900 becoming the local bullies and despots of the Republican era and being succeeded, in systemic terms, by the cadres or party secretaries in the countryside today. A responsible scholar will see flaws in such comparisons, so what we obviously need is a bit of irresponsibility. Why not? Each generation learns that its final role is to be the doormat for the coming generation to step on. It is a worthy, indeed essential, function to perform.

The broad scope of this book makes it of course a limited piece

of work. Whoever sets out to portray within readable compass the modern transformation of an ancient civilization has to write at a high level of generality, dealing with institutions, trends, and movements more than with the lives of people. Except for a few selected cases, how Chinese individuals reacted to modern times can only be suggested. However, I have tried to convey the Chinese experience in terms that American non-Sinological readers may readily understand.

During the nineteenth and twentieth centuries China's people, who are cultural as well as political patriots, have experienced a humiliating fall from seeming superiority to an abject inferiority, followed by long-continued and fervent efforts at national revival, which now seem to be succeeding. When fully perceived, this will be one of the most dramatic stories of all time.

In the last 185 years the Chinese people have traveled a rocky road, beset by forces of change from both within and without. From outside have come five wars of foreign aggression, from the Anglo-Chinese Opium War of 1839–42 to the eight years of Japanese invasion, 1937–45. Though gradually mounting in intensity, these foreign attacks (except the Japanese) were largely superficial compared with the five revolutionary civil wars within China during the same era: the massive Taiping Rebellion of 1850–64 and attendant risings, all failures; the Republican Revolution of 1911, a change of polity; the part-way Nationalist Revolution of 1925–28 for unity against foreign imperialism; the Kuomintang-Communist civil war of 1945–49; and finally the ten years of Mao Tse-tung's Cultural Revolution, 1966–76, which was a climax both of revolutionary aspiration and of self-created national disaster. To get these various movements within a single view, against their background of social and cultural change, is a real challenge. Needless to say, I could not have attempted to meet it without the assistance of many other scholars, whose help is inadequately acknowledged at the end of the book. Primarily I have been able to put this account together because since 1936 I have been at the junction point between Sinology and history in one of the world's great graduate schools, where talent is motivated by the Ph.D. system to apply itself in a remarkably concentrated fashion. Book after book, especially since 1946, has built an edifice of knowledge and insight that now appalls beginners and dazzles an old professor. Into these publications in English has flowed a wealth of docu-

mentation and scholarship from China, Japan, Europe, and elsewhere. I have not been able to do it all justice, but I am consoled by the thought that, if I had, the result would be unreadable.

As the vicar said of the porridge, "It's pretty good, what there is of it; and there's quite a lot of it, such as it is."

April 1986 J.K.F.

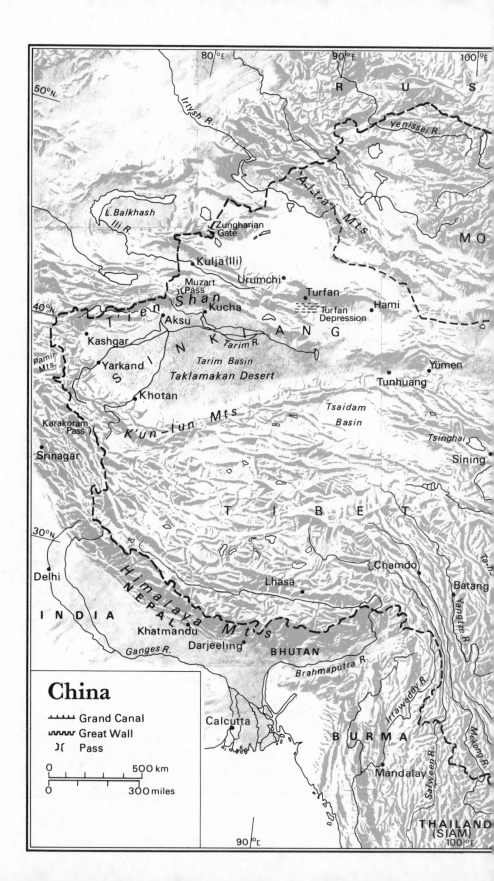

China

‒‖‒ Grand Canal
⌇⌇⌇ Great Wall
)(Pass

0 _____ 500 km
0 _____ 300 miles

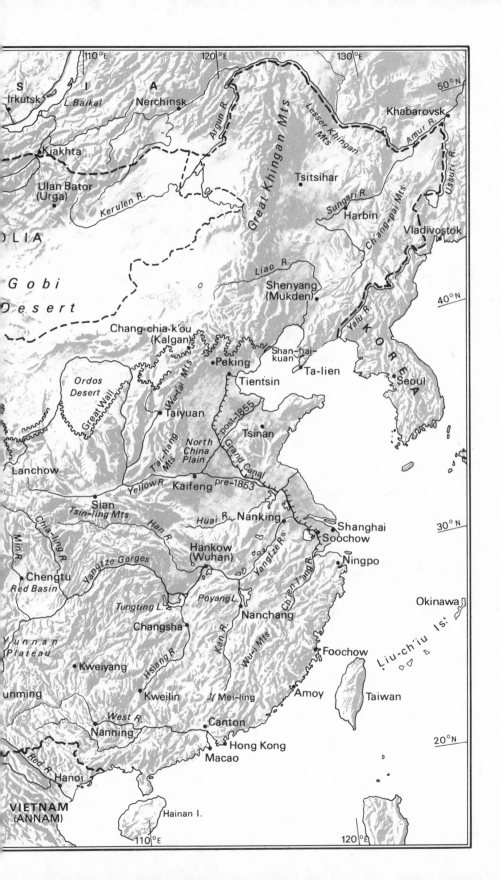

1

Understanding China's Revolution

FLYING ON INTO CHINA from Shanghai these days, one can see how close to nature the people live. The whole Yangtze delta, intricately dotted with lakes and crisscrossed by canals, is green cropland. Even its towns and villages are green with trees and household crops, and in place of motor roads the canals are silver thoroughfares of irrigation water. This delta has been the world's biggest food producer for at least seven hundred years. Until a century ago its "tribute rice," towed and poled in narrow barges eleven hundred miles up the Grand Canal, fed Peking. Today it feeds one of the world's most crowded cities, Shanghai.

Flying southwest from the gray metropolis one soon crosses hills that have been leveled piecemeal by terracing, so level that water can stand in the rice fields cut into their sides. Here man has rebuilt nature just as permanently as American roadbuilders in the Rockies, but without machines. The terraces are monuments to what muscles can do. The broad lakes south of the Yangtze that fill up every year when it floods are the inland seas that appear in Chinese landscapes. Though remote from the ocean, they make Central China truly a region of "mountains and waters" (*shan-shui*, the name for landscape paintings). Cloudbanks and haze make the lakes and mountains seem larger, limitless, and mysterious to the traveler privileged nowadays to see China from the air.

If on the other hand you fly northwest from Shanghai toward Peking you are soon traversing the dry North China plain. It is dotted with villages at roughly half-mile intervals much as our Middle Western wheatfields used to be punctuated by family farmsteads, each typically consisting of a white house and big red barn surrounded by a windbreak of trees. China's earth-walled villages also have clumps of trees, at roughly half-mile intervals. But, while the family farmsteads of Iowa and Kansas have been disappearing in recent years, the similarly spaced North China villages have had a demographic explosion. A village that used to have two hundred mouths to feed by intensive hand cultivation now may have three hundred or so. No scene can more poignantly suggest the overpopulation that keeps the Chinese people in poverty.

How are we to get an image of this China of a billion people? Superimpose it on a map of the U.S.A. and the two countries are roughly the same size. But, whereas the Mississippi drains our Middle West to the south, the Yangtze, a bigger river system, drains Central China to the east into the Pacific. Whereas our north-central prairie states in the last hundred years have become a new international breadbasket, the Chinese have trouble even feeding themselves. Much more of China is dry desert and jagged mountains. The cultivable land area is only about half what we have, yet the population is four times as large. China's poverty per capita is a first big difference.

The second difference is more subtle—China's continuity in the same place. The Atlantic civilization of Western Europe and the Americas has seen its political-cultural center move westward from Athens to Rome, then to Madrid, Paris, London, and New York. The corresponding movement in China has been only a few hundred miles, from Sian near the lower bend of the Yellow River south to Hangchow-Nanking, and north to Peking. All the historic sites of four thousand years of Chinese history lie close together. For us it would be as though Moses had received the tablets on Mt. Washington, the Parthenon stood on Bunker Hill, Hannibal had crossed the Alleghenies, Caesar had conquered Ohio, Charlemagne's crowning in the year 800 was in Chicago, and the Vatican overlooked Central Park. In other words, China's landscape is loaded with history in a way that ours is not.

American cultural roots, of course, go back equally far, to the classical antiquity of the Mediterranean, contemporary with China's

classical antiquity. But Americans descend from immigrants of re-
cent times who brought their cultures selectively with them into a
new land and so acquired two great advantages—a better ratio of
people to resources, and a greater freedom from the hold of tradi-
tion. This let us develop our forms of individualism. It also inspired
us to invent machines just at the dawn of the great age of technology.
The Chinese, whose technology had once been ahead of medieval
Europe, suddenly found themselves left behind. They are struggling
to catch up.

But here a third difference handicaps them, for they have been
obliged to modernize from within their own cultural tradition, which
resists change. The new technology of transport, industry, and com-
munications has been native grown in the West but a foreign import
into China. The railway age of the late nineteenth century, for exam-
ple, knit the American nation together; whereas China's age-old
network of lakes, rivers, and canals made railways less essential in
South China, while conservative fear of foreign encroachment
delayed the railway in North China. Again, our empty Middle West
became the world's breadbasket by mechanizing agriculture;
whereas the crowded Chinese had to keep on feeding themselves by
hand, every year transplanting the world's biggest rice crop from
seedbeds into paddy fields.

Meanwhile, the two great institutions that have held the Chinese
state together—the ruling elite and the writing system—have coex-
isted in mutual support for three thousand years. As early as 1850 B.C.
a military-priestly ruling class making records in an ideographic
script directed mass labor to build walls of tamped earth at the
ancient Shang dynasty capitals of Chengchow and Anyang (in pres-
ent-day Honan province). Hoe agriculture by the masses and the
collection of rents and taxes by the elite have typified China's villages
ever since.

A hundred years ago when the railroad and the McCormick
reaper were building our Middle West, they found no takers in
Honan province. The official class and their colleagues the local gen-
try, all trained in the Confucian classics, found no mention there of
steam power and mechanical reapers. How would the peasants oc-
cupy their time if they were not to hoe and sickle their crops? This
is still a fair question even for Marxist bureaucrats today in Honan.

Note that John Murray Forbes of the Boston firm of Russell and

Company decided in the late 1840s to take his profits out of the tea
and opium trades on the China coast because he could invest them
more profitably in the Middle West, where he organized the Michi-
gan Central Railway and then the Chicago, Burlington and Quincy.
In contrast, the governor-general in charge at Shanghai as late as
1876 purchased the first little twelve-mile railway opened by foreign
merchants from Shanghai to Wusung, and promptly had it destroyed.
This official (Shen Pao-chen) was a leader in trying to Westernize
China but, as he explained to the emperor, he could not let the
British have a joint railway ownership with China or even joint man-
agement; China must control her own modernizing, and moreover
the local feeling was violently against railways.

Incidents of this sort suggest that China's slowness to modernize
in material matters involving technology has been part of a larger
inertia, an understandable disinclination to change her social values,
culture, and institutions. These are deeply imbedded, products of
historical factors, some of which are still at work. Take first the natu-
ral terrain and human adjustment to it, that is, ecology. Early Chi-
nese civilization grew up in North China rather far from the ocean.
The most ancient Shang dynasty sites are in the region where the
Yellow River comes out of the mountains and starts its four-hundred-
mile trip across the North China plain. The contemporary civiliza-
tions of Egypt and the Tigris-Euphrates valley (Babylonia) grew up
on great rivers that connected with the sea, but the Yellow River did
not do so. Its course across the North China plain, carrying up to 10
percent of silt, had no valley to guide it. Dike building against its
tendency to flood over the landscape each season began quite early,
but the dikes only had the effect of elevating the river bed above the
adjoining countryside until such time as a dike might break and the
river could flood again. And so the Yellow River reached the sea
sometimes north of the Shantung peninsula and sometimes south of
it. It was not a great artery of transportation.

This landlocked condition of early China contrasted with the
cultures of the Mediterranean basin—the Phoenician sea traders, the
Greeks on Crete and the Peloponnesus and their antagonists across
the sea in Asia Minor, and then the Romans and their antagonists at
Carthage. The Atlantic civilization of Western Europe came into its
national flowering when the Italians, Portuguese, Spanish, English,
French, and Scandinavians, all of them gifted with peninsulas or

islands that connected quickly with the sea, inevitably became sea-farers. Commerce carried by water was an engine of national growth until eventually the European nations each voyaged overseas to establish colonies and empires in rather recent times.

While the European nations were exploding in this fashion, the Chinese people had imploded by filling up their beautiful country with a dense population. For the ancient Chinese there was nowhere to go overseas, no great rival states to trade with and suffer invasion from.

The Chinese implosion made use of rice culture to pack more and more people into the area of China proper. On a given plot of land a combination of rice and irrigation water used to produce a larger crop than the dry farming of millet or wheat. All that it took was many nimble workers, who lived on the rice crop but at a low level of productivity per person. Rice culture meant that the Chinese farmer used his mattock and water buffalo to prepare paddy fields in which rice was planted, transplanted, and harvested by hand. This rice culture was permanently labor-intensive. South China was also crop-intensive—other crops could be only marginal to rice. As a result government, landlord, and peasant were tied into a self-per-petuating stratification of roles not easy to change. Farming had to remain small-scale, forgoing mechanization and its economies of scale. Improved minor techniques and strains of rice could increase production and therefore population but not change the relationship of cultivator to landowner and tax gatherer. In contrast the dry farming of North China and Europe was more precarious, more at the mercy of natural disasters, but at the same time more amenable to diversity of cropping, concentration of central control, and large economies of scale. In less-populous Europe, moreover, the extensive dry-land farming began to use the horse, which prepared the way for eventual mechanization. All this made for a higher degree of change in social structure and polity.

The density of China's population had social consequences. Farm-ing was done by families in which patriarchs held sway. Without primogeniture, all the sons shared their patrimony. The Chinese individual grew up as part of a family collective, generally unable to go off to sea and either make his fortune or die of scurvy and ague. Chinese lived within the family system as its loyal creatures, very conscious of kinship relations and differences of status between gen-

erations and between the sexes. From very early times daughters married into other families, whereas sons brought their wives home into their own family. Women were the subservient element. Granted that such differences were only of degree and that ruling patriarchs and unfortunate daughters-in-law could be found in other societies, the Chinese society nevertheless by its crowding of families upon the land developed distinctive institutions.

Of these institutions the Chinese state was the most distinctive. In the most ancient recorded era the ruler of the state was the head of a dominant family lineage. He and his kin and assistants became skilled in the art of governing. Early on, the ruler acted as a shaman, who communicated with the ancestors and other unseen forces of nature. Aided by animal sacrifice, he consulted the ancestors on behalf of his people, as the oracle bones testify. Literacy appeared first in the oracle bone inscriptions that recorded the ruler taking the auspices and getting guidance from the ancestors. Thus the ruler from the very beginning was closely connected with the religious belief system and with the writing system. The state power that emerged, therefore, embraced and made use of the culture. The literate elite who could assist in government were normally part of the state apparatus. The result of China's implosion, in short, was a remarkable integration of state, society, and culture. While Confucius and the other philosophers of the Hundred Schools were trying to advise rulers as to how order could be achieved, they already had in mind the unity of society under one ruler as the best way to maintain the peace. The Western type of pluralism had less chance to emerge in China. No church could be separate from the state, nor could outlying provinces become separate nations.

Two major differences resulted from this situation. The first was that the ancient Chinese empire had to inaugurate the functions of bureaucratic government. Han dynasty officials were sent out to administer given areas for fixed periods and lived on stipends while remitting tax quotas under the control of a system of correspondence and central government surveillance. Bureaucracy permitted centralized rule but required the training of an elite to be officials. By the seventh century, when Europe was in the Dark Ages, the Chinese central government had created the examination system: applicants for official life indoctrinated themselves by mastering the classics and proving their loyalty to the principles of imperial

Confucianism. Meanwhile, they learned how to have the population control itself through "Legalist" systems of mutual responsibility and therefore mutual surveillance.

A second result of China's implosion was the early flowering of the arts and technology of civilization. The agrarian-bureaucratic society recruited from the whole talent pool an elite, who became chroniclers, artists, connoisseurs, philosophers, and functionaries. By the period of the T'ang and Sung dynasties from the seventh through the twelfth century, the resulting Chinese civilization seems undoubtedly to have been superior to that of Europe. The proof lies not only in Sung landscape painting and the neo-Confucian philosophy of Chu Hsi and others, but also in the long series of Chinese firsts in technology. As Francis Bacon long ago remarked, the three technical feats that were molding modern European history were printing, the compass for sea navigation, and gunpowder. All three first appeared in China. As Dr. Joseph Needham has explicated in a dozen volumes, there was a great deal of innovation in Chinese technology. The result was that China achieved a cultural superiority over all other East Asian regions, the after-effects of which have lasted to this day. A sense of cultural superiority is inbred in the Chinese people. This of course has made it all the harder for them to suffer the humiliations of backwardness in modern times.

To modernize, in short, China has had farther to go and more changes to make than most countries, simply because it has been itself for so long. The result has been a tremendous hold of inertia, which has made China's revolutionary changes spasmodic, sometimes inhibited, and sometimes destructive. If modernization can grow out of one's recent experience as it has in the United States, people are under much less strain than if modernization requires a rejection of the Virgin Mary and the Founding Fathers, a denial of the values of one's grandfather, and an acceptance of foreign models.

"Modernization," of course, never operates alone. Defined as a people's development of and response to modern technology, modernization is always interacting with the indigenous cultural values and tendencies. This means that while modernization leads to a degree of "convergence" of all countries, because modern science and technology are international influences subjecting all peoples to the same stimuli, nevertheless each people must respond in its own fashion, according to its inherited circumstances, institutions, and

values. On this basis China's revolution has now led to some conver-
gence of Chinese and foreign elements in a new Chinese cultural
synthesis. But do not jump to the conclusion that *they* are becoming
more like *us*. It can also be argued that under the pressure of num-
bers and uncontrolled social evils, *we* are obliged to become more
like *them*. Admittedly the modernization influences on China have
come thus far mainly from outside, but in the future that we all face
together, the balance may someday shift.

China will also figure in the underdeveloped field of comparative
world history. First of all, on the political plane, China is the oldest
surviving universal empire. It has usually been based on military
conquest of the agrarian society buttressed by bureaucratic adminis-
tration and a religious cult of the emperor. China under the Han was
contemporary with the Roman empire and rather comparable in
scope and achievement. In particular the rule of the Manchu dynasty
in China from 1644 to 1912 may be compared with that of the
Moghul dynasty in India from 1526 to 1858, with the Tokugawa
shogunate in Japan from 1600 to 1868, and again with that of the
Romanov dynasty in Russia from 1613 to 1917. It may also be com-
pared with the Ottoman empire from the 1300s to the twentieth
century.

Second, on the plane of world economic relations, the expansion
of Europe which opened the modern age was a response not only to
the spice trade with the East Indian archipelago but also to the teas
and silks, ceramics and other objets d'art and luxury goods of the
Chinese export trade. The fact that the Europeans were more mobile
and the Portuguese and Dutch opened the European trade with the
Indies and then with China and Japan indicates merely that the
Europeans were have-not peoples. The luxury goods and spices they
sought were in the Far East. By the time the Europeans arrived,
however, China's overseas expansion into the Nan-yang or Southern
Ocean was already under way. The bureaucratic-agrarian Chinese
empire had sent expeditions into Indonesia only in the period of the
Mongol conquests and did not follow them up even in the three
decades of the Ming exploratory voyages from 1405 to 1433. The
Chinese state did not colonize overseas, even though it was an easy
voyage to Southeast Asia with the monsoon winds. Chinese seafarers
and merchants, however, developed a lively trade between China

and Southeast Asia. After the Ming collapse in 1644 Chinese expatriate merchants assumed a leading role in the new state of Siam while others laid the foundations of family fortunes in Malaya and the Indies. Under the Portuguese and Dutch empires of conquest, the Chinese middlemen—local merchants, concessionaires, fiscal agents —became an essential part of the colonial scene. When Chinese cheap labor began to go as migrants to the Americas in the middle of the nineteenth century, they were only opening the later phase of this Chinese diaspora, which the Chinese state never tried to promote or utilize. Thus China came into the modern international trading world long before it deigned to enter the world of international relations and diplomacy. Obviously comparative world history gives us untapped possibilities for constructing the big picture.

Much of Western study of China has assumed as its target the whole entity "China" or "Chinese culture." This simplistic approach to the largest human group has come from several sources: the Chinese tradition of the (at least ideal) unity of the empire and the homogeneity of its indoctrinated Confucian values; the acceptance of this intellectual-cultural unity by the Jesuit missionaries, European savants, and early Sinologists; and modern Western interest in cultural systems, the Chinese being the most distinctive. From the outside and at a first rather ignorant approximation, the long-sought unity (superficial though it was) of the Chinese political realm could be assumed to exist also (as a model or ideal) in the social-cultural realm. The meeting of civilizations and cultures requires at first rather gross entities like "the West," "the modern world," even "modernization" and "imperialism," to say nothing of "nationalism." Only by large generalities can we begin to think and talk, especially in a great age of sociology.

All the above is at a high level of generality—the sort of thing we should learn in the eighth grade. If knowledge grows in the conscious mind from the general to the particular, from macro- to micro- deductively (as I would argue), then we should not be surprised at the relative absence of particularity in our mental image of China—a region stretching north to south as far as from Siberia to the Sahara and peopled by almost one-quarter of humanity. It says a good deal for our simple-mindedness that we can call this mini-universe "China" and then go on to look at France, Germany, Mexico, or the

U.S.A. as equal entities when they are actually all parts of Christendom.

However, the growth of historical social science (or social scientific history) is breaking down this simplistic approach to China as a single entity. This raises China studies to a higher level of complexity without changing the essential problem: how to think within one's own cultural milieu about life in another cultural milieu. Historians have always been up against this problem. It is now faced with more awareness and "China" is becoming fragmented accordingly.

This increase of wisdom among observers of China runs head on into a central myth of the Chinese state, one of the great preconceptions of China's political life—the belief in the innate unity of the Chinese realm (*t'ien-hsia*, "all under Heaven"). Let us note how this compelling concept developed. From ancient times the Chinese ruler had generally combined the functions of church and state by making himself both the moralist and the military leader, the exemplar of conduct and the dispenser of justice. His omnicompetence combined all the major functions of the state, including the state cult of the emperor who represented all mankind before the forces of nature. He was the One Man, the kingpin of the social and political edifice. By nurturing the image of the Son of Heaven at the pinnacle of the human scene, dynastic families learned how to centralize the strings of power and maintain a unified state as the best means to ensure peace, order, and prosperity among the people. This ideal of unity has persisted as the Chinese state has grown in population. Since this growth has posed serious questions not only of food supply and survival but also of organization and central control, it has increased the already onerous burden on the unified Chinese state today.

For proof, look at a global map. Something over a billion people live in Europe and North and South America. These billion-odd Europeans and Americans live in about fifty sovereign and independent states, while the billion-odd people of China live in only one single state. This startling fact has been a commonplace known to every high school student around the world but almost no one so far has analyzed its implication. It reminds us that, lacking a separation of church and state or a primary distinction between domestic and overseas, the Chinese state has been more comprehensive in its claims and expectations. Perhaps for that very reason it gradually

became more superficial to the life of the people. The central impe-rial power had to assume and permit the existence of a great variety of local conditions, from arctic to tropical, from wet to dry, from more to less populous.

In the last analysis, the European-Chinese difference was in the people's expectations. China was actually unified in its superficial fashion only about two-thirds of the time but unity remained the ideal. Europe was unified in religion and culture by all lying within Christendom (except for Arab or Turkish incursions), whereas the attempts at European unification were always thwarted by local sovereignties. No political unifier after Charlemagne, no Bonaparte or Hitler, ever succeeded, partly because he was not expected to.

All this points up the seldom acknowledged truism that anyone who tries to understand the Chinese revolution without a consider-able knowledge of Chinese history is committed to flying blind among mountains.

The current vogue of social history, describing how the common people lived and got on together, is surely to be welcomed and a stimulus to all historians. It would be a great mistake, however, to think that we know about the political events of Chinese history as we know about those of Europe and America. On the contrary, social history has absorbed our interest at a time when political history and the institutional history that goes with it are both still obscure in the case of China. We may compare the peasantry of France and Kiangsu or the merchants of Holland and Szechwan till the cows come home and yet never appreciate the greater drama in which they were playing their part. There is no substitute for building history on a factual basis of events and the leaders of events before one goes on to understand the common people. Not only did the emperor leave the principal record in China, he was also the most important person with the greatest influence. If we are going to make sense of the modern revolution we must start with dynastic rulers and how they came to power and governed China.

PART I

LATE IMPERIAL CHINA:
GROWTH AND CHANGE,
1800–1895

2

The Manchu Rulers' Outlook
from Peking

THE MANCHU OR CH'ING DYNASTY that ruled China from 1644 to 1912 was the climax of a long development of relations between the settled farmers and bureaucrats within the Great Wall and the sometimes expansive and conquering nomadic tribes of the Inner Asian steppe. Chinese foreign politics from the time of the Han dynasty and its contest with the nomadic Hsiung-nu had been concentrated upon the Inner Asian frontier. Tribal intrusions into the agricultural zone of North China began very early, well before the unification of 221 B.C. The Chinese state thus was born with a frontier problem and developed great skill in dealing with it in any number of ways.

The secret of the Manchus' rise and success in taking over China was the fact of their geographic position and ethnic composition on the fringe of the great Ming empire. Beginning as a tribal confederation of perhaps a million and a half people, the Manchus developed those precise features of warfare and politics that would bring success.

First of all they looked to the great tradition of the Mongol conquest. The Mongol tribes of the open steppe to the west of Manchuria had consolidated their striking power under the charismatic leadership of Chingghis Khan (Genghis Khan) about the year 1200. It is remarkable that the Mongols overran not only Central Asia, Persia, and south Russia but even advanced into Europe as far as the Danube

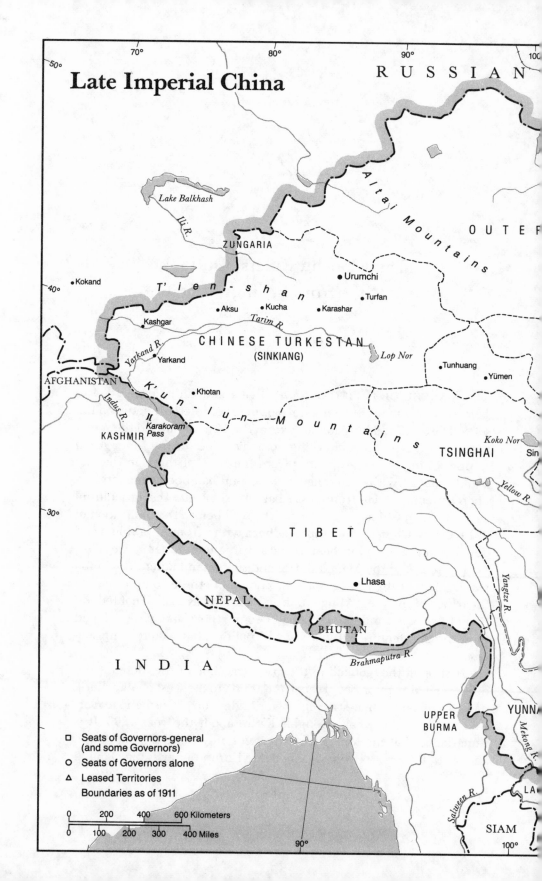

Late Imperial China

RUSSIAN

Altai Mountains

OUTER

Lake Balkhash

Ili R.

ZUNGARIA

Urumchi

Kokand

T'ien-shan

40°

Aksu Kucha Karashar Turfan

Kashgar

Tarim R.

CHINESE TURKESTAN
(SINKIANG)

Lop Nor

Tunhuang

Yümen

Yarkand R.

Yarkand

K'un-lun

Khotan

Indus R.

AFGHANISTAN

Karakoram
Pass

Mountains

KASHMIR

Koko Nor

TSINGHAI

Sin

Yellow R.

30°

TIBET

Lhasa

NEPAL

Yangtze R.

BHUTAN

Brahmaputra R.

INDIA

UPPER
BURMA

YUNN

Mekong R.

□ Seats of Governors-general
 (and some Governors)

○ Seats of Governors alone

△ Leased Territories

Boundaries as of 1911

Salween R.

LA

SIAM

0 200 400 600 Kilometers
0 100 200 300 400 Miles

70° 80° 90° 100

90° 100°

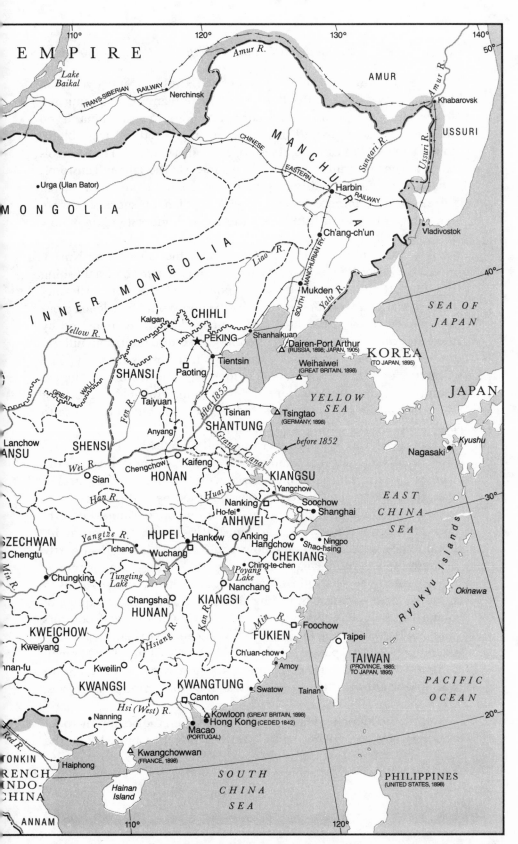

© George Colbert

long before they were able to conquer the Southern Sung dynasty in China. They succeeded only in 1279 by outflanking the Sung defenses along the Yangtze by a conquest of Southwest China. Even then the great emperor Khubilai Khan (reg. 1260–94) was able to found a dynasty in China that lasted less than a century. The Mongols were too entirely different from the Chinese in thought and customs. They were true nomads of the open steppe, not suited to a settled bureaucratic-commercial existence. Their Manchu successors were far superior in their institutions, strategy, and understanding of how to govern China.

A great Manchu achievement under the founding leader Nurhachi in the early 1600s was to create a nation in arms by establishing the Eight Banners as military components of the state. All able-bodied Manchu warriors became bannermen, but their lands were not concentrated in one area and their leaders were appointed by the emperor. Thus the tribes were integrated into nontribal military units that could be controlled and kept from breaking away. The stimulus for the banner system evidently came from the Mongol example, as did the Manchu writing system. Mongols to the west were in fact the first allies collected by the Manchus in their rise to power before the invasion of China.

Moreover, the Manchus were not full nomads but lived in a region of mixed hunting, fishing, and agriculture next door to the Chinese pale in southern Manchuria. Nurhachi began as a vassal of the Ming, and as the Chinese power declined he and his successors were able to build up their state on its frontier, out of Chinese control and yet incorporating Chinese administrators into their government. Finally they were able to take power in North China in 1644 partly because the late Ming weakness permitted a Chinese commander at the Mountains-Sea Pass (Shan-hai-kuan) to invite them in as allies to suppress rebels against the Ming. In their subsequent conquest of China the Manchus relied upon these early Chinese collaborators from South Manchuria, three of whom proceeded to lead armies and build up great satrapies in South and Southwest China. The Manchu conquest in fact was not complete until the boy emperor K'ang-hsi was able to suppress the great Rebellion of the Three Feudatories, 1673–81.

Third, the Manchus were thus prepared from the beginning to set up a dyarchy of Manchus and Chinese to govern China. While the

Mongols had used non-Chinese foreigners like Marco Polo as a privileged group in their administration because they could not trust the Chinese themselves, the Manchu emperors from K'ang-hsi on down were able to use the examination system in full force and recruit Chinese talent for a proper Confucian-minded government. The Manchu conquest, therefore, avoided a social revolution and the deposition of landlords. On the contrary it left them in place, providing they submitted. It built a Manchu-Chinese government on the foundation of the Ming government. The great Ch'ien-lung Emperor, who ruled for sixty years, 1736 to 1795, like his grandfather K'ang-hsi from 1662 to 1722, became a magnificent patron not only of Chinese fine art, painting, and poetry but also of literature and the imperial administrative compilations of laws and documents.

The agrarian-bureaucratic style of the Ch'ing regime was necessitated by its being directed by alien Manchu conquerors, whose first priority was by every means to hold on to power. The emperor's great campaigns were conducted not for reelection every four years but for the killing of rebels or neutralizing of dissidents wherever they could be found. The imperial revenues were singularly unmodern because trade was hardly taxed at all and the light land tax was parceled out among revenue-surplus and revenue-deficit provinces mainly to maintain troops and bureaucrats. The conquering dynasty simply lived off the country it had conquered. Economic development in the modern sense, other than maintaining flood control and granaries and mining copper for coining, seems to have been a materialistic concern quite beneath the dignity and probably beyond the technical competence of magistrates. They could get rich from fees and squeeze. Why do more?

It is noteworthy, however, and used to be underreported by Chinese historians, that the Manchus retained power partly by secret means. The Yung-cheng Emperor, who ruled between K'ang-hsi and Ch'ien-lung, perfected an "eyes-only" system of palace memorials by which he could receive secret communications direct from certain provincial officials and reply to them directly as his local informants on the provincial officialdom. In fact the flow of this correspondence became so great that about 1731 the emperor set up half a dozen top officials in a Grand Council to help him handle it. Revenues from imperial lands and monopolies remained beyond the knowledge of Chinese officials. All documentation for the emperor continued to be

written in both Chinese and Manchu, and some secret deliberations could be recorded only in the ruler's language. While Chinese and Manchus shared the high offices at the capital, Manchus functioned in the provinces only at the top level, as governors-general, usually brigaded with Chinese provincial governors, or as provincial army commanders. The Ch'ing rulers had still another string to their bow in the form of Chinese bannermen, mainly from South Manchuria, who were attached directly to the dynasty and could be used as especially reliable servitors in the imperial provincial administration. The Ch'ing court could rely also on bondservants *(pao-i)*, that is, Chinese who had been attached like slaves to the Manchu conquerors and whose success in officialdom was therefore owing to their masters. But behind the ancient court rituals lay a well-developed control system.

For financial security, the Manchu dynasty ran its own secret treasury quite separate from the salt and land taxes and other revenues that busied the Peking Board of Revenue. These separate funds were in the Imperial Household Department, which managed imperial lands, fines and confiscations, tributes and special taxes, and monopolies of furs from the Northeast and also of ginseng (a phallic-shaped root that was and still is the Geritol of East Asia). The Household Department also handled silk manufactures at Hangchow and Soochow, ceramic kilns at Ching-te-chen, and the customs duties on foreign trade at Canton—altogether quite a large flow of funds that the regular Chinese tax administrators never saw. The Imperial Household Department, for example, had a Secret Accounts Bureau, into which payments were made by officials guilty of peculation, in order to redeem themselves by sharing their profits with the rulers.

Peking troops and officials were fed by rice shipments from the Yangtze provinces via the Grand Canal. Thus special troops, special funds, and a special food supply all helped to preserve the Manchu conquerors' grip on China. But, seen in its context in the enormous society around it, the old Ch'ing regime shrinks in size to a thin stratum of tax gatherers, magistrates, and military who performed architectonic functions of a centralizing and supervisory sort but were peripheral to the life of the people.

The People's Republic even today impresses us as a vast, oceanic society governed by a superficial bureaucracy that is headed by a rather small selection of central power holders. The magnitudes of

people at all levels have enlarged, and top and bottom have been more closely connected by modern communications. But the old framework of a very few ruling over very many is still visible.

How the thin stratum of Manchu conquerors kept their grip on gargantuan China has always been a fascinating question. Of course they did it, like the British in India, by coopting the native ruling class. But, while keeping the Chinese local elite (gentry class) in place, they had both to stay on top of it and to steer their course so that the Ch'ing ship of state, on its sea of Chinese, did not capsize. They became so adept at hanging on to power that they catered to Chinese conservatism and delayed the rise of a modern order. China, to be sure, always absorbs her conquerors, but in the Ch'ing case it took 268 years.

The centrality of Mao Tse-tung's crystal sarcophagus in his mausoleum on the main axis of Peking was no accident. It continued the centrality assumed by the Sons of Heaven during the Ming and Ch'ing dynasties from 1368 to 1912. Going north from Mao, past the memorial to the revolutionary martyrs, you cross today the great square where 300,000 people can stand on numbered positions, and finally reach the red T'ien-an-men. Standing centered on the balcony of this Gate of Heavenly Peace, Chairman Mao paradoxically used to review his people marching for unheavenly class war. Today you can go still further north to the high red walls of the Noon Gate, from which Ch'ing emperors used to watch the kotows of tribute envoys and the dismemberment of rebels. Of the five barrel-vaulted tunnel entrances under this gate, the central one was used only by emperors, the one on the east by civil officials, that on the west by military, and the outermost ones by minor persons. Once inside the Forbidden City walls you face across the vast courtyard the great yellow-tiled Gate of Supreme Harmony, beyond which stand in sequence the three audience halls on their triple-tiered terraces of white marble. The three imperial thrones are on the central axis.

The east and west gates of the palace, close to the Noon Gate and southern wall, in imperial times were used respectively by civil and military officials coming for audiences or other business. Less imposing than the gates on the axis, their massive metal-studded wooden doors could nevertheless shut out the common people. By day they were normally open, each guarded by a score of Manchu troops.

At noon on October 8, 1813, more than a hundred desperate villagers from south of Peking gathered in tea and wine shops outside these western and eastern palace gates. They were believers in the secret sect of the Eight Trigrams (the ancient divination chart used in the *Book of Changes*). They worshiped the progenitor of all mankind, the Eternal Unborn Mother, and shared the faith of their sect masters that a great cosmic holocaust was about to destroy the world and that the Eternal Mother would send down the new Maitreya Buddha of the Future to save the faithful, beginning with them. They had learned to recite the secret eight-character incantation, "Eternal progenitor in our original home in the world of true emptiness," and had long discussed the Great Undertaking (rebellion) upon which they were now embarked.[1] The vague idea was that a few determined heroes could seize the palace, whereupon the people would rise. At a signal they tied strings of white cloth around their waists and as turbans on their heads, seized knives from under the sweet potatoes and persimmons in their peddlers' baskets, and rushed inside the gates. The east gate guards banged the doors shut after only five had got in, but about seventy made it through the west gate. Instead of pushing on toward the great forecourt that visitors today enter from the Noon Gate, these rebels rushed north toward the imperial residence area, the Great Within.

Once inside the palace maze of gold-roofed buildings, red doors, and paved courtyards, these untested, ignorant, and superstitious villagers were soon cut off and killed or captured. But not before the young Manchu Prince Mien-ning, attracted from his studies, had called for his fowling piece and bagged two of them. Government forces quickly suppressed this pathetic rising, which had also seized some North China villages and a county seat. In three months they killed "70,000" (i.e., an awful lot of) people, many by the ostentatious slicing process used to discourage traitors.

But Prince Mien-ning, who became the Tao-kuang Emperor, ever after retained a lively fear of the Chinese masses. Rightly so. By the time he died in 1850 the gigantic Taiping Rebellion was under way in South China, led by another sect, in this case a bastardized Christian sect, arisen among the populace. For, while the emperor played his cosmic role of centrality and sponsored a state cult of his person, the common people of China's peasant villages harkened to

other beliefs less concerned with social order, more romantically devoted to personal salvation.

In the early 1800s Chinese society consisted of some 300 million farmers whose deeply ingrained way of life set them apart from the city folk, the artisans, merchants, landlords, scholars, and officials who then made up the remaining 80 or 100 million of China's population. Modern times since 1800 have seen two revolutions get under way in China, centered respectively in town and countryside. Best known to us, because so fully recorded by the ruling class, has been the revolution to remake the Chinese state, using modern technology of all kinds to build an industrialized modern nation equal to nations abroad. Less known and more mysterious to us, and even to modern Chinese patriots, has been the social revolution within the mass of China's rural society. Here Mao Tse-tung became the final catalyst, a helmsman through stormy seas, unleashing forces of peasant protest reminiscent of 1813 and the mid-nineteenth century. No end to the remaking of village life is yet in sight, because the solutions to rural problems, the meeting of villagers' aspirations, are not yet assured. It is plain, however, that modern China's dual revolution began most concretely and consciously at the level of the state and its ruling class. The new ideas and modes of change only gradually filtered down to the people. Meantime the holders of power, the imperial officials and the local elite, made history the easiest way, simply by recording it. In fact their record centered on the emperor, what he decreed, his ritual acts. But here at the center the breakdown began.

His portraits show the Tao-kuang Emperor (1821–1850) as a sorry-looking little man with a long, narrow face. A contemporary missionary gossip called him "lank in figure and low of stature, with a haggard face, a reserved look, and quiet exterior"—altogether a taciturn individual, chiefly noted for his parsimonious efforts to keep the empire solvent.[2] The quickest way to point up Tao-kuang's inadequacies is to try to imagine him as the Mao Tse-tung of his day, the ritually venerated and supposed-to-be charismatic leader of the Chinese state and society, whose conduct set the style and whose ideas announced the way for all right-thinking people. Even from the great space-time distance of the other side of the earth 150 years later, one can see at once that Tao-kuang was no Mao Tse-tung.

Perhaps it would be more realistic and historically comparable to say that he was no Andrew Jackson, or most certainly of all, no Queen Victoria. Properly appreciated, this contrast begins to explain why China took so long to have a revolution. With Tao-kuang and his ideas in the White House or Buckingham Palace, the U.S. or U.K. would have had a revolution immediately, no doubt about it; but Tao-kuang reigned in China for thirty years, 1821 to 1850.

The first count one might now make against the Tao-kuang Emperor was that he was a Manchu, not Chinese at all. Chinese ethnicity, a sense of proto-nationalism, would lead within two generations to a full-fledged modern patriotism among the elite. The Manchus' days were numbered, as we can sagely remark in retrospect, yet their being the rulers of China, as already indicated, was not an accident. In fact we must posit the unpopular notion that in 1800 the "Chinese empire" was not as purely Chinese a creation as it seemed. It was in fact a Sino-"barbarian" empire, politically speaking, which normally included China and parts or all of Inner Asia. As one evidence note that the capital at Peking was on the far northern frontier of China, with about 95 percent of the Chinese people living to the south of it. But, though it was on the edge of China, Peking was at a central point, in military-strategic terms, between China, Manchuria, Mongolia, and the Northwest region on the route to Central Asia. Peking was not simply the capital of China, it was the capital of the empire of East Asia.

The outer world was deceived by the fact that farming within the wall had long supported a dense population of a hundred million or so and by the 1830s in fact supported about 400 million, while all of Inner Asia contained hardly more than 15 or 20 million people. For military and political purposes, this imbalanced picture was misleading. Inner Asia had long supplied horses and mounted archers that could win battles in China. More than that, it supplied warriors and power holders who had the tribal-dynastic loyalties of a small minority group. They had to be constantly on guard and cohesive in order to maintain their identity and keep their grip on power. In a word, a Manchu was on the throne in Peking because all of China's long history had given Inner Asian invaders a constant role in the power structure of China's government.

The Manchu emperors trained assiduously for this job. Their task was to be both Chinese and Manchu—so Chinese that the Chinese

literati ruling class of say ten million would accept them as proper Confucian emperors, so Manchu that they could control and lead their two to three million fellow Manchus.

They performed this bicultural feat so well that the Chinese accepted them as emperors of China. So did the Europeans. So indeed do some political scientists of today, innocent as they generally are of China's earlier history. Yet the traditions and institutions of alien rule in China are one essential ingredient for understanding why Chinese nationalism and the modern revolution were so long delayed. This is not a minor topic, nor should Han Chinese patriots of today be allowed to sweep it into the dustbin of history without confronting its implications.

As a prince the future Tao-kuang Emperor memorized the classics along with his brothers in the palace school, working long hours, strictly disciplined. When he became emperor in 1820 he was one man without an identity problem. His imperial role was unique in the realm. When he ventured outside the Forbidden City to his summer palace northwest of Peking, where thousands of Chinese and foreign tourists now jam the traffic, the emperor's palanquin moved at a smart trot on the backs of sixteen or thirty-two yoked bearers. Guards lined the route at short intervals, facing outward. All shop fronts, doors, and any windows were closed as for nighttime, while yellow sand was spread along the dusty street. The palanquin's curtains were drawn, like those of official limousines today.

Most Manchu rulers liked to get back to the informal ease of camp life by summering north of the wall in Jehol. Other than that, the emperor had a heavy burden of ritual ceremonies. "The emperor's responsibilities," K'ang-hsi had written in his day, "are terribly heavy, there is no way he can evade them. . . . If an official wants to serve, then he serves; if he wants to stop, then he stops. . . . Whereas the ruler in all his hard-working life finds no place to rest."[3] The point was that, unlike his officials who followed routines, the emperor also had to make arbitrary decisions. His choice of men as officials was as crucial for the Ch'ing administration as the appointment today of professors to tenure is for American universities, but he had the further problems of disciplining and promoting high officials, who were often on the take and gouging the people. The emperor had to be unpredictable and ruthless to keep his bureaucrats on their toes. In this respect his role called for a Mao Tse-tung type of cantankerous

willfulness, ever ready to sacrifice old comrades in the service of an imperious inner vision. Here again, Tao-kuang, once on the dragon throne, was less than draconian.

He had several major duties, first of all to keep the dynasty going by procreation. This was one thing he had to do in person. The aim was to produce princes in numbers sufficient to include a talented successor. The palace therefore contained a harem of young Manchu women selected by multiple criteria of origin, shape, texture, smell, and personality. Folklore written up and widely savored in unofficial histories described the One Man's bigger-than-life sexual routine: from among his concubines' nameplates, presented on a tray at dinnertime, the emperor selected one for the evening. Carefully cleaned and anointed, she was wrapped nude in a rug and carried on the back of a eunuch to the foot of the imperial bed, into which she then crawled from the bottom up. Folklore further described how eunuchs kept the time outside and soon shouted, "Time's up," in accordance with a dynastic rule aimed at preserving the emperor.

The great K'ang-hsi, during his sixty-year reign (1662–1722) had twenty sons and eight daughters who grew up. (Evidently female infants were sometimes "weeded out" as in Japan at that time. Boy babies had no superior "right to life"; they were simply more useful.) Ch'ien-lung had seventeen sons and ten daughters, Chia-ch'ing five and nine. Tao-kuang fathered nine sons and ten daughters.

In Tao-kuang's palace eunuchry had come down from ancient times as a means of having harems managed without questions about paternity. Eunuchs came mainly from North China and were manufactured by cutting off scrotum and penis, binding the wound with a plug in the urethra, and allowing no drinking water for three days. When the plug was removed, if urine gushed out, the eunuch was in business; if not, he would die fairly soon.

The Ming had had up to seventy thousand eunuchs in Peking, who built up a security system and wound up terrorizing scholars and officials alike. The Manchus were more strict, with fewer concubines and only about one to three thousand eunuchs. Nevertheless Tao-kuang had had palace eunuchs as his tutors, servants, and playmates. The beauty of a eunuch was that he was outside the family system and completely dependent upon his master. But, having been created by corrupting nature, he lacked social standing and might well go in for corrupt power grabbing within the palace. The Man-

chus avoided the Ming practice of using eunuchs outside the palace and employed Chinese bondservants (captured slaves) and Manchu or Chinese warriors (bannermen) instead.

Tao-kuang also followed the Manchu custom of avoiding the Chinese foot fetish. The Manchus preserved their identity partly by letting their women, who, before the conquest, had always done the camp work, leave their feet unbound. This lower sexual standard of living was a price they paid, without recorded complaint, for power over China. Tao-kuang came to the throne at age thirty-eight, and everything we know about his private life (which is next to nothing) suggests he was devoted, in the fashion of his time, to his empress, and on family matters (allowing for cultural differences) would have been at one with Queen Victoria.

Another imperial task was to keep the government going by supplying it with officials. Here Tao-kuang was the beneficiary of two millennia of Chinese inventiveness in the management of power— a heritage longer developed than that of any Western ruler except perhaps the Pope, who, however, lacked the Son of Heaven's breadth of experience in things like building a Grand Canal, commanding armies in Mongolia, and controlling the military by exalting civil officials. The Han dynasty had invented bureaucracy at a time when Rome was still using private individuals to be tax farmers and to handle public works. Bright minds continuously perfected the Chinese system. Long before Europeans had paper and printed books, the T'ang set up the examination system to produce candidates for officialdom who were thoroughly self-schooled in orthodoxy. This was as great an invention as representative government, which it preceded in time and has made largely impossible in China ever since.

The examination system took a man over a dozen hurdles in the space of twenty or thirty years. Those who emerged from it had lived an examination life so concentrated on the classical literature that they had made themselves a race apart. Scholars were typically unmuscular, aesthetically refined, and spoke a language intelligible only to their kind, a small elite trained in the principles of bureaucratic government.

About 500 B.C. Confucius had sought the moral basis for maintaining the social order. After the chaos of the Warring States (403–221 B.C.) gave way to the unified empire, the Han dynasty enshrined his

teachings amid the corpus of thirteen classics inherited from antiquity. Two thousand years later they still stood like a monument, buttressed by later philosophers and a mountain of commentaries. The only thing comparable is the Christian Bible, which however has a narrower focus and represents less practical experience. To find a Western equivalent of China's classical learning one would have to combine the Good Book with the Graeco-Roman classics. Here again, China's world was more unified.

To prepare for the examinations a boy began at age seven or so and in about six years memorized the *Four Books* and *Five Classics,* which totaled 431,000 characters. To develop a working vocabulary of say 8,000 to 12,000 characters, he memorized a passage of 200 characters every day on the average. Prepared also in the fine art of calligraphy with a brush, he sat for the county examination held in two out of every three years. Its five day-long sessions eliminated the dunces. He then took the three-day prefectural examination, which in turn qualified him to compete in the four-day *qualifying* examination. Strict rules governed all this: guarantors and teachers had to appear to back each candidate, his identity was carefully established, he was thoroughly searched, his papers were marked only by his seat number, his every act was monitored. He was allowed to go to the toilet only once in the day and so kept a chamber pot under his seat. Meanwhile, the examiners were kept sequestered for days on end until the results were worked out. Cannon shots and processions began the ceremony, banquets concluded it, honor accrued to the successful. They had now *qualified* as licentiates and could compete in the *real* examination system!

This lower level of licentiate degree holders totaled in the 1830s about a million men, who formed the bottom tier of the literati or so-called "gentry" elite. They were set apart from the mass of commoners in costume and privileged status. Magistrates were not supposed to have them beaten with the small or large bamboo.

So desirable was this elite status that the state found it could make money by selling it. And so about a third of the licentiates were actually men who bought their degrees with a money payment. This practice acknowledged that not all men of genius were literarily gifted, and if the examination system was to be the main channel for rising in the world, it had better let vigorous personalities make use of it lest they destroy it from outside. It was expedient to let a minor-

ity of merchants' and landlords' sons pay their way into the upper class. The degrees they bought were designated as purchased for all the world to see, and so they were contained within the system. Tao-kuang's need for funds led him to push this sale of lower degrees. He appointed the provincial directors of education who supervised the local examinations, and the hoary system seemed strong enough to withstand a bit of inflation. Men who would really become high officials still came up by merit through the regular exams.

These were at three levels—at the provincial capitals, at Peking, and finally at the palace. Every three years imperially commissioned examiners were sent to each province to head the big staffs that processed the thousands of candidates in the enormous examination compounds with their separate cubicles in row after row of long sheds. Elaborate security precautions, far beyond Pentagon levels, engulfed both the candidates and their examiners. Within the enormous compounds the hundreds of examiners were sealed into their areas with their food supplies for as long as a month. The separate cells in the long lanes of cubicles were bare except for three boards to use as shelf, desk, and seat. Into them the thousands of candidates took their bed rolls, food, chamber pots, ink stones, brushes, and certified writing paper, prepared to spend three days and two nights in succession. It took the first day to get everyone certified, double-searched, numbered, and settled. The first questions were distributed on the second day at dawn; the answers were delivered as the candidates came out on the third day. This routine was then repeated twice more.

Hundreds of copyists then copied all the papers in red ink, others proofread and certified them, and so the examiners never saw the originals while judging them. Candidates were known only by number, everybody watched everybody twice over, and the system was as foolproof and universalistic as one can possibly imagine. In general, out of ten thousand, a hundred might pass. Few camels passed through this needle's eye—unless they were camels of wealth and influence.

The candidates per province might total 5,000 or 7,000 or even 10,000 or 12,000 men, but the quota of degrees available—i.e., the number who could pass—might be limited to say 50 or 90. By setting quota limits, the government controlled the process and could keep the rich and cultured provinces from dominating the rest of the

country. Kiangsu, for instance, in centers like Soochow and Nanking, produced much of the talent, but its candidates could not exceed the quota; thus Manchu Peking could clip the wings of the rich gentry of the Lower Yangtze provinces, much as the American Congress in its national programs often tries to limit the influence of the eastern establishment.

What did the examinations deal with? Much dirt has been cast on the "eight-legged essay" style as a mental straitjacket. Adopted by Ming organizers in 1487, this style required a balanced, antithetic treatment of an essay topic in no more than seven hundred characters under each of eight major headings. The training was a bit like that for extempore debating in the Midwest not so long ago, when contestants as they came onto the platform were told to argue for the affirmative or the negative of a prepared topic. It was a training in form and verbal facility.

On the other hand, late Ch'ing examinations did not lack for substance. They tested both knowledge and moral policy judgment, like the *Analects* quotation used in 1738: "Scrupulous in his own conduct and lenient only in his dealings with the people." In 1870 at the provincial examination in Wu-ch'ang each of the 61 candidates who succeeded (out of some 8,500) wrote five papers: (1) on fine points of textual interpretation in the classics, (2) on organizational details in the twenty-four histories, (3) on the various forms of military colonies, (4) on variations of method in selecting civil servants, and (5) on details of historical geography.[4] A Cambridge tripos or Honour Mods. at Oxford seem almost trivial in comparison.

The built-in ambiguity of Chinese characters challenged the minds of those who used them. It was a weakness that produced strength, for the proper understanding of classical Chinese required a well-stocked mind, a grasp of context at all times, and a sophisticated imagination, greater than was required of Western schoolboys parsing Latin. It has been suggested that medieval Europe's lack of paper and printed books challenged the schoolmen and early university scholars to expound, define, and dispute great issues in speech, leading to a stress on logical analysis rather than mere quotation of authority. If such a notion is correct, we may also speculate that the very deficiency of Chinese writing, with regard to specificity of statement, made intellectual demands on the Chinese literati that produced first-class minds. They had to pick their way through a

minefield of ambiguities and recondite allusions. Ask any foreigner who has tried to translate Chinese classical poetry.

The examinations at the capital and then at the palace were even more hedged about with security to keep papers anonymous when judged and yet afterward be certain who had written them. Since scholars could compete any number of times, many kept at it throughout their entire lives. They were centered on examination passing like perpetual graduate students. Many passed one level only on their third, fourth, or fifth attempt. The father of Tseng Kuo-fan, the exemplary defender of Confucian orthodoxy against rebellion, won his licentiate on his seventeenth try, at the same time as his son. When Chang Chien of Kiangsu finally took top honors at the Peking palace in 1894 he said he had spent 35 years preparing for examinations and 160 days actually in examination halls. His was not an extreme case.

Out of this labyrinthine system, which I have barely begun to describe, emerged men about thirty-five years old who had spent at least a quarter of a century in the strenuous discipline of classical scholarship. This made them masters of the Confucian morality, which sanctioned the exercise of power. When appointed officials, they knew the words and ceremony that should accompany their every act.

But they also knew many colleagues and were in fact enmeshed in webs of personal relationships with teachers, examiners, same-year graduates, fellow provincials, and others, to say nothing of the swarms of relatives who had heard of their success and joyfully came to live off them. In short, the strictly impartial examinations produced finely honed talent, but the particularism of Chinese social life set the stage for corruption.

The examination system was inevitably biased in favor of those families that had enough means to educate their sons and also a family tradition of scholarship to spur them on. By the 1800s, however, the system was honeycombed by corrupt practices among conniving candidates (one might write another's paper), servants (who might be tutors in disguise), and examiners (who took bribes and played favorites). In short, any system in which men work together can be corrupted by them. The cribbing jacket of striped design, each stripe composed of the microscopic characters of the *Four Books,* was only one way to beat the system.

Unfortunately for the common people, the elitist classical education for the official examinations dominated the whole field of education. If villagers employed a scholar to teach a private school, he treated each boy as a potential examination candidate, with little thought for general or practical knowledge or skills like arithmetic that might help him in ordinary pursuits. Memorizing texts until one could "back" them (recite them from memory) left little time for explication or understanding of what was memorized. The hard-nosed missionary Arthur H. Smith called the process "intellectual infanticide."[5] In short, there was no formal education designed to meet practical needs among the common people.

Tao-kuang thus found himself up against high ideals and flawed performance. His Confucian government was supremely moralistic in aim and tone. It was supposed to represent the Son of Heaven's benevolent intent to give the people peace and order and thereby retain Heaven's mandate to rule over them. There was no legal problem here. The ruler could retain the mandate as long as he could suppress rebellion. It was a free political marketplace. This doctrine combined a bit of the European divine right of kings with the germ of a concept of popular sovereignty. ("Heaven sees as the people see" was the classic aphorism.)

The difference from representative government was that the office holder answered upward to the ruler more than downward to an electorate. Consequently the ruler's success depended on motivating and controlling his officials, and for this purpose there was found to be no honor or display that could provide more consistent motivation than the acquisition of wealth. As usual, an old saw summed it up in four characters: *tso-kuan fa-ts'ai,* "become an official and get rich." This is what kept the examinations the main channel for men of ambition. But it also meant that in hard times a contest might develop between the emperor and his officials, between state and bureaucracy. Which would get to keep more from the people?

Since the art of government lay in controlling bureaucrats, Tao-kuang used all the sophisticated devices his predecessors had created: He interviewed magistrates between their three-year tours of duty. He got reports from his censors, who regularly toured the provinces to pick up and check out the gossip. He had governors of provinces and governors-general (usually over two provinces) report

together and so assume responsibility for each other. Tao-kuang gave up his grandfather's custom of going on southern tours because they tended to bankrupt the areas passed through. But he made full use of the system of "palace memorials" from provincial officials sealed and delivered for the emperor's eyes only. By replying with his own brush in red on the document and returning it in the same manner to the memorialist directly, he could by-pass all others. This kind of correspondence with second-level bureaucrats could collect the dirt on their superiors without the ruckus of public whistle blowing. High officials, the higher the better, were not infrequently cashiered, disgraced, and packed off in chains when the emperor received proof against them.

Modern philosophers see in Confucianism a constant moral tension because one must try to do the right thing in a chaotic social environment that makes it all but impossible. Ch'ing officials could be tensed up for more practical reasons too. Their imperial lord and father was watching them.

Tao-kuang began the day's business at dawn with half a dozen or so high officials selected as his closest advisors. This decision-making body since 1731 had had its own seal as a "military plans office" but it considered everything important and is known to us as the Grand Council. It was an informal agency in the Inner Court, meeting inside the palace. This put it above the Outer Court, made up of the heads of the long-established Grand Secretariat and Six Ministries (or Boards).

These ministries had come down more than a thousand years from the T'ang and dealt with Personnel, Revenue, Ceremonies, War, Punishments, and Public Works. Each magistrate in the provinces had counterpart sections within his headquarters compound *(yamen)*. The Six Ministries were even more immutable and far more comprehensive than the G1, G2, G3, and G4 of the American army, but they provided a similar framework for the automatic division of labor. In comparison, most Western governments are simply a hodgepodge of ad hoc makeshifts. In fact the Six Ministries were so incapable of altering their elephantine routines that the emperor and Grand Council acted sometimes through them and sometimes around them. Thus they dealt directly with the top provincial authorities on all matters of importance, but left routine matters to the ministries.

Tao-kuang's edicts, usually in answer to problems presented in memorials, went out over the land by the horse post. This far-flung institution, descended from the T'ang and perfected by the Mongols, maintained some two thousand post houses at roughly ten- to thirty-mile intervals on the major routes extending northeast, northwest, west, south, and southeast from Peking. Tough couriers bound up groin, stomach, and chest to preserve themselves and used relays of horses to ride 200 or even 250 miles a day.

Sending the emperor's mail 750 miles in three days, as was done between Peking and Nanking when concluding the Opium War in 1842, puts the American pony express in the shade. In 1860 its riders used 157 stations to cover the 1,838 miles from St. Joseph, Missouri, to Sacramento but it usually took them about ten days.

Chinese officials and convoys of silver or official goods might proceed more slowly by the local foot post, a government transport service that might use mule carts and donkeys, or sampans in the South, camels in the Northwest. Putting up at government hostelries, officials would usually take a month or six weeks to get across China from the capital to Canton or to Chengtu in Szechwan. Thousands of documents were en route through this two-speed network every day, and thousands of clerks were busy scrivening, copying, and filing this freshet of paper. When the business of Inner Asia was piled on top of that of the eighteen provinces of China, the emperor and his councilors had little rest.

The Manchu rulers' skill in manipulating Chinese officialdom within the eighteen provinces of China proper was equaled by their very different methods for controlling other parts of the empire. Tibet, for example, under the rule of the Dalai Lama at Lhasa, had become an essential part of the Mongol world when the Yellow sect of Lamaism, a reform movement, spread its influence among the Mongols after 1400. To control the Mongols the Manchu rulers therefore became patrons of the Dalai Lama as a religious potentate and eventually during the eighteenth century sent troops three times into Lhasa to maintain Ch'ing influence. Meanwhile the Manchus had continued the astute Ming system for keeping the Mongols divided and at peace. They appointed or confirmed the appointment of all Mongol chiefs and princes. The tribes were organized into leagues and their boundaries fixed. Intertribal relations were kept under close scrutiny, and by patronizing the Lamaist church the

Manchus also supported a counterweight to Mongolian tribal politics. In this way it was made impossible for another Chingghis Khan to arise and unify the Mongolian peoples for conquest.

After Manchuria, which was kept in the north as a hunting land and preserve for Manchu tribal customs, the rulers in Peking had established control quite early over Mongolia and Tibet. It remained for them to achieve the conquest of Chinese Turkestan, the region east of the Pamirs, which includes the grasslands of the Ili corridor north of the mountains and the desert oases on the old silk route south of the mountains leading to Kashgar and thence to India or Afghanistan. The Ili region was the home of the Western Mongols, whom the Ch'ing defeated in 1696 but still had to invade and conquer in the 1750s. The Manchus' concern for this gateway leading across central Asia to the west had been inherited from the Han and the T'ang, the two strong and expansive Chinese dynasties that had extended their control along the caravan routes leading to Rome and later to Europe. The strategic importance of this area was evident to Manchu rulers in Peking who had grown up in the tradition of the Mongol conquest and preceding dynasties of conquest and were determined to keep their flank under safe control. Once they had defeated the Western Mongols in the 1750s, the Ch'ing closed their grip on Kashgaria, that is, the oasis trading cities of the Tarim Basin encircled by the world's highest mountains.

Here they faced the problem of dealing with Islam, which had spread eastward into Asia at the same time it spread westward through North Africa and into Spain in the seventh and eighth centuries. No people could have been culturally more different from the Manchus. The intensity of the Islamic faith made it subject to violent sectarianism and the mounting of holy wars against the infidel but also against deviant sects. The Ch'ing dispensation in Kashgaria was superimposed upon the ruling chieftains or begs, who were incorporated into the administrative hierarchy, confirmed in office, and given their special status and privileges. The Ch'ing also accepted the operation of Islamic law as handled by the church. By maintaining Manchu garrisons and offering the benefits of caravan trade with China, the rulers in Peking were able to maintain an uneasy control from a distance. Their versatility in making use of Confucianism, Lamaism, and Islam in different cultural sectors of their empire is evident.

One result of alien rule was a stronger monarchy that verged on autocracy. Whereas T'ang and Sung emperors in the era from 600 to 1260 had often reigned while letting prime ministers rule, from Mongol times the emperors ruled in person. Of course there were other factors than alien rule at work—like the growth of government problems requiring central decisions.

However, alien rule under the Manchus also produced conservatism, for the Manchus when they took over the Ming government left it largely intact, merely inserting a Manchu element into it at key spots in their control system. The Manchus innovated only in this defensive fashion, to keep things as they found them or control them more tightly. As aliens, moreover, they were less able to mingle with China's common people, more confined to contact only with their collaborators in the ruling strata.

Again, their strategic preoccupation with Inner Asia, in order to defeat or control all possible rivals for power there, kept them busy on the landward side of the empire, minimally concerned with the seaboard and its foreign trade. As tribal warrior-administrators metamorphosed into bureaucratic rulers over agrarian China, the Manchus were least in tune with the burgeoning commercialism of the Yangtze Valley and southeast coastal ports. Maritime trade and naval power were low among their priorities. They had little sympathy with entrepreneurs, kept their own people out of trade, and penalized anyone who went abroad. All in all, their influence seems to have been backward- and inward-looking, defensive and xenophobic.

One principal task for Peking was the administration of frontier trade with foreign peoples. This was handled through the device of the Chinese tribute system: The rulers of foreign states were classified as outer tributaries, more distant than the inner tributaries, who provided their annual quotas of support from the Chinese provinces and the peripheral states like Korea and Annam (Vietnam). The tribute system as a defensive diplomatic weapon was based on China's preponderant commercial wealth and attractiveness. Rulers close at hand, where Chinese armies might invade their domains, sent tribute to Peking regularly and might even come in person, accepting the Chinese terminology in their communications as well as the Chinese calendar. They and their emissaries performed the kotow and presented gifts, which were requited by the emperor. The

result was that tribute had become thoroughly mixed with trade. Under the Ming dynasty the astute Islamic traders of Central Asia had presented tribute from their alleged overlords when they traded at Peking. Ethnic Chinese, rice merchants in Bangkok, shipped rice to China under the guise of tribute from the Siamese king. The tribute system in short had become a stumbling block to egalitarian diplomatic relations in the European style. The British envoy Lord Macartney, sent in 1793 to open relations with China, had refused to kotow but had presented magnificent gifts, as did his successor, Lord Amherst, in 1816.

After 1800 the Europeans threatened China so basically because they did not accept Confucianism. Unlike China's barbarian conquerors, who had changed the ruling power but not the system, the Europeans believed in a pluralism of equally sovereign nations, whereas the Son of Heaven ruled by the tenets of imperial Confucianism. This alone was enough to keep China out of step with the pluralistic outer world, for the Confucian society was a hierarchy with the emperor at the top of the pyramid. He was in fact the last of the universal rulers of antiquity who had survived into the new era of nation states with his claims unimpaired, because he prudently chose never to push them too hard. Confucian principles of form *(li)* that imposed order on the material flux of the world *(ch'i)* made the emperor the keystone in the arch of social order.

Confucius' basic assumption had been that all men (he left women for later times to deal with) are by nature well disposed and have an innate moral sense. Men are therefore educable and can be moved, especially by virtuous example, to do the correct thing. A second assumption was that the ruler's virtuous conduct led men to accept and follow his authority. This principle of "government by virtue" kept Confucian-type rulers always very concerned to look good, and very upset by adverse criticism, especially in written form, which is so relatively imperishable. Instead of a welter of individual criticisms, an emperor preferred to have everybody on the team, helping to enhance his image as high priest in the worship of Heaven, filial son in the reverence of ancestors, supreme administrator and dispenser of justice, commander-in-chief, patron and even practitioner of arts and letters. Finally, he was the One Man whose ritual observances kept humanity in tune with the cosmos. What a man he had to be!

Being emperor of China, for all its burdens, was one of the world's

healthiest occupations. The Sun King, Louis XIV (1643–1715) dazzled Europe by reigning from the age of five, but ruled France, after the death of Cardinal Mazarin, from 1661 to 1715. The K'ang-hsi Emperor reigned from the age of eight and ruled China in person from 1669 to 1722. His grandson, Ch'ien-lung, after sixty years on the throne abdicated in order not to outshine K'ang-hsi, but actually held power another three years until he died in 1799. These two sixty-year reigns, each of them five times as long as the presidency of Franklin D. Roosevelt, gave China political stability—perhaps even too much.

Ch'ien-lung the autocrat had the major encyclopedias updated and brought all of Chinese literature into one great collection of 36,000 volumes, while purging it of 2,300 works he deemed unseemly. He put his seal on all the greatest paintings and published among other things 43,000 poems. He did nothing small-scale. In his last years corruption reached a new height. The sixty-five-year-old emperor began to dote on a handsome and preternaturally venal twenty-five-year-old Manchu bodyguard named Ho-shen, who soon became chief minister, married Ch'ien-lung's youngest daughter, and set up a systematic squeeze on the empire. By 1800 this organized corruption had metastasized throughout the bureaucracy and netted Ho-shen a fortune found to be worth perhaps a billion and a half dollars. Big money in 1800.

Ch'ien-lung set an unsurpassable standard and also bequeathed insuperable problems. His long era of domestic peace literally doubled the population without equally building up the administration of government. His "Ten Great Campaigns" to suppress rebels on the frontiers were followed by the nine-year rising of the White Lotus (1795–1804). The Ch'ien-lung reign was a hard act to follow and also to clean up after. His son the Chia-ch'ing Emperor (1796–1820) found things very difficult. For Tao-kuang they were to be a disaster.

To understand what happened to Tao-kuang's regime after 1821 we must begin paradoxically with a quick look at what earlier Western observers have thought happened. After all, history is in our minds. It is what we think happened. We can hardly proceed without examining our own preconceptions, the conventional wisdom that each of us brings to the subject. Let us therefore note certain interpretative tendencies among China specialists.

3

Some Theoretical Approaches

EVER SINCE THE EARLY SPECULATION that the Chinese originated as the Lost Tribes of ancient Israel, each generation of China scholars has offered its own idea of the nature of Chinese society. Even though vague or even unconscious, this accumulation of theories gives us most of our repertoire of interpretations. It is an interesting grab bag. We can best begin by noting broad categories.

First is the old tradition of "exceptionalism," which stresses the differences between China and the "Western" or outer world—for example, the Chinese writing system. Exceptionalism was for a long time the special turf of the Sinologue.

Second is the quite opposite "comparative sociological" approach now being vigorously asserted, which assumes that Chinese society has features comparable to those of all other societies—for example, a family kinship system. A subcategory of this view is the Marxist "Europeanization" effort, which tries to find in China the phases of European history—for example, feudalism and the rise of a bourgeois capitalism. Another subcategory is the patriotic Chinese effort to find "equivalence," which sees in China's past features similar to Western experience—for example, a "Chinese Renaissance" in the early twentieth century. All these approaches differ less about the main facts of China's history than about their interpretation, how they fit with other facts to make verifiable patterns of events.

On balance, comparison of Chinese with European history runs into many discrepancies. For instance, China's population doubled along with industrialization after 1949, but it had also doubled in the eighteenth century long before industrialization began. For another example, Chinese scholarship became more critical and independent after mid-Ch'ing but it failed entirely to question the basic assumptions of the inherited wisdom and create a new world view, as the Enlightenment was doing in Europe. Again, the French Revolution after 1789 glorified the nation state and violently expanded French power. In contrast, the Chinese revolution after 1949, though expected by outsiders to be aggressive abroad, signally failed to be so. (China entered the Korean War in 1950 essentially to defend her industrial base in Northeast China. In the India-China boundary hostilities of 1962, China simply defended her boundary claims.) Neither the social psychology nor the pattern of events proved to be at all similar in China and Europe. While the Russian Revolution is often compared with the Chinese, the differences are still striking: thus the Bolsheviks first seized the cities and then collectivized the countryside, while the Chinese Communists reversed the order, conquering the cities from the countryside. European comparisons offer little help in understanding China's revolution. This is one of Karl Marx's ideas that should have been given more publicity. It might have saved a lot of trouble.

With the above tendencies in mind, we can easily prognosticate that there will be trends of "revisionism" or reappraisal such as have appeared in more mature fields of modern history outside China. One such trend is to seek in earlier times the origins of well-known historical situations. Thus China's nineteenth century "backwardness" may be ascribed by exceptionalists to domestic causes, such as a failure of the Chinese state to lead the way in "modernization," whereas the Marxist-Leninist ascribes it to the external evil of exploitative "imperialism." This controversy of course hinges on matters of degree. The Manchu Ch'ing dynasty (1644–1912), for instance, lacked the values and institutional capacities to lead in modernization; at the same time the Manchus chose to prolong their rule by acquiescing in the imperialism embodied in the unequal-treaty system inaugurated in 1842. Again, the economic effect of foreign privilege in the treaty ports may be variously shown in some respects to have been "oppressive" and in other respects to have

been "stimulating" to native economic development. Imperialism was like a medicine that builds you up as it tears you down.

One comment applies to all such interpretations—they are at such a high level of generality that they take inadequate account of differences between one time and another and one place and another within China. This has stimulated studies of local histories in limited periods, certainly a wise move when dealing with so big and various an area as China. But this leaves the narrative historian who (perhaps anachronistically) tries to picture "the Chinese Revolution" up against great conflicts of evidence and interpretation. One can only say *"Caveat lector,* proceed with caution."

Another general tendency among modern historians of China has been to proceed from the better known outside to the less known inside, beginning with the "impact" of foreign relations and then looking for the Chinese "response" to this Western impact. The Marxist paradigm, for example, dates the modern period from the Opium War of 1839–42. Since this puts the ball in the imperialists' court as though outsiders were the dynamic element in the Chinese scene, revisionists have searched for the impact of China's past upon her nineteenth-century disasters. The notion of China's homeostatic or steady-state inertia, tending to continue in habituated ways, stresses the continuing influence of three thousand years of history. Understanding of the Opium War is thus to be found in the Ch'ien-lung period, 1736–96, when domestic difficulties beset the Manchu dynasty.

This being the present state of the art, we follow it here: China's great revolution of the twentieth century began with the disasters of the nineteenth, the roots of which lie in the eighteenth century. Of course this retrogressive way of thought could soon land us back in the prehistoric Shang dynasty (and indeed it will, in certain respects). But we want to correct the gross imbalance by which the center of gravity of China's history has seemed to lie in the hands of foreigners outside the country. Far from it! Disaster came because China, unlike Japan, was so unresponsive to the pull of Western gravity.

Revolutions in the Western world have occurred generally within the culture that gave them birth. In general parlance they have been primarily political, a change of the political system, which in some cases has made possible a change in the economic and social systems. I have grave doubts that one may speak of "revolution" in China

without forfeiting an essential point, namely, that China has undergone not only political, social, and economic revolution but indeed a transformation of the entire culture. This notion goes back to the assumption that the Chinese culture is identifiably different from that of Europe, which has influenced so much of the world. In the Chinese culture, for example, until very recently nationalism (political sovereignty within a common culture) has seldom been as identifiable as culturalism (loyalty to a way of life and thought). Like the Chinese writing system, the Chinese empire was unitary and all-embracing. These doubts lead me to think that the term "transformation" is a more precise term to describe what has gone on in China. However, I can see that, except in religious terms, "transformation" lacks the excitement of "revolution"—a term which I take to cover the entire historical process of modern times in China.

Each generation has its preferred explanation of Chinese behavior. Currently sociologist-historians have offered, as a general explanation of China's political weakness, a theory that the old Chinese society was organized in superior-subordinate statuses, or as some prefer, "authority-dependency" relationships.[6] People had more vertical relationships than horizontal. Of the five Confucian relationships only that of friend-to-friend was horizontal. Child rearing stressed authority. A young child was often pampered but at the same time strictly disciplined. Instead of self-reliant, he became reliant on others; a vertical relationship of superior-subordinate set up a mutual dependency between the two. In the end a Chinese youth was trained to act out a dependent role when he was in a condition of dependency and act out an authoritarian role when he was in a status of authority. The result was that if a person who was in authority did not act accordingly, ordering dependent persons about and demanding obedience, his authority status might be weakened.

This type of relationship in turn led the individual to stress his personal relations with others, not only superiors and subordinates but friends at his own status level, all of whom might be of use at some time. When security depended upon these relationships, the individual did not expect to stand alone. This in turn entailed the necessity of reciprocal conduct. Gifts or favors to a friend, superior, or subordinate set up an obligation of reciprocity, which might be called upon in the future. The result was to create a world of specific obligations to specific people rather than a concern for principles to

which other people subscribed in abstract terms. In case one had to choose, the personal relationships might win out over abstract principles.

The characteristic trait of the superior was to be domineering and arbitrary. This had of course applied particularly to officials under the old regime, in which official status was the top level. Combined with the taboo against muscular work by intellectuals, this had meant that the old-style officials should not acquire technical knowledge, least of all in mechanical arts, but should remain generalists who expected their subordinates to handle technical matters.

At the official level the training in literacy and classical learning led to the production of excellent documents, sometimes beautifully written in fine calligraphy, which, however, would not be pursued into action. Officialdom wrote and passed papers but expected others to implement their plans. The plans might be based on woeful ignorance but nevertheless would be circulated. Bureaucrats were more concerned with interpersonal relationships within their faction and its various modes of functioning than they were with its public accomplishments. A subordinate typically would refrain from giving criticism of a superior lest it threaten the superior's authority.

Corruption in the Western sense was therefore built into the Chinese polity. It was one of the prerogatives of office that the official should acquire wealth through his post as an official. This was consonant with the old Chinese custom of tax farming. All taxgathering officials had to meet a quota, after which they could keep the rest for themselves and their establishment. There was therefore no real opprobrium in waxing rich in office if it accompanied a proper meeting of tax quotas. Moreover, since the official's welfare depended upon those above him and others within his circle of personal relationships, he had no incentive for considering the welfare of those below him and not within his circle.

In this type of politics, therefore, factions devoted to principles were the exception. Factionalism was based on personal relations, and its purpose was to enhance the power of the authority figure and those dependent upon him within the faction. Factional rivalry was nonideological and very personal.

One result was to induce passivity in subordinates as well as in the mass of people below the official level. Authority figures should not and could not be challenged and consequently conflicts could not be

resolved by mutual discussion and compromise except at the village level within a peer group. Criticism endangered authority and was therefore unacceptable. Thus national unity required unity of ideology. Variety of thought would endanger it.

This interpretation of Chinese politics continues with the point that, because the old China was governed by ethics more than by law, an ethical consensus was a necessary glue to hold things together. For a Chinese government to succeed on the old basis required a sense of moral community exemplified in an orthodox ideology and upward-looking commitment to an established leadership with one person at the top.

This theory has relevance to local government in recent times. Down to about 1900 a sense of reciprocity between superior and inferior was evidenced in the relationship between the emperor and his officialdom, most immediately, and between the emperor and the upper gentry more broadly. (The upper gentry consisted of officials in and out of office, degree holders at the higher levels, especially provincial and metropolitan, and big landed families.) A similar relationship then obtained locally between the upper gentry, who still had roots in the villages or rural estates, and the lower gentry (possessors of the first-level degrees, some of which were for sale, the buyers being chiefly merchants). The lower gentry used their status as superior to the commoners in order to manage local affairs and superintend a great many public services, such as repair of walls and temples, management of ferries and of dike-building, upkeep of local temples, provision of food relief in time of need and similar managerial activities, often at the behest of upper gentry. The upper gentry, in short, having more official status and power, acted as patrons and supervisors of the lower gentry, who in turn handled public problems in the villages as superiors of the commoners. In the ideal picture, this continuum of ethical obligations and reciprocal duties stretched throughout the society from top to bottom.

The break-up of the old order in modern times began when modernization trickled down disruptively from city to countryside. The upper gentry, when they moved into the modernizing cities, had their land managed by professional bursaries as rent and tax collectors on their behalf from a distance. This trend produced a split between upper and lower gentry and left the latter more on their own and with more opportunity for corruption and fleecing of the peasantry.

By the twentieth century and especially after the abolition of the examination system in 1905, the local gentry became the strongmen and bullies at the village level, using their authority to levy increased taxes and fees. Their rapacity and self-seeking in turn estranged them from the common people. Instead of being patrons who recognized the reciprocal bond between superior and inferior, the lower gentry knew no law but their self-aggrandizement. Taxation thus became an increasing burden upon the peasantry as the twentieth century wore on. This led to a disintegration of the moral community and the political system erected upon it. New forms of organization had to be found.

Other interpretations of Chinese motives and behavior have been suggested. The theory above is currently popular—but of course it is no substitute for a knowledge of events as they unfolded.

Our narrative will now proceed through a succession of phases. First, in early nineteenth-century China tension grows up between new growth and old institutions, between the increase of people and trade and the hidebound unresponsiveness of government and scholarship.

Second, the impact of the ancient combination of domestic disorders and foreign troubles leads to a late nineteenth-century condominium between conservative dynastic government and foreign treaty-port privilege.

Third, when the era of imperialism reaches its height in the 1890s, movements for reform and for revolution begin to compete and interact. The competition is between modernization of material-intellectual life and the more slowly developing social change of values and institutions. Evolutionism and nationalism mark this groping for a new China.

Fourth, a seesaw develops between these efforts. The three revolutionary conflicts of 1911–13, 1923–28, and 1946–49 see interaction between the forces of material change and cultural change, between technology and values. The contest has been still under way in the People's Republic (1949–85).

The immediately following chapters will indicate how the late imperial government and social order met insuperable problems and began to fall apart in the face of growth and change within Chinese society.

4

The Growth of Commerce
Before the Treaty Period

WITH A LITTLE RETHINKING we can see how the Anglo-Saxon merchants of the nineteenth century failed to appreciate the sophistication of Chinese economic life. After all, the Anglo-Saxons were the apostles of material progress, which was the most exciting thing in their experience, and they found no plumbing and no steam engines in China. The imperial government did not make available modern statistics. The treaty-port foreigners did not speak Chinese, nor did they travel through the "interior," stopping in Chinese inns and having tea with local merchants in their guild halls. In effect, since the Chinese were deficient in firepower and other material improvements, the Western "China hands," with their limited vision of things Chinese, quite naturally succumbed to the ethnic arrogance of the Victorian era. They generally concluded that the sprawling, crowded, and publicly unclean China that they could see, smell, and hear was obviously "medieval" and consequently "backward." The China hands—merchants, missionaries, and consuls—were the primary observers in their day, and so produced the punditry of the time. The modern Western Sinologist working with Chinese and Japanese scholars is now pioneering in the appreciation in retrospect of the old China's achievements as well as weaknesses. We have no reason, of course, to conclude that the punditry of today on China will not eventually be superseded like that of our

predecessors of the nineteenth century.

The first corrective that comes out of recent scholarship is a reappraisal of imperialism. Hobson, Lenin, and others at the turn of the century were in the thrall of the materialistic interpretation of history served by the new science of economics. The idea of imperialist financial exploitation was strongest in the minds of the imperialists who aimed at the exploitation. More subtle effects, like modernization, technology transfer, the buildup of infrastructure and the spirit of nationalism were not of equal concern. In fact the record is now seen as very mixed. Imperialism might be truly exploitative in some situations but in others more like a crude form of development. Sometimes it was even materially good for you. The real bite of imperialism was psychological. It was most of all humiliating and therefore a political evil to any proud people.

Thus the idea of imperialism was a principal imperialist import into China. Note the curious imbalance it created in China's modern history. We can see successive phases:

1. The aggressive European powers recorded their martial exploits, from the British Opium War (1839–42), through the Anglo-French invasion of 1856–60, the Sino-French fighting over Vietnam in the 1880s, down to the Japanese victory of 1895 and the anti-Boxer invasion of 1900. A rich literature of memoirs and government documents accumulated on the foreign side. When H. B. Morse after 1900 pulled together the record on China from the British Blue Books, he quite properly called it *The International Relations of the Chinese Empire*. Yet it became the principal work on modern China, even having a chapter on the Taiping Rebellion because it figured in Anglo-French relations.

2. Modern Chinese historians began with Morse and progressed by getting at the Chinese equivalent of Blue Book history. A full century after the Opium War they worked out in the 1930s what instructions the Tao-kuang Emperor had given to Commissioner Lin when he negotiated at Canton with Captain Charles Elliot, whose instructions from Queen Victoria's government had been published ninety years before in 1840. The Chinese side was slow to catch up.

3. The imbalance of foreign over domestic was perpetuated. In the 1930s to 1960s when the governments of the day put out volumes of documents on "Chinese modern history," foreign relations stole the show. Obviously China's foreign relations had absorbed much

official attention and produced files easy to publish. But what about the actual experience of the Chinese society and state? Did foreign relations dominate it in fact? Or was it only so in the minds of foreigners and later Chinese patriots?

Our first problem is to stop looking at nineteenth-century China and seeing eighteenth-century Europe. To be sure, one's home-grown categories have to be applied to a new field of study, else we cannot analyze it, but this allows us too often to find (or not find) what we seek.

When we look at China in 1800 the first thing that strikes the eye is a remarkable paradox: the institutional structure of the society, especially the government, was showing little capacity for change, but the people and therefore the economy were undergoing rapid and tremendous growth. Until recently this paradox remained largely unnoticed. It may well be called a contradiction between substructure and superstructure. China's modern history began with the Opium War of 1840 both in the thinking of the Western powers that invaded China in the nineteenth century and also in the thinking of the Marxist revolutionaries who have represented the latest phase of that invasion. Early foreign observers noticed that the structure of government from Ming to Ch'ing had hardly altered, the tribute system for handling foreign relations remained active at least in the ritual forms of the Ch'ing court, and the government had not noticeably expanded or developed in comparison with what the Jesuits had reported three hundred years earlier. The result was a European impression of an "unchanging" China.

Recent research has made it plain that this was a very superficial judgment that applied only and mainly to institutional structures like the bureaucratic state and perhaps the family system. The facts of Chinese life were far otherwise. As of 1800 the Chinese people had just completed a doubling in numbers that was even more massive than the contemporary growth of population in Europe and America. With numbers came trade. Aside from some petty exactions by imperial customs collectors, the vast Chinese empire was a free-trade area, more populous than all of Europe. Production of crops for comparative advantage was far advanced: the Lower Yangtze provinces specialized in rice production while the provinces just to the north produced cotton for exchange. Craftsmen in many centers produced specialties recognized all over the country: chinaware at

Ching-te-chen, iron cooking pans in Canton, silk brocade from Hang-chow and Soochow. Enormous fleets of Chinese sailing vessels (junks) plied the highway of the Yangtze River and its tributaries, while thousands of others sailed up and down the China coast, taking southern fruit, sugar, and artifacts to Manchuria and bringing back soybeans and furs. One early British observer was amazed to calculate that in the 1840s more tonnage passed through the port of Shanghai at the mouth of the Yangtze than through the port of London, which was already the hub of Western commerce.

Exuberant growth and lethargic institutions bear upon one of the great conundrums of modern Chinese history—China's failure in spite of her high level of technology and resources to achieve a breakthrough into an industrial revolution comparable to that in contemporary Europe. This great contrast between China and the Atlantic community in the nineteenth century has given rise to various explanatory theories. One of the most widespread has been the "we was robbed" notion, that China's growth into capitalism was impeded by Western imperialism and its jealous and baleful repression of Chinese enterprise. This theory except among true believers has been exploded, not least because it assumes the primacy of China's foreign trade in her productive processes. To be sure the imperialism of the unequal treaty system after 1842 held China back in that a protective tariff was prevented by treaty while foreigners lorded it over Chinese in the sanctuary of the treaty ports. Amassing the numerous details of imperialist iniquity creates a quite adequate basis for patriotic humiliation and anger. But this by no means settles the economic problem. The non-emergence of capitalism in the Chinese economy goes back much further than the Opium War and the era of imperialism. The basic fact was that China could not increase her productivity per person and so break out of what has been called the "high-level equilibrium trap," the situation where a high level of pre-steam-engine technology remained in balance with a circular-flow of production and consumption that inhibited investment in industrial development. One part of this trap was the enormous muscle supply that made machinery unnecessary. Another reason was that there was little creation of credit or accumulation of capital available for investment. The dynasty and ruling class lived by tax gathering more than by trade.

In effect the China that entered modern times a century and a

half ago had achieved a high degree of homeostasis, the capacity to persist in a steady state. Like a human body whose self-righting mechanisms maintain levels of temperature, blood pressure, respiration, heartbeat, blood sugar, and the like within small ranges of normal variation, China's body politic and social had institutionalized a whole series of practices that would tend to keep it going along established lines: salt distribution seasoned the cereal diet, night soil fertilized the vegetables, pigs were raised on human offal, dikes prevented floods, government granaries ensured against famine. The mutual-responsibility system automatically policed the neighborhood, performance of family obligations gave security to its members, the doctrine of the Three Bonds tied the individual into the family and the family into the state, while the examinations inoculated the new talent with orthodoxy. The "law of avoidance" (that no official could serve in his native province) kept down nepotism. Rebels founded new dynasties only to perpetuate the system. This old China was an artful structure, full of local variety within its overall plan, decentralized in material ways but unified by a ruling class with a sense of form and a self-image created by history.

Let us begin by getting a picture of life in the village. The "average" peasant in the 1800s, if we guess from the data of later times, probably had a family of five, including two unmarried children and a parent. A big house with several courtyards, sheltering the nuclear families of two or three sons, was only for the affluent. A peasant dwelling had a beaten earth floor and thatched roof in the North, stone and tile in the rainy South. Northerners might all sleep on a wide mat-covered brick bed with flues within it for warming in winter. Universally windows were covered with paper, not glass. The latrine was next to or above the pig pen. Water came in buckets on a shoulder pole from a village well. Clothes were washed without soap by beating in well water or beside a stream, canal, or pond.

This "average" farmer probably was part owner-cultivator and part tenant. In any case he and his family worked three or four small strips of land at some distance from one another, carrying hoes or sickles back and forth, producing mainly for their own subsistence. Near cities and trade routes they might add cash crops. Their life was lived mainly in the village among neighbors from day to day, punctuated by regular trips to the market town, say, one hour's walk away,

where seasonal festivals, itinerant storytellers, or a theater troupe would enliven the year.

Not having been peasants, we are hard put to imagine their inner consciousness. We know the rational-superstitious balance was different and the horizon of concerns vastly more limited, but while the peasant's basic human feelings would no doubt be intelligible to us, there were other attitudes, social drives, and values that would be hard for us to grasp or accept. Supposing "human nature is the same everywhere," still its social manifestations may differ enormously.

Village neighbors, being fixed and lacking automobiles, played larger roles than city or suburban neighbors do with us. Communal activities included not only wedding and funeral ceremonies and the attendant feasts but also mutual arrangements for crop watching against thievery, and defense against bandits. In fact Chinese villagers formed associations, made contracts, and organized collective activities in many lines without reference to officialdom. These arrangements were normally among households and by being collectively accepted formed a legal structure. Thus families who claimed a common ancestor formed a lineage, and a lineage often held property to maintain graves and rites of ancestor veneration, or to keep up instruction in a school available for lineage offspring. Farm households might also join in irrigation projects and agree contractually on the allocation of water rights. They might agree to support religious worship in a temple or enter into a business enterprise to mine coal or sell sugar. A lot went on among the people beneath the notice of the state.

Another thing we know is that villages as units had a lively sense of self-interest, and violent feuds with neighboring villages often resulted, sometimes over water rights, boundaries, or other tangible issues, sometimes from more abstract causes of sectarian faith or accidents of personality or history. Sporadic warfare might result, one community, sect, or confederation against another. Such struggles focused on purely local issues far beneath the provincial, to say nothing of the national level. In short, violent strife, in regions so far studied, seems to have been built into the agrarian social system. The resulting slaughter of enemy villagers might be accompanied by pillage, rape, barbarous torture, and wholesale destruction. The bucolic life was often far from peaceful.

Like any human structure, Chinese society existed in tension, and

by the nineteenth century the equilibrium of its parts had grown precarious. First, the balance between land and people was upset by increase of numbers.

The mechanism of population growth in eighteenth-century China, when numbers more than doubled, is still largely unknown. Long-continued domestic peace had helped. So did quicker-ripening rice strains from Southeast Asia and new crops of maize (corn), peanuts, and sweet potatoes from America. The faster-ripening rice permitted more double-cropping. The American crops could grow in sandy margins where rice could not. Moreover, migrants from the eastern provinces opened up new land in the Northwest and Southwest, terracing hilly regions not formerly cultivated. The population as it grew produced more night soil to be used as fertilizer for the fields. Possibly diseases were better controlled, as by variolation to prevent smallpox. Other factors may still be discovered.

Behind the enormous further increase to about 430 million by 1850 lay the fact of a broad base of perhaps 150 million to start with about 1700, so that a very modest rate of growth was quite enough to crowd the landscape. Long-term motives included the Chinese love of children and investment in them as old-age insurance. It was a sacred duty to beget sons to carry on the family line and the pious reverence for its ancestors at the household shrine and in the clan temple. The well-to-do invested in secondary wives and progeny instead of the motorized equipment of today's household. More people meant more hands in the family economy. Thus conscience and calculation both led to more births. It was an uninhibited procreation like the spawning of fish in the sea, since marital sexuality was the last refuge of privacy and still (unlike today) the least-regulated activity in community life.

This growth of numbers was naturally accompanied by growth in the commercial economy. All sorts of economic indicators showed this: more junks plying along the coast; more banks set up by wealthy Ningpo families in the new port of Shanghai; more business for the remittance bankers of central Shansi, who almost monopolized the transfer of official funds; more exports of Fukien teas and Chekiang or Kiangsu silks by way of Canton; and more imports of opium to meet a craving for the drug that was in itself a symptom of demoralization.

Increase of trade, however, did not break out of the pattern of

government licensing of commercial monopolies and the limited aim of collecting tax quotas without encouraging investment for growth. Let us cite examples.

If one tries to name one commodity almost universally needed by the American people today it would, I suppose, be gasoline. In the old China it was salt, a dietary necessity for eaters of cereals and vegetables who seldom saw meat. To pursue the analogy (for what it is worth), the American oil barons of Dallas today would find their eighteenth-century counterparts in the salt merchants of Yangchow, whose opulent lifestyle was the envy of the age. Since the Yangchow merchants differed in being under the government, not independent of it, their history may be instructive.

To begin with, the government salt monopoly had come down from ancient times. In the early 1800s salt was produced variously by evaporation of sea water on the coast, by boiling brine lifted from hundreds of deep salt wells in Szechwan (some went a thousand feet down, with bamboo tubing), or from certain inland salt mines or lakes. Salt production was handled by monopoly merchants, whose hereditary rights supported wealthy families. These rights or *kang* allowed the monopolists to sell the product to distribution merchants, who managed the actual business of transporting salt under license. A shipment so licensed and registered could be delivered only to the point specified, where government depots handled the complex local distribution to the populace. Salt intendants in each province, in a complex, self-sustaining bureaucratic network, collected license fees and sales taxes at the main points of production and distribution. The Board of Revenue at Peking got about a sixth of its total receipts from this monopoly. As late as the 1890s, when the land tax and Maritime Customs duties were estimated at 32 million taels each, the salt revenue was estimated at 13 million.

The salt monopoly was a great device for accumulating merchant capital and at the same time for corruption between merchants and officials. One index to the vitality of the system is the reform urged by the scholar-official Wei Yuan in the producing region of North Kiangsu. In the 1832–33 reform the large monopoly rights of the *kang* merchants were supplemented by smaller shipments sold by a ticket system *(p'iao)*, so that smaller purchasers with less capital could function in the trade. Even so, by the time official salt reached its consumption market, its price had been raised by the successive

commission, transport, and handling charges, including the official peculation normal to such operations. This made a considerable incentive for smuggling. Perhaps half the total salt was illegally produced and distributed by smuggling gangs on more difficult, roundabout routes, but the cost of preventing this smuggling would have eaten up any gain in receipts. On the other hand, the smugglers could never take the government's basic profits away from it. So officials and smugglers coexisted.

In their heyday the salt merchants, organized in their own guild and with their own temple, were the leading social class in places like Yangchow or Hankow. As the most wealthy merchant stratum, they increasingly supported philanthropies and were called upon for contributions to flood control, defense, and other public enterprises. The reform represented by the ticket system in the early nineteenth century of course opened the door for private enterprisers on a smaller scale than the big hereditary monopolists. Bureaucratic control was reduced during the Taiping war, after which came what Rowe calls the "privatization" of the salt trade, part of a general trend.

Suppose your family firm *(hang)* had belonged to the Ningpo tea guild in the second quarter of the nineteenth century. Your best supply of teas would come from the Bohea Hills on the upper waters of the Min River upstream from the port of Foochow. Tea of course was produced in many parts of South China. A family farm might have its own tea bushes. But the combination of soil and climate in the Bohea Hills, plus the traditional skill of nimble-fingered young women in picking, sorting, roasting ("firing") and otherwise processing black and green teas (differently processed), allowed export to fastidious customers all over China as well as to the European East India companies at Canton. Batches ("chops") from local producers would be purchased by traveling buyers ("guest merchants," *k'o-shang*), who arranged for export from the region. In season, the long lines of tea bearers would have poles attached to their burdens so that, when they stopped to rest, the tea packages would never touch the ground. This was the scene explored in disguise by the pioneer botanist Robert Fortune, who in the 1850s collected tea plants for British India, where government quality control eventually let Indian tea eclipse Chinese tea on the world market.

Suppose your Ningpo tea firm had established its base of opera-

tions in the rapidly growing port of Shanghai. Ningpo was a much older emporium, a port for tributary trade with Japan in medieval times. Like Canton, Foochow, Shanghai, and Tientsin, Ningpo was situated several miles up a river so that its port could not easily be raided by pirates. As the trade expanded, the Ningpo tea guild, like Ningpo bankers, became prominent in Shanghai's domestic trade.

If you were shipping a tea cargo five hundred miles up the Yangtze to a trade center like Hankow, you would probably get a berth on one of the Lower Yangtze types of trading junks. Arriving in Hankow after many days, you would find a very busy port on the peninsula formed by the Yangtze and its tributary the Han River coming in from the northwest. Opposite across the Yangtze on the south would be the provincial walled capital of Wu-ch'ang, part of what is now called Wuhan. In Hankow you would deal with agents or brokers to sell and distribute your tea. The export of teas through Canton grew to twenty million pounds a year in the last days of the East India Company monopoly. Yet one could hardly conclude that the foreign export trade was more than one area of growth. Supposing a pound of tea supplied an affluent person for a year, the Chinese domestic market certainly had many more than twenty million affluent customers for the Bohea product.

One secret of China's domestic trade after the eighteenth century was water transport. Water routes north from Canton, for example, went over one or the other of two passes, with short portages to reach the river systems of Kiangsi and Hunan. Even in the arid North the Han River route went several hundred miles toward Sian, while in East China the Grand Canal became an artery of private commerce as well as official foodstuffs. China's muscle-power resources, used with the greater efficiency of water transport, could obviate the comparatively high cost of moving goods long distances by land.

Study of Hankow, the most commercial part of the three Wuhan cities, illustrates commercial development, since Hankow was a focal point of exchange on trade routes coming from all parts of China: (1) The route by the Hsiang River in Hunan brought spices and other tropical products that reached China through Canton, as well as some of the woolens that the British East India Company was obliged to unload on the Hong merchants, who found little use for them in the local heat. In return down this route, Canton received rice from Central China. (2) The Upper Yangtze route above Hankow used

different vessels, and so the rice from Szechwan for the Lower Yangtze was often transshipped at Hankow if not Ichang. The timber production in Szechwan eventually gave way in the late nineteenth century to Szechwan opium destined for Shanghai. (3) Up the Han River to the Northwest went brick tea for the overland trade to Russia. The lower reaches of the Han were a cotton-growing area. (4) Hankow's major trade, of course, was down the Yangtze, shipping Hupei and Hunan rice to help feed the Lower Yangtze cities and contribute to the rice shipments that went up the Grand Canal to Peking. From the Lower Yangtze came the salt shipments collected at Yangchow from the coastal producing area north of Shanghai. Rice and salt were both essential to the Chinese diet.

The extensive exchanges through Hankow argue for the thesis that by the middle of the eighteenth century if not before China had a genuine national market, in which supply from any sector might meet demands from anywhere else. Of course this applied only to certain commodities. The cellular self-sufficiency of local areas still characterized most of the economy. Like the beginning of the Renaissance in Europe or the onset of a commercial revolution in China, the date when a national market emerged depends on what weight you give to what evidence. The rise of China's national market can be measured by the growth of specialized merchant groups, such as wholesalers, retailers, itinerant peddlers, all overlain by a stratum of brokers and commission agents, who offered their services to principals at a distance in the interregional trade.

One symptom of the rise of commerce had been the proliferation in the eighteenth century of native-place associations, generally known as guilds, which were set up primarily to facilitate merchants' activities. Most guilds represented counties or prefectures (groups of counties) rather than whole provinces. Other guilds were devoted to certain trades, and sometimes the two were combined, as in for example the Ningpo teamen's guild. The guild provided the facilities of a hostel, a meeting place, an acknowledged membership, and a capacity to represent group interests, as in organizing a boycott or registering complaints. Another guild function was arbitration of commercial disputes, and trade guilds also of course provided warehouse facilities. They were entirely unofficial agencies, though the officials might acknowledge their existence.

A guild hall would be a series of buildings surrounded by a com-

pound wall, not unlike a *yamen*. The formal entrance would lead
through the major halls for meetings and observances, while smaller
quarters along the sides provided work and living space. The cultural
functions of guilds included religious veneration of the patron deity
or historic figure reverenced by the guild. The Hui-chou Guild at
Hankow had as its patron Chu Hsi while the Shao-hsing Guild had
Wang Yang-ming. Thus the merchants honored these idols of the
scholar-class.

The facilities might include not only dormitories for people pass-
ing through but also schools for education in preparation for exami-
nations, and possibly an opera stage. Guilds took on the regulation of
commerce in place of the local government. In certain matters the
entire guild might act as a unit, for instance in setting regulations or
in guild boycotts. In fact guilds did about everything except indus-
trial production. Both Rotary and Kiwanis, if they had functioned in
the old China's commercial centers, would have been considerably
impressed.

Guilds were financed by entrance fees. They would also make
investments in real estate, and money might be raised by a bond
issue. Rent from shops and other properties might be considerable.
The Shensi-Shansi Guild at Hankow had a fine temple and hostelry
and rebuilt a section of the city, from which it collected valuable
rents. After the Taiping Rebellion the entire complex was rebuilt.

Guilds served the community in a variety of ways. Philanthropic
activities were important—providing food for the poor, taking care
of public thoroughfares, building bridges and improving the water
supply, assisting in firefighting, including the construction of fire
lanes where buildings would be removed (the firemen would use
water-pumping equipment). In time of need they contributed to
local defense. All of this represented Confucian "public-minded-
ness." Thus the guild organization moved toward providing munici-
pal services as a responsibility. They were still another symptom of
the strength of the private merchant community.

Between organization by place and organization by trade, the
guild system presented an extremely complicated and internally
differentiated structure. During the nineteenth century the creation
of trade guilds was the major area of growth in the system. As time
went on the combination of native-place guilds with others from the
same general area produced larger structures. The spurt in growth

of guilds, for example at Hankow, in the late nineteenth century was a new phase in a domestic development long under way.

Naturally the whole guild structure sought official recognition and patronage. In fact the cultivation of official connections was essential for their welfare. Many merchants acquired gentry status by purchase of degrees if not by examination. Inevitably the major guild organizations in a city might band together in a larger organization by a system of linkages or confederations. Guild alliances proved most useful in affecting economic policy, if necessary by boycotts. All this verged upon a kind of municipal government, especially in a time of common need as in the Taiping Rebellion (1850–64).

From this background it is easy to see that the Chinese chambers of commerce that were put together in the 1900s as innovations were little more than a further stage in the kind of merchant-gentry municipal organization that had already grown up. Thus we can conclude that, while the Western impact gradually mounted to become unsettling in the 1890s, before that time there had been a natural domestic growth of private commercial-social organization. This trend included the increasing dependence of the state on revenues from commerce together with less-stringent regulation of it. This latter relaxation of regulation was part of the provincial officials' effort to raise greater revenues from an expanding local trade.

In the nineteenth century the organization of trade was getting beyond the family firm, and true partnerships suggestive of joint stock companies were being set up. Their trading operations had to pay great attention to the multiform Chinese currency system, in which each locality and each trade might have its own unit of account, the differential ounce of silver (tael), that required a lot of bookkeeping. Economists, to be sure, revel in aggregate data, but such are unavailable for 1800. While we can cite evidence of tendencies toward a national market, we lack overall statistics to position it on a scale between medieval and modern.

Not unnaturally the British and American merchants at the new treaty ports (which entered into their heyday after the Taiping Rebellion had been quelled in 1864) attributed the growth of trade to their own influence as an arm of the world market. This view was no more wrong than the usual foreigner's preoccupation with his own small picture of China. In fact, however, the rise of treaty-port trade in the late nineteenth century was in large part a revival of the

vigorous commercial life already present in pre-Rebellion China.

For example, the brick-tea trade to Russia in the modern centuries was only a continuation of the tea-for-horses exchange with the Mongols as early as the Sung period. In short, tea had been a principal export to the barbarians long before the arrival of the East India companies by sea. As a commodity produced in some regions but consumed in all, tea had at one time lent itself to government monopoly. The natural instinct of Chinese officials in late imperial times was to get it under some sort of license control by setting up monopoly merchants who could collect an official tax. Chinese licensed monopolists were of course anathema to the foreign traders of the new free-trade era and were the subject of much consular correspondence with local officials. The actual regulation of the trade, in which tea samples might greatly vary from the consignments received and quality control was therefore a principal task, was undertaken by the tea guilds themselves. One of their functions was to maintain standards in the trade and ensure its regularity in opposition to the get-rich-quick operations of Western entrepreneurs. The failure of the Chinese government to step in and ensure nationwide quality standards for the tea trade led by the twentieth century to Japan and India taking the world market away from China. But in retrospect this failure looks like a result of the decentralization of China's economic life, in other words the domination of trade by the private merchants organized in their guilds. In any case the maturity of merchant organization under guilds did not produce entrepreneurs intent on investment in industrial production. Quite the contrary, it was probably a disincentive to European-type capitalism.

One essential for industrial investment is the availability of credit, but here again China's undoubted development had its limitations. The credit structure that facilitated China's domestic commerce began at the lowest level with the pawnbroker and usurer, sometimes the same person, who provided small sums to people in need. At the top level before the arrival of foreigners, the transfer of credit as well as of official funds interregionally was handled by the remittance banks that centered among families in the Fen River Valley in Central Shansi. By establishing nationwide branches, often tied in by bonds of kinship, a Shansi bank in one region could receive funds and issue an order on a branch bank in another region, where the funds

in question would be made available at a slight discount for the transfer charge.

In between these top and bottom levels were several categories of large and small money shops or "native banks," as the foreigners called them *(ch'ien-chuang)*. The small ones might serve merely their local residential communities, but the large ones were usually connected with chains of native banks extending along trade routes or between major cities. Such chains could, of course, be most easily set up by the natives of one place, such as Ningpo or Shao-hsing in northern Chekiang, whose banking connections stretched up the Yangtze from Shanghai and along the coast. These intercity banking networks expanded with the growth of trade. In the open competition among them, many banks might issue their own bank notes in the absence of legal tender of the realm authorized by Peking. In other words, the native banks created credit by issuing their bank notes to merchants and even officials. They knew, of course, that a certain portion of specie must be held in reserve, but the amount of the bank notes they issued to a customer might be far greater than his deposit with them. The bank notes' value was stated usually in terms of silver or copper cash and they were payable to bearer. Of course this system led to the evil of speculation on credit and possible bankruptcy of the creditor as well as the speculator. But, in this era of premodern conveniences, city residents were not numbered and ticketed by a watchful government, and a defaulting banker might simply close shop and disappear in the crowd. Efforts to police the banking system and punish defaulting speculators were regularly made by government officials in the light of their duty to respond to citizens' complaints. One major device for regulation was the requirement of guarantors in the traditional Chinese manner, men of substance who stood surety for a given banker as they did also for merchants. At the same time the bankers' guilds in common self-defense tried, through their members, to curb fraud. Along with this the banking guilds took on the supervision of credit, including the setting of the local rate for different kinds of units of account or taels. Thus the effort was made to regulate the anarchy of the credit market.

In this way Chinese commerce by the early decades of the nineteenth century was being facilitated "through such innovative services as bills of exchange, deposit banking, book transfers of funds

between depositors, overdraft credit and . . . negotiable and transferable credit instruments."[7] Banking was another of those "old Chinese customs" that was undergoing rapid development before the treaty ports were opened.

However, this growth of production and consumption seems not to have appreciably changed the productivity per person, the increase of which is a key to the development process. The withdrawal of capital from current consumption and its allocation to purposes that would improve productivity might have begun with the infrastructure, like the building of telecommunications, roads, and eventually railroads, or it might have been put more directly into heavy industry, which requires a large initial investment. This is the kind of investment that the developers of Meiji Japan were able to achieve, but it was not achieved by the late Ch'ing Government or even the provincial leaders, much as some of them tried. One can only conclude that China was too stuck in her old ways, which were marked by growth in volume of people, product, and exchange, but not in the efficiency which constitutes productivity per worker, which in turn amasses capital for investment in the modern mechanized type of economy. The growth of population and of commerce began by simply producing more of the same. There is much evidence of the increased activity of the private sector in economic life and of the development of a credit system which would later be susceptible to a centralized use for investment. But meanwhile more people meant more muscles to use instead of machines—cheap labor power—which was probably a disincentive to radical innovation. To the availability of cheap muscle power was added the widespread incidence of monopolies, corruption, and ostentatious consumption as alternatives to productive investment.

If we compare China with Europe in the early 1800s, strong contrasts at once emerge. The eighteenth century, to be sure, had seen rapid population growth accompanied by an increase of trade in both areas. But, while Europe in the 1790s was in the throes of the French Revolution and its militantly innovative aftermath, the Chinese empire was chiefly beset by the White Lotus Rebellion of 1795–1804, a purely traditional peasant-based rising that foreshadowed dynastic decline but nothing new. Contemporary Europe had also accumulated the ingredients of the Industrial Revolution, when machines greatly increased the productivity of capital and labor. Some

have tried to find a process at work in China comparable to Europe's "proto-industrialization." But evidence does not support this search for China's equivalence. The "putting-out system" for cottage production of commercial goods for a merchant, for example, was far from a new development in early modern China, and at all events it would not necessarily lead to a higher stage of economic organization, namely capitalism. On the contrary, China remained stuck in its labor-intensive circular-flow economy at a high level of pre-modern, muscle-powered technology. In the course of time commercialization might conceivably have led on into industrialization, but it had not yet begun to do so.

However, recognition of the growth of commerce and of the private sector in China, before the foreign incursion under the unequal treaties of the 1840s and '50s, is a significant finding. It puts the Western "opening" of China in a new light. It cuts the foreign invader down to size, reduces the importance of the long-assumed "Western impact," and gives late imperial China its due as a society not static but in motion. The primary fact was that economic growth was principally if not wholly in the private sector, leaving the government behind and more superficial than ever. As we have always suspected, China's center of gravity lay within, among the Chinese people, and that is where the ingredients of revolution accumulated.

5

Problems Within Chinese Society

ECONOMIC GROWTH naturally had its social and political effects. These were evident in the increase in unemployed literati, peasant migration, official corruption, military weakness, and social cleavages among the people. Out of all this came a generation of rebellion.

One contribution to the Ch'ing Government's downfall was its failure in the early nineteenth century to keep up with the growth of population and commerce by a commensurate growth of government structure and personnel. For example, the government did not raise the provincial quotas of successful degree holders who could emerge from the examination system. Originally these quotas had been set to maintain some kind of geographical balance, so that the great preponderance of the degree holders would not be from the Lower Yangtze provinces—not unlike arranging membership in the U.S. Congress so that all areas would be included. But, as the number of talented men capable of achieving degree status increased, the rigidity of the quotas closed the door to many of them in their effort to join the government ranks. One result was an increasing effort to attach such talent to the government in the form of advisors *(mu-yu)*, deputies *(wei-yuan)*, and expectant officials *(hou-pu,* "waiting to be appointed"). But this only increased the competition for preferment without increasing the efficiency of ad-

ministration. The institutional structure of government failed to expand until later in the century.

One effect of this limitation of upward mobility was that a myriad of young literati seeking office became frustrated hangers-on of the government offices or *yamen,* where staffs were swollen and job competition induced all sorts of bribery and corruption. Personal favoritism began to skew the procedures of administration and deny the Confucian ideal of devotion to principle. Personal cliques and patronage networks began to upset the impartiality of the examinations, taxation, and justice. Squeeze took over. Since provincial officials were normally tax farmers, expected to produce established quotas of revenue and keep the surplus for their own expenses and profit, whenever the officials' morale was low, they would gouge the people unmercifully. This official rapacity, inflicting hardship upon the common people, began to rouse rebellion.

Growth of trade did not mean peasant livelihood improved. On the contrary, numbers of the destitute and unemployed from crowded areas migrated to marginal lands in the mountainous West and Southwest, where government was thinly spread. The famous but little-studied White Lotus Rebellion is one example of this trend. China's population explosion had led farmers to move into marginal areas as well as into the new frontier of cultivation in Manchuria. In the mountainous region where Hupei, Shensi, and Szechwan meet, settlers from Central China had newly established themselves, extending the scope of Chinese rice cultivation in a comparatively unproductive peripheral region. The White Lotus Rebellion that arose in this area had certain classical features: it was inspired by a secret Buddhist folk religion that believed in the Eternal Mother. However, the various leaders (some of them women) who headed the armies and decentralized assemblies by which followers were organized were unable to agree on a Buddhist savior or Maitreya incarnate or on a pretender to lead a revival of the Ming dynasty. The White Lotus sectarians thus remained disunified as well as decentralized, forming a tenuous network of communities. They built defensive stockades around their mountain villages and defied the Ch'ing tax collectors. One of their slogans was the well-known "the officials force the people to rebel." The rising was of course nativist and anti-Manchu. However, the White Lotus does not seem to have been a rising among oppressed peasants on account of heavy tax collec-

tions. County magistrates and their underlings were comparatively few and weak in resources. To some undetermined extent the White Lotus seems to have arisen to take the place of an inadequate government, which had not yet developed in this frontier region its usual functions of public works, ever-normal granaries, and examinations for the ambitious. By 1800 the Manchu banner forces, partly because so many commanders profited from the funding of their military complex, were unable to suppress these rebels. The rebellion was ended only after the new Chia-ch'ing Emperor found incorrupt Manchu commanders. They also used Chinese militia, who now excelled the vaunted Manchu bannermen as a military force. To discerning scholars versed in the lore of the dynastic cycle, the fortunes of the Ch'ing dynasty seemed to be turning downward.

The hard crust of corruption in the best-documented imperial institutions has been abundantly described. Take for example the massive Grand Canal transport network, which took Lower Yangtze rice north to feed Peking. Khubilai Khan in the late thirteenth century had extended the Grand Canal on a northern course to his newly built capital at Peking; and the Ming and Ch'ing had used it ever since as a great artery of north-south trade, safer from storms and pirates than the sea route around the Shantung peninsula. A large administration under two governors-general handled the grain transport and managed the thousands of grain boats that every year tried to get through the canal locks (a Chinese invention) in Shantung en route northward. Grain boats 30 feet long with crews of 10 men were annually poled and hauled some 1,100 miles, traversing a high point 140 feet above sea level in order to supply 400,000 tons of rice to the Peking granaries. They carried private cargo too.

One of the problems of canal traffic was that it had to cross the Yellow River. Over the centuries the director-general of the Yellow River Conservancy had built up a bureaucracy comparable to that of the two directors-general of grain transport. Dikes along the river were mended by engineers so competent that they could use comparatively vast imperial allocations of funds to build dikes that would look good enough but last only a few years. The point was that the officialdom made great profits from the imperial expenditures.

Meanwhile, the Grand Canal transport was handled by a large bureaucracy plus thousands of bargemen. Ancestors of these bargemen had been assigned to their functions some generations before

and had often by a sort of subinfeudation arranged for the actual work to be done by nonhereditary gangs of boatmen. From all this paraphernalia of officials, boatmen, and their barges the imperial officials derived considerable profit, which they would not lightly forgo. As breakdown and silting of the canal impaired its efficiency in the early nineteenth century, the old idea arose that transport of rice by sea around the Shantung promontory would be cheaper and more efficacious. In a crisis in 1826 such transport was actually arranged by hiring merchant vessels, but the vested interests of the Grand Canal system were so strong that this improvement was promptly given up. Inefficiency won out.

The population explosion did a great deal more than weaken the government. In economic life the superabundance of human muscles made labor-saving devices uneconomical. Why dam a stream for waterpower, as the Europeans were doing, when labor was dirt cheap and could continue to be used instead for textile spinning and weaving? Indeed, why use mules and a cart when porters were so available? Porters needed only paths to follow, not roads laboriously graded at odds with the contour of rice terraces. The stern oar *(yu-lo)* to move a sampan used manpower very efficiently, as did the Chinese barrow balanced over its centered wheel. On land or water, mechanical transport by steampower would face stiff human competition.

Even animal power was at a disadvantage. The human hoe still outdid the traction plow, and consequently China remained less prepared to make the shift that came so naturally to Western farmers, from animal traction to automotive traction. As a result, seeders, cultivators, reapers, binders, and the whole Caterpillar family remained unfeasible, as they are even today. Production was locked into a muscle-power technology.

Socially, the flood of people was even more deleterious because life was reduced more and more to a grim struggle for survival. Generosity and philanthropy became luxuries that family members could ill afford. As the primary units for survival, families had to watch every rice grain. Some evaded taxes by enlisting as clients of more powerful landowners, and became peons supplying girls, workmen, and guards for their patrons. The self-sufficient owner-farmer had a harder time, needing protection against the officials' *yamen* runners, the big house's bullies and enforcers, and the bandits who emerged from the unemployed and destitute.

Not only local order but also personal morality declined as people proliferated. Natural calamities of flood, drought, famine, and pestilence became more severe because greater numbers were affected. People lost confidence in the future as well as in the work ethic. Virtue brought uncertain rewards. Those who lived by their wits survived better. Sycophancy, cheating, prostitution of boys and womenfolk, smuggling, violence, all had their uses in the struggle. Confucian conduct often became a public sham. After 1800 popular demoralization evidenced in opium smoking set in first amid the minor officials, *yamen* underlings, and troops of the establishment, but as poppy production spread within China, peasant producers took up the habit too.

These evils that flowed so largely from numbers changed the quality of Chinese life. Inevitably it became more brutish and uncertain. Honest officials who died poor became illustrious paragons because their example was so rare. A society that in Sung and even Ming had accepted the individual often on his merits now became suspicious of all seemingly worthy motives, fearful of strangers, and ungenerous. The struggle for survival meant that all ideals were risky, like daily life itself. Such fluctuations in welfare and morale had occurred before, but now in the late Ch'ing comparison with the West revealed more basic and systemic weaknesses.

Take as a first example the writing system. In effect, Chinese writing that enabled Chinese, Japanese, Koreans, and Vietnamese scholars to communicate with one another was a great common channel of contact among those that knew it. Merchants speaking the mutually unintelligible languages of Canton, Shanghai, and Shansi province could get along fine, in writing. Recent research concludes that functional literacy (as distinct from the classical learning) was rather widespread—among 30 to 45 percent of males and 2 to 10 percent of women, not unlike seventeenth-century England. In other words the common people became literate on a need-to-know basis so that they could often communicate in simple writing and keep accounts.

But literacy is not a yes-or-no condition like pregnancy. The definition of "literacy" determines the rate of it. In the old China the real divider was the classical learning—not only the many thousand complex characters but also the several layers of meaning that some characters had accumulated over the centuries and, finally, the hard-

won knowledge of texts and commentaries. This "literacy in the classics" was what set the classically trained literatus a world apart from the illiterate or barely literate commoner. The very thing that admitted the scholar into his upper-class privileged status removed him from the life of his fellow men. Would-be officials spoke the lingua franca of the Peking dialect (*kuan-hua,* official speech). Conversation replete with classical quotations and allusions, in terms that a peasant even if literate could not understand, were the hallmark of the literati. The separation was reinforced by the ironbound tradition that men of learning did not use their muscles, even their hands, except for calligraphy. This bifurcation of Chinese culture into classically literate and comparatively illiterate compartments buttressed the ruling-class position. The examinations were a ritual that preserved and rationalized this great social division.

Another social division was between the sexes. Rather than celebrate the difference between them in chauvinist style, let us note a special Chinese invention for keeping women in their place.

Of all the many unexplored facets of China's ancient history, the subjection of women has been the least studied. Women were fitted into the social and cosmic order (which were a continuum) by invoking the principles of Yang and Yin. All things bright, warm, active, male, and dominant were Yang while all things dark, cold, passive, female, and yielding were Yin. This dualism, seen in the alternation of night and day or the contrast of the sun and moon, was a readymade matrix in which women could be confined. The subjection of women was thus a sophisticated and perfected institution like the other Chinese achievements, not a mere accident of male biceps or female childbearing as might be more obviously the case in a primitive tribe. The inequality between the sexes was buttressed with philosophical underpinnings and long-continued social practices. Symbolic of woman's secondary status was her bridal night: she expected to be deflowered by a stranger, a husband selected by her family whom she had never seen before. Even though the facts may often have been less stark, the theory was hard-boiled.

Out of all this complex of theory and custom by which the Chinese world was given an enduring and stable order, the most neglected aspect is the institution of footbinding. This custom arose at court in the tenth century during the late T'ang and spread gradually among the upper class during the succeeding Sung period. By the

Ming and Ch'ing eras after 1368 it had penetrated the mass of the Han Chinese population. It became so widespread that Western observers in the nineteenth century found it almost universal, not only among the upper class but throughout the farming population.

Footbinding spread as a mark of gentility and upper-class status. Small feet became a prestige item to such an extent that a girl without them could not achieve a good marriage arrangement and was subjected to the disrespect and taunts of the community. In short, bound feet became *de rigueur,* the only right-thinking thing to do for a daughter, an obligation on the part of a mother who cared about her daughter's eventual marriage and success in life. The bound foot was a must. Only tribal peoples and exceptional groups like the Manchu conquerors or the Hakka Chinese migrant groups in South China or finally the mean people, that lowest and rather small group who were below the social norms of civility, could avoid binding their daughters' feet.

The small foot was called a "golden lotus" or "golden lily" *(chin-lien)* and was much celebrated in poems and essays by male enthusiasts. Here is the early Sung poet Su Tung-p'o (1036–1101):

Anointed with fragrance, she takes lotus steps;
Though often sad, she steps with swift lightness.
She dances like the wind, leaving no physical trace.
Another stealthily but happily tries on the palace style,
But feels such distress when she tries to walk!
Look at them in the palms of your hands, so wondrously small that
 they defy description.

The Sung philosophers stressed women's inferiority as a basic element of the social order. The great Chu Hsi (1130–1200) codified the cosmology of China as magistrally as his near contemporary Thomas Aquinas (d. 1274) codified that of Western Christendom. When he was a magistrate in Fukien province, Chu Hsi promoted footbinding to preserve female chastity and as "a means of spreading Chinese culture and teaching the separation of men and women."

By the Ming period the overwhelming majority of Han Chinese women all over the country had artificially small feet. The Manchu emperors many times inveighed against it in hortatory edicts, but to no avail. Male romanticizing on the subject continued unabated as in this poem of the fourteenth century:

Caught by the gentle wind,
Her silk skirt ripples and waves.
Lotus blossoms in shoes most tight,
As if she could stand on autumnal waters!
Her shoe tips do not peek beyond the skirt,
Fearful lest the tiny embroideries be seen.[8]

There can be no doubt that footbinding was powered by a sexual fetish. Chinese love manuals are very specific about the use of bound feet as erogenous areas. All the different ways of taking hold of the foot, rubbing it with the hands, and using the mouth, tongue, and lips are explicitly catalogued. Many cases are recorded with the verisimilitude of high-class pornography. Meanwhile, the aesthetic attractiveness of the small shoes with their bright embroidered colors was praised in literature, while the tottering gait of a bound-foot woman was considered very fetching as a symbol of feminine frailty, which indeed it was. In fact, of course, bound feet were a guarantee of chastity because they kept women within the household and unable to venture far abroad. Lily feet, once formed, could not be unlocked like a chastity belt. By leaving only men able-bodied, they ensured male domination in a very concrete way.

Thus the prevalence of footbinding down to the 1920s, while the movement against it began only in the 1890s, vividly index the speed and scope of China's modern social revolution. This may be less comprehensible to white American males than to white women, or especially to black Americans, for Chinese women within the present century have had an emancipation from veritable slavery.

While footbinding is mentioned in so many foreign books about China, it is usually passed by as a curious detail. I don't think it was. It was a major erotic invention, still another achievement in Chinese social engineering. Girls painfully deformed themselves throughout their adolescence in order to attract desirable husbands who, on their part, subscribed to a folklore of self-fulfilling beliefs: for example, that footbinding made a vagina more narrow and muscular and that lotus feet were major foci of erotic sensitivity, true erogenous zones, a net addition of 50 percent to the female equipment. Normal feet, we are now told by purveyors of sexual comfort, are an underdeveloped area sensually, but one must admit they are a bit hard to handle—whereas small lotus feet could be grasped, rubbed, licked, sucked,

nibbled, and bitten. The garrulous Jesuit Father Ripa, who spent a decade at the court of K'ang-hsi in the early 1700s, reported that "Their taste is perverted to such an extraordinary degree that I knew a physician who lived with a woman with whom he had no other intercourse but that of viewing and fondling her feet."[9] Having compacted all their nerve endings in a smaller area, golden lilies were far more sensitive than, for example, the back of the neck that used to bewitch Japanese samurai. After all, they had been created especially for male appreciation. When every proper girl did it, what bride would say that her sacrifice, suffering, and inconvenience were not worth it? A bride without small feet in the old China was like a new house in today's America without utilities—who would want it? Consequently in the 1930s and '40s one still saw women on farms stumping about on their heels as they worked, victims of this old custom.

A girl's foot was made small, preferably only three inches long, by pressing the four smaller toes under the sole or ball of the foot (plantar) in order to make it narrower. At the same time it was made shorter by forcing the big toe and heel closer together so that the arch rose in a bowed shape. As a result the arch was broken and the foot could bear no weight except on the heel. If this process was begun at age five, the experience was less severe than if a little girl, perhaps in a peasant household, had been left with normal feet until age eight or ten so that she could be of more use in the household.

> When I was seven [said one woman to Ida Pruitt], my mother . . . washed and placed alum on my feet and cut the toenails. She then bent my toes toward the plantar with a binding cloth ten feet long and two inches wide, doing the right foot first and then the left. She . . . ordered me to walk but when I did the pain proved unbearable. That night . . . my feet felt on fire and I couldn't sleep; mother struck me for crying. On the following days, I tried to hide but was forced to walk on my feet . . . after several months all toes but the big one were pressed against the inner surface . . . mother would remove the bindings and wipe the blood and pus which dripped from my feet. She told me that only with removal of the flesh could my feet become slender . . . every two weeks I changed to new shoes. Each new pair was one- to two-tenths of an inch smaller than the previous one. . . . In summer my feet smelled offensively because of pus and blood; in winter my feet felt cold because of lack of circulation . . . four of

the toes were curled in like so many dead caterpillars . . . it took two
years to achieve the three-inch model . . . my shanks were thin, my
feet became humped, ugly and odoriferous.[10]

After the first two years the pain lessened. But constricting the
feet to a three-inch size was only the beginning of trouble. By this
time they were very private parts indeed and required daily care,
washing and manicuring at the same time that they had to be kept
constantly bound and shod night and day. Unmanicured nails could
cut into the instep, bindings could destroy circulation, blood poison-
ing or gangrene could result. Massage and applications of hot and
cold water were used to palliate the discomfort, but walking any
distance remained difficult. It also produced corns on the bent-under
toes, which had to be pared with a knife. Once deformed to taste,
bound feet were of little use to stand on. Since weight was carried
entirely on the heels, it had to be constantly shifted back and forth.
Since the bound foot lacked the resilience of a normal foot, it was a
tiring and unsteady support.

Footbinding, in short, had begun as an ostentatious luxury, which
made a girl less useful in family work and more dependent on help
from others. Yet, once the custom had spread among the populace,
lotus feet were considered essential in order to get a good husband.
Marriages, of course, were arranged between families and often by
professional matchmakers, in whose trade the length of the lily foot
was rated more important than beauty of face or person. When the
anti-footbinding movement began at the end of the nineteenth cen-
tury, many mothers and daughters, too, stubbornly clung to it to
avoid the public shame of having large feet. The smallness of the foot,
in short, was a source of social pride both to the family and to the
victim. First and last one may guess that at least a billion Chinese girls
during the thousand-year currency of this social custom suffered the
agony of footbinding and reaped its rewards of pride and ecstasy,
such as they were.

There are three remarkable things about footbinding: First, that
it should have been invented at all—it was such a feat of physio-
psycho-sociological engineering. Second, that once invented it
should have spread so pervasively and lasted so long among a gener-
ally humane and practical-minded farming population. We are just
at the beginning of understanding this phenomenon. The fact that

an upper-class erotic luxury permeated the peasantry of Old China, for whom it could only lower productivity, suggests that the old society was extraordinarily homogeneous.

Finally, it was certainly ingenious how men trapped women into mutilating themselves for an ostensibly sexual purpose that had the effect of perpetuating male domination. Brides left their own homes and entered their husband's family in the lowest status, servants of their mothers-in-law. Husbands were chosen for them sight unseen, and might find romance in extramarital adventures or, if they could afford it, bring in secondary wives. But a woman once betrothed, if her husband-to-be died even as a child, was expected to remain a chaste widow thereafter. Mao remarked that "women hold up half the sky," but in the old China they were not supposed to lift their heads. The talent that one sees in Chinese women today had little chance to grow and express itself. This made a weak foundation for a modern society.

Thus by the time of the growing Western contact in the mid-nineteenth century there was a good deal more wrong with China than population pressure and corruption. If the four-fifths or so of the women with bound feet accepted their handicap as a matter of course, the four-fifths or so of the men who were farming the land faced more obvious inequalities.

Tenantry was more prevalent in South China, where the soil, aided by heat and water, was more productive. Most farmers in the North were owner-tillers. But everywhere the press of numbers enhanced land values and made landlordism the ideal form of investment. Since property values depended on the maintenance of order, the growing numbers of the poor were more and more ready to join a class struggle against the better off, who relied upon government to preserve the established order. When government faltered, rebellion had usually ensued, and a new dynasty, Chinese or foreign, had restored the complex equilibrium between state and society. But after 1840 new ideas gained ground on the Chinese scene: nationalism and egalitarianism, first of all. The one attacked alien rule by the Manchus, the other attacked the Confucian ruling class. Both found expression in the Taiping Rebellion.

The Taiping Movement followed the classic pattern of peasant risings in most respects—as a religious sect it won followers, orga-

nized them in an army, raised the flag of a new regime, and then expanded far and wide in a great burst of energy and violence. This pattern sounds familiar from both earlier and later times, but specific personalities gave it expression and made all the difference in what actually happened. The founder, first of all, had to acquire a team of loyal followers by sheer force of personality. Chu Yuan-chang had been such a man in the 1350s and '60s. Once leader of a band of warriors, he had founded his Ming dynasty by defeating upstream and downstream rivals along the Lower Yangtze. Based at Nanking, he took over the south, expelled the Mongols from the north, modeled his regime especially on the T'ang of seven hundred years before, and became a megalomaniac only by degrees.

The Taiping founder was Hung Hsiu-ch'uan, the faith he preached was his own version of Old Testament Protestant Christianity, and his Heavenly Kingdom of Great Peace ruled at Nanking from 1853 to 1864. But many things doomed it from the start, as though Chinese society were prepared to give birth to a new dynasty but the foreign environment of the nineteenth century instead produced an abortion. The chance for a new national life was missed.

After Hung had failed a fourth time in the Canton examinations in 1843, he exploded in rage at the Manchu domination of China and then read some Christian missionary tracts, which seemed to explain the visions he had had during an earlier mental illness: God the Father had evidently called him to save mankind and Jesus was his Elder Brother. Hung became a militant evangelist for a moral life to serve the one true God. A month with a Baptist missionary with the memorable name of Issachar Jacox Roberts in 1847 gave him examples of how to pray, preach, sing hymns, catechize, confess one's sins, baptize, and otherwise practice fundamentalist Protestantism. The tracts, which remained Hung's major source of Christian doctrine, had been written by the early Cantonese convert Liang Fa, who saw in the Old Testament a story of a chosen few who with God's help had rebelled against oppression. Liang stressed the righteous wrath of Jehovah, more than the loving-kindness of Jesus, and gave Hung barely a fingerhold on Christian theology. But with his first two converts Hung created an iconoclastic monotheism potent enough to set up the Taiping theocracy yet too blasphemous to win foreign support, too intent on the one true God to permit cooperation with secret societies like the Triads, and too bizarre and irrational to win

over Chinese literati, who were normally essential to setting up a new administration.

The God-Worshipers' Society, as the sect first called itself, got started in a mountain region of Kwangsi, west of Canton, variously populated by Yao and Chuang aborigines and Chinese Hakkas like the Hung family, that is, migrants from North China several centuries before, who retained a northern dialect and other ethnic traits like opposition to footbinding. As a minority in South China, the scattered Hakka communities were uncommonly sturdy and enterprising, as well as prone to defend themselves.

How Hung became the rebel king of half China is a story like that of Napoleon Bonaparte or Adolf Hitler, full of romantic drama, the mysteries of chance, and personal and social factors much debated ever since. His converts had the faith that God had ordered them to destroy Manchu rule and set up a new order of brotherhood and sisterhood among God's children. Leadership was taken by six activists who became sworn brothers, among whom Hung was only the first among equals. The chief military leader was an illiterate charcoal burner named Yang, who had the wit to receive God's visitations and speak with His voice in a way that left Hung sincerely speechless. Several of the other leaders were low-level scholars. None was a mere peasant. They got their political-military system from the ancient classic the *Rituals of Chou.* Their movement was highly motivated, highly organized, and austerely puritanical, at first even segregating men from women.

Taiping Christianity half-borrowed and half-recreated for Chinese purposes a full repertoire of prayers, hymns, and rituals, and preached the brotherhood and sisterhood of all mankind under the fatherhood of the one true and only God. Unlike the passivity of Taoism or the otherworldliness of Buddhism, the Protestant Old Testament offered trumpet calls to a militant people on the march against their oppressors. The original corps of Hakka true believers from Kwangsi were the bravest in battle and the most considerate toward the common people. And no wonder! Hung's teaching created a new Chinese sect organized for war. It used tried and true techniques evolved during 1,800 years of Christian history to inculcate an ardent faith in each individual and ensure his/her performance in its service. Taiping Christianity was a unique East-West amalgam of ideas and practices geared to militant action, the like of which

was not seen again until China borrowed and Sinified Marxism-Leninism a century later.

Hung probably never said, "A single spark can start a prairie fire," but Mao Tse-tung could have got the idea from the God-Worshipers' success story. Kwangsi in 1850 was far from Peking, lightly garrisoned by Manchu troops, and strongly affected by the influx of opium runners and pirates driven inland along the West River by the British navy's pirate hunting along the coast. The growing disorder inspired the training of local self-defense forces, including both militia and bandits, with little to choose between them since all lived off the people. The small congregation of God-Worshipers, like other groups, armed for self-defense, but secretly and for a larger purpose. By late 1850 some twenty thousand true believers answered Hung's call to mobilize, and they battled imperial troops sent to disperse them. On January 11, 1851, his thirty-eighth birthday, Hung proclaimed himself Heavenly King of a new dynasty, the Heavenly Kingdom of Great Peace.

The militant Taiping faith inspired an army of fierce warriors who in the early years kept to a strict moral discipline, befriended the common people, and by their dedication attracted recruits and terrified opponents. They carried a multitude of flags and banners, partly for identification of units. Instead of wearing the queue that the Manchu dynasty required as a badge of loyalty (such a tangible symbol!), the Taipings let their hair grow and became the "long-haired rebels," even more startling for establishmentarians to behold than student rebels of the Western counterculture a century or so later.

In China the fifteen-year civil war from 1850 to 1864 was tremendously destructive to life and property. Some six hundred walled cities changed hands, often with massacres. While the American Civil War of the early 1860s was the first big contest of the industrial era, when rail and steamship transport and precision-made arms were key factors, the Taiping-imperialist war in China was the last of the pre-modern kind. Armies moved on their feet and lived off the land. No medical corps attended them. Modern maps and the telegraph were lacking. Artillery was sometimes used in sieges but the favorite tactic was to tunnel under a wall, plant gunpowder, and blow it up. Navies of junks and sampans fought on the Yangtze and its major lakes to the south, but steamships were a rarity. Muskets were

used but much of the carnage was in hand-to-hand combat with swords, knives, pikes, and staves. This required motivation more than technical training. An invading army might make up its losses by local recruitment, conscription, or conversion of captives, but a commander could not always count on such troops' standing their ground, much less charging the enemy. Imperial generals brought in Manchu and Mongol hereditary warriors, but the humid South often undid them and their cavalry was no good in rice fields. The struggle was mainly Chinese against Chinese. Official reports of armies of 20,000 and 30,000 men, sometimes 200,000 and 300,000, make one wonder how they were actually fed and what routes they traveled by, in a land generally without roads. Troop totals were always in round numbers and should probably be scaled down.

In 1851 the Taiping horde erupted northward, captured the Wuhan cities, and early in 1853 descended the Yangtze to take Nanking and make it their Heavenly Capital. Their strategy was what one might expect of an ambitious committee dominated by an illiterate charcoal burner: ignorant of the outer world, they left Shanghai in imperial hands and failed to develop any foreign relations. Dizzy with success, they sent inadequate forces simultaneously north to conquer Peking and west to recover Central China. Both expeditions failed. Commanders operated pretty much on their own, without reliable intelligence, communications, or coordination, simply coping with situations that arose. Absorbed in religion and warfare, the Taiping leaders were inept in economics, politics, and overall planning.

Lacking trained administrators, they generally failed to take over and govern the countryside as a base area for supplies of men and food. Instead they campaigned from city to city, living off the proceeds of loot and requisitions, much like the imperial armies. All this resulted from their narrow religiosity, which antagonized, instead of recruiting, the Chinese scholar-gentry class who could have run a government for them. One result was that the local landed elite remained in place in the countryside. No social revolution occurred. Meanwhile a watering down of their original faith and austerity hit the movement.

Within Nanking the leaders soon each had his own army, palace, harem, and supporters. They spent much time elaborating systems of nobility, honors, and ceremonies. Missionaries who called upon the

Taiping prime minister in 1860 found him wearing a gold-embroidered crown and clad like his officers in robes of red and yellow silk. Egalitarianism had continued for the rank and file only.

The original leadership had destroyed itself in 1856 when the Eastern King, Yang, the chief executive and generalissimo, plotted to usurp the position of the Heavenly King, Hung, who therefore got the Northern King, Wei, to assassinate Yang and his supporters, only to find that Wei and his supporters, drunk with power, had to be assassinated by the Assistant King, Shih, who then felt so threatened that he took off to the west with much of the army, leaving Hung sitting on a rump of his own incompetent kinfolk.

Both Nationalists and Communists of a later day have tried to salvage from the Taiping Movement some prototype of anti-Manchu nationalism and social reform. The Taipings were against all the usual evils—gambling, opium, tobacco, idolatry, adultery, prostitution, footbinding; and they gave special scope to women, who supported and sometimes served in the army and ran the palaces in place of eunuchs. But the Taiping calendar and examination system, using tracts and Hung's writings, were no improvement on the old; the ideal communal groupings of twenty-five families with a common treasury never spread over the countryside; the Westernization program of the last prime minister, Hung's cousin, Hung Jen-kan, who had spent some years with missionaries, never got off the ground. Meantime the ignorance and exclusivity of the Taiping leadership, their lack of an economic program and failure to build creatively on their military prowess, led to the slaughter and destitution of the Chinese populace. Mass rebellion had seldom commended itself in China. Now it gave a bad name to Christianity too.

Yet Hung's appropriation and use of Christianity were by all odds China's greatest borrowing from the West before the 1890s. Taiping Protestantism enforced the Ten Commandments with death penalties. When that stubbornly odd-ball British consul Thomas Taylor Meadows saw the Taiping Northern King, Wei, in 1853, he recited the Decalogue to him. Wei was thunderstruck—"The same as ourselves!" he cried. "The same as ourselves!"[11]

The Protestant missionaries of course resented the infringement on their studious monopoly of God's Word. The more literal-minded were outraged at Hung's claim to be Jesus' Younger Brother and his injection of the Chinese family system into the Christian Heaven in

the person of God's and Jesus' wives. Hung's adaptations may strike us today as undoubtedly the best chance Christianity ever had of actually becoming part of the old Chinese culture. What foreign faith could conquer China without a Chinese prophet?

But the few missionaries who ventured to Nanking, though well received, got the distinct impression that Taiping Christianity did not look to them for basic guidance. Even the Taiping Chinese viewed themselves as central and superior, though generally polite to all "foreign brothers" *(wai hsiung-ti)*. Their Sixth Commandment, "Thou shalt not kill or injure men," used the traditional Chinese gloss, "The whole world is one family, and all men are brothers." Hung's *Three-Character Classic* for children to memorize recounted God's help to Moses and the Israelites, Jesus' life and death as the Savior, and the ancient Chinese (Shang and Chou) worship of God (here unwittingly following the Jesuit line). But the rulers of Ch'in, Han, and Sung had gone astray until Hung was received into Heaven in 1837 and commissioned to save the (Chinese) world by driving out the Manchu demons. This was true cultural miscegenation but few missionaries could stomach it. So they missed the boat. Meanwhile, Catholic France had opposed Taiping Protestantism on principle as still another outcropping of the evil unleashed by Martin Luther.

The Taiping Heavenly Kingdom went the way of Carthage—only the name survived. The record is biased because the imperialists destroyed all Taiping writings, except for those preserved mainly by foreigners (some were found only in this century in French and British libraries). Leaders of ability emerged in the final years, but too late. A cause for which so many gave their lives must have had much to offer, but only in comparison with the effete old order under the Manchus.

Suppression of the inept and ill-directed Taiping movement depended simply on whether the imperial side could pull itself together, no easy task. But, although nearly every province was invaded by the Taipings, few were held, whereas the dynasty still had a bureaucratic framework of magistrates able in some places to collect taxes and even forward revenues. A new provincial trade tax of "a thousandth" *(li-chin* or *likin)* began to be levied on goods in transit or for sale. Taxes were secured from the opium trade, which was legalized by British demand in 1858.

After a decade of hapless crisis-coping that emptied the treasury

and well-nigh exhausted the dynasty's mandate to rule, a new boy emperor succeeded to the throne in 1860 and Peking in 1861 finally had a coup d'état. In brief, the die-hard anti-foreign element, which had fought the British and French without success since 1856, was replaced by a new Manchu leadership dedicated to a dual policy: in foreign relations, to accept the treaty system in order to appease the foreign powers; domestically, to put Chinese in command in order to defeat the rebels. This began a restoration of Ch'ing power.

The new commander against the Taipings was a Confucian scholar from Hunan, Tseng Kuo-fan, who really lived by the Confucian code and made the system work again, though with alterations. Sent home from Peking to organize militia in 1852, Tseng was appalled by Taiping impropriety and set himself to build an army for defense. Following tradition, he recruited commanders of similar character, personally loyal to himself, who selected their subordinate officers, who in turn enlisted their soldiers man by man, creating in this way a network of leaders and followers personally beholden to one another and capable of mutual support and devotion in warfare. It was a military application of the reciprocal responsibilities according to status that animated the family system. And it worked. Soldiers were carefully selected from proper families and well paid and trained.

Tseng developed an inland navy on the Yangtze, set up arsenals, and husbanded his resources. As the Taipings' original Hakka soldiers from South China became depleted, Tseng's Hunan Army began to win. Once the suspicious Manchus recognized that they had to chance it and trust Chinese loyal to the old order, Tseng was able to put his chief lieutenants in as provincial governors and so mobilize a concerted war effort in Central China. He methodically hemmed the Taipings in from upstream, where the Hupei-Hunan capital of Wu-ch'ang had changed hands six times, and from downstream, where Anglo-French forces, having got their treaties accepted by fighting their way to Peking in 1860, finally abandoned neutrality and helped defend the Shanghai-Ningpo area.

Suppression was a bloody business. Resources were lacking even to feed, much less employ, prisoners of war. When the key Yangtze city of Anking had been besieged for a year, the starving Taipings finally surrendered. The receiving officer wrote in his diary that he consulted his commander, Tseng Kuo-ch'uan (Tseng Kuo-fan's

brother), who said, " 'Too many fierce rebels! What are we going to do with them?' I replied: 'Slaughter is the only good way.' [Tseng] said: 'Even for slaughter some means must be devised.' I replied: 'The camp door will be opened slowly and the rebellious bandits admitted ten at a time; thus it will take only half a day to kill them all.' [Tseng] said: 'That my heart cannot bear; I'll commission you to do it.' I then . . . made the preparations. From 7 in the morning to 7 in the evening over 10,000 rebels were all killed, and then I went to report." ("10,000," *i-wan,* of course means a great many. At the unlikely rate of killing ten rebels a minute, necessarily by hand rather than with modern improvements like machine guns, only 7,200 could have been killed in twelve hours.) When Tseng Kuo-ch'uan wrote to his brother the commander-in-chief expressing remorse, Tseng Kuo-fan, who was a paragon of Confucian rectitude, wrote back, "Inasmuch as you are commanding troops, naturally you must take killing rebels as your purpose. Why should you regret killing many men?"[12]

Since this was a routine operation, estimates of China's depopulation by twenty million in the Taiping era seem if anything too little. After the Heavenly Capital at Nanking was finally taken and looted in 1864, Hung having died of illness shortly beforehand, the Lower Yangtze provinces required a generation to recuperate.

The Taipings were only the biggest and best-known rebel movement of their day. Secret societies rose at Amoy (Sha-men) and Shanghai. Others attacked Canton. Nien bandits terrorized North China. Muslim Chinese revolted in Yunnan and in Shensi-Kansu. Miao aborigines rebelled in Kweichow. So many millions of hapless people were killed that the fighting eventually ran out of steam. Modern estimates are that China's population had been about 410 million in 1850 and, after the Taiping, Nien, Muslim, and other smaller rebellions, amounted to about 350 million in 1873.

Thus the coercion of China by Western gunboats and even the Anglo-French occupation of Peking in 1860 were brief, small, and marginal disasters compared with the mid-century rebellions that swept over the major provinces. The Europeans and Americans who secured their special privileges in China's new treaty ports were on the fringe of this great social turmoil, not its creators; for some Chinese at the time they represented a new order and opportunity, but for the great majority they were unimportant.

The failure of the Taipings to Christianize China, in their own bizarre fashion, should not lead us to accept the outworn platitude that the Chinese have been impervious to foreign religions. Far from it. The Buddhist conquest of China beginning in the first and second centuries A.D. was both contemporary and parallel with the rise of Christianity in the West. Both figured in the combination of "barbarism and religion" (in Edward Gibbon's phrase) that supplanted the Han and early Roman empires. The Buddhist age in China, from the mid-fourth century to the end of the eighth, witnessed Buddhist predominance at court and a general Sinification of Indian Buddhist teachings to make a distinctly Sino-Buddhist amalgam. This process saw the proliferation of half a dozen Chinese sects of Buddhism and the widespread growth of monasteries, which soon became great landowners and presented a fiscal control problem to the Chinese state. But whereas Europe fell apart as new nations like France, Spain, and England began to emerge, in China the T'ang dynasty (618–907) reestablished a unified empire, and its bureaucrats soon began to bring the Buddhist church, both its personnel and its revenues, under control.

Another comparison with the impact of Christianity on modern China can be seen in the Chinese absorption of Islam. Early Islamic contact was by sea in the southern ports of the T'ang and Sung. Ch'üan-chou in Fukien was the Arabs' Zayton. Both there and at Canton were Arab trading communities with their own mosques, a result of the great Islamic diaspora of the seventh century and later. Christianity on the other hand had first reached China overland in the form of the heterodox sect known as Nestorian Christianity. This spread among the Mongols even before the Franciscan William of Rubruck reached the Great Khan's court in 1253–55. By that time of course Islam was well established in Central Asia and playing a role in Mongol life. Under the Yuan dynasty, Islamic merchant groups known as *ortaqu* handled economic monopolies for the Mongol overlords in China. Christianity reached China by sea only in the sixteenth century.

As a result of its approach to China from West Asia on the trade routes, Islam found an early lodgment among the peasantry of Northwest China in Kansu and Shensi. Presumably from there, with the Mongol invasion of Southwest China to outflank the Sung, it spread to Yunnan and Kweichow. Relations among Islamic sects were often

as militant as those between Catholics and Protestants in Europe. Islamic revivalism, like the second Great Awakening that sent Protestant missionaries out of the Atlantic community, was highly fundamentalist in nature, usually led by true believers in the teachings of the Koran who had completed their pilgrimage to Mecca and felt called upon to wipe out corruption and self-seeking among the faithful. The sect of the Nacqshbandiyya, for example, had inspired the holy war of Kotan upon Kashgar early in the nineteenth century.

Thus while the Taiping rebels in the 1850s created a travesty of Protestantism that was soon exterminated, the Muslim rebellions that followed in the 1870s and '80s in Southwest and Northwest China were based on a religious faith firmly rooted among the Chinese population.

Perhaps the greatest difference between Christianity and Islam from the Chinese point of view was that the early Islamic capacities in trade and science coming from West Asia were little threat to the established order of imperial Confucianism, whereas by the nineteenth century Christianity seemed to be part and parcel of the modern European industrial and military power. The Chinese ruling class felt directly threatened and so rejected the foreign religion. Thus the very surge of Western expansion that brought Christianity to China made it less acceptable there.

The conventional wisdom about China, as usual, has changed. It used to be that Britain's victory in the Opium War of 1839–42 began China's modern history by opening the way to disasters like the Taiping Rebellion, which was the next thing Karl Marx's generation in Europe heard about after the Opium War. The new conventional wisdom is quite different. Domestic growth was already making the old imperial order fall apart. New social forces were emerging that would eventually revolutionize Chinese life.

Western Christian influence through the Taiping movement became a caricature in the hands of Chinese rebel zealots. In a quite different fashion Western commercial influence on China would be conveyed through the orthodox commercial establishment once the treaty ports were opened.

6

The Western Intrusion

CHAPTER 5 has noted how established institutions of the imperial government were becoming inadequate to meet its needs: the Manchu bannermen, the salt monopoly, the Grand Canal and Yellow River Conservancy, the examination system, all were showing strain. This was evidenced most spectacularly in the tribute system for Ch'ing foreign relations.

For the holders of power, China's great revolution began in the 1830s. The Chinese place in the world rather suddenly began to turn inside out. The great security problem of the empire for two thousand years had been on the Inner Asian frontier—what to do about the striking power of nomad cavalry erupting from the arid grasslands beyond the Wall, where China's type of labor-intensive farming could never supplant the sheepherding and hunting economy of the tribal peoples. Whenever the tribes had been mobilized by a great leader, like Chingghis Khan in the early 1200s, China had faced trouble. Every statesman in Peking knew the long story of the Inner Asian menace and the many Chinese stratagems devised for meeting it.

But in the 1830s the scene was reversed. For 250 years the Europeans coming by sea had bought China's ingenious handicraft products, especially tea and silk, but also chinaware, lacquer, cloisonné, and curios of many kinds. This European trade had been rather

peaceful but it had never been easy to balance. The importation of Jesuit missionaries was hardly a commercial transaction and in any case the demand for them had fallen off to zero in the middle of the eighteenth century. The exports to Britain had been balanced by imports of unsalable woolens, Indian raw cotton, and specie. But now in the 1830s Indian opium rather quickly became a major import. Soothing some and enslaving others, it became the marijuana/heroin of the time. Worse than that, British officials turned up at Canton for the first time demanding recognition as diplomats representing a sovereign power that claimed equality with the Son of Heaven. Worst of all, this incredible presumption was backed by superior naval gunpower. Peking's strategic posture, oriented toward Inner Asia, had to be suddenly turned around. The foreign menace was now on the other side of the empire, along the southeast coast. It was as if NATO and the Pentagon overnight had to focus not on Moscow but on Tierra del Fuego and Capetown, places that had never before mounted threats worth considering.

The significance of the Opium War when it came would be that China's refusal to enter the family of nations on the basis of diplomatic equality and reciprocal trade had resulted in a British use of force. The British victory had turned the Chinese emperor's international status upside down. Instead of being universal ruler at the top of civilization, he became a semicolonial anachronism.

In developing a policy to deal with maritime problems, Peking was at a disadvantage in having no body of precedent to fall back on. Maritime problems had been at the level of frontier defense by provincial authorities committed only to pirate suppression. The precedent on the coast consisted of the Japanese-Chinese pirate-raiding problem: in the sixteenth century Japanese from Kyushu, not under central Japanese control, had raided the Lower Yangtze and Chekiang coasts, incorporating in their ranks large numbers of coastal Chinese pirates. These raids were a local police problem, not one of interstate relations. Ming assistance to Korea against Hideyoshi's invasions of the 1590s was in the guise of support for a bordering tributary. It exhausted the Ming but led to no settlement with Japan. When the Tokugawa unified Japan in 1601 and later, a policy of seclusion soon followed. Chinese trade continued at Nagasaki without state-to-state relations. After the Manchu conquest of 1644, the Chinese rebel Koxinga and his successor (and son) held out on For-

mosa until 1683, but this again was a border problem. Ch'ing policy was to close the frontier, depopulate the coast, ban foreign trade, and starve out the dissidents. Meanwhile the Dutch were treated as tributary traders. So also the Canton trade was kept within the passive-defensive tributary framework.

The Ch'ing's only experience of diplomatic state-to-state relations was with the Russians, both on the Inner Asian frontier and at Peking. Russian relations for two hundred years had been contained within the tribute system, but they bulk larger in the Ch'ing record than the provincial Cantonese relations with the British and other maritime powers. Russia figured in the Ch'ing grand strategy for Inner Asia. Britain did not.

Manchu foreign policy, like the Manchus themselves, has been little studied but it was in fact a very lively and engrossing topic. Ever mindful of their own conquest of China, the Ch'ing kept an eye out for rivals on the frontier. In the early 1830s, Tao-kuang's chief border problem was not at Canton but in Inner Asia, specifically Chinese Turkestan, the outside region that had figured so often in Chinese history. It had been a chief focus of imperial policy century after century, more important than Korea or Vietnam. Peking's strategists naturally faced westward, leaving the sea at their backs, out of sight and mind. Except for coastal pirates, the sea had brought no problems.

Inner Asian relations naturally began with the Mongols, whose tribes had been gerrymandered by the early Ming conquerors of Mongolia so as to form leagues with newly fixed boundaries whose princes were highly honored, tightly supervised, and carefully watched. The great K'ang-hsi had told Mongol princes in 1687, "You have been respectful, reverential and obedient as to a parent. . . . You need only look up respectfully to see the emperor's grand conception of treating all men with equal benevolence."[13]

By 1839 the central Confucian concept of paternal rule had been enshrined in psalm-like rhetoric that might well have roused the Vatican to envy. Here is geographer Li Chao-lo describing the emperor's treatment of the Mongols:

> He encompassed them like Heaven and Earth. He nourished them like their father and mother. He gave them illumination like the sun and moon. He overawed them like the lightning and thunder.

When they were starving, he fed them. When they were cold, he clothed them. . . . When they were in trouble, he saved them. He estimated their abilities and appointed them to official posts. He differentiated them by means of noble ranks and lands. . . . He taught them through literacy and cultivation. He extended his control over them by means of regulations. From a single commoner's tiny plot of land the Son of Heaven got no profit. . . . He improved their teaching but did not change their customs. He regulated their polity but did not change their values. . . . If they rebelled, the emperor reduced them to submission. If they absconded, he forgave them. If they returned to their allegiance, he overlooked their shortcomings.[14]

The only trouble was that Chinese Turkestan in the 1830s was farther away than Mongolia, less attuned to Confucian doctrines of benevolence and reciprocity, and more susceptible to Islamic passions. Only recently conquered, it was as strange to its new Manchu rulers as newly conquered India was to the British imperialists across the Karakoram-Kunlun massif to the south. In the decades when the British were coming to India by sea seeking riches, the Manchus were conquering Inner Asia for strategic reasons, to safeguard China. This is why the area bulked so large in the view from Peking.

The British saw their China trade as a further extension of their India trade—this we have long known. But if we now want to understand China's modern history from the Chinese side, we must put ourselves in Tao-kuang's place. From Peking he saw the Europeans on the frontier at Canton as on a par strategically with the equally exotic Muslims who traded on China's far western frontier at Kashgar. But the British East India Company was so much easier to handle! Tao-kuang knew that calculating traders could be policed simply by stopping their trade (*wei li shih shih* was the constant report, "they think only of profit"), whereas Muslims if stepped on religiously could become irrational fanatics. In fact, if Tao-kuang had ever exchanged thoughts with his contemporary, Lord William Bentinck, who governed British India from 1828 to 1835, they might have shared some dismay, even distaste, over the problem of ruling Muslim peoples.

For the Manchu raj in Turkestan the first problem was distance. Flanked by Tibet on the southeast and Mongolia on the northeast, the region was bisected by the T'ien-shan, the Mountains of Heaven.

North of them were the grasslands of the Ili Valley. This was and is still today China's Far West. Like the American West, it had cowboys, open range, and tribal peoples, some of whom were distantly related to the Amerindians. It was 3,500 miles from Peking and could be reached only by caravans on trails that traversed plains and deserts to approach snow-capped mountains. It connected back East by a pony express that took six weeks.

On the other hand, it was far from being an unknown new frontier. Inner Asia had seen Chinese armies marching across its deserts since the time of the Roman republic. The Chinese empire at its high points under the Han and T'ang had found Turkestan an essential strategic flank from which to seek leverage on nomads in the belt of grassland that led westward from Mongolia through the "gateway of the Nations" in the Ili region north of the T'ien-shan range. For the Mongol empire set up by Chingghis in the early 1200s this region had been a control zone of communication (the khanate of Jaghatai); the Manchus found it a key to controlling the western Mongols. Indeed, one great strategic feat of Ch'ing armies in the eighteenth century had been the expeditions to conquer Ili in the 1750s and so ensure the stability of Chinese Turkestan. Ili had a garrison of 13,000 Manchu troops.

On the south of the T'ien-shan was the Tarim Basin, so called from its Tarim River. It was inhabited chiefly in oases that perched between foothills and desert, where the small mountain-fed rivers had not yet disappeared into the sands. Each oasis sustained a commercial city on the trade routes running variously to China, India, and West Asia. Turfan, Karashahr, Kucha, Aksu, Kashgar, Yarkand, Kotan, and other ancient centers made a necklace in the Tarim River basin within an arc of the T'ien-shan, Pamir, and Kunlun ranges. It was often called Kashgaria from its major city. Over these various oasis routes the silks of Han China had gone to Rome, and medieval travelers like the Polos had made their slow way to Khubilai Khan's summer capital, Coleridge's Xanadu.

By the 1830s Peking had created a network of political-military control over the diverse economies and societies of this vast arid expanse. The oases held only about 300,000 people and were lightly garrisoned, to avoid bankrupting them. The people included Uzbeks, Kazakhs, and Kirghiz. They were part of the Turco-Iranian civilization and believers in Islam. Representing an eastward extension of

the great Muslim culture of the Middle East, they were poles apart from Chinese in their intense religiosity.

China had absorbed and Sinified the Buddhism that came from India in the first millennium of the Christian era. China accepted some things from Christian missionaries in medieval times, again in the seventeenth century, and would do so again in the nineteenth and twentieth centuries. But Islam was unique in winning to its faith large chunks of the Chinese populace in the Northwest and Southwest. Chinese Muslims oriented to Mecca were an unabsorbed anomaly in the Confucian empire. How to deal with this militant foreign faith among the non-Chinese of Central Asia was a real challenge.

We have noted how the Manchus met it by ruling through local governors (begs) whom they appointed. But in governing Turkestan the begs as Muslims left legal cases to be settled by the Muslim law of the Islamic religious establishment. The populace generally lived by the Islamic calendar, and their religious, educational, and cultural life was dominated by the leaders of the faith. The Ch'ing rulers at Peking collected taxes, especially on trade, and tried to keep order. But their imperial Confucianism could not digest and could only occasionally coopt the self-sufficient and all-embracing order of Islam, which was a state within the state. Religious risings consequently were the Manchus' chief problem.

Saintly families or khojas, descended from the Prophet or other early religious leaders, had great popular influence. In fact, one of these khoja lineages had ruled Turkestan for a time before the Manchu conquest of the 1750s. In exile west of the Pamirs in Kokand, they nursed their claims and sometimes led cavalry raids across the mountain passes into Kashgaria. One scion of this line of khojas was Jahangir, who became a problem just after Tao-kuang came to the throne.

Jahangir's holy war against the Ch'ing was triggered by a dynamic conjunction of faith and commerce. In brief, the westward trade of Kashgar was dominated by merchants of Kokand, whose ruler paid tribute to the Ch'ing emperor. This had become the usual practice around China's borders, in order to smooth the path of foreign trade. Chinese rulers had found it a useful defense to tell trade-hungry foreign potentates that if they wanted to buy and sell in China they could send envoys to kotow at Peking. It was as simple as that. No tribute, no trade.

Kokand had therefore enrolled as a tributary, had kept Jahangir confined, and in turn had been paid a large yearly gift from the Ch'ing as a reward for such admirable sincerity. But, as Kokandian merchants became more influential in the principal market at Kashgar, Kokand asked for special privileges: lower taxes on its trade and appointment of its own resident to superintend Kokandian traders in Kashgar. They wanted the flag to follow the trade, much as the British were soon to demand at Canton.

When these demands were refused in 1817, Kokand released the impetuous Jahangir, who at once proclaimed a holy war to recover Kashgar and after much confusion achieved a devastating invasion of Chinese Turkestan in 1826. A Ch'ing relief expedition of 22,000 men crossed the arid trail from one oasis to the next and so reconquered Kashgar in 1827. One of its commanders was Yang Fang (1770–1846) from Kweichow, who had become a soldier at age fifteen and shown such ability against the White Lotus rebels in 1801–1804 and the Three Trigrams rising in 1813 that he had been made a marquis and commander-in-chief in three different provinces. Through ruses, bribery, and sectarian treachery Jahangir was betrayed and Yang Fang captured him. In 1828 he was sent to Peking, where Tao-kuang had him ritually presented at the imperial temple of ancestors before being quartered in the manner appropriate to his treason.

Having used force decisively, the Ch'ing next pressured Kokand to give up its demands for trading privileges by stopping all its Turkestan trade and confiscating the tea and rhubarb of its traders. Kokand retaliated by invading Turkestan in 1830. The Ch'ing commanders resisted—at Yarkand, for example, the imperial agent, Pich'ang, a Mongol, beat off four attacks. But Kokand's commercial power and military nuisance capacity were both now evident and Peking's envoys gradually worked out a settlement with Kokand, which by 1835 provided that (1) Kokand should station a political representative at Kashgar with commercial agents under him at five other cities; (2) these officials should have consular, judicial, and police powers over foreigners in the area (most of whom came from Kokand); and (3) they could levy customs duties on the goods of such foreigners. In addition, the Ch'ing indemnified traders they had dispossessed.

Tao-kuang's experience in handling these Islamic frontier fighters

and traders in Turkestan was the background from which he approached the British problem. After the Opium War with Britain erupted in 1839, Manchu victors in the last border war tried their hand in the new one. Tao-kuang sent General Yang Fang, now seventy and quite deaf, to defend Canton, but he found no way to vanquish British gunboats. Books on border defense by Pi-ch'ang, the Mongol defender of Yarkand in 1830, were studied on the China coast, and by 1843 Pi-ch'ang himself was governor-general at Nanking in charge of the opening of Shanghai to foreign trade.

That Ch'ing policy toward the British in 1834–42 should be based on Ch'ing experience on the trading frontier of Central Asia in 1826–35 was perfectly natural. Western ignorance of this fact has buttressed our already weighty sense of uniqueness, which can now be deflated. For Tao-kuang and his court the Turkestan settlement with Kokand in 1835 was an exercise in barbarian taming, which achieved a stable frontier by giving local commercial concessions. The Opium War settlement with Britain in 1842–43 proved to be very similar, an attempt to apply on the South China coast certain lessons learned in Inner Asia.

This view of the "Opening of China" flies in the face of the conventional wisdom both of Western liberalism and of revolutionary Marxism-Maoism. Both these latter views of the Opium War stress the expansion of industrial Britain. They point to the growth of European trade at Canton in the period roughly from 1760 to 1834, especially the British thirst for Chinese tea, which had to be paid for by selling to China something that self-sufficient land would buy. Other than silver and Indian raw cotton, the only thing in growing demand after about 1800 was opium.

At first opium had been actually smoked like tobacco, that is, by dipping shredded leaves in opium solution and igniting the mixture (called *madak*) in a tobacco pipe. The smoke was about 0.2 percent morphine, quite mild. But in the late eighteenth century smokers began to put a little globule or bolus of pure opium extract in a pipe over a flame and inhale the heated water-and-opium vapor, which was about 9 or 10 percent morphine, a powerful narcotic. Opium imports, mainly from the official British Indian government production, had grown rapidly after 1820. The Anglo-American shippers brought opium legally by their own laws to the China coast, whence Chinese smugglers took it illegally by Chinese law into the country.

They were part of a not-so-underground smuggling network that bribed local officials and in fact paid handsome sums even to the imperial household. (Unlike the tobacco industry later on, the opium industry had no need of advertising.)

Tao-kuang's prohibitions were futile until it was realized in the 1830s that opium addiction had invaded the bureaucracy, even the palace eunuchs in Peking, and the military, some of whom were quite unfit for duty as a result. By 1836 it was seen also that opium imports were draining silver abroad and creating a fiscal crisis in China by making tax payments due in silver more dear in terms of copper cash, the people's currency. These political and economic considerations, once added to the emperor's moral duty, inspired the anti-opium movement and Lin Tse-hsu became its righteous protagonist.

Lin was the best type of official, loyal and principled, but of course ignorant of the world outside China. He had had a distinguished career as a can-do administrator, and when Tao-kuang sent him to Canton in 1839 to wipe out the opium evil, Commissioner Lin entered world history as the Chinese patriot who attacked the foreign menace. After he had forced the British traders at Canton to hand over their opium stocks, he was watching the drug being publicly mixed with lime and sluiced into the sea in June 1839 when a foreign observer, Elijah Bridgman, of Belchertown, Massachusetts, the first American missionary to China, offered the warning that the British would surely retaliate. Lin replied, "We are not afraid of war, we are not afraid of war;" and when war came Tao-kuang at first backed him up.[15]

The Opium War of 1839–42, all agree, was a classic iniquity. Opium sales to China were necessary to balance the triangular trade that moved Canton teas to London, and London goods and investments to India. The leading British opium merchants on the China coast, headed by Dr. William Jardine of Jardine Matheson & Company, helped Palmerston work out the aims and strategy of the war. They leased vessels to the British fleet, along with pilots and translators, and from their continued sales of opium accumulated the silver that the British expedition bought and used for its expenditures in China. It was indeed an opium-colored war, even though the basic issue was whether Peking would accept relations with Britain as between equal states. By refusing to give up his ancestral claim to

superiority, Tao-kuang found himself loaded with the unequal treaties.

What's wrong with this picture? Only that it is the afterthought of slightly guilt-ridden liberals (who were able to stop the Indian opium sales only in 1917) or of Marxist-minded patriots (who have to live with the fact that Chinese were the opium distributors within China and soon became the principal producers). For the past-minded historian concerned with what Tao-kuang and his mandarins actually had in mind, the picture is a bit different. The concessions following the British war on the seacoast were remarkably similar to the concessions made to militant Kokand on the Central Asian frontier a few years before.

As the late Joseph Fletcher, the brilliant Central Asianist, has pointed out, the Anglo-Chinese settlements at Nanking and later included (1) extraterritoriality (foreign consular jurisdiction over foreign nationals), an upgrading of an old Chinese practice, (2) an indemnity, (3) a moderate tariff and direct foreign contact with the customs collectors, (4) most-favored-nation treatment (an expression of China's "impartial benevolence" to all outsiders), (5) freedom to trade with all comers, no monopoly (long the custom at Kashgar)—all this followed the 1835 example with Kokand. Moreover, designated places for trade (treaty ports) were an old Chinese frontier custom, and equal relations without the kotow had been common on the Kokand and Russian frontiers far from China proper.[16]

Manchu statesmanship was consistent on the two frontiers but there were two major differences: First, Britain, the United States, and France were expansive maritime powers from another world, addicted to sea power, violence, law and treaty rights, and for them the first treaty settlement of 1842–44 was only a beginning of encroachment. Imperialism supervened. Second, the concessions that the Ch'ing could use to stabilize Kokand-Kashgar relations far off in Central Asia could only damage Ch'ing prestige if used in China proper. The Manchus had inherited the tradition of China's central superiority when they took power at Peking. Anyone who ruled there had to exact tributary obeisance from outsiders as part of the job of being Son of Heaven. So the unequal treaties were a defeat that grew bigger as time passed. The Ch'ing defeat sapped the Manchus' prestige and inspired intra-elite criticism that would lead on into a sense of Han national interest. In the last analysis the Manchus in

accepting the opium evil for the Chinese people had put their own dynastic interest first.

Manchu realism-opportunism had been evident in Tao-kuang's treatment of that patriotic figure Commissioner Lin, whom he had at first supported. But when war had brought nothing but British victories, and the invincible British fleet finally arrived off Tientsin, Tao-kuang reversed course, denounced and demoted Commissioner Lin, and sent trusted Manchu negotiators to settle terms and appease the British wrath. First the Manchu grandee Ch'i-shan forestalled another British attack on Canton by making a deal to give them Hong Kong. (For going so far on his own he was cashiered, sent back from Canton in chains, and had his private fortune confiscated.) Next the imperial clansman Ch'i-ying negotiated not only the British settlement but also the American and French treaties of 1844.

During his six years (1842–48) in charge of the new Western relations, Ch'i-ying pursued a policy of personal friendship and became a great barbarian tamer. After all, British rule in India was a historic feat like Manchu rule in China. Ch'i-ying, who kept a stiff upper lip, and the British envoy Sir Henry Pottinger of the Bombay Army, who had made his name administering Sind, could understand each other. Sir Henry was said to be "up to all the tricks and chicanery of the native courts, and . . . will not allow himself to be humbugged."[17] Even so, he was in for surprises. Ch'i-ying treated him like a slightly barbarian brother. In corresponding with the British envoy, Ch'i-ying explicitly became his "intimate" friend (spelling it out in Chinese characters, *yin-t'i-mi-t'e*). As imperial commissioner he went to the new British colony of Hong Kong in June 1843 on a British gunboat. He embraced Pottinger "with all the warmth and sincerity of an old friend and was even visibly affected by the strength of his emotion at our meeting again." Ch'i-ying then spent five days seeing the Hong Kong establishment, exchanging ratifications of the Nanking treaty, and at banquets sang operatic airs and played "guess-fingers." During thirty years in India Pottinger had met nothing like this. Ch'i-ying said he wanted to adopt Pottinger's son, having none himself, and he persuaded Pottinger to exchange pictures of their wives. As he explained to Tao-kuang, "the English barbarians think much of women and little of men."

In 1844 at the height of his success in soothing the Western invaders, Ch'i-ying summed up for the emperor the methods to be used.

"Certainly we have to curb them by sincerity, but it has been even more necessary to control them by skillful methods. . . . With this type of people from outside the bounds of civilization, who are blind and unawakened in styles of address and forms of ceremony . . . it would be of no advantage, in the essential business of subduing and conciliating them, to fight with them over empty names and get no substantial result."

Tao-kuang commented: "They could only be managed in this way." But fourteen years later when Ch'i-ying reappeared at the Tientsin treaty negotiations of 1858, the British interpreters in a very nasty way read him this memorial they had found in his files seized at Canton. The old man lost face, and the emperor sent him a silken bowstring with which to strangle himself. Pioneering in transcultural relations has always been risky business.

In retrospect it seems that abolition of opium had been mainly a Chinese but also a Manchu policy, to save the people, but when Britain proved invincible, appeasement became the necessary Manchu policy, to save the dynasty. From this time the Manchus' grip on China began to slip, though they were clever enough to get the foreigners' support and survive for another seventy years, until 1911. Meantime the Anglo-Indian and Chinese opium distributors had a good thing going, and administrators on both sides went along with it, thankful for the revenues.

What do you do if you are trading in China but not able to speak the language or understand the currency? Of course, like all outsiders who have participated peripherally in Chinese life, whether consular, commercial or Christian, you acquire native helpers.

Compradors (from Portuguese "buyers," in Chinese, *mai-pan*) had first emerged at Canton as minor agents for the purchase of ships stores for the East Indiamen. The main lading of teas and silks for the East India Companies' fleets had come through the licensed guild (Cohong) of the so-called Hong merchants. However, after free trade broke out in 1834 with the rise of private foreign firms, they found themselves obliged to deal with the whole gamut of guilds, banks, and the marketing systems in general. The intermediaries employed by foreign merchants were still called compradors but they now handled all aspects of the foreigners' business within China, becoming in effect their indispensable Chinese partners. They were of

course under contract as subordinates of the conquering Westerners.
They did not belong to the same clubs, though the foreign denizens
of the Shanghai Club ("longest bar in the world") might have been
surprised to know the sophistication of China's merchant-guild life.
With their foreign contacts and protection, compradors became
China's first modern entrepreneurs, investing in all sorts of new
ventures in the treaty ports and sometimes becoming far richer than
their employers.

Foreign trade at the newly opened treaty ports (Canton, Amoy,
Foochow, Ningpo, Shanghai) faced many perplexities. The treaties
tried to graft free enterprise under commercial law onto an economy
made up of more collectively organized groups of licensed mer-
chants who followed customary procedures.

For example, one of the anomalies in foreign eyes was that the
treaty-port trade which came to benighted China as the commercial
handmaiden of civilization, seemed at first not to be very important
in China's domestic economy. The foreigners of the nineteenth cen-
tury, of course, had no way of knowing the extent of China's commer-
cialization. The Maritime Customs statistics after 1864 were devoted
to foreign trade primarily and dealt with the native trade or junk
trade only from an observer's point of view. The British administra-
tors of the early treaty system were apostles of the free trade cur-
rently popular in Britain. They found it expedient to issue transit
passes to foreign merchants so that their goods passing inland would
not be further taxed beyond the point of entry. Similarly, a foreign
merchant not selling his goods at one port could get a drawback and
take them to another treaty port without increase of tax. These
ingenious devices for giving the foreign merchant his opportunity to
reach the Chinese market were almost at once turned to Chinese
advantage. Chinese merchants not only invested heavily in foreign
firms, like the Russell & Company steamship line, in which Chinese
had a third of the capital; they also set up dummy foreign firms
headed by minor factotums in treaty-port foreign firms, so that in the
name of the dummy foreign firms transit passes could be secured for
what was essentially Chinese trade. Though the Anglo-American
habitués of the Shanghai Club were only dimly aware of it, they were
thus utilized in the already extensive commerce of the Chinese em-
pire.

This raises the point that China's slowness to modernize her com-

mercial life, in the Western sense of the term, was certainly in part due to the considerable adequacy of the commercial life she already had. As with the examination system and the government bureaucracy, the established system worked well enough to obviate or defer its "modernization." Once again, we can only conclude that China was so "backward" because she had been so advanced.

The conventional wisdom that the Chinese bureaucratic state was unconcerned with or even hostile to commerce is now undergoing extensive revision. In the nineteenth century it appears that Chinese officialdom made many efforts to facilitate commerce for the simple reason that it provided them with revenue. One estimate is that 74 percent of all revenue came from the land tax in 1753, whereas by 1908 the land tax provided only 35 percent. Here again the revision of inherited notions is beginning to give us a more realistic picture of China's pre-nineteenth- and nineteenth-century commercialization.

From their first arrival in the treaty ports the British consuls began a running battle with Chinese officials over the imposition of "transit taxes." This was a widespread and complex system of small taxes on goods in transit. The customs administration, under the Board of Revenue and the Board of Works, had a total of twenty-nine offices at strategic commercial points over the empire, each of which had a fixed annual quota due to be paid to Peking, totaling 4⅓ million taels, a not inconsiderable revenue. Each office might have outlying offices on the routes of trade converging on a central place, such as Hangchow, Nanking, and other Yangtze ports, and most of these ports later became treaty ports. After the Chinese Maritime Customs got started in 1854 and later, the established Ch'ing system was known to foreigners as the "native customs." (In 1901 it was finally put under the Maritime Customs because its proceeds were earmarked to pay off the Boxer Indemnity.) Before the mid-nineteenth century, however, it was an administrative system handled from Peking that secured revenue by taxing the movement of goods and vessels under what came to be known as the "native tariff." The Maritime Customs handled the taxation of China's foreign trade under the treaty tariff, but the relationship of native to foreign trade had become a problem as soon as the treaties were established in the 1840s. When foreign vessels entered the coast trade of China, many shippers on them were Chinese merchants. The general approach

was that they should be taxed according to the "native tariff," but the situation quickly became very murky when foreign and Chinese merchants cooperated to fuzz up the ownership of goods. The Chinese officials involved were much moved by the fact that Maritime Customs duties were reported and transmitted to Peking in toto, whereas native customs collections were a part of the provincial officials' take and anything they collected over their quotas due to Peking could be at their disposal. Chinese provincial officials wanted to keep Chinese trade under the native tariff while the British encouraged Chinese merchants to ship on foreign vessels subject to the rather limited treaty tariff.

The symbiosis of foreign and native commercial styles and mechanisms was visible in many sectors. For a first example, take native shipping in the junk trade.

During the commercial expansion of the eighteenth century thousands of sailing junks of many types were added to the carrying fleets along the China coast, up the rivers and on canals and lakes. Let us note an example, a type used in the coastal waters of the Yangtze delta, called the "Kiangsu trader," a seaworthy ship with a high stern, often brightly painted. Like all junks it has a sternpost rudder such as the Chinese made use of a thousand years before the Europeans. The hull is divided into half a dozen watertight compartments, also an ancient Chinese invention, and the two masts carry sails with battens that can be hauled close to the wind. Other types of junks were specially constructed for inland waters, some for towing up the Yangtze and other rivers. Speed was not their object. They were simply durable, economical, and efficient cargo carriers.

When steamships began to be used on China's main rivers in the late nineteenth century, the junk fleet expanded to handle the increase of local trade on the innumerable waterways of the Central and South China inland transport network. In short, China's wind- and muscle-power water transport system was not superseded by the arrival of steamships. Instead, it seems to have grown because the muscle power was so cheaply available.

At the same time Chinese merchants' enterprise was such that they were soon operating steamships of their own. The major flag carriers on the coast and up the Yangtze continued to be the British firms of Jardine and Butterfield, but these were the facilities known to foreigners and connected with international traffic. Meantime,

though to an as yet unascertained degree, the steam engine began to be used on small craft of many sorts under entirely Chinese auspices. This fact no doubt contributed to the retardation of railways in South China. Steam power was already being applied to water transport through the hinterland without the expense of building railroad rights of way and track. In short we can conclude that steam transport was simply incorporated into the existing commercial network. In this as in so many other respects, the unequal treaties brought less drastic changes to China than the foreigners thought they did.

7

Efforts at Modernization

IF WE NEED TO LOOK BACK at China's economic development before appraising the treaty-port influence after 1842, the same applies, but in spades, to China's early Westernization. What was the received wisdom of the scholar-officials who tried to begin modernization? What were their skills and their blind spots? Let us begin by looking at certain inadequacies in their inheritance—the statecraft tradition in administration, new growth in classical scholarship, and a bare beginning of studies of the West.

China's effort to Westernize was called by the classical term "Self-Strengthening" so as to emphasize China's autonomy and initiative. The impetus came from several sources—first of all from the scholar-administrator's tradition of statecraft, which stressed the search for knowledge "of practical use to society." Practitioners of statecraft sharpened their wits on problems like getting the tribute grain shipped up the Grand Canal to feed Peking. As noted above, the canal had silted up, the Yellow and Huai rivers sometimes flooded over it, bureaucratic lethargy had overtaken the grain-tribute administration, and the hereditary grain-junk troops were corrupt and rebellious. The statecraft answer, in the 1820s, had been to ship the rice for Peking by sea around the Shantung peninsula. This was proved feasible, but vested interests blocked its continuation. (The solution after 1872 would be to create a Chinese steamship line and

give it a monopoly of the rice shipments.)

Statecraft pragmatism had guided Commissioner Lin in his valiant but vain effort to stop the opium trade in 1839. But Lin's ignorance of the world outside China had led him blindly to challenge the British empire just at the start of the age of Palmerston. Too late, Lin tried to find out what had hit him. His friend Wei Yuan used some of the intelligence Lin had gathered to construct a world geography of the "maritime countries" that had broken through China's horizon.

The statecraft tradition that Wei Yuan exemplified had had a long gestation during the Ming-Ch'ing era. A brief look at this tradition will cast light on the strengths and weaknesses of China's late imperial administrators who grappled with *yang-wu,* "overseas matters." Particularly important is the question of their ability to innovate.

In brief, economic growth in the eighteenth century had been paralleled by intellectual developments in scholarship that form a telling contrast with the contemporary Enlightenment in Europe. Chinese classical scholarship has usually been as opaque to Western readers as the Church Fathers. But recent studies now let us see how Chinese classicists, after being confined to ivory-tower erudition, began to grapple, a little late, with China's real problems. (May this be called a "proto-Enlightenment"? I don't think so.)

This growth of scholarship occurred in the academies *(shu-yuan)* that proliferated during the eighteenth century. The typical academy was a self-contained residential unit, situated ideally in a rural setting among ancient trees and hills that looked out upon the "mountains and waters" *(shan-shui)* so prevalent in landscape paintings. Classical scholarship went along with an austere Confucian life style, close to nature. The Fu-wen Academy at Hangchow, for example, appears in a perhaps idealized painting as a complex of one-story buildings grouped around a succession of courtyards that ascend a small forested valley. Headed by distinguished scholars, Fu-wen was given presents of imperially sponsored books by both the K'ang-hsi Emperor in 1685 and Ch'ien-lung in 1754. This imperial patronage exemplified the Manchu rulers' concern to keep the Chinese scholar class properly under their wing.

The Manchus had also inherited from the Ming a formal system of "schools" at county, prefectural, and provincial levels. Rather than being residential colleges, these "schools" seem to have consisted of

the qualified examination candidates enrolled in each area, who were encouraged in their continued self-indoctrination in preparation for the next level of examinations. This governmental supervision of the literati, made palatable by official status and even stipends, had aimed to foster orthodoxy and prevent the rise of factionalism such as had plagued the politics of the late Ming period.

Among Chinese scholars still resentful of the Manchu conquest, the Ch'ing at first had banned the setting up of academies and all political discussion, but literary societies and poetry groups could not so easily be suppressed. In the early eighteenth century "charitable schools" *(i-hsueh)* were allowed to be set up by family funds under official supervision.[18] In 1733 Peking began to permit the revival of academies, still under official control, to help scholars prepare for the examinations. By 1750 semi-official, semi-autonomous academies began to emerge under the sponsorship of high officials. In these institutions philological and textual studies became ends in themselves. By 1800 several dozen such academies, especially in the Lower Yangtze, were providing the stipends, libraries, and quarters for serious study of Chinese history and classics out from under direct official control.

The key to this growth of more-autonomous scholarship was the patronage of high officials, whose wealth could bring talented scholars into their entourages *(mu-fu)* to compile and edit works of scholarship. One exemplar of this trend was Juan Yuan, an energetic bibliophile and compiler who served as a high official in Chekiang, Kiangsi, and Hupei, and then as governor-general at Canton (1817–26), where he founded the Hsueh-hai T'ang academy and superintended many significant publications. For example, the *Huang Ch'ing ching-chieh* in 360 volumes reprinted 180 works by 75 authors of commentaries on the classics during the Manchu (Ch'ing) era. Juan Yuan's production of such *collectanea,* anthologies, catalogues, dictionaries, and the like, employed a large corps of scholars on funds that came partly from the leading Hong merchant in foreign trade, known to the West as Howqua.

What new views did this spate of scholarly works have to offer? In brief the eighteenth century saw a going back to the earliest texts of the classics in order to counter the arid philosophical moralism of the neo-Confucianism that had been dominant in China since the Sung. The new look was called the Han Learning as distinct from the

Sung Learning and its specialty was philological criticism of the classics on the basis of careful evidential *(k'ao-cheng)* scholarship. Examination of classical texts revealed that certain passages in the *Book of Documents (Shang-shu),* for example, had been forgeries interpolated from other texts. This was news indeed, not unlike the discovery of the Dead Sea Scrolls and Gnostic Gospels in Biblical studies. It broke the crust of orthodoxy. Han Learning scholars in particular used the New Text *(chin-wen)* versions of the classics, i.e., the older versions newly discovered in Later Han.

The philological emphasis of evidential *(k'ao-cheng)* research stimulated a revival of the Sung Learning's stress on moral principles. This sometimes produced a Han-Sung eclecticism on the part of scholars concerned after the mid-nineteenth century with the problems brought not only by foreign contact but also, and more important, by the evident downturn in the health and fortunes of the dynasty.

Because Wei Yuan was an outstanding example of a statecraft scholar who confronted the West from a background in the Han Learning, his career is quite instructive. In the eight years from 1813 to 1821 he studied in Peking on a government stipend. He joined the New Text school in reinterpretation of the classics through empirical textual research, but at the same time accepted the argument of the Sung Learning that history depends upon virtuous leaders who have a high sense of morality. By 1825 he had become editor of a principal collection of Ch'ing writings on statecraft. These essays by Ch'ing officials and advisors of officials *(mu-yu)* dealt with the nuts and bolts of administration, particularly financial, such as the salt tax or the government land tax or administration of the Grand Canal grain transport system—how to keep the system working. Administrative devices were no more important than moral leadership in a period of apparent decline. In applying this doctrine, Wei Yuan participated in the effort to transport the tribute rice to feed Peking by ship around Shantung instead of by the Grand Canal transport system, which was breaking down. Wei also helped reform the official salt monopoly that distributed sea salt from the coast north of the Yangtze to inland regions. In order to obviate smuggling, the price of salt was lowered.

Another subject he pursued was the ten great campaigns of the Ch'ien-lung Emperor by writing after 1829 a military history of the

Ch'ing. This led him to the problem of coastal defense. All this background prepared him for his book, *Illustrated Gazetteer of the Countries Overseas,* a widely influential geographical work promoting strategic suggestions. Foreign trade and the management of foreign traders began to receive the attention that Ch'ing strategists had theretofore reserved for Inner Asia. This made Wei a committed ally of Commissioner Lin in his effort to control the opium trade at Canton. But, while Wei Yuan's book on the maritime countries took note of European incursions into Southeast Asia through trading ports and naval gunfire, he seems to have accepted the 1842 cession of Hong Kong to Britain. He conceived of it as a useful appeasement of the British, not as the entering wedge of Britain's informal empire. It was still not easy for him to think in terms of naval power.

The governor of Fukien, Hsu Chi-yü, had done even better and used Western maps and data secured from missionaries to compile in 1848 a systematic account of all countries and their histories. Britain, he found, having colonized America in the middle years of the Ming, had taxed them too harshly and lost control, but she retained India and was penetrating Southeast Asia. "The population of England is dense and the food insufficient. It is necessary for them to import. . . . More than 490,000 people are engaged in weaving. The weaving machine is made of iron, and is operated by a steam engine, so it can move automatically."[19] Among Britain's six hundred warships (as of 1850) were one hundred steamships. Steam engines, the governor found, were being adapted in America even to pulling carts on iron rails.

For the ordinary Chinese literatus Governor Hsu's new view of the globe was much more novel than nuclear physics is to us and certainly as unsettling. The gap steadily widened within the ruling class between those aware of foreign things and the great majority who were still absorbed in the classics and examinations. Some leading officials collected a large entourage of able young specialists, some of whom went abroad and mastered foreign languages and learning.

The effort began just in time to meet general disaster. The forty years beginning in 1860 form a distinct era in the buildup of the Chinese Revolution—a time when the old system seemed to work again and some Western ways were adopted, yet China's progress was so comparatively slow that she became a sitting duck for greater

foreign aggression. The imperialist rivalry of the powers came to a terrifying climax in the 1898 "scramble for concessions," and the period ended with troops of eight nations occupying Peking in 1900. Obviously these were the four decades when China missed the boat. While Japan ended her seclusion, adroitly began to Westernize, got rid of her unequal treaties, and was prepared to become a world power, why did China fail to do the same?

This question has haunted Chinese patriots throughout the twentieth century. At first the explanation was found in Social Darwinism. China had simply lost out in the competition for survival among nations. Partly this was due to her tardiness in ceasing to be an ancient empire and becoming a modern nation. The fault lay within.

By 1920, however, a more satisfying explanation was offered by Marxism-Leninism. The fault lay with the capitalist imperialism of the foreign powers who invaded China, secured special privileges under the unequal treaties, exploited Chinese markets and resources, and suppressed the stirrings of Chinese capitalism. Since many foreigners announced loudly that they were going to do just that, all sides could agree. The same decades saw the triumph of colonialism all around China's periphery. Burma and Malaysia were taken over by Britain, Vietnam by France, Taiwan by Japan. Foreign aggression and exploitation were too plain to be denied.

Two generations of argument over these explanatory theories have come to rest in the 1980s on a "both . . . and" formula: internal weakness invited foreign invasion, just as Confucius said 2,500 years ago. The real argument has been over the proportions between the two and the timing of their influence. As the onward march of scholarship helps us to learn more about China within, I believe the claims of Marxism-Leninism will be watered down as time goes on but no one can deny their validity in many important respects.

How does this apply to 1861–94? The era began with a joint leadership of Manchus and Chinese, at Peking and in the provinces, who agreed on a general program of appeasing the Anglo-French invaders while suppressing the Chinese rebels. There are few better examples of how to turn weakness into strength, though sometimes at the expense of the Chinese populace.

By mid-1860 a revived Taiping offensive had invaded the Yangtze delta, taking the major cities of Hangchow and Soochow and threatening Shanghai, while at the same time an Anglo-French army

arrived off Tientsin in two hundred ships, and fought its way to Peking. Facing this double disaster, the Manchu leadership executed a neat double appeasement: they finally gave Tseng Kuo-fan supreme command against the Taipings, abandoning the old rule that Chinese civil officials should not control armies in the provinces, and they accepted the Anglo-French demands to open China further to foreign trade and proselytism. As they put it in the dynastic councils, the rebels were an "organic disease," the foreigners merely an "affliction of the limbs." (This of course would be the way Chiang Kai-shek phrased his problems with Japanese invasion and Communist rebellion in the 1930s and 1940s.) All the British wanted was trade; so their opium trade was legalized and inland trade on the Yangtze promised them as soon as the Taipings (who stubbornly prohibited opium) should have been destroyed.

American and British mercenaries, like F. T. Ward of Salem, Massachusetts, were hired to use steamers and artillery in amphibious warfare around Shanghai. Having got the terms they wanted at Peking, the British and French abandoned neutrality and let officers like C. G. "Chinese" Gordon fight the Taipings while, even more important, foreign merchants sold Remingtons and howitzers to the imperial armies. Anglo-French forces had returned from humbling Peking to defend Shanghai and the Yangtze delta, and so help save the dynasty.

In this way the Ch'ing restoration of the 1860s secured foreign help while still expounding the classical ideology of rule by virtue. Tseng Kuo-fan, whose sangfroid at the slaughter of Taiping prisoners we have noted, set the tone of the restoration by his admirable strength of character and rather simple-minded faith in the Confucian ideals of proper behavior.

"Barbarian affairs are hard to manage," he wrote his understudy Li Hung-chang in 1862, "but the basic principles are no more than the four words of Confucius: *chung, hsin, tu,* and *ching*—faithfulness, sincerity, earnestness and respectfulness. . . . *Hsin* means merely not to tell a lie, but it is very difficult to avoid doing so. . . .

"Confucius says, 'If you can rule your own country, who dares to insult you?' If we are unified, strict and sober, and if hundreds of measures are fostered, naturally the foreigners will not insult and affront us without reason." (Obviously, a man so indoctrinated with

the Confucian virtues could be entrusted with the fate of the dynasty.)

"In your association with foreigners," Tseng told Li, "your manner and deportment should not be too lofty, and you should have a slightly vague, casual appearance. Let their insults, deceitfulness, and contempt for everything appear to be understood by you and yet seem not understood, for you should look somewhat stupid."[20]

What better prescription could one suggest for swallowing pride and appeasing an invader? The Manchus at court had quoted the ancient saying "Resort to peace and friendship when temporarily obliged to do so; use war and defense as your actual policy." The dynasty and its Chinese ruling class were in the soup together.

After Tseng Kuo-fan died in 1872 the lead in dealing with foreigners for the next thirty years was taken by Li Hung-chang, a tall (over six feet), vigorous, and extremely intelligent realist, who was eager to take responsibility and became adept at hanging on to power. He was devoted to the art of the possible and, working within that limitation, became the leading modernizer of his day. Although Li Hung-chang himself went around the world only toward the end of his career in 1896, he realized from the first moment his troops got their Remington rifles that foreign things were the key to China's defense and survival. He became the leading advocate of what Peking a century later under Deputy Premier Deng Hsiao-p'ing would call "modernization."

Li had benefited from the fact that his father had been a classmate of Tseng Kuo-fan in the top examination of 1838. After Li won his provincial degree, he studied under Tseng at Peking. He got his own top degree there in 1847, and in the early 1850s went back to his native place (Ho-fei in Anhwei) to organize militia against the rebels, much as Tseng was doing in Hunan. He assisted the provincial governor in campaigns and then in 1859 joined Tseng Kuo-fan's staff, became his chief secretary, and drafted his correspondence. When the Ch'ing court was finally obliged to give Tseng overall command in 1860, Li had his chance.

Backed by Tseng to organize his own Anhwei army on the model of Tseng's Hunan army, Li in April 1862 used seven foreign steamers hired by refugee gentry to bring his troops down the Yangtze to Shanghai. At age thirty-nine he now became governor of Kiangsu province at the fulcrum of Sino-foreign relations. Shanghai he found

to be an Anglo-French military base, with foreign troops far better armed and trained than his Chinese forces. Troops so armed could take over China! Indeed, he feared "the hearts of the officials and of the people have long since gone over to the foreigners." He felt himself "treading on frost over ice." Could Shanghai be kept from a foreign takeover? Li rushed to buy Western arms and build up his Anhwei army. Within two years he had forty thousand men with ten thousand rifles and cannon using thirty-six-pound shells. He got Western cooperation against the Taipings but kept it strictly within limits.

In this way Li Hung-chang moved in on the ground floor of the late Ch'ing establishment. Having qualified first as a scholar, he won the dynasty's confidence as a general commanding troops. His Anhwei army helped surround and strangle the Taipings in the Lower Yangtze and then in the late 1860s finished off the Nien rebels, whose cavalry had been raiding all across North China. Purchasing foreign rifles, setting up arsenals, and drilling troops gave the dynasty the edge over dissident peasants from this time on. Simultaneously the British with their gunboats and troops at Hong Kong and the treaty ports and on the Yangtze became an integral part of China's power structure, helping to maintain political order in the interests of foreign trade.

Meanwhile the Yangtze province governors recommended to the court by Tseng Kuo-fan represented the new generation of loyal Chinese officials who in the 1860s led armies and thereafter used Western ways, beginning with Western arms, to strengthen the Chinese state and forestall further rebellion. The post-rebellion period saw a new Manchu-Chinese and central-provincial balance in which Chinese initiatives were skillfully fostered but contained by Manchu control over the imperial prerogatives of appointment, promotion, and dismissal of officials as well as allocation of revenues.

In this same era, the interests of the Ch'ing dynasty and of Britain's informal empire in East Asia were linked by that extraordinarily unobtrusive and effective Irishman Robert Hart, who built up the Imperial Maritime Customs Service to administer the foreign trade of China. After 1842, when foreign merchants enjoyed an extraterritorial immunity from Chinese law, the Ch'ing customs collectors had found that colluding with foreigners to mutual benefit was much

easier than coercing them on behalf of the emperor's revenue. This tended to make the treaty tariff a joke and leave trade at the mercy of organized Sino-foreign corruption. But in 1854 the foreign consuls at Shanghai got "foreign inspectors" installed in the Ch'ing customs house to appraise the duties honestly, and by treaty this system was extended to all the treaty ports, eventually some forty places. Hart as inspector general from 1863 to 1908 took full responsibility for appraising and reporting the duties due. He hired an international staff (mainly British) to do this in each port, and so assured Peking of a reliable and growing revenue that its own customs superintendents were obligated to receive and account for.

Robert Hart was a rather slight and quiet young man of keen intellect and cultural sensitivity. He learned his Chinese language and how to deal with Chinese officials during an apprenticeship of four years, 1854–58, as British interpreter and vice-consul at the sleepy port of Ningpo, south of Shanghai. From there he went to Canton for a year as secretary to the Anglo-French commission that governed the city through the unhappy Ch'ing officials captured there in 1858 and left in office. When Hart resigned from the British service and was finally installed in 1863 as I.G. (inspector general) at Peking, he found himself at age twenty-eight an insider close to the high councils of the Ch'ing government. Prince Kung, the boy emperor's uncle who headed the administration, was only thirty, and these two young non-Chinese, though from different worlds, found themselves confronting the problems of the Chinese empire together. Unlike the activist-imperialist minister Harry Parkes, who was the darling of the Shanghai-minded because he browbeat the natives with gunboat diplomacy, Hart became a devoted supporter of the Chinese interest as he saw it. Though he was a dictator over the Customs Service, he knew his place as a Ch'ing employee and practiced the virtues of proper behavior extolled by Tseng Kuo-fan —beginning with the hardest of all virtues in Peking, keeping his mouth shut.

Naturally he became the middleman in all sorts of diplomatic crises. In 1864, for instance, Chinese Gordon secured the surrender of eight Taiping commanders at Soochow by promising to spare their lives, but his superior Li Hung-chang promptly took the usual precaution of having them decapitated and so traduced Gordon's honor.

There was hell to pay, until Hart saw each party separately and saved both Victorian honor and Chinese face. The Ever Victorious Army went back into action.

On May 11, 1864, Gordon bombarded Changchow all morning and then, explaining that "the beggars inside" would conclude he had "finished work for the day," at one o'clock he attacked.[21] While Hart and Li Hung-chang stood together on a hillside to watch, Gordon led one of three assault groups and was first through the narrow breach himself. Changchow fell, but Li and Tseng did not let their Western allies participate in the subsequent capture and looting of Nanking that ended the rebellion.

From 1870 to 1895 Li Hung-chang was governor-general at Tientsin but still in command of units of his modern-armed Anhwei army. At the court's behest he coped with one foreign crisis after another—murder of Catholic nuns at Tientsin; the Japanese takeover of an island kingdom long tributary to China, now known as Okinawa; the ushering of another tributary, Korea, into treaty relations with the Western powers so as to offset the territorial ambitions of Japan and Russia; the long and confusing hostilities and negotiations with France over its takeover of still another tributary, Vietnam. This last case was so confusing because not only Li but also Peking and the Chinese minister in Paris got into the act, while four French cabinets came and went and the French navy also took part. Robert Hart finally secured the peace by having his London agent negotiate secretly in Paris in 1885. Negotiating to conclude France's war against China over Vietnam in the 1880s was as long drawn out as the Nixon-Kissinger effort to end America's Vietnam War in the 1970s. However, far fewer people were killed in the rather second-rate Sino-French hostilities.

Li's acting as Peking's de facto foreign minister was symptomatic of Peking's institutional backwardness. Foreign affairs were still frontier affairs, not central government affairs. There was still no foreign office, only a committee of the Grand Council known as the Tsungli Yamen, which discussed foreign issues that reached Peking. Li was appointed to keep foreign problems at a distance from the capital.

In his diplomacy he tried the two-thousand-year-old gambit of "using barbarians to control barbarians." This Chinese defensive specialty was of course elementary all over the world, though usually less quaintly phrased. For example, while not encroaching on Chinese

territory, the Americans talked so much peace and friendship, even "good offices" in time of trouble, that they seemed good barbarians to use.[22] In 1879 when ex-President U. S. Grant passed by on his world tour, Li sought his good offices because Japan had absorbed China's small tributary Liu-ch'iu (Okinawa). But the wily old general staged a second Appomattox: Li had to give up Chinese objections to American suspension of Chinese immigration while Grant in Tokyo found the Japanese legally entrenched and immovable. Later Li sought American mediation regarding Korea, French Indochina, and Japan's treaty terms in 1895, all to no avail. They were all *vox et praeteria nihil.*

Li Hung-chang's diplomatic efforts gave him high visibility, and Western journalists occasionally touted him as the "Bismarck of the East." The comparison can be instructive. Li Hung-chang (1823–1901) no doubt had many of the abilities of his German contemporary Otto von Bismarck (1815–98). He was a big man, an astute diplomat and energetic administrator, above all a realistic practitioner of the possible, who for forty years played principal roles in China. But, while Bismarck between 1862 and 1890 engineered and won three wars to create the German empire and dominate central Europe, Li confronted rebellions at home and foreign aggression on China's borders that led the Ch'ing empire steadily downhill. While Bismarck was fashioning a new balance of power in Europe, Li had to deal with the breakup of the Ch'ing tribute system that had once provided a kind of international order in East Asia. The Iron Chancellor held central executive power among a people already leading the way in modern science, industrial technology, and military nationalism. Li Hung-chang never held central power but only represented Peking as a provincial governor-general. His influence hung by the thread of his loyalty to the regent for two boy emperors in succession, the Empress Dowager Tz'u-hsi, a clever, ignorant woman intent on preserving Manchu rule at all costs. Li's loyalty to his ruler had to be expressed in large gifts and unquestioning sycophancy, to the point where in 1888–94 Li's North China navy, racing against Japan's naval buildup, had to divert its funds to build Tz'u-hsi's new summer palace. In place of a Bleichroder, who financed Bismarck in the clinches, Li Hung-chang had to collect his own squeeze by the usual age-old filching from his official funds. After he negotiated the secret Russo-Chinese alliance in 1896 he received a personal gift of

a million roubles. Some said he amassed a fortune worth $40 million. It is plain that he got some things done, but he led the late Ch'ing effort at modernization only by persistent pushing and constant manipulation of an intractable environment.

This was a two-front struggle, to find out the practical secrets of Western power and also to convince indoctrinated fellow officials that imitating the West was necessary. Tseng Kuo-fan, for example, supported the Shanghai Arsenal and it built a steamship, on which he even ventured to sail. But he opposed telegraphs, railways, and other uses of Western technology as likely to harm Chinese livelihood and give foreigners too much influence. Li had to steer a devious and indirect course. For instance, Tseng offered him the conventional Confucian wisdom (or balderdash) that "warfare depends on men, not weapons" (an old idea, but modified today by a thought of Mao Tse-tung's). Li countered by describing British and French warships he had visited. "I feel deeply ashamed," he said, at China's inferiority in weapons. "Every day I warn and instruct my officers to be humble-minded, to bear the humiliation, to learn one or two secret methods from the Westerners."

If we recall the American need in public discussions of the Cold War era to first reassure an audience that Communism, the enemy, was not for us, we can sympathize with Li Hung-chang's problem. To the court at Peking he wrote in 1863: "Everything in China's civil and military systems is far superior to the West. Only in firearms it is absolutely impossible to catch up with them. Why? Because in China the way of making machines is for the scholars to understand the principles, while the artisans put them into practice.... The two do not consult each other.... But foreigners are different.... I have learned that when Western scholars make weapons, they use mathematics for reference."

Li also pointed to the Japanese success in learning to navigate steamships and make cannon. If China could stand on her own feet militarily, he prophesied, the Japanese "will attach themselves to us." But if not, "then the Japanese will imitate the Westerners and will share the Westerners' sources of profits."[23]

By 1864 Li ventured to recommend that science and technology be added to the topics in the examination system. From today's point of view this was surely the starting point for China's adaptation to the modern world. But the idea never had a chance. Even the proposal

that regular degree holders be recruited to study Western science in the interpreters' college that Hart was financing at Peking, and in similar small government schools at Shanghai and Canton, was shot down.

The imperial tutor Wo-jen, a Mongol who dominated the Peking literary bureaucracy, spoke for the orthodox majority: "The way to establish a nation is to stress propriety and righteousness, not power and plotting . . . the minds of people, not technology. . . . The barbarians are our enemies. In 1860 they rebelled against us." They invaded Peking, he continued, burned the imperial summer palace, killed our people. "How can we forget this humiliation even for a single day?" Why, he asked, was it necessary to "seek trifling arts and respect barbarians as teachers? . . . Since the conclusion of the peace [in 1860], Christianity has been prevalent and half our ignorant people [the Taipings] have been fooled by it. . . . Now if talented scholars have to change from their regular course of study to follow the barbarians . . . it will drive the multitude of the Chinese people into allegiance to the barbarians. . . . Should we further spread their influence and fan the flame?"[24]

These sentiments coincided with the vested interest of every scholar who taught, and every young man who studied, the classics. Modern learning was effectively kept out of the examinations until they were finally abolished in 1905.

The modernization of China thus became a game played by a few high officials who realized its necessity and tried to raise funds, find personnel, and set up projects in a generally lethargic if not unfriendly environment. Hope of personal profit and power led them on, but the Empress Dowager's court, unlike the Meiji Emperor's in Japan, gave them no firm or consistent backing. Tz'u-hsi on the contrary found it second nature to let the ideological conservatives like Wo-jen stalemate the innovators so that she could hold the balance. Since South China was as usual full of bright spirits looking for new opportunities, especially in the rapidly growing treaty-port cities, the late nineteenth century was a time of much pioneering but little basic change. Westernization was left to the efforts of a few high provincial officials partly because this suited the central-local balance of power—the court could avoid the cost and responsibility—and partly because treaty-port officials in contact with foreigners were the only ones who could see the opportunities and get foreign help.

On this piecemeal basis Li Hung-chang found allies in Cantonese entrepreneurs whose long contact with Westerners gave them new channels to climb up. For example there was a T'ang clan based ten miles from Macao who grew rich making shrimp sauce and selling it there. The clan steadily gained influence during the nineteenth century as its members passed local and provincial examinations. However, Tong King-sing (T'ang T'ing-shu, 1832–92) opened up a new channel. He learned English in a missionary school, became an interpreter in the Hong Kong police court and the Shanghai customs house, and after 1863 grew wealthy as Jardine's top comprador. From investing in pawn shops and native banks he moved on to shipping companies, insurance, and even a newspaper. Meanwhile he bought degree status and an official title, which the dynasty was now selling for revenue. From 1873 Li Hung-chang got Tong's assistance in his industrial-development projects.

Instead of battling his fellow Confucians on the intellectual front, Li found it easier to compete with foreign economic enterprise in China. China's domestic commerce in private hands was already actively expanding. Li pursued the traditional idea of enlisting Chinese merchant capital in projects that would be "supervised by officials but undertaken by merchants," something like the salt trade. After all, the proportion of China's national income that passed through the government's hands and sticky fingers was still very low.

Li in 1872 started a joint-stock steamship line, even calling it the China Merchants Steamship Company, and soon got Tong King-sing to be the manager. But merchant capital came forward only in small amounts. The crash of 1877 allowed Li to buy up the fleet of Russell and Company, the Boston firm that with Chinese merchant help had inaugurated steamboating on the Yangtze. But a majority of the funds had to come from official sources. When in 1885 Robert Hart lent one of his young customs commissioners (H. B. Morse, Harvard '74) to advise the China Merchants' managers, Morse found the company overloaded with personnel and being milked of its profits. It survived by hauling the tribute rice to Tientsin and making rate deals with the British lines of Jardine, Matheson & Company and Butterfield and Swire, who continued for the next fifty years under the unequal treaty system to dominate water transport within China.

When Li Hung-chang in 1876 started the Kaiping coal mine north

of Tientsin to fuel his steamships and give them return cargo to Shanghai, he made Tong manager of the mining company. At Kaiping Tong brought in a dozen Western engineers and installed modern pumps, fans, and hoists. Soon Kaiping had a machine shop, telephones and telegraphs, and a small railway, and was producing 250,000 tons of coal a year. It was so successful that Peking could not keep its hands off. A Chinese squeeze artist from the court succeeded Tong, squeezed the company dry, and kept it going mainly on foreign loans. Finally in the Boxer crisis of 1900 a British company, represented by an up-and-coming American mining engineer named Herbert C. Hoover, got control of it. China's legal counsel in London later claimed that this takeover was almost indistinguishable from grand larceny. After 1912 the Kaiping mines were run by the Anglo-Chinese Kailan Mining Administration.

A similar spottiness marked Li's first venture in sending students abroad. This had been proposed by another Cantonese, a school classmate of Tong named Yung Wing, who had gone so far as to accept missionary support and make it to Yale. He became Yale's first Chinese graduate, in 1854. Trying to make himself useful back in China, he was eventually sent out to buy the machinery for the Shanghai Arsenal. Finally in 1872 he was given charge of the Chinese educational mission that during the next decade brought 120 long-gowned Chinese youths to America. The first batch, selected by Tong King-sing, included seven of his relatives, and the third group, his nephew T'ang Shao-i.

On the advice of the Connecticut commissioner of education, Yung Wing set up headquarters in Hartford, but President Porter of Yale suggested the students should board with families up and down the Connecticut Valley. Soon they learned to tuck their queues under their caps and play very smart baseball, while Yung Wing himself married Mary Louise Kellogg of Avon, Connecticut. Yung Wing's co-supervisor, a proper long-gowned scholar, was horrified: the boys were becoming barbarized. They were not mastering the classics in preparation for their examinations back in China! In 1881 the project was abandoned. Chinese students came to America again only thirty years later, not as young teenagers, and without their queues and classics, after the end of the dynasty.

The 120 students from the Hartford project made their mark in China's foreign relations and industrialization after 1900. If the pro-

ject had continued after 1881, China's modern history might have been different.

As time went on some of Li Hung-chang's protégés as well as some of his rivals moved into industrial enterprise as bureaucratic capitalists. Still using the formula of "official supervision and merchant management" or sometimes "official and merchant joint management," they became sponsors and/or investors in textile mills, telegraph companies, coal-iron-and-steel complexes, and modern banks. Their official and personal interests sometimes overlapped so fully that the conflict of interest, if anyone had looked for it, could not have been unscrambled. But their industrial leadership was more bureaucratic and monopoly-oriented than it was innovative and risk-taking. The capital funds invested were not great nor was the management always skilled. In the great global development of late nineteenth-century capitalism, China remained a backwater. It was not invested in as colonies were, nor did it develop great staple exports. British India and Japan got ahead in supplying tea and silk to the world by standardizing their national product. But for this China had no leadership.

Li Hung-chang had two principal rivals, one early in his career, one later. Tso Tsung-t'ang (1812–85) came from Hunan and until the age of forty had been a scholar of broad practical interests in agriculture and geography but had failed three times to win his top degree at Peking and gave up trying. After 1852 he distinguished himself as a military commander. As Tseng Kuo-fan's nominee he became governor and governor-general of Chekiang and Fukien in charge of strangling the Taipings from the south. Tso was then sent against the Nien movement in North China and finally against the Muslim rebellions in the Northwest and in Chinese Turkestan.

Hardly a generation had passed since Jahangir's invasion of Kashgar and the war and peace with Kokand. The Manchu dynasty's weakness against rebels in Central China had as usual inspired Muslim risings in West China as well as Kashgaria. By the 1870s a general from Kokand known as Yakub Beg had thrown off Ch'ing control south of the Mountains of Heaven, while the Russians had occupied the strategic Ili River region north of them. The whole distant area seemed lost.

Li Hung-chang meantime saw Japan rising and Korea endangered, and sought funds for coast defense and a navy. Why waste

scarce resources on a probably futile effort to recover Central Asian steppes and deserts? Tso Tsung-t'ang, however, was truly stubborn and determined. He persuaded the court to invest in a long campaign of reconquest on the grounds that Central Asia had been a primary concern of the three great emperors of the eighteenth century and was still strategically important. By 1873, after five years, Tso had pacified the Northwest. Now with Peking's support he continued to build up his forward supply bases and train his generals and sixty thousand troops, until in 1876 they dashed across the desert road to Turkestan (as far as from Kansas City to Los Angeles) and brilliantly recovered what soon became the province of Sinkiang ("New Dominion"). The Russians by 1881 agreed to withdraw from Ili. Peking's courtiers were impressed with China's evident ability to slaughter Muslim rebels and checkmate Russian imperialists.

Li Hung-chang's later rival rose to prominence in this time of euphoria. Chang Chih-tung (1837–1909), a brilliant scholar, was eloquently bellicose against Russia and then against French encroachment in Indochina, one of a "purist" group of armchair strategists, who constantly demanded the chastisement of all and sundry barbarians. When Li Hung-chang negotiated a possible settlement with the French in 1884, this war party attacked him as a softy in forty-seven memorials. They were righteous denouncers of malfeasance wherever found, except on the part of the Empress Dowager, who held power. But, when given responsibilities, the "purists" did poorly except for Chang Chih-tung, who proved to be not only honest and uncorrupt, and a significant ideologue of Confucianism, but also very fertile and energetic in projects for modernization.

Chang started a mint at Canton and then had eighteen years as governor-general at Wuhan, where he promoted railway projects and China's first steel works, using coal and iron from Central China. Most of all Chang pursued education: in Canton he founded an academy and a press to print Ch'ing classical studies; at Wuhan he set up an array of new schools and trained a modern army. Chang was a very busy conservative reformer, obsequiously loyal to the power holder and known for popularizing the slogan "Chinese learning for the fundamental principles, Western learning for practical application," by which he bamboozled himself and many others into thinking one could pour new wine into the old bottle, modernize on the old foundation, revive Confucianism to achieve modernity, and gen-

erally go forward while standing pat. Of course he faced the problem of all bureaucrats working for the throne—how to make innovations that would actually change China's institutional structure without seeming to threaten the crabbed ruling power.

The payoff from Self-Strengthening came in the Sino-Japanese War of 1894–95. Because of her size, the betting was on China, but Li Hung-chang knew differently and tried to stall off the war. China had begun navy building in the 1870s. For a time Robert Hart, who was creating a preventive fleet for customs work, acted as China's agent to buy gunboats, and he privately saw a chance of being appointed inspector general of Coast Defense. However, the job was left divided among the high provincial officials, and especially Li Hung-chang. During the 1880s Li purchased steel cruisers and got instructors and advisors from Britain, but later Krupp outbid Armstrong and two bigger German vessels were added. In the late 1880s, however, funds for the Chinese navy were scandalously diverted by a high-level official conspiracy to build the Empress Dowager's new summer palace instead. By Hart's estimate the navy "ought to have a balance of 36,000,000 taels [say U.S. $50 million], and lo! it has not a penny." In September 1894 he found "they have no *shells* for the Krupp's, and no *powder* for the Armstrongs."[25] In the war with Japan only Li Hung-chang's North China army and fleet were involved (not those in Central and South China) and some of the navy's shells were found to be full of sand instead of gunpowder.

When China's Ch'ing dynasty restoration after thirty years confronted Japan's Meiji restoration in warfare, the two protagonists were Li Hung-chang and one of Japan's founding fathers, Itō Hirobumi. They had first met in 1885 over the Korean question and agreed that Japan and China should both stay out of Korea, where they were backing rival factions. Li noted, however, "In about ten years, the wealth and strength of Japan will be admirable . . . a future source of trouble for China."

Sure enough, when the Japanese intervened in 1894, ostensibly to quell Korean rebels, they routed Li's North China army and in one of the first modern naval battles, off the Yalu River, sank or routed his fleet. It was commanded by an old cavalry general who brought his ships out line abreast like a cavalry charge, while the Japanese in two columns circled around them. Today when tourists visit the marble boat which stands in the summer palace lake outside Peking,

they should be able to imagine a caption on it—"In memoriam: here lies what might have been the late Ch'ing navy."

In 1895 when Li was sent to Shimonoseki to sue for peace, he and Itō had a polite dialogue, which was recorded in English. Li said: "China and Japan are the closest neighbors and moreover have the same writing system. How can we be enemies? . . . We ought to establish perpetual peace and harmony between us, so that our Asiatic yellow race will not be encroached upon by the white race of Europe."

Itō said: "Ten years ago I talked with you about reform. Why is it that up to now not a single thing has been changed or reformed?"

Li could only reply, "Affairs in my country have been so confined by tradition that I could not accomplish what I desired. . . . I am ashamed of having excessive wishes and lacking the power to fulfill them."[26]

From our perspective today, the startling thing is that China's first modern war should have been left on the shoulders of a provincial official as though it were simply a matter of his defending his share of the frontier. The Manchu dynasty has of course been blamed for its non-nationalistic ineptitude, but the trouble was deeper than the dynasty's being non-Chinese; the fault evidently lay in the imperial monarchy itself, the superficiality of its administration, its constitutional inability to be a modern central government.

The Ch'ing dynasty had survived rebellions of the Chinese people but its foreign relations now got out of hand. Japan's victory over China threw the Far East into a decade of imperialist rivalries. In order to pay off the indemnity, China went into debt to European bondholders. In order to check Japan, China invited Russia into Manchuria—until the Russo-Japanese War of 1905 left Russia confined to the north and Japan triumphant in South Manchuria and Korea. Meanwhile Russia, Germany, Britain, and France in 1898 all occupied spheres of influence in China. These consisted usually of a major port as a naval base, a railway through its hinterland, and mines to develop along it. All in all, China seemed about to perish. A new generation had to come to the rescue.

The fifty-five years from 1840 to 1895 had illustrated the old syndrome of "internal disorder, external disaster" *(nei-luan, wai-huan)*. The dynasty saved itself at the expense of the people by appeasing the foreigners and getting their weapons to suppress re-

bellions not only in the Lower Yangtze but in Northwest and Southwest China and Central Asia. Foreign powers nibbled away at the peripheral tributaries, not only the Ili region but also the Liu-ch'iu Islands (Okinawa), Vietnam, Korea, and even Burma. Aside from the foreign warfare with France and finally Japan, this era saw a pervasive invasion from the West. Steamships and the telegraph speeded up transport and communication. Urbanization of the major treaty ports created new foci for cultural change. After a loss of population in the 1850s and '60s, growth resumed with all its problems, but now the government tried to catch up with the situation. The Ch'ing regime was reinvigorated by a restoration of dynastic power, which however brought with it fundamental changes. Chinese officials with personally loyal regional armies rose to leadership in the provinces, while Peking cooperated with the British and others in beginning to modernize its armed forces, diplomatic relations, and foreign trade. Most significant was the diversification of the growing upper class, the emergence in the cities of professional people not under official control, in the haven of the treaty ports, and the continuing amalgamation of the landlords, gentry degree holders, and merchant classes as the commercialization of agriculture went forward.

Study of the West gradually began and some students were sent abroad, but instead of taking a strong leadership in modernization, the Ch'ing regime cautiously husbanded its power within a general position of Chinese weakness. As Christian missions and other foreign contact expanded, Chinese society began to be opened up to modernizing influences from outside. But the institutional structure of dynastic monopoly over the top level of the decentralized administration began to change only slowly.

Did the Ch'ing restoration of the 1860s succeed? The answer is mixed. From the dynasty's point of view, the imperial government survived the rebellions. The throne still commanded the loyalty of its high officials as the source of their examination degrees, their appointments down to the county *(hsien)* level, their instructions by imperial edicts and decrees, their promotions, rewards, and punishments. In other words, the official system continued to function. Within this seeming continuity of institutions, however, power was slipping away from Manchus to Chinese, from Peking to the provinces, and within the provinces from higher gentry (provincial degree holders, officials, and large landlord families) to lower gentry

(degree holders of the lower levels or by purchase, local managers, merchants, and clients of the top elite). By 1895 the imperial Confucian-Manchu synthesis of state and society had begun to come unstuck. The high provincial officials were now Chinese, who financed their regional armies out of local trade taxes. Prolonged warfare had fostered a trend toward local violence and regional militarization that would grow drastically in the twentieth century. The imperial government's revenues now came more from trade taxes than ever before. High territorial officials governed by using private entourages of experts *(mu-yu)* and conducted their local foreign relations with foreign consuls, often aided by their colleagues of the Imperial Maritime Customs Service. Nominal sovereignty still resided in Peking, but the treaty ports, which were by this time the major cities, were not under Peking's control. The Westernizing projects were handled by the *mu-yu,* who often embezzled the funds in their charge. "Official supervision and merchant management" did not open the door to private enterprise but rather to a new height of official corruption and "bureaucratic capitalism."

However, this rather negative assessment of China's halting first efforts at modernization reflects treaty-port scoffing at China's backwardness in an era of rapid development in Japan and the West. Further studies should disclose a groundswell of change not heretofore perceived in Late Imperial China.

PART II

THE

TRANSFORMATION

OF THE LATE

IMPERIAL ORDER,

1895–1911

8

Reform and Reaction

THE HISTORY OF ANY NATION is of course nationalistic—that is, it tends to filter out the activities of foreigners within the country. In the case of China, however, this is not feasible. To be sure, China's history has been made primarily by Chinese people. But outsiders like the Mongol and Manchu conquerors have also figured in it and by the same token Christian missions have had their influence, especially during the unequal-treaty century 1842–1943. Discussion of the reform movement therefore may well begin with the Christian contribution to it. Missionaries by their calling were reformers at heart, and their efforts at once brought them into conflict with the Chinese establishment.

Protestant missionaries and the Chinese local elite were as natural enemies as cats and dogs. Both were privileged, immune to the magistrate's coercion. Both were teachers of a cosmic doctrine. Rivalry was unavoidable.

In the view of the local scholar elite, missionaries in China were foreign subversives, whose immoral conduct and teachings were backed by gunboats. Conservative patriots hated and feared these alien intruders, but the conservatives lost out as modern times unfolded, and the record thus far available comes mainly from the victorious missionaries. The record shows few Chinese converts to Christian faith but a pervasive influence from missionary good works.

We can easily understand why no subject has been more controversial than the missionary movement's contribution to Chinese life. Thousands of Christian young people from America and Europe devoted their lives to work in China, trying, in their sometimes bizarre fashion, to help the people they found there. Their voluminous reports to their home constituencies had great influence in the West but their various roles in Chinese life are less clear. The new Chinese Marxist elite are hardly more enthusiastic about missionaries in retrospect than were their Confucian predecessors at the time.

The converts were rather few for obvious reasons. Take the example of the China Inland Mission, founded by a thirty-four-year-old Englishman, Hudson Taylor, in 1866, because he saw "a million a month were dying" in China, "dying without God," and were therefore being consigned to eternal hellfire. "Ancestral worship is idolatry from beginning to end," said Hudson Taylor. The fate of all idolators, he said, "is in the lake of fire." By the 1890s the China Inland Mission had six hundred missionaries at work, living Chinese-style in the interior, competing with the Catholic fathers. G. E. Morrison noted their problem. "They tell the Chinese inquirer that his unconverted father, who never heard the gospel, has, like Confucius, perished eternally."[27] A man's conversion, in short, would condemn his father and all his line to burn in brimstone forever. Not many would buy this proposition.

The official record in Chinese is mainly concerned with missionary cases raised with the Chinese government by foreign consuls after riots or other outrages.

Protestant missionary activity in China can be described under a succession of phases. The exploratory phase began with the arrival of the Englishman Robert Morrison in 1807 as a member of the staff of the British East India Company at Canton—the only way he could be got into the country. A few other British subjects followed and did pioneer work mainly among Chinese Overseas communities in Southeast Asia. Americans began to come in 1830 and until 1860 were similarly confined to the treaty ports and the immediate hinterland, where they were allowed to go if they could get back by evening. Already the missionaries found that the Confucian-trained gentry were their great enemies, while the less-educated common people particularly in the countryside were more open to proselytism. Not that they were easily converted—decades of work often

produced fewer than a hundred converts.

A second period from 1860 to 1900 saw the gradual spread of mission stations into every province under the treaty rights of extraterritoriality, and also the right of inland residence slipped into one treaty by a devout French interpreter. In the "Christian occupation of China" as it was unwisely called in 1907, missionaries brought their small schools and rudimentary medicine into the major cities, where examination candidates could occasionally be leafletted. But for the most part the Americans, who had usually come from farms, found that life in the countryside was more congenial and offered a better prospect of competing with Confucianism. The growth of the Protestant Christian church was slow but steady. Although the number of Chinese converts and practicing Christians rose by 1900 to over 100,000, this was a mere drop in the Chinese bucket. However, the Protestant missionaries were great institution builders. They set up their compounds with foreign-style houses managed by Chinese servants and soon were developing schools and dispensaries or public-health clinics. The first Chinese they won for Christ were partly clients and coworkers, like the cook or the tract distributor, but soon they also included some gifted and idealistic men who were impressed by foreign ways and were willing to embrace the foreign religion. In the nineteenth century many of the Chinese reformers took on Christianity partly because the trinity of industry, Christianity, and democracy seemed to be the secret of Western power and the best way to save China.

Getting the Christian message into Chinese continued to be a considerable problem. Early in the nineteenth century and at first glance the Protestants seemed to the Chinese to be merely another sect of a Buddhist type, with a belief system, a savior, moral guilt, and a way to atone for it—elements which most of the great religions have in common. The belief was that Christianity had developed as a Western offshoot of Buddhism. At any rate the early missionaries seemed to be promoting another kind of sect with its special doctrines and esoteric practices. Since most religious sects in China had long since been proscribed, like the White Lotus religion *(Pai-lien chiao)*, they were generally secret organizations. After the spectacular Jesuit contact of the 1600s, Christianity was banned by the 1724 edict of the Yung-cheng Emperor, who declared it to be heterodox and therefore a menace to the social order.

The missionaries had a long struggle on their hands to master the Chinese language and work out the terminology they needed to convey their message. One device was to create their own imitation classics. For example their imitation of the Chinese primer the *Trimetrical Classic (San-tzu ching)* presented a simplified Christian cosmology comparable to the Confucian doctrine propagated in the original. Yet as late as the 1870s missionaries were calling their substitute classic the "sacred teaching" *(sheng-chiao)*, which sounded fine to Christians but at the same time meant Confucianism to non-Christians.[28] China was so sophisticated in religious teachings that there was a rather full vocabulary already in being to designate God, the soul, sin, repentance, and salvation. Missionary translators were up against it: if they used the established term, usually from Buddhism, they could not make Christianity distinctive. But if they used a neologism they could be less easily understood. This problem became most acute at the central point in Christianity, the term for God. After much altercation the Catholics wound up with Lord of Heaven, some Protestants with Lord on High, and others with Divine Spirit. In fact a translation into Chinese of the Bible produced a stalemate in which the missionaries could not agree on what to call the basic kingpost of their religion.

As if this terminological ambiguity and similarity to Buddhist and Taoist cults already in China were not enough, a fortuitous factor posed a great problem for Christianity in China. As we have seen, the Taiping Rebellion, which ravaged half the country from 1850 to 1864, began as a Christian heterodox sect of God-Worshipers and concocted a cult that used the Bible in translation as the binding medium for a revolutionary movement. Some missionaries when they first heard about the Taipings concluded that Christ was winning China, but more information soon convinced them that the Taipings were so doctrinally confused and uncultured in manner that Christian missions could give them no support. For similar reasons the Taipings had no appeal to the Confucian scholar-gentry, and the imperial Ch'ing officials in the provinces were able to destroy them. One major result was not only devastation of the Yangtze provinces but destruction of the Protestant missionary image. After 1864 it took a lot of explaining to reconcile a Chinese Confucian scholar to the idea that Christianity could give him a new life.

As Christian converts accumulated, mainly in the treaty ports,

they began to form a decentralized community. When in 1868 Young J. Allen began to publish in Chinese the *Church News,* converts contributed letters to it. Pioneer missionaries had long since found that Western geography and customs had a great interest for Chinese readers, and Allen and others began to put out a magazine, the *Wan-kuo kung-pao (Review of the Times)* that reported on the international scene. Weekly from 1875 to 1883 and monthly from 1889 to 1907 this journal spread world news to the Chinese scholar class. Partly because it was so ably written in classical Chinese by the Chinese editors, this journal being first in the field gave the missionaries a direct channel to the scholars and officials who were grappling with the problems of the outside world. In the 1890s the ablest missionaries (like the Welshman Timothy Richard) pursued a program of reaching the scholar class and so had a considerable influence on the reform movement.

Unlike the Protestants, the Catholic priests wore Chinese dress and were less interested in modernization. American Catholics did not become active through the Maryknoll Mission until 1915. Until then the French were the main protectors and sponsors of Catholicism in China. They had little commercial interest there.

Both Protestants and Catholics inherited the lore of the Chinese anti-Christian movement from the seventeenth century. Fundamentalist Confucian scholars had denounced Christianity from the first and spread a folklore that attributed gross immorality and black magic to the foreigners. During the nineteenth century fundamentalist Confucians used this literature to inflame city mobs and attack Christian premises. Particularly in the 1890s the foreign menace stimulated this kind of resistance to mission work. It died away only after 1901.

What was it like to be a top scholar in Peking in 1895? Let us imagine it in terms equivalent to those of America almost a century later. If you were a top scholar (*chin-shih,* "metropolitan graduate"), a winner in the old China's form of democratic competition through examinations, it would be much as if you had received tenure at your university and also been elected to Congress; you had made it into the ranks of permanently historical figures. You also bore a responsibility for the future of your country. You had to stand up and be counted.

Suppose also that your country had just been thoroughly defeated by a foreign power hitherto considered inferior both in size and culture, and that moreover the victor represented evil incarnate like the Nazis or in the Cold War era like the Antichrist represented by Communism. The bad guys had won and you were obviously heading into an unspeakable disaster, perhaps a breakup of the United States into foreign satrapies. For China this was not merely a defeat by some other civilized power but a real subjection to the powers of darkness and convulsive change represented by the Western countries. Consider that the Westerners had the morals of animals, men and women both holding hands and actually kissing in public (why not copulate?). By inventing powerful machines this outside world had overwhelmed the order of man and nature that had created civilization and the good life. Chaos was at hand.

Of course the past can never exactly be recreated but we know that the Japanese victory in 1895 was a tremendous shock to the members of an elite who felt responsible for the fate of their society. As scholars graduated from the examination system and accepted for high office they had a primary duty to advise the ruler and help save the situation.

In 1895 several factors had suddenly converged. First was the foreign menace, which had produced three wars and three defeats for China through naval firepower on the coast. New weapons of war, incredibly destructive, were now wielded by these outsiders. Second, to this fact of foreign power was added the undeniable fact of foreign skill, not only at war-making but in all the practical arts and technology of life. The steam engine on ships and railroads had speeded up transportation beyond all compare. Public services of paved roads, gas lighting, water supply, and police systems could be seen demonstrated in Shanghai and other ports.

Third, because many felt that technology and the arts were an expression of basic moral and intellectual qualities, it was plain to such people that traditional China was somehow lacking in these capacities that the foreigners demonstrated. True, the West had allegedly learned its mathematics from ancient China and borrowed many things, like chinaware, silk, paper and printing, gunpowder, and the compass, all of which had originated in China. But plainly these Westerners were more than mere imitators. Their mathematics and other intellectual skills had developed further in such a way

as to give them their overwhelming power.

The crisis and humiliation produced by these considerations led to the inescapable conclusion that China must make great changes. Something in China was fundamentally wrong. Because China's common people did not contribute to government and most of the elite were too well ensconced in habitual ways to provide intellectual leadership, only scholars could tackle this problem.

"In a great release of enlightenment, I beheld myself a sage," wrote K'ang Yu-wei. He was twenty-one at the time, a precocious scholar from a distinguished Cantonese family. He had immersed himself not only in the Confucian classics but also in Buddhism and the Western learning then available in translation. His teacher had cautioned him against "undue feelings of superiority." Later his closest student and colleague, who ought to know, said K'ang had an "extremely ample power of self-assurance. . . . He refuses to adapt his views to fit facts, on the contrary, he frequently recasts facts to support his views."[29] The combination of a syncretic mind and "sublime self-confidence" enabled K'ang to put together several strands of Chinese thought in a new prescription as to how Confucianism could meet China's needs. He thereby led a breakthrough into modern times.

By 1895 China's military and technological backwardness was an established fact that no informed upper-class person could deny, least of all the thousands of classical scholars who had assembled in Peking for the triennial examinations. The news of Li Hung-chang's signing on April 17, 1895, of the treaty of Shimonoseki which ceded Taiwan and South Manchuria to Japan, touched off a furor. To be sure, at the "suggestion" of Russia, France, and Germany, Tokyo was obliged to forgo taking South Manchuria at this time, but the message of this European intervention was the same—China's humiliation.

K'ang led the way in drafting a long memorial to the throne and more than twelve hundred examination candidates signed it—an almost unique expression of consensus on high policy, the sort of thing that even officials were not ordinarily permitted to discuss among themselves. Although inspired by a sense of nationalism, the righteous indignation and high moral principles expressed in the memorial echoed the strident *ch'ing-i* ("pure discussion") style in

which scholars out of power, when given opportunity, lambasted the policies of those in power.

The memorial urged that the peace treaty be rejected, the capital be moved inland to carry on the war, and numerous reforms be carried out to secure talent, stop corruption, promote modern learning, and build up the state economy.

The list of desirable reforms was now a mile long. It had been steadily accumulating for more than fifty years with additions by a succession of writers, beginning with Wei Yuan at the time of the Opium War. Several secretaries and advisers of Li Hung-chang had contributed; so had Christian missionaries, Taiping rebels, diplomats who went abroad, and early Chinese journalists in Hong Kong and Shanghai.

Reform came naturally in the late Ch'ing. Statecraft scholars had been raised on the categories of government offices and operations described in the Ch'ing statutes—the many kinds of taxes, the nine ranks of officials, the flow of documents by the official post, the salt gabelle, the grain tribute, and myriad other administrative devices. For such people the Western countries and now Japan offered a cornucopia of new ways that might be adapted to China's needs. On the broadest level, parliaments could create a firmer bond between ruler and people. Meantime government patents or rewards could encourage inventions, repair of roads could help trade, mineralogy could improve mining, agricultural schools could increase production, translations could broaden education—the list was endless. For system-minded list makers it was seductive stuff. Every scholar could rattle off his pet list of things to advise the power holders to do and so save China.

But, before the reform movement could gain broad support, a philosophical sanction had to be found for China's borrowing from abroad and changing the old ways. This sanction had to be found within Confucianism, for it was still the vital faith of China's ruling class. It called for statesmanship in the service of the Son of Heaven. Only an insider, a latter-day sage, could perform the intellectual task of updating this Confucian teaching. This was K'ang Yu-wei's great contribution. He was expert at finding in China's classical tradition the precedents that would justify its adaptation to the present.

K'ang's starting point was the New Text movement, in which Ch'ing scholars had attacked the authenticity of the Ancient Text

versions of the classics, upon which the Neo-Confucian orthodoxy since the Sung period had been based. This whole subject, needless to say, was at a level of complexity like that of the Christian doctrines of the Trinity or of predestination. No slick summary can really do it justice. But for us today the point is that the New Text versions came from the Early Han (B.C.) while the Ancient Text version had become standard in the Later Han (A.D.) and had remained so for the Sung philosophers who put together the synthesis we call Neo-Confucianism (in Chinese parlance the Sung Learning). To repudiate the Ancient Text versions in favor of the New Text (which were really older) gave one a chance to escape the Neo-Confucian stranglehold and reinterpret the tradition.

In 1891 K'ang published his *Study of the Classics Forged during the Hsin Period* (A.D. 9–23). He concluded that "the classics honored and expounded by the Sung scholars are for the most part forged and not those of Confucius." This bombshell was eruditely crafted and very persuasive (though not now generally accepted). In 1897 K'ang published another blockbuster, his *Study of Confucius' Reform of Institutions,* claiming that Confucius had actually composed, not merely edited, the major classics as a means of finding in antiquity the sanction for institutional reforms. K'ang also cited New Text classical sources to buttress his theory of the Three Ages of (1) Disorder, (2) Approaching Peace and Small Tranquility, and (3) Universal Peace and Great Unity. The world was now entering the second age in this progression, which implied a doctrine of progress. K'ang Yu-wei had secured most of his ideas from earlier writers, like Wei Yuan and the journalist Wang T'ao, but he marched to his own drum. This enabled him to smuggle the ideas of evolution and progress into China's classical tradition at the very moment when these ideas were sweeping the international world.

Indeed K'ang Yu-wei and his best student, the Cantonese *Wunderkind* Liang Ch'i-ch'ao (1873–1929), were quick to accept the Social Darwinism of the 1890s. They wrote books on the sad fate of hidebound nations like Turkey and India and the success stories of Peter the Great's Russia and Meiji Japan in the struggle for survival of the fittest among nations. In short, the radical reformers were ardent nationalists but still hoped that the Ch'ing monarchy could lead China to salvation. As K'ang put it in 1895, China's "principles, institutions, and culture are the most elevated in the world. . . . Only

because her customs are unenlightened and because of a dearth of men of ability, she is passively taking aggression and insult. . . . China is in imminent peril . . . the popular mind is perturbed. . . . If we . . . are divided among ourselves . . . then, alas, the fate of our sacred race will be unspeakable, utterly unspeakable!"[30]

Profiting from the example of Protestant missionaries, some of whom were now making a special appeal to the scholar-official class, K'ang and Liang began to úse the modern devices of the press and of study societies that sponsored discussion of public problems both in print and in group meetings. K'ang even advocated making the worship of Confucius into an organized Chinese national religion. But his main hope was a traditional one, to gain the ear of the ruler and reform China from the top down.

His chance came in 1898, when each imperialist power demanded a sphere of influence and China seemed about to be carved into pieces. Since 1889 the idealistic young Emperor Kuang-hsu had been allowed nominally to reign while his aunt the Empress Dowager (popularly called the Old Buddha) kept watch on him from her newly furbished summer palace. The emperor, now twenty-seven, had been reading books, not a safe activity for a figurehead, and his old imperial tutor, a rival of Li Hung-chang, recommended K'ang Yu-wei to him.

When K'ang met with high officials in January 1898, one led off pompously, "The institutions inherited from the ancestors cannot be changed." K'ang replied, "We cannot preserve the realm of the ancestors. What is the use of their institutions?"

Li Hung-chang asked, "Shall we abolish all the Six Boards and throw away all the existing institutions and rules?" K'ang replied, "The laws and governmental system . . . have made China weak and will ruin her. Undoubtedly they should be done away with." Plainly he was a wild man.

Nevertheless, as the crisis deepened in 1898 the emperor gave him his confidence. Their first audience lasted five hours. K'ang said, "China will soon perish." The emperor replied, "All that is caused by the conservatives." "If Your Majesty wishes to rely on them for reform," K'ang said, "it will be like climbing a tree to seek for fish." K'ang then attacked the examination system because it prevented officials from understanding foreign countries. The emperor replied,

"It is so. Westerners are all pursuing useful studies while we Chinese pursue useless studies."[31]

Between June 11 and September 21, during just one hundred days, Kuang-hsu issued some forty reform decrees aimed at modernizing the Chinese state, its administration, education, laws, economy, technology, and military and police systems. Unfortunately, unlike the first hundred days of FDR, which legislated the New Deal in 1933, the radical reformers' hundred days of 1898 remained largely on paper while officials waited to see what the Old Buddha would do. She waited until nearly everyone in the establishment felt threatened, and then staged a military coup d'état. She confined Kuang-hsu to the southern island in the palace lake (where another chief of state, Liu Shao-ch'i, would be kept seventy years later), and executed the radicals she could catch. K'ang and Liang escaped to Japan. Eighteen ninety-eight made it pretty plain that China was not going to be remade from the top, at least not soon.

After his brief period close to the center of power in 1898 K'ang became a political organizer, founder of newspapers among Chinese abroad, and proponent of the cause of the Kuang-hsu Emperor in the hoped-for guise of a constitutional monarch. As his political fortunes waned he pursued a passionate interest in traveling around the world with one or another of his daughters, became interested in astronomy and the place of the earth among the heavenly bodies, and pursued a lively interest in what would now be called science fiction. At the same time he constructed the argument for a utopianism of egalitarian proportions that would have horrified the members of the Chinese scholar class if they had become widely known. In his posthumously published book, *Ta-t'ung shu* (variously translated as *The Great Commonwealth* or *One World*, etc.) he indulged in a utopian wiping out of all distinctions and particularly the Confucian rules of behavior. In this utopia women would have equal rights with men, marriage would be a simple contract and divorce equally simple, frontiers and other barriers between parts of the world would come down, everybody would have access to everything. Property, the family, the state would all go, while technological improvements would be managed (somehow) by government under law. This utopianism would soon be pursued by Chinese anarchists, but in the early 1900s it was too far out, too blasphemous, to be formally published.

One thing about K'ang Yu-wei's idea of one world is worth noting: it was a cosmopolitan view to embrace all mankind in a new socio-cultural order. While K'ang represented a force of nationalism, his ideas transcended the nation-state and contemplated a utopia that is still one of the great ideals in the world. This met the requirement that any new Chinese world view would have to be of worldwide application in a cosmopolitan scene, not a parochial one or simply nationalistic.

K'ang Yu-wei's utopianism had revolutionary implications. He had first reinterpreted Confucianism and second, in *The Great Commonwealth*, written down about 1902, had by implication attacked the whole Confucian order of status and conduct according to status. Indeed, a comparison of *The Great Commonwealth* and the *Communist Manifesto* reveals their agreement on abolition of private property and the bourgeois family based upon it, socialized education in public schools, emancipation of women, reduction if not abolition of nationalism, and centralization of all production under the state. There is no evidence K'ang ever read Marx and of course they differ regarding violent class struggle vs. reform. But utopianism was obviously in the air.

K'ang Yu-wei's thinking by no means became the mainstream of reformist thought. The Westernization movement since 1860 had been posited on the dualism of spirit and matter, which led to Chang Chih-tung's famous slogan, "Chinese studies for the framework of values, Western studies for practical purposes." There were other ways of phrasing it, but the main idea was simply that Chinese culture had its own way of life and value system while Western technology dealt simply with the practical and mechanical aspects of society. This dualism would have many adherents under various banners as the century wore on. Indeed, the conflict between culture and technology is still with us.

The 1898 reform movement was followed by reaction. The Empress Dowager ordered local militia organized and turned down Italy's me-too request for a sphere of influence. She gave ear to the most die-hard Manchu princes, whose palace upbringing had left them ignorant of the world and proud of it. Some of them became patrons of a peasant secret society, the Boxers. Since secret societies were universally anti-dynastic, which was why they were secret, this turning of the Manchu court to active support of the superstitious

Boxers was an act of utter despair. It also revealed the Manchu die-hards' lack of elementary common sense.

The Boxer movement was straight out of China's past, descended from the Eight Trigrams rebellion of 1813, as though no history had intervened. Expressing the violent desperation of credulous masses in the countryside, it surfaced in North China in the late 1890s under the name *I-ho ch'üan,* meaning it was a branch of the ancient calis- thenic fighting or boxing art *(ch'üan)* devoted to righteousness and harmony *(i-ho).* Devotees of the ritual became possessed by spirits who made them happily invulnerable to bullets.

Conditions of drought, famine, and destitution had worsened in North China while the foreign menace, represented, for example, by German mining prospectors in Shantung province, seemed to upset the "spirits of wind and water." Railways threatened to violate ances- tral graves and also throw carters and boatmen out of work. Worst of all were the Chinese Christians: "Catholics and Protestants have vilified our gods and sages . . . conspired with the foreigners, de- stroyed Buddhist images, seized our people's graveyards. This has angered Heaven," read Boxer placards.[32]

Early in 1899 the Boxer slogan was the traditional one, "Over- throw the Ch'ing, wipe out the foreigners," but by late 1899 it be- came "Support the Ch'ing, wipe out the foreigners." The Manchu princes, and even the Old Buddha for a time, felt they heard the voice of the common people, the final arbiter of Chinese politics. They proposed to work with it, not against it, and so solve their problem of foreign imperialism at one blow.

Though social cataclysms are usually complex and mysterious, in this one several aspects stand out. Foreign provocation of the Chi- nese ruling class, Manchu and Chinese alike, had gone on since the 1830s and steadily grown in intensity. It reached a peak in 1898. Purblind resistance to change had centered in the Manchu dynasty, which catered to Chinese conservatism and xenophobic pride. A blow-up was almost inevitable. In the sequence of events, each side aroused the other. Legation guards in the spring of 1900 went out shooting Boxers to intimidate them. By June 13–14 Boxers broke into Peking and Tientsin, killing Christians and looting. On June 10, 2,100 foreign troops had started from Tientsin to defend the Peking lega- tions but got only halfway. On June 17 a foreign fleet attacked the coastal forts outside Tientsin. On June 21 the Empress Dowager and

the dominant group at court formally declared war on all the powers. As she said, "China is weak. The only thing we can depend upon is the hearts of the people. If we lose them, how can we maintain our country?" (By country she meant dynasty.)

The Boxer Rising in the long, hot summer of 1900 was one of the best-known events of the nineteenth century because so many diplomats, missionaries, and journalists were besieged by almost incessant rifle fire for eight weeks (June 20–August 14) in the Peking legation quarter—about 475 foreign civilians, 450 troops of eight nations, and some 3,000 Chinese Christians, also about 150 racing ponies, who provided fresh meat. An international army rescued them, not without bickering, after rumors they had all been killed. The Empress Dowager with the Emperor safely in tow took off for Sian by cart. The allied forces thoroughly looted Peking. Kaiser Wilhelm II sent a field marshal, who terrorized the surrounding towns, where many thousands of Chinese Christians had been slaughtered; 250 foreigners, mainly missionaries, had been killed across North China. Vengeance was in the air.

But the Chinese provincial governors-general who had led the effort at Self-Strengthening also coped with this crisis. Li Hung-chang at Canton, Chang Chih-tung at Wuhan, and the others had decided right away in June to ignore Peking's declaration of war. They declared the whole thing was simply a "Boxer Rebellion" and they guaranteed peace in Central and South China if the foreigners would keep their troops and gunboats out. This make-believe worked. The imperialist powers preferred to keep the treaty system intact, together with China's foreign debt payments. And so the War of 1900, the fourth and largest that the Ch'ing fought with Western powers in the nineteenth century, was localized in North China.

The Boxer protocol signed in September 1901 by the top Manchu prince and Li Hung-chang with eleven foreign powers was mainly punitive: ten high officials were executed and one hundred others punished, the examinations were suspended in forty-five cities, the legation quarter in Peking was enlarged, fortified, and garrisoned as was the railway, and some twenty-five Ch'ing forts were destroyed. The indemnity was about $333 million, to be paid over forty years at interest rates that would more than double the amount. The only semi-constructive act was to raise the treaty-based import tariff to an actual 5 percent (no protective tariff had ever been allowed, of course).

Negotiating this debacle was Li Hung-chang's last official service to the old order; he died a few weeks later. Sir Robert Hart, still I.G. in Peking after surviving the siege, wrote to his London agent, "Poor old Li was at work thirty hours before death: wonderful vitality, wonderful determination not to succumb and not to let anybody have a say in things so long as he was to the fore to decide!"

On her return to Peking in January 1902 the Empress Dowager, according to Hart, "was most gracious, bowing and smiling on the foreigners who crowded on the walls at the Chien-Men [Front Gate] to watch the entry." Later he noted: "The Court is over-doing it in civility: not only will Empress Dowager receive Ministers' wives, but also Legation *children!*"[33] A photograph of 1903 shows the Old Buddha, seated, clasping the hand of the American minister's wife (Sarah Pike Conger), who had survived the siege in 1900 and now stood beside her.

How are we to appraise all this blood-and-thunder drama? What was in it for the Chinese people?

The quickest answers are of course the simplest. Revolutionaries of later times, looking back on the events of 1895–1900, have seen in them the bankruptcy of a repressive and exploitative partnership sealed in 1860 between the Ch'ing dynasty and the foreign powers. One need not buy all the Marxist-Leninist formula of domestic feudalism collaborating with foreign imperialism to see verisimilitude in this general pattern. Once Peking had accepted the treaty system of foreign privileges for residence, trade, and missionary work, the foreign powers became supporters of the established order. Their arms helped suppress the Taiping and other rebellions. Their technology helped the Self-Strengthening movement.

But, once one looks below this level of generality the picture fragments. Foreigners helped and foreigners hindered China's progress. There was really no sustained partnership, much less a conspiracy, in any direction. Was Li in league with British imperialism? Not appreciably. One day in 1893, for example, the first Chinese cotton textile mill, sponsored by Li Hung-chang in Shanghai and just outside the Foreign Settlement boundary, had a fire. The British business leaders who ran the Shanghai Municipal Council all day refused to let its fire department cross the boundary, so the whole mill burned down.

When it came to the reform movement, foreign contact and influence helped create it. But it was done by piecemeal interaction, in

a great variety of ways, and not the result of policy. The pioneer Hong Kong journalist Wang T'ao, for example, got his reform ideas partly from living in Scotland for two years (1868–69) while helping the missionary James Legge translate the Chinese classics. Touring around Scotland, London, and Paris gave him the "field experience" necessary to make him one of China's first "Western experts." Many of his ideas were later picked up by K'ang Yu-wei.

Yet the reform movement was a chapter in the history of Chinese thought, not Western thought. It dealt with Chinese premises and problems in the Chinese language. Before we call it simply a response to foreign stimuli, we must acknowledge the dynamic vitality of the Chinese tradition of which it was the latest phase. The long record of Confucian reformism is just beginning to be studied. In the 1980s Deng Hsiao-p'ing is indebted to it.

9

The Genesis of
the Revolution of 1911

CHINA AFTER 1900 became a different place. Missionary educators like Calvin Mateer contrasted the 1860s with the 1900s: "Then everything was dead and stagnant; now all is life and motion."[34] Journalists wrote of a New China, Young China. The Yale historian Mary Wright speaks of "the rising tide of change." She sees it sparked by nationalism, evident in the anti-imperialist struggle for treaty revision and rights recovery, the domestic push for a centralized nation-state, and, less important, the effort to get rid of the Manchus. Their dynasty was already very close to losing Heaven's mandate (the acquiescence of the people) but no successor authority was yet in sight. In brief, the energizing of the Chinese body politic produced in the 1900s a multitude of movements all interacting contemporaneously. Modern times had arrived, and our analysis of events will have to scramble all across the board.

Let us begin with the growth of the media of communication. China after 1901 participated in the worldwide rise of the popular press, international news reporting, and mass publication of books and journals. But, before we give the Chinese an avuncular pat on the back for their precocious development of the modern media in the twentieth century, we would do well to recognize the long Chinese tradition of book production, which antedated European book publishing by several hundred years. One knowledgeable guess is

that as of 1750 there were more printed books in China than in Europe. The modern media had deep indigenous roots; adaptation was called for more than invention *de novo*. Beginnings have been made in the study of the old China's libraries, local histories (gazetteers), imperial collections and censorship, poetry and belles-lettres, popular fiction of several types, distribution of official documents, and local news sheets—a large area for further exploration. By 1900 the literate urban elite had hundreds of novels to read for amusement. The chief innovations were to distribute Western works in translation, to publish news and comment on public issues, and to begin to reach the literate upper level of the peasantry.

In the background of reform had been the growth of journalism and publication, particularly in Shanghai, which rapidly facilitated the spread of ideas in urban centers. This can be traced back to Chinese precedents and also to the missionary press of the nineteenth century. Even before they were allowed in the treaty ports after 1842, Protestant missionaries had pursued the writing of tracts in Chinese to reach the common people. In 1897 Liang Ch'i-ch'ao founded in Shanghai the newspaper *Shih-wu-pao* to express the ideas of the reform movement. In the same year the Commercial Press was established as a publishing house to produce a new literature for broad consumption. It began to publish textbooks as well as religious works and build up a modern library and research department. It led the way in the new techniques of printing and in 1915 published a new Chinese dictionary, the *Tz'u Yuan*. The Commercial Press's chief rival, the Chung-hua (China) Book Company was founded in 1911.

The foreign press in Shanghai had begun with the *North China Herald* of 1850. Eventually it began to produce a Chinese version, and in 1872 an Englishman founded the *Shen-pao*. This successful enterprise during the 1880s produced a pictorial, *Tien-shih-chai hua-pao*, using woodblock prints that illustrated the news as well as interesting phenomena. As the Shanghai press grew up, two or three leading papers reached circulations of 50,000 (by the 1930s, 150,000). They joined the modern world by having regular reporters in Peking whose telegraphic reports daily conveyed the national news.

This rapid growth was accompanied not only by serious political discussion of the Manchu dynasty's reform movement from 1901 to 1911 but also by the rise of modern fiction. Liang Ch'i-ch'ao in exile

in Tokyo published a series of journals and advocated the key role of fiction to awaken people and change their ideas. The earliest novel writing for political purposes was performed by Liang as part of his crusade to save China. Shanghai newspapers began to run special columns and supplements on subjects like education, science, and the status of women. They found that the serialization of novels expanded their readership. As the urban audience enlarged, both the reform press and the revolutionary press printed "entertainment fiction."[35] Love stories and detective stories, knights-errant and early science fiction began to cater to an urban middle-class audience.

In addition to the media, we should also note how the year 1901 ushered in the third and most influential phase of Christian missions. After the defeat and punishment of the Boxer rebels, who had been used by the dynasty to try to drive out all foreigners, missionaries first of all, the long tale of atrocities created a martyrology among the missionaries, while the retribution of the Boxer protocol demonstrated who had been the victors. Protestant missionaries played an increasing role in Chinese life. The door was finally open for an influx of Western ideas and ways, and the missionaries were people on the spot who had already established their institutional position and could now move further, for example, from schools to colleges.

Those missionaries not killed by the Boxers now became fixtures in the landscape. They were at work in every province, spreading Western medicine with its special capacity for surgery, bringing girls into their primary and middle schools, encouraging the movements against opium and footbinding, teaching young people how to hold meetings and discussions, and by their mere presence from abroad, enlarging the Chinese horizon. Christian missions had their heyday in China from the 1900s to the 1930s. Although they created a Chinese Christian church of considerable talent and vigor, I suspect that, when the story is finally traced out, their indirect social-institutional influence will appear more significant than their Christian doctrine.

However, China's modern history was China-made, not foreign-made, though foreign activity was a stimulus both negative (foreign aggression) and positive (foreign learning and institutions). The chief political feature of the 1900s was the rise of nationalist sentiment. Though long delayed, this now arose from China's sense of cultural identity that lay deep within the society and its traditions. It had accepted the Sinified Manchu dynasty. It had to accept the Western

presence in the treaty ports. Out of the statecraft tradition, plus foreign examples, had come the Self-Strengthening movement, then the reform movement, then the Boxers. But neither the bureaucratic administrators nor the radical scholars had been able to create a new order to meet China's needs, and of course the peasant rebels had not even tried. The one thing evident to many by 1900 was that revolution to destroy the old order was the only remaining alternative.

Naturally the revolution would be fueled by nationalism, a concern to preserve China as a political entity in the world of nations that now crowded in upon her. But this new nationalism symbolized something more—a readiness to look outward and respond to foreign stimuli, the sort of thing that the maritime-commercial Chinese of the southeast coast had done since medieval times but usually as a minority in the great agrarian-bureaucratic empire. Only in eras of weakness like the Southern Sung, with its capital in the south at Hangchow, had this maritime China been able to assert its interest in overseas trade. Usually the dynastic regimes, like the Yuan, Ming, and Ch'ing, had remained strategically absorbed in landward relations with Inner Asia, whence might come their rivals for power. Now in the twentieth century, however, the prime menace came indubitably from overseas, and maritime China, as the front line of contact, produced leadership to meet it.

Maritime China in modern times consisted partly of the treaty ports and partly of the Overseas Chinese communities in Southeast Asia and other parts of the world. In the seventeenth century, after the fall of the Ming, Vietnam had received Chinese refugees. About the same time Overseas Chinese merchants developed a dominant position in the foreign trade of Siam, which supplied rice to South China under the nominal guise of tributary trade. When Batavia, Manila, and finally Singapore were founded by Europeans, their Chinese communities developed with great rapidity. Particularly in the East Indies, Chinese became a middle stratum between the Dutch overlords and the mass of Javanese population. While the Indochinese opium trade is best known from the British record, the Indian opium supply also flowed into Southeast Asia, partly in Chinese hands.

The diaspora of Chinese to the New World came later than the lodgments in Southeast Asia and was differently constituted, since the Chinese in the American environment could not be merchants,

brokers, monopolists, and other assistants of government as in Southeast Asia, but were restricted to largely manual labor of the sort that helped to build the American railways and produced Chinese laundries and restaurants across the land. The coolie trade built up Chinatowns in San Francisco, Vancouver, Cuba, and even the American East Coast. Their exposed position as cultural enclaves in foreign lands stimulated Chinese patriotism, and the revolutionaries found immediate support financially and morally among them.

In all the Southeast Asian ports the Chinese communities by the end of the century had developed chambers of commerce as well as their own schools and secret societies to knit the communities together. Thus at the turn of the century the revolutionary movements led by Sun Yat-sen and K'ang Yu-wei eagerly sought support from the Chinese abroad. The Ch'ing Government also began to realize that its countrymen overseas should no longer be executed if they came home after going abroad but should be cultivated as part of the national Chinese interest. Consular officials were sent overseas and sometimes government delegations, who competed with the revolutionaries.

The maritime China of Southeast Asia is only beginning to be studied. By the turn of the century it had a Chinese press and public opinion, which operated through commercial institutions with a considerable sense of autonomy. Overseas Chinese made their way back to the mainland and took the lead in industrial development, witness the Nanyang Brothers Tobacco Company. As the twentieth-century revolution unfolded, individuals with a capacity to speak English emerged from the Chinese abroad, like the foreign secretary of the Wuhan Government of 1926, Eugene Chen from Trinidad. In the trading ports under the treaty system Overseas Chinese found entrepreneurial opportunities. Charlie Jones Soong, for example, came back to Shanghai from the United States to be a Christian missionary. Soon this led him into publishing and other enterprises, while he arranged for the education of his children in the United States.

Sun Yat-sen (1866–1925) became the most prominent anti-Ch'ing revolutionary just fifty years after Hung Hsiu-ch'uan's early disciples had begun to recruit the God-Worshipers. The times were different but foreign, and indeed Christian, influence still played a crucial role in giving the leader his start. Sun grew up in Hsiang-shan county between Macao and Canton, the area longest in contact with foreign-

ers. It had sent many emigrants overseas and many talented people, like Li's manager Tong King-sing, into the treaty ports.

It was traditionally anti-Manchu country, and the valor of the Taipings was prominent in the folklore of Sun's childhood. But for British opposition, Sun thought, Hung might have ousted the Manchus. Sun became a Christian as part of his general Westernization. This began at the Iolani School in Honolulu, where Yat-sen at the age of thirteen had gone to join his elder brother in 1879. Sentiment at this British Anglican school was pro-Hawaiian independence, against American annexation. Sun graduated with the second prize in English grammar and then began more advanced studies in Oahu College (which later became Punahou School) until his brother sent him home lest he become entirely foreignized. At home, however, Sun desecrated the village idols and was expelled to Hong Kong. There he was baptized in 1884 as a Congregationalist and studied at the College of Medicine founded by Dr. Ho Kai, who had acquired medical and legal training and a British wife in England and was an early advocate of reform in China.

This foreign upbringing not unnaturally inspired Sun's patriotism, and in the midst of his medical studies he also took an interest in the Chinese classics. But he was of peasant origin and Western background. In his revolutionary career he capitalized on his foreign contacts and was least successful in leading the classically trained literati. In the end Christianity was useful to his cause, as it had been for Hung Hsiu-ch'uan, but his fundamental motive was nationalism.

China by the 1890s differed from China in the 1850s almost beyond recognition. (Of course this was true of much of the world, especially Japan and America.) In China the port cities had grown up, their streets clogged with rickshas (*jin-riki-sha*, "man-power carts"), an invention from Japan that married ball-bearing wheels to cheaply-paid leg muscles. The steam engines used in factories, railways, and steamships were often still imported. Foreigners and their equipment were as pervasive as in an outright European colony. The big houses with British-type lawns and gardens in residential areas, the horse carriages and racing ponies, the foreign banks, trading firms, and clubs, all overlay the expanded Chinese service trades and staffs that looked after them as a new aristocracy, settled in the Middle Kingdom but not of it. Foreigners, including now the Japanese, had plainly come to stay. At Hong Kong the taipans had already built

their estates high up in the cool mist of the Peak, accessible by the Peak Tram.

For Sun Yat-sen's purposes of revolution, Chinese society was now being fragmented by the emergence of new roles and alternative paths of upward mobility. There was first of all the chance to work for foreigners as servants or compradors, in treaty-port shops, or as ricksha coolies, chit coolies (human telephones), or dog coolies. Possibly these last gave rise to the oft-mentioned (but never photographed?) sign at the Public Garden on the Shanghai bund (waterfront), "No Dogs or Chinese Allowed"; one aim at least was to keep the foreigners' dogs, when taken out by the dog coolies, from defiling the foreigners' grass.

Within the old China's social structure new professions had emerged outside the scholar-farmer-craftsman-merchant classification: the military had a new respectability, and officers trained in academies were attaining some of the prestige formerly reserved for scholars. The line between landlord-gentry and merchant was blurred; merchant-gentry now acquired degree status, just as the roles of official and merchant became homogenized in bureaucratic entrepreneurs. Cheap rural labor flocking to the cities to handle cotton or tobacco had just begun to produce a class of factory workers, though still impossible to organize as a proletariat. Most important, the abolition of the classical examinations, the new school system, missionary education, and city life in general were producing a new intelligentsia no longer tied in irrevocably to the classical examinations; some of them were becoming journalists, a new profession, and creating a public opinion. Dr. Sun himself was forging a new role, that of professional revolutionary, a forerunner of the party organizer.

As a pioneer Sun Yat-sen showed all the flexibility necessary to his task. In time he worked with Triad Society strongmen, Japanese expansionists, American missionaries, Chinese students, Overseas Chinese merchants, Comintern agents, warlords, anyone who would listen. Too sincere to be a mere opportunist, he was too practical to cling to an ideology. He often dissimulated or compromised. The writings he left are banal. Others were better orators. What was his appeal?

The answer seems surprisingly simple. A slight figure, of medium height, Sun seemed to be working for a cause that he knew to be far

bigger than himself, and people respected him for it. He had cha-
risma, a personal magnetism, and certainly deserves A for Effort.
Despite his repeated failures he was later touted by the Kuomintang,
which needed a Lenin to whom Chiang Kai-shek could be the succes-
sor, as its founding father. Sun's lectures on *The Three People's Princi-
ples* were pressed into service as an ideology. Anyone who has edited
political speeches will see why they were not the "Gettysburg Ad-
dress."

In the last analysis, Sun Yat-sen acquired seniority in the field of
revolution, with all the accumulated connections and prestige that
seniority could still provide in Chinese life. And he learned as he
went along. In 1894 he took a long, rather run-of-the-mill reform
proposal to Tientsin to present to Li Hung-chang, but Li was too busy
to see him. He turned to revolution.

Sun's first secret organization was the Revive China Society,
founded with a hundred Overseas Chinese members in Hawaii late
in 1894. The Hawaiian Republic had just been set up (the American
annexation came in 1898), and Sun's society aimed at "overthrow of
the Manchus, the restoration of China to the Chinese, and the estab-
lishment of a republican government." Sun then organized a small
branch in Hong Kong in 1895 in time to take advantage of the
widespread unrest throughout the empire touched off by Japan's
victory.

As cover he set up an Agricultural Study Society in Canton and
used a Christian bookstore. The main plot was for a force of Triad
Society fighters to take their arms in barrels labeled "Portland ce-
ment," enter Canton by the ferry from Hong Kong early on October
26, seize the government offices, and kill the officials. Supporting
groups would converge from elsewhere. Through Dr. Ho Kai the
plot received favorable though nonspecific write-ups in the Hong
Kong British press even before the event. But the authorities were
tipped off. The ferried fighters arrived a day late, to be greeted by
the police. The whole thing was a fiasco and everyone not arrested
ran for cover. The pay-off for Sun was that educated Christians plot-
ting to rouse mass violence evoked the memory of the Taipings, and
Sun, who escaped to Japan, was now the known leader with a price
on his head. No "prairie fire" had been touched off, but it became
more possible.

When Sun went to London in 1896 he was tailed, seized, and

imprisoned in the Chinese legation for twelve days. But, before they could ship him back to China as a "lunatic," he got a message out to his former Hong Kong medical professor, who alerted Scotland Yard, *The Times,* and the Foreign Office, who got him released. This international incident made Sun instantly famous and convinced him of his revolutionary destiny. During nine months in England, like Karl Marx he read voraciously in the British Museum library, wrote adroit letters and articles for the press and a popular book, *Kidnapped in London.* His British experience was a great plus, although the Hong Kong government, then as now opposed to being a base for anti-mainland troublemakers, banished Sun for five years. He could pass through but not stop there.

By the time Sun returned to Japan in 1897 his fame had preceded him. Eager young Japanese Pan-Asianist "men of determination" were looking for a Chinese leader whom they could assist in the regeneration and modernization of China. Sun was just the idealistic and committed conspirator they wanted. He took the name Nakayama (in Chinese, Chung-shan, "Central Mountain") and he even looked Japanese, little mustache and all. The Pan-Asianists included Japanese secret society expansionists and were very active. In 1898 they also welcomed K'ang and Liang from Peking, and Liang and Sun even considered cooperating until K'ang Yu-wei said no. Compared with these top scholars, who had masterminded the Emperor's hundred days, Sun was an upstart. The K'ang-Liang movement to "protect the emperor" quickly rivaled Sun's, in fact outdid it in raising Overseas Chinese money for revolt in China. When 1900 threw the whole country into an uproar, K'ang-Liang followers with secret society help planned a rising at Hankow, but it was discovered and forestalled by Chang Chih-tung.

Sun and his Japanese backers aimed at South China more systematically. They chose a seacoast village near the Hong Kong New Territories, easy to supply by sea or land, and recruited Triad Society members, who were ethnic Hakkas and professional bandits. But then the usual happened, or failed to happen. Arms hoped for from Japanese sources could not be sent. Government troops closed in. Fighting erupted and for a fortnight the Waichow (Hui-chou) Rising, as it is called, took off—peasants joined up, ambushed imperial forces, and supplied the rebels—before the effort petered out. Sun Yat-sen was soon back in Japan at square one again. The formula of putting

imported arms in the hands of secret society fighting men had not worked out.

A foreign stimulus of even greater potency now grew up in Japan. The leaders of China's new scholar-official generation congregated mainly in Tokyo, where thousands of Chinese students, half on provincial government scholarships, each year flocked to the Kanda section. There they learned their nationalism the quick way, by being in a foreign land. Often taunted by Japanese children for their antiquated queues and long gowns, they felt humiliated by China's weakness and backwardness. As scholars they were, after all, the people who should manage the polity. All presumably were intent on rising in the world, and they were subdivided by provincial loyalties the same as they would have been in Peking. But they formed a self-conscious and cohesive community, nevertheless, with a strong sense of responsibility for China's fate. That issue no longer hinged on simply borrowing foreign devices. The question was how to create a nation state, and this was basically a question of political philosophy.

The so-called borrowing of Western, and also Japanese, ideas for this purpose was not accidental but in fact a conscious process of selecting what would fit into China's circumstances or hook onto China's tradition. For example, when the classics of Western liberalism were translated—works of Adam Smith, J. S. Mill, T. H. Huxley *et al.*—the translator (Yen Fu) stressed the value of liberal principles *not* to secure individual freedom under law but rather to build up the *nation's* wealth and power by each individual's energetic efforts at self-realization.

The same collectivist strain appeared in the writings of Liang Ch'i-ch'ao, who came into his own in Tokyo as the teacher of the new generation. He published a series of Chinese journals in which he summarized Western learning, as filtered through Japanese translations, and updated his avid readers on Western political thought and institutions; he fostered Chinese novel and short-story writing, all for the same purpose—the "political renovation" of the Chinese people. This term (*hsin min,* "a new people," "renewal of the people") came from the Confucian classic *The Great Learning,* and in 1898 Liang meant by it essentially the integration of participating individuals in their group and of groups in communities, finally constituting an organic nation: "ten thousand eyes with one sight, ten thousand hands and feet with only one mind, ten thousand ears with one

hearing . . . then the state is established ten thousandfold strong."[36] This call for strength through unity was more collectivist than liberal, although it demanded participatory democracy and popular sovereignty.

As his horizon expanded in Japan, Liang enlarged *hsin min* to mean a "new citizen." He argued that the old China had developed a high private morality in the domain of family ethics. But it had remained fragmented, deficient in public morality and civic virtue, the domain of social ethics. Thus he chipped away at the narrow loyalties and family-centered selfishness of Confucian China in the search for collective democracy and a strong nation. Liang has sometimes been called the progenitor of modern Chinese liberalism, but his goal was quite different from individual freedom through civil liberties.

Liang's tour of the United States by rail for five months in 1903 took him to more than a dozen major cities. As a well-known Chinese reformer he was received by the Chinese communities everywhere and had a chance to observe local institutions as well as the American establishment. He was received by President Roosevelt and also by J. P. Morgan, "the Napoleon of the business world."[37] But he returned to Tokyo quite disillusioned with American democracy. He had found it shot through with mediocre politicians, corruption, disorder, racism, imperialism, and other warts. In short, he got our number, and it turned him off. He was more impressed with the ideas of statism developing in Japan and Germany. He concluded the Chinese people should not imitate the U.S.A. Because his aim was the transformation of the Chinese people to become active and responsible citizens, he foresaw the need for a long period of education, what later became known as "tutelage," before they could behave as citizens. Tutelage could be supplied only by an enlightened despotism.

Political scientists have analyzed the common view of "democracy" held by China's whole reform generation from Liang Ch'ich'ao and Yen Fu right through to Mao and Deng. In this view inherited from optimistic (man-is-educable) Confucianism, good government rests on a natural harmony of interest between the ruler and all individuals, the people. Both seek the welfare of the state ("national wealth, strong military") because the enlightened Confucian-trained individual recognizes that social order will make his life livable while disorder will endanger it. In this state-centered view

every individual should develop his abilities and so contribute more to the common good. The proper individual therefore goes along, fits in, and pulls his weight, and this is "democracy." Antisocial anti-collectivists are, as Mao put it, not part of "the people." An "I-will-be-heard" contention against authority is fundamentally immoral.

Liang's stand on the individual's rights vs. the state later had a direct influence on Mao and the CCP in general. The urgency of China's salvation in the 1900s under the imperialist menace would be repeated, as a basis for suppressing individual rights, during the Japanese invasion of China in the 1930s and '40s. In retrospect it is plain that neither Liang Ch'i-ch'ao nor Mao Tse-tung after him, when they inveighed against bureaucratism, posed the question that the famous political philosopher Huang Tsung-hsi had posed in the seventeenth century, the question of tyranny at the top and how to prevent it by a dispersion of power among the elite-led institutions of society. This was not a doctrine of human rights. In the early twentieth century, nation came before individual.

Still Confucian in his family life and personal self-discipline, still interested in Buddhism, Liang wound up a reformer, opposed to violent revolution. He felt it would only spill China from the frying pan into the fire—witness the instability of French government since 1789. Instead, he argued for constitutional monarchy in China as the most feasible transition to modernity.

Possibly the majority of the five to fifteen thousand Chinese students annually in Japan during the late 1900s would have accepted Liang's reasoning, but it did not satisfy the one or two thousand activists, who were bent on overthrowing the Manchu dynasty. Liang's reasoned view of imperialism as China's long-term enemy confronted the activists with insoluble problems. How could one resist the foreign powers before one controlled the Chinese government? Revolution must have a plain target and the Manchus were made to order—non-Chinese, in power but weak, with no allies. Since it was anti-Manchu, the revolution was anti-monarchic, and this made it republican, Q.E.D.

The ever-resourceful Sun Yat-sen meanwhile had recognized that, to recruit intellectuals as organizers, one must have a theory of revolution, a vision of what it would bring. In 1903 he began to write articles. The intellectual device he came up with was the Three People's Principles *(San-min chu-i):* in Western parlance, national-

ism, democracy, and socialism. In Chinese these terms were a bit different. The first *(min-tsu chu-i)* meant both people and race combined in a nation. The second *(min-ch'üan)* was people's rights or power. The third *(min-sheng)* was a classical term, people's livelihood. Reduced to its ancient essence, it suggested that the populace should be kept well enough off so they could pay their rents and taxes. In fine, these were basket terms fillable by different ideas at different times or places—very like a Western campaign platform. Instead of Marxist socialism Sun was enamored of Henry George's single-tax theory then popular, a gimmick to appropriate future unearned increases of land values and so check land speculators (a panacea long since consigned to history's dustbin). This single tax Sun called "equalization of land rights," but it had precious little to do with agricultural land rent or tenantry. He also invented a "five-power constitution" by adding examination and censorial (control) functions to the trinity of executive, legislative, and judicial. If Western states had three, China could have five, as simple as that. In 1904 Dr. Sun tried out his new ideology (there was more to it, of course) while recruiting activist students in Europe. In 1905 he returned in triumph to Tokyo.

The activists among the Chinese students in Japan came from four major areas: the Central China provinces of Hunan and Hupei, the Canton region, Shanghai and the Lower Yangtze area, and Szechwan. They published journals, held meetings, and formed secret revolutionary groups based on these provincial ties. It took the busy efforts of the Japanese expansionists who had early backed Sun Yat-sen to corral all these rather competitive groups in one room in August 1905 and set up the Revolutionary Alliance *(T'ung-meng hui)* to unify the Chinese Revolution under Sun's leadership. At thirty-nine he had ten to twenty years' seniority, a knowledge of the world and foreign friends, contacts with Overseas Chinese financiers and secret-society fighters, reputation and self-confidence. He offered a short cut, to bring China to the forefront with the latest model of government, not only to catch up with the West but to forge quickly ahead of it. Unencumbered by Liang Ch'i-ch'ao's grasp of China's history and civic unpreparedness, Sun could leap forward. The students loved it, took the oath, learned the secret passwords and handshakes, and approved a complex structure of officers, branches, publications, and programs. Soon there were a thousand members. The

strategy was to by-pass the problem of imperialism and so get imperialist help to create a Chinese Republic.

Since the Kuomintang (National People's party) was to be formed in 1912 out of the Revolutionary Alliance and some minor groups, its inheritance is of interest. The Alliance of 1905 was a Japanese-arranged marriage of provincial groups in which Central China supplied the most members and leaders, including both the top military man (Huang Hsing) and the top party organizer (Sung Chiao-jen). The Cantonese contingent was second. But Sun Yat-sen's peasant-foreign background set him apart from the young scholars of landlord-official gentry families who formed the membership. In their background was little motivation for social revolution to remake the life of the peasant masses. They had never gone among the people for that purpose. They came from the ruling-class elite, and accepted Sun's leadership on sufferance, as that of an activist who could get results by synthesizing foreign help, Overseas funds, and Triad Society warriors to seize power.

Ardent patriots and activists themselves, the young Alliance members readily subscribed to goals that were little more than slogans. These included the pride-satisfying thought that China's revolution could be a kind of quickie, cheaply engineered to put China on top of the world again. In their journal, *The People's Report (Min-pao)*, they lambasted Liang Ch'i-ch'ao's gradualism as too little and too late. China, they felt, must be saved at once by becoming the latest thing, a republic. The Alliance attempted seven or eight risings before 1911. All failed. In 1907 Sun was banished from Japan, in 1908 from French Indochina. The Alliance program began to peter out and fragment, renouncing Sun's leadership. Its chief contribution was to symbolize rebellion and create a brotherhood of young revolutionaries, some of whom became leaders of the republic.

Unification of the student rebels in 1905 coincided with the onset of the Manchu dynasty's reform movement to strengthen the Chinese state and the dynasty's position in it. The Empress Dowager was still capable of nimble footwork, and she accepted in 1901 most of the reform package that the young emperor had fruitlessly decreed in 1898. The difference was that now most of those in power accepted reform as unavoidable.

The dynasty's reform program began with setting up modern schools and sending students abroad for training, mainly in Japan,

with results we have just noted—many of them became ardent anti-Ch'ing advocates of a republic, whatever that might be. Schools were rather quickly set up in China, partly by the simple tactic of renaming the two thousand or so old classical academies. But finding teachers for the new Sino-Western curriculum was not so easy. The aim was not public education, in any case, but the more effective training of prospective officials. Having taken the plunge, Peking soon found that the new schools and the old exam system could not coexist, as had been hoped, because the old private preparation in the classics was so much cheaper and easier to pursue; and so in 1905, in order to buttress the new school system, the thirteen-hundred-year-old exam system had to be abolished. Chang Chih-tung, one of the masterminds in setting up new schools, tried to bolster their morale and decorum. He prescribed light-blue gowns for his students, hats with red tassels, and even an edifying song, "The Holy Son of Heaven plans for self-strengthening. . . . Hygiene makes the people strong and healthy. . . . Honor parents, respect rulers."[38] But the roof was off the Confucian temple and it was draughty with the winds of change.

In military reform a new figure emerged, one of Li Hung-chang's protégés, who now became his successor as governor-general at Tientsin, Yuan Shih-k'ai. Yuan had risen as a military more than a civil official. From 1903 he led the way in military modernization, building up six divisions of a new North China army. He used German and then (cheaper) Japanese instructors and set up schools for the various branches of infantry, artillery, cavalry, engineering, and even more modern specialties like signals. His officers became more like gentlemen—at least, five were later to be presidents or premiers of the Chinese Republic.

But this North China (Peiyang) army was still at the provincial level, on a par with similar but less potent armies in other provinces, because a central-provincial balance was still basic to the government of China. The military, to be sure, was gaining on the civil component of government—had been ever since the 1850s—but a centrally run national army was still impossible. Central financing and a Peking-based general staff were not feasible. The major executive activity was still provincial, while the edicts of the Son of Heaven performed a sort of legislative function, authorizing, admonishing, scrutinizing, punishing, but not directly taking charge. As the mili-

tary gained social prestige, students in Tokyo (like young Chiang Kai-shek from near Ningpo) acquired military training. Soon the new army officer corps in China was honeycombed with crypto-revolutionaries dedicated to overthrowing the Ch'ing. Such men, specialized in modern armed violence, could supersede the mercenary riff-raff that had been fielded so ineffectively by the old secret societies.

Administrative reform to build up a unitary state met similar systemic problems. Growth was strongest in the major provinces, which became the main channel for the elite activism of the new compound class of gentry-and-merchants. Private initiative and enterprise had been growing steadily since the eighteenth century but now needed expression in institutional structures. In response provincial and some municipal governments set up new bureaus to deal with matters like foreign affairs, police (internal affairs), education, commerce, communications, agriculture, and industry. Peking tried to catch up by creating new ministries to superintend these new functions. For example, provincial bureaus of commercial affairs first promoted local chambers of commerce, commercial newspapers, and business and industrial schools in the provinces. Only later in 1903 did a ministry of commerce blossom forth in Peking, which remained a clearinghouse rather than the dynamic source of innovation. Provincial administrations, focused on dynamic port cities like Shanghai, Tientsin, Canton, Wuhan, were leading the way. Peking was not in control.

Similar decentralization hamstrung the effort at fiscal reform. China had no "common purse" that received and accounted for all revenues. Instead a myriad of fixed sums were listed as quotas due from a multitude of specific sources, and allocated to a multitude of specific uses. By modern standards the country was undertaxed, but corrupt tax evasion by the rich and powerful put a heavy burden on small producers. Revenues were tied into the support of officials and soldiers. For instance, the seven million ounces of silver to maintain the Manchus in Peking came from fifty-two sources over the empire. Tax reform would threaten rice bowls and so was resisted. Because of the quota system (really tax farming) actual tax collections remained unknown, unbudgeted, and unaccounted for. Nationwide budgeting was attempted in 1910 but soon became a guessing game because both the provinces and Peking were collecting statistics and

setting tax rates, independently and without coordination. Making the Chinese empire into a unitary state like France, with Peking in the place of Paris, proved utterly impossible.

Finally, constitutionalism was the panacea of the day. This was presumably demonstrated in 1905 when Japan, which had had a constitution since 1889, defeated Russia, which had none until after her defeat. The lesson seemed perfectly obvious, so Peking sent missions around the world to scrutinize all available models. The Japanese model won out. As Prince Itō Hirobumi advised the Chinese mission in his statesmanlike way, if the emperor conferred the constitution on the people then he could remain above it and not be bound by it; on no account should supreme power be let slip into the hands of the people. The Empress Dowager could not have agreed more thoroughly. In 1906 she announced that a "constitutional polity" would be forthcoming. In 1908 she set forth constitutional principles to be realized over a nine-year period of tutelage. In 1909 consultative provincial assemblies, elected from a small qualified elite, met and soon sent to Peking representatives who vociferously demanded a real parliament. In October 1910 a consultative national assembly met in Peking, but the nationwide constitutional movement was not satisfied. Finally, in April 1911 the Ch'ing carried its governmental reorganization further by appointing a cabinet, which, however, was topheavy with Manchus—out of thirteen ministers, only four were Chinese! Six months later came the revolution.

The Empress Dowager did not live to see it. She had died on November 15, 1908, though only after the usually healthy young emperor, still confined to the palace, had died, it was announced, on November 14. This was only one of the most notable coincidences in the Old Buddha's long and murderous career. China's other woman ruler had been the T'ang Empress Wu (690–704), who usurped the throne, backed Buddhism and the bureaucracy, and combined great ability with considerable impropriety. Against this background, one can understand the suspicion encountered more recently by Mme. Chiang Kai-shek and Mao's wife Chiang Ch'ing as women close to power.

The Manchu leadership left behind by the Empress Dowager was thoroughly unmemorable: a child emperor, a venal regent, vainglorious young princes, effete courtiers, all of them together just smart enough to inhibit change but quite incapable of leading it. They

dismissed Yuan Shih-k'ai as too strong a leader in 1909 and Chang Chih-tung died in the same year. The end of the dynasty was only a question of time.

Behind both the student movement for revolution and the dynastic program of reform we must visualize the broad role of China's ruling class, the gentry elite. Before 1860 and even in 1895 they were predominantly degree holders and in large part from landlord or at least well-to-do families. By 1911, they had become vastly more variegated. They now included merchants and bankers and even some industrial entrepreneurs, absentee landowners living in the newly swollen cities and managing their holdings through rent-collecting bursaries, scholars not only of the classics but also of Western learning, modern-trained army officers, and professional men in the modern walks of life, including journalism, the Christian church, and politics. China's political renascence had brought a great increase of numbers in this ruling class, but its core still centered about family wealth, learned skills, and social status connected with government, as the careers of a few outstanding leaders will indicate.

Chang Chien (1853–1926) of Kiangsu won the first degree at fifteen in 1868 and competed six times at three-year intervals before he got his provincial degree in 1885. He then competed at Peking five times, finally getting his top degree in 1894 and in the palace examination was made the top scholar of the empire at age forty-one. But he elected to shun bureaucratism for industry. He used the skilled labor and long-staple cotton of his home county to set up a spinning mill in 1899 and compete with the Japanese and Indian imports of cotton yarn. For this he secured tax benefits and some of his capital and machinery through his high-level connections with officialdom. His merchant partners were of less help. Prospering, he set up three more mills and also went into cotton growing, steamships, and flour, oil, and salt production. His philanthropy produced schools, technical colleges, roads, parks, and homes for the orphaned and aged in his hometown. He promoted provincial education and railways and in 1909 headed the Kiangsu provincial assembly—quite a success story.

T'ang Shao-i (1860–1938) came from the delta region near Macao that produced not only his comprador uncle (Tong King-sing) but Sun Yat-sen and Yung Wing, the Yale man who headed the educational mission to Hartford, Connecticut, in 1872–81. Sure enough,

young T'ang was in the third contingent to Hartford and studied at
Columbia before the whole mission was recalled. Speaking English,
he was used in Korea and eventually became deputy to China's
aggressive resident there, Yuan Shih-k'ai. As Yuan rose to promi-
nence, T'ang went along, handling his foreign relations and espe-
cially the projects for railway building. He typified the Young China
type of patriot, who could assert China's rights in English. As a diplo-
mat, he got Britain to acknowledge China's suzerainty over Tibet. In
the foreign ministry he set up an office in charge of the foreign
Inspector General of Customs, who still controlled the service but
now under nominal supervision. (T'ang Shao-i thought there ought
to be some *Chinese* commissioners of customs!) He also helped start
the suppression of opium growing. These and other reform efforts for
the recovery of Chinese rights made foreigners view him as a danger-
ous radical.

Wu T'ing-fang (1842–1922), born in Singapore and therefore a
British subject, went to the British school in Hong Kong, became a
court interpreter and newspaper editor, and then studied law in
London, becoming the first Chinese barrister. When he returned to
Hong Kong, the governor, who was just eccentric enough to make
forward-looking appointments, liked him, and Wu at age thirty-five
became Hong Kong's first Chinese to practice law, to be a magistrate,
and to serve on the Legislative Council. He mobilized Chinese com-
munity leaders by getting them to serve on the Alice Memorial
Hospital board, but his growing influence aroused colonial opposi-
tion. In 1882 Wu joined Li Hung-chang's staff, set up training schools
and a railway, and got into diplomacy. He twice shone as minister to
Washington (1897–1901 and 1907–1909) and also in the reform of
Ch'ing law codes.

Though infected by a nationalist ardor to save China from imperi-
alist encroachment, the activist gentry of the ruling class found chan-
nels of action first on a provincial basis, most concretely in the provin-
cial assemblies of 1909 and later. Provinces, after all, were the size
of European countries and the most intelligible units of discourse,
with which individuals still identified themselves. Provinces were
defined by culture and history, set apart by their dialects (in South-
east China really local languages), their cuisines, their economic and
strategic geography, and their common bonds of folklore and tradi-
tion. Patriotism began at home and the gentry elite of New China

organized most easily in the provincial metropolis, which had usually been the center for the old provincial examinations, the training of new armies, and the contact with foreign ways that stimulated change. Provincialism could thus express the broad sentiment of nationalism in the most effective way. Chambers of commerce were added to earlier types of associations and a "self-government" movement got under way among the gentry elite, aroused by foreign encroachment as well as foreign example. Both grew up on provincial bases. In one incident after another, provincial interests opposed the dynastic effort to build up a competent central government. Chinese vs. Manchu sentiment rested on provincial vs. central underpinnings.

Most striking was the "rights recovery" movement as applied to railway building. After a remarkably slow start—China had only some 240 miles of railroad by 1896—the imperialists of 1898 secured contracts for several foreign banking syndicates to build railways and manage them until foreign bondholders were repaid their investments with interest. Provincial merchant-gentry groups tried to meet this menace by building their own lines, but found themselves short of funds. Yet they regarded Peking's plans for a national system as a sellout to the foreigners. (Many felt Peking had sold out long before.) In 1911 Peking tried to nationalize all provincial lines, an obvious technological imperative. The Szechwan elite mounted a "railway protection" movement, and violently defied the Ch'ing government. This prelude to revolution was led typically by degree holders of means with landlord-merchant backgrounds who had studied in Japan and participated in the provincial assembly. The chief secret society in Szechwan, the Society of Brothers and Elders (Ko-lao hui), joined in overthrowing the Ch'ing but was soon shunted out of the new gentry-led power structure.

Thus in the early 1900s the Chinese ruling stratum was very much on the move, but not the Chinese farming people.

The rise of the gentry-merchant coalition had ominous implications for community life in the villages. Merchant investment in land raised its value, while the old-style gentry landlords moved to the cities and their formerly mutually dependent and reciprocal personal relations with their tenants gave way to impersonal relations of the marketplace. The sense of community was lost. Moreover, the lower gentry (one level above the commoners) were drawn into the

cash nexus too and intensified the pressure for rent payments and exploitation of the peasantry. The private owner-cultivator began to lose out to the big land investors from the cities—a bit like the American farm family confronting the money power of agribusiness corporations.

In the Chinese case, however, the new hybrid stratum of gentry-merchants increasingly exploited the countryside from the cities by the use of force. Local militarization necessitated by the rebellions after 1850 had later been kept under control by the new regional-provincial armies. But, as the late Ch'ing lost vigor after the 1890s, armed men locally-controlled reflected the decline of central power. Village magnates and local bullies of the lower gentry began to use their own armed forces and so local militarization found a new lease on life. Warlordism after 1916 was the ultimate manifestation of this trend.

This combination of circumstances by the 1920s would produce a situation in the rich farming country between Canton and Hong Kong where peasants were "landlords' slaves. . . . The rent was collected in a Rent Hall equipped with ladders, ropes, chains, whips, rods and other instruments of torture. A peasant in arrears was locked in there and even strung up in the 'monkey hang' pending the selling off of his ox or son or the marrying off of his wife."[39]

In inaugurating reforms, no one consulted the masses in the villages, but they found themselves more heavily taxed to pay for modern schools, roads, armies, and industries, none of which tangibly helped their situation. In the countryside the popular response to modernization was often violent opposition to it. Everything that New China wanted to do put up the tax rates and tended to squeeze the peasantry before any benefit reached them.

The Revolution of 1911 was essentially a collapse, not a creation. The Ch'ing monarchy died, and the main problem was how to bury it and what to put in its place. Dr. Sun Yat-sen, the father of the Republic, was abroad at the time, money-raising in the States. The Revolutionary Alliance had staged its tenth putsch, in April 1911 at Canton under command of the number-two leader (Huang Hsing from Hunan); but all the usual gremlins appeared—poor security, last-minute changes, non-coordination—until finally one group of fighters mistook another's identity and they dispersed each other with gunfire.

The events of the Double Ten (tenth day of October) 1911 were touched off by accident: a New Army officers' plot at Hankow was exposed, somewhat less than three thousand troops rebelled to save themselves, the Manchu governor-general and military commander fled in fright, and a local brigadier was pressed into leadership of an independent regime. Within six weeks all of the southern and central and some of the northwestern provinces had declared their independence of the Ch'ing—a prairie fire indeed, but only at the provincial level. In almost every case the new provincial government was headed by a combination of the New Army commander as military governor and the provincial assembly. In effect, the moderate-minded reform gentry in the provinces had continued their elite activism by declaring the independence of their provinces. In this way they broke free of Peking's control and maintained their political and economic dominance at the local level. They were far from interested in social revolution. No masses were involved to speak of, and any peasant disturbances were quickly suppressed.

Leaders of the Revolutionary Alliance had to hurry to catch up with events. The number two, Huang Hsing, took command at Hankow against imperial forces deployed by Peking, where Yuan Shih-k'ai was recalled to be, on his own terms, prime minister and commander-in-chief under the waning dynasty. He negotiated with the provisional government of the Chinese Republic set up at Nanking by the rebellious provinces and the Alliance leaders. The two sides were represented by T'ang Shao-i (for Yuan) and Wu T'ing-fang, the Republic's first foreign minister. Sun Yat-sen came back in time to be installed at Nanking as provisional president on January 1, 1912, but he at once offered to resign in favor of Yuan if Yuan would support the Republic. The points on which nearly all patriots agreed were that China must have a parliament to represent the provinces, that the country must be unified to forestall foreign intervention, most probably by Japan, and that Yuan, a military organizer known as a reformer, was the one man with the ability, experience, and prestige to head the government. So Yuan worked it out. The boy emperor, P'u-yi (known sometimes as Henry P'u-yi), abdicated on February 12, 1912. Sun resigned. Yuan was elected at Nanking and inaugurated provisional president at Peking March 10. Through a remarkable series of compromises, both prolonged civil war and lower-class risings as well as imperialist intervention had been avoided. A main

issue now lay ahead—who or what was to take the place of the Son of Heaven and dynastic government?

By this time many young men of the revolutionary generation were widely conversant, at least on paper, with the political ideas and disputations of the West. Like Japan's modernizers, they could quote the classics of Western thought and spurn their own heritage as outdated. Yet the hard facts of China's problems and practices had not changed all that much. In the result, many ideas from the outer world were discussed and tried out in the early Chinese Republic, but only a few were able to take root.

PART III

THE ERA OF THE
FIRST CHINESE REPUBLIC,
1912–1949

10

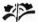

The Early Chinese Republic
and Its Problems

THIS AND THE FOLLOWING CHAPTER deal with opposite sides of the
street, respectively political and cultural. The early Republic's politi-
cal life has had a bad press because China's patriotic unifiers of later
times were appalled at the disorder of the warlord era and stigma-
tized it in vitriolic terms. On the other hand, the considerable cul-
tural achievements of the same period have been researched only
more recently. They tell an upbeat story. This contrast between the
political and cultural records as thus far appraised no doubt reflects
major tensions within Chinese society. At some future time the two
stories must be integrated to make a balanced picture.

To begin with the politics—the new Chinese nationalism, roused
by imperialist aggression, had demanded national unity in self-
defense. Foreign relations continued to spotlight the role of Presi-
dent Yuan as defender of the nation and symbol of its unity. But right
away China's national interest seemed very much like that of the old
Manchu empire—for example, in Inner Asia, where both Outer Mon-
golia and Tibet broke away from the Republic.

In other words, China may have been declared a republic but it
was still also an empire. The Manchus' takeover of Inner Asia had
created buffer territories on China's landward side and under Pe-
king's control. The Republic could not turn these Inner Asian territo-
ries loose without making them into a strategic menace. Thus the

revolution, which brought a sort of self-determination to the Chinese people, kept them in a colonialist-imperialist posture toward the adjoining peoples in Tibet, Sinkiang, and Mongolia. The nationalism that had triumphed in China was infectious, but the Chinese Republic had to oppose it in Inner Asia. However, the device of calling non-Chinese peoples national minorities and promoting their cultures while denying their freedom had not yet been invented (in the Russian empire inherited by the Soviets). For a time the Inner Asian peoples got out of Peking's control.

Russian trade and influence had been growing in Outer Mongolia, where Chinese encroachment and taxation, on the other hand, were resented. In December 1911, following the example of the provinces in China, Outer Mongolia declared its independence. By 1915 three-way negotiations between Russia, Outer Mongolia, and China had produced a slick formula: China retained a nominal face-saving "suzerainty"; Outer Mongolia had its local autonomy; and Russia gained economic rights, trained a Mongol army, and in effect established a protectorate, free from outside interference because Outer Mongolia was not a sovereign state.

In Tibet the late Ch'ing had asserted China's suzerainty even more forcefully than in Mongolia. Peking announced a program to reform Tibet's antediluvian theocracy and sent an army to Lhasa in 1910. The Dalai Lama, who ruled Tibet, fled to India. But he made a comeback after the 1911 Revolution and in 1913 declared Tibet's independence. Anglo-Chinese-Tibetan negotiations in 1914 then produced another formula: Tibet had autonomy; Britain recognized Tibet's independence, while China did not and continued to claim Chinese suzerainty. Since Britain had a major trading interest but did not claim a protectorate, as British India had once contemplated, the Tibetans ran their own affairs yet failed to gain international recognition as a sovereign state. China was still the nominal ruler.

This was the background that later allowed the Mongols to escape from the Chinese into the Soviet orbit while the Tibetans remained legally part of China without an independent status in international law and so at the mercy of the Chinese Revolution.

Sinkiang, with its scattered and mixed population of Muslim Kazakhs and Kirghiz, Chinese Muslims and Han Chinese among others, was not easy to keep under control. Ch'ing military garrisons were mainly in the Ili region north of the Heavenly Mountains (T'ien-

shan). They had to deal with the Kazakh and Kirghiz nomad tribes in that region and with the Muslim oasis cities on the trade routes in Kashgaria south of the Heavenly Mountains. Han Chinese were barely 10 percent of the population and so the Ch'ing had followed a divide and rule policy. Fortunately in 1912 power was put in the hands of a metropolitan graduate of 1890 named Yang Tseng-hsin, who had had long experience in Kansu and later at the oasis city of Aksu and the provincial capital at Urumchi. Yang's conduct of affairs from 1912 until his assassination in 1928 speaks well for the caliber of administrators turned out by the old examination system. He had to maintain his garrisons without undue taxation of the native peoples, suppress all efforts at local rebellion, and insulate Sinkiang from the contamination of warlord China. Soon he had to temporize with the Soviet Revolution. In 1920 and 1924 he negotiated trade agreements with the USSR, accepting its policy of economic infiltration, but in 1928 he threw his allegiance to the KMT government at Nanking shortly before his murder by a subordinate rival. In this way Sinkiang was on the whole kept out of power politics, retained under Chinese jurisdiction, and allowed a degree of progress through heavy-handed suppression of dissent.

Yuan Shih-k'ai's foreign relations were even more pressing on the domestic front, where provincial revenues had dwindled, and his government was constantly short of funds. The late Ch'ing had secured a foreign loan in April 1911 from a four-power consortium of British, French, German, and American banks. Yuan now negotiated for a big loan of £25 million sterling (big in those days) from a five-power consortium of British, French, German, Russian, and Japanese banks. This Reorganization Loan would mortgage China's salt revenues but would pay Yuan's troops. It was the kind of ambivalent deal foreigners could approve as statesmanlike and patriots denounce as a sellout.

Yuan's major problem was institutional. By abolishing the 2,100-year-old monarchy in 1912, the revolution had decapitated the Chinese state. It still looked to one man to head the government. But Yuan found himself successor to the emperor of China with no emperorship to lean on, no throne to sit on. The Son of Heaven even when stupid, like that late Ming emperor who spent his time in carpentry, had had all sorts of prerogatives and institutional supports to keep his office functioning. He had been the focal point of adminis-

tration as well as the high priest of the state cult of Confucius, commander-in-chief of the armed forces, major patron of art and letters, and in modern terms the chief executive, legislative, and judicial authority in the realm. In 1912 Yuan was expected to be some of these things but not others—yet who was to decide which? Once the old totality at the top was splintered, answers did not come automatically. So, just when China's triumphant nationalism demanded strong leadership, the leading institution had been taken apart for repairs, a change of models. China was not simply changing horses in midstream, she was trying to shift from a four-horse chariot to a limousine without being swept away in the flood. Could Yuan create a new role for himself as chief of state?

Yuan Shih-k'ai as he took charge at age fifty-two in 1912 had one trait like Deputy Premier Deng Hsiao-p'ing, who visited America in 1979. He was not only a can-do administrator but also the shortest man in any group, so short in the neck that he preferred the Western to the stiff-necked Chinese costume. Yuan's record was impressive, the best available: born into a loyal scholar-official family, he shifted from the classical examination rat race into a military career, and at age twenty-six was catapulted (or as Deng Hsiao-p'ing would say, helicoptered) by Li Hung-chang into a military-diplomatic post as Chinese resident in Korea opposing the Japanese influence there. Yuan's upward mobility was phenomenal. Like Li, he cultivated the Empress Dowager and Manchus at court and rose as a modernizer, especially as an army builder. (Only after 1906 was Yuan's army financed directly by Peking.) He had trained it near Tientsin in 1895–99, and in 1901 succeeded Li as governor-general there and became a leader in the dynastic reform program in general. Yuan got things done. He had the further merit of having been victimized and cashiered by the Manchu court in 1909 after the Empress Dowager died. When he became president in 1912 he had a large stable of new army generals and modern-minded reforming officials to use in his administration. He knew how to make the old system work, but it turned out that, like a muscle-bound halfback, his strength was his weakness: he had no vision of a new system.

Most Chinese patriots in 1912 accepted the idea that China was politically backward by universal or at least Western standards (which were at that time the same thing); so she had to catch up by having a parliament to represent the people and a cabinet to head

the administration. Foreign models showed that it took political parties to organize a parliament, and a number of Chinese parties were formed by K'ang Yu-wei, Liang Ch'i-ch'ao, and others. Many were no more than cliques or factions gathered around a prominent figure who was patron to a group of followers—organized by personal patron-client relations, not around a party program. As to the cabinet, whether it should be responsible to the president or the parliament was still being debated.

Standing in the way of all these plans, however, were several stumbling blocks inherited from imperial Confucianism. First, in social structure—the ruling-class elite had expanded and differentiated but the peasant masses, though restive in many small uprisings quickly suppressed, were still politically inert. Majority rule through a widespread suffrage—counting noses—was considered a silly way to choose officials that would only let stupidity prevail; the idea of representation was not established; a meritocracy of those qualified by skill, status, and wealth was tacitly expected to continue. Second, in political authority—the cure for disorder was felt to lie in strong executive leadership; personal loyalty to the power holder was one ingredient of domestic peace; the idea of a loyal opposition seemed anomalous and contradictory; law giving was part of ruling, and even the division of executive and legislative powers was little understood and less accepted. Third, in values—governing was a moral responsibility borne by virtuous men to benefit the populace as Confucius taught; harmony was to be prized, not legalistic bickering or competition; an entire administration should be unified in support of the ruler. Any modernizer who wanted to change these inherited assumptions had an uphill battle to fight.

Sun Yat-sen, for example, believed in domestic harmony in the national interest. Yuan beguiled him to come to Peking in August 1912 for weeks of harmonious talk about a single national political party. It would include everybody who was anybody and would run the show. Sun said that in view of "the great crisis of our nation . . . we can hardly afford to insist upon our different party policies." China's goal, he said, was "catching up and surpassing the powers, east and west." Sun's number two, Huang Hsing, said they must make the new China "the pathfinder of the world socialist revolution."[40] Both Sun and Huang declared their confidence in Yuan and their own withdrawal from politics in order to guide railway and

mining development, respectively. It was a high point in the reign of harmony and President Yuan.

When the president in March 1912 appointed T'ang Shao-i to be prime minister and form a cabinet, T'ang found opinions differed as to whether his cabinet should be responsible to him personally, to the president, or to the parliament. He appointed a cabinet, but its members felt loyal to President Yuan, not Prime Minister T'ang. The prime minister had as yet no budget, no party organization, no patronage, and no power over his cabinet members. He was obliged to resign in June, and the cabinet became presidential.

The young Alliance leader from Hunan, Sung Chiao-jen, led a movement to set in motion multiparty parliamentary government. Sung was a precocious young revolutionary organizer deeply devoted to Western liberal ideals of representative democracy. He had already performed a Jeffersonian task in drafting the provisional constitution. In August 1912 he engineered a merger of the Revolutionary Alliance with four small groups to form the Nationalist party or Kuomintang. National elections were held in China in the winter of 1912–13, still on the basis of a very restricted and indirect franchise. In 1909 the proportion of registered voters for the elections to provincial assemblies had been roughly four per thousand persons in the population, far under 1 percent. In 1912 this figure increased to somewhere around 5 percent of the population. Voting was a distinctly elitist activity. The mere idea of an election was so novel, and the list of eligible voters qualified by education and wealth was so restricted, that the event attracted little notice abroad.

This first and only electoral procedure in China comparable to liberal representative government was designed to elect members of the provincial assemblies and the two houses of the parliament. Sung Chiao-jen orchestrated the KMT campaign to appeal to the gentry elite. Like all others, he advocated national unity but his main stress was on provincial autonomy. This was to be ensured by elected governors and by local self-government through election of local councils. The prime minister was to be chosen by the majority party in the parliament. By February 1913 the KMT had won a majority of the seats in it. Sung Chiao-jen was encouraged to hope that he could reduce Yuan's power by legitimate constitutional means, maybe even make him a figurehead.

This attack on his authority by newfangled contrivances of elec-

tion campaigning and division of powers struck Yuan as disloyalty close to treason. He had shot generals for less. Struggling to find revenues for his central government, he felt beleaguered and responded in his own way. His tendency to assassinate his opponents had already made many of them nervous. Assassination of officials by revolutionaries had been an accepted, or at least widely practiced, way of demonstrating sincere commitment to the cause, especially when you were caught. But now the top power holder, already noted for his training of modern police forces for Chinese cities, was finding it a useful way to decide policy disputes, much as a surgeon might tire of setting bones and go in for amputation, quicker and cheaper. Nothing daunted, Sung Chiao-jen, now the prospective leader of the parliament, persisted in his courageous if quixotic effort to make parliamentary democracy work in China. He campaigned for the KMT to be an opposition party and control the cabinet. But before parliament convened Yuan had him shot dead at the Shanghai North Station in March 1913, age thirty-one.

Yuan at once claimed that Sung's Hunanese colleague Huang Hsing had done it (it was so utterly improbable it just might be true), until a Shanghai court, beyond Yuan's control, documented the facts. But on that very day Yuan announced completion of the big Reorganization Loan and final recognition of his government by the foreign powers. Once again, he had got away with murder. The imperialist powers knew how their bread was buttered in China. They could work with Yuan. He would not rock the boat or mobilize Boxer-type risings against foreign privilege.

This sorry tale, so briefly summarized here, was at the time only one thread in the strand of events. More important in the concerns of the day was the continuing menace of imperialism, especially from Japan after Europe plunged crazily into war in 1914. Japanese troops quickly supplanted Germany in her sphere in Shantung province, and then in 1915 Japan presented the notorious 21 Demands to President Yuan, trying to make China a Japanese protectorate. Britain advised compliance, American opinion objected. Yuan gave in part way. The incident highlighted China's persistent weakness but also Yuan's indispensability.

Emboldened by foreign recognition, Yuan had closed in on the KMT, dismissed its military governors in the southern provinces, suppressed their defensive rebellion in mid-1913, dissolved the KMT

as a public body, suspended the parliament in a reign of terror, and then abolished the provincial assemblies and local councils. He finally became president for life and announced he would be emperor. This last was too much. Armed opposition stopped it and Yuan died, worn out, in June 1916.

Yuan Shih-k'ai's betrayal of the Republic has given historians a great chance to moralize. One need not deny the influence of bad character on sad events to see also certain institutional factors at work. For example, policy under Yuan was still being made by the traditional flow of correspondence. Officials reported events and their actions to the one man at the top, who responded with confirmation, rejection, praise, or blame and so set policy. To inject into this quick, closed executive procedure the action of ill-informed and contentious politicians who claimed a legislative prerogative seemed not only useless but downright dangerous. Few could see any gain in fragmenting responsibility. To be sure, the Americans governed themselves by a "division of powers," but it was under the supremacy of law, whereas Chinese government was still personal, under "men of ability," who bore the concrete responsibility. In the general Chinese view and even among revolutionaries, Sung Chiao-jen's effort had seemed divisive, much though his killing was deplored and resented.

One failure in the early Republic was Yuan's lack of innovative imagination, perhaps the usual failing of chief executives battling to retain power. The American legation, at any rate, saw him as lacking "breadth of view. . . . He knows nothing of government except the absolutism of the old regime."[41] His goal became a centralized bureaucratic state, much like Peking's goal of the 1900s. Thus he revived the worship of Confucius and other outworn devices while suppressing the new politics, representative assemblies, and the press with a reign of terror. At the Temple of Heaven in Peking he conducted the ancient imperial worship of Heaven though he was modern enough to go there in an armored car. His political council opined that "we have entered upon a new era . . . in which all marks of inequality are obliterated, and therefore the worship of Heaven should be made universal."[42] Everyman his own emperor. This would be China's improved democracy, to be attained by reviving and using the past. The result was a fiscally conservative, quite active, and in some respects modernizing dictatorship.

Could it have been otherwise? Eminent foreign observers, steering by their dangerously little knowledge of China, thought an emperor was needed. The Englishman James Bryce, whose book *The American Commonwealth* had sanctified our democracy, toured China and recommended a monarchic revival. Charles W. Eliot of Harvard, who also acquired the expertise of a brief visitor to China, helped arrange for the first president of the American Political Science Association (A. J. Goodnow) to become Yuan's advisor on constitutions. Professor Goodnow was a pioneer contributor to the functional approach to politics. From his Peking experience he concluded China lacked what it took to be a liberal democracy. The rule of law, individual rights, even discipline were missing. "Absolutism," he said, "must continue until she develops greater submission to political authority, greater powers of social cooperation and greater regard for private rights."[43]

In effect these Anglo-American experts on democracy had come to the same conclusion as Liang Ch'i-ch'ao and Sun Yat-sen, that the Chinese people needed a period of tutelage in the effort to build up citizenship and a sense of public responsibility. Unfortunately, the American Political Science Association has received a bad press because Dr. Goodnow seemed to support Yuan Shih-k'ai's move toward imperial dictatorship.

The president of Peking University declared that the military governor of Shantung had "the physique of an elephant, the brain of a pig, and the temperament of a tiger." This man (Chang Tsung-ch'ang) was the prototypical warlord who gave the genus a bad name. Born of "mean people," a part-time trumpeter and head shaver and "a working witch who was skilled at exorcising evil spirits," he grew up tall and broad, well over six feet, and fearless in combat.[44] In the Russo-Japanese War of 1904–1905, he fought for the Russians and, once in power in the 1920s, kept some four thousand White Russian guards. There were Russians also in his harem of forty assorted women. Detractors called him the "Dog-Meat General" for a betting game he enjoyed, and he was known among the populace as "Old Sixty-Three" because his virile member when erect equaled a stack of sixty-three Yuan Shih-k'ai dollars. (This datum has never been verified.) When in control of Peking he executed editors and journalists, and in Shantung he killed peasant members of secret

societies and hung their heads on the telegraph poles. He was greed and violence personified. He flourished as a fighter and as a supporter of the "Warlord of Manchuria" (Chang Tso-lin) who was trying to control North China.

The Dog-Meat General was of course an extreme case. Other warlords as they gained local power began as reformers, bringing in modern improvements and showing a concern for the people until they were caught up in the power struggle and had to exploit everyone they could. In one sense the big warlords were symbols of the profound disintegration of the political order. They tried to sit on top of a thoroughly fragmented society in which local bullies, bandit chieftains, and petty warlords all represented a situation of increasing political chaos.

The warlord era was bounded at the beginning by Yuan Shih-k'ai and at the end by Chiang Kai-shek, both of whom headed a nominally unified polity. The twelve years from Yuan's death in 1916 to the Nationalist Government reunification in 1928 saw political fragmentation under military commanders, most of whom were provincial governors. The central power, after its long decline since the mid-nineteenth century, remained vestigial in the Peking Government, which kept China's diplomats abroad and ran the Post Office and some other services at home. No one, neither the foreign powers nor the warlords, wanted a breakup of China. Nor did any warlord try to found a new dynasty. Instead they tried to organize coalitions to defeat rival coalitions, but they worked only with armies, not with new ideas and parties that could mobilize popular support. The warlords were curiously hung up and limited in scope. They were able to make or buy arms and conscript troops, march across and despoil the landscape, but unable to set up stable modern governments.

One cause of this abortive situation was the fact that China was fragmented in another way too, between the native authorities and the foreigners. As the central power declined, foreign influence grew into the vacuum. For example, when provincial declarations of independence in 1911 threatened the unity of the Maritime Customs Service, which maintained China's foreign credit and debt payments, the foreign commissioners of customs, instead of simply appraising the duties due, for the first time now began to receive and transmit them to an international bankers commission in Shanghai. This saved China's credit for borrowing abroad, though it

further infringed upon her sovereignty.

By this time the accumulated unequal treaties allowed foreign participation in Chinese life in a semicolonial fashion, that is, foreigners did not control the polity, though their privileges impaired its sovereignty, but they did take a hand in municipal administrations as well as national public services. In the Maritime Customs, the Post Office, the Salt Revenue Administration, and elsewhere foreigners continued to serve as salaried Chinese government administrators. The customs and salt revenues were of course earmarked to pay off foreign loans and indemnities. Foreign consuls were responsible for municipal government functions in concession areas of the major treaty-port cities, and the biggest of them, Shanghai, was run by the British-dominated Shanghai Municipal Council. Most of China's big cities were not only treaty ports but accessible by water; and so the fleets of British, American, and some other countries' gunboats could police them in case of disorder. This made the treaty ports (i.e., most of the major cities) into neutral havens free of warlord despoliation.

Shanghai came to represent both the best and the worst aspects of China's modernization. As in other late-developing countries this seaport became the metropolis. In imperial times Soochow had been the Lower Yangtze emporium, but as the Yangtze delta kept expanding toward the sea Shanghai came to be at the junction point where the sailing junks of the inland waters met the different types of sailing junks in the coastwise trade from Hainan Island to Manchuria. The growth of Shanghai was facilitated by its being in the Yangtze delta, the most productive rice area in the empire, from which the annual rice quotas for Peking were poled up the Grand Canal for five hundred years during the Ming and Ch'ing. With this hinterland Shanghai could be fed, and the canal system supplemented by the railroads provided easy access.

Since Shanghai developed under foreign aegis it should be compared with other ports that grew up as part of the European invasion of the East. Cities like Bombay and Calcutta, Rangoon, Bangkok, Singapore, and Jakarta had been relatively unimportant before the arrival of European sea trade. Such cities were characterized by culture conflict and miscegenation both of peoples and of ideas. After the Taiping Rebellion drove the Soochow gentry to seek a safe haven under foreign guns in Shanghai, it became a new Chinese-populated city but still largely under foreign jurisdiction. In this way Shanghai

played many roles—first as a seedbed for modernization and foreign trade after 1843 and in industry after 1896. It also became China's main center for reform and revolutionary thinking, which were supported by the publishing industry, the growth of newspapers, and the formation of an increasingly vocal public opinion. The foreignized public services of a modern city went along with a Westernized lifestyle, the influx of foreign ideas as well as customs, and an uneven balance of sovereignty between the Chinese Government and the foreign consuls who administered their extraterritorial rights. Chiang Kai-shek, when he published his book *China's Destiny* in 1943, was quite right to regard Shanghai as a sink of iniquity, a fact which he knew from personal experience.

A funny thing happened in the local government of the city. The municipal services were built up under the Shanghai Municipal Council, which in the 1910s was still dominated by the British trading community. The SMC expanded its jurisdiction by building roads out into the so-called external-roads areas. It brought in Sikh policemen to handle the crowds of Chinese, in addition to employing Chinese in all its services. Under a British inspector-general, successor to Hart, the Chinese Maritime Customs ran the port. The whole scene was oriented toward trade, and its lifestyle most visible to the foreigners was semicolonial. The Shanghai Club still did not admit Chinese. The racecourse, which is now a people's park or market, still had races. The YMCA and Protestant and Catholic colleges brought civilizing influences. But the great mass of the Chinese labor force, having come in from the inexhaustible resources of the countryside, was not organized in labor unions. Factory legislation was slow in developing under the SMC, and the Chinese population grew simply because the treaty port was both a center of trade and industry and a haven from warlord exactions that were all too evident outside its boundaries.

In this semicolonial situation, the operation of the Chinese government of Shanghai was severely limited. Its jurisdiction was kept out of the International Settlement and the French Concession to the south of it so that the Chinese administration of government was really limited to the fringes of the city. Even the concept of a Chinese greater Shanghai was not thought up until the 1920s. To be sure a Chinese magistrate helped the consular administration handle judicial cases involving Chinese. The Shanghai Mixed Court until 1925

was about the only agency representing Chinese political power, such as it was.

In this situation the vacuum of government over the Chinese population was filled by an underworld dominated by the Ch'ing-pang or Green Gang. This traditional type of brotherhood disciplined its members by force and money to handle all the rackets of a modern city—prostitution for all and sundry, extortionate protection for merchants, connivance with the foreign police especially of the French Concession, and control of the drug trade in particular. Opium from upriver found its way to Shanghai in increasing quantities. There was no way that the SMC could suppress or control these activities, and so the foreigners and the Chinese underworld maintained a marriage of convenience. Foreign residents, who numbered a few thousand, felt confirmed in their belief that the Chinese people were naturally given to vice, racketeering, and undercover government.

Meantime, in commerce the inland steamship services were still predominantly British. Covering most of the provinces was a network of installations and Chinese agents for kerosene, the most widespread product of modernity, since it gave the peasantry better illumination than candles or a wick in wood oil. It was distributed by Texaco or other Standard Oil Company subsidiaries from America or by the Asiatic Petroleum Company, an affiliate of the Anglo-Dutch combine Royal Dutch Shell. The other principal foreign business for mass consumption was the cigarette industry, led by the British-American Tobacco Company, mainly organized by James B. Duke of North Carolina. Its compradors lent seed and credit to North China cultivators, collected the crop, and supplied it to curing centers and half a dozen big cigarette factories. In tobacco, competition came from the Nanyang Brothers firm from Southeast Asia. Chinese firms were already competing with foreign business. A modern Chinese business class was rapidly emerging in the foreign-run parts of the country, beginning in the British crown colony of Hong Kong and the Shanghai International Settlement.

Also scattered over the provinces was a network of several hundred small missionary schools together with churches, clinics, and hospitals. These were partly a creation of the growing community of Chinese Christians, modern-minded and patriotic people who responded to the Christian message and found in it basic teachings and

effective institutions that seemed much needed in the Chinese scene. As the native faiths lost vitality in a time of disorder, Christianity had its opportunity on a wider scale than it had had during the Ming-Ch'ing transition of the seventeenth century.

All these religious installations, like those of business, were staffed in large part by Chinese and were parts of the newly emerging society of the Republic. At the same time they were all protected by treaty provisions for extraterritoriality, which made foreigners and their property and servants immune to Chinese law except through their own foreign consular channels. China's semicolonialism thus kept a considerable array of public functions free of warlord domination. Simultaneously the "foreign omnipresence," as Professor Mary Wright calls it, provided an object lesson that both humiliated and infuriated Chinese patriots while also giving them models to emulate or avoid.[45]

All in all, warlordism was a strangely limited kind of disorder. It did not vitally affect the foreignized, modern-urban fringe of China, nor did it hit directly the great peasant mass in villages not on the line of march. Warlords and missionaries often worked things out: one American missionary wife in Chengtu (John P. Davies's mother) found the bullets of a warlord besieging the city were hitting the mission residence. She wrote both generals, inside and outside the walls, and they stopped shooting to let the American family squeeze through the city's north gate for a vacation in the hills.

Warlords moved their armies along the waterways, railways, and new highways at the expense of the populace they encountered, and they bled their provinces for taxes. But their actual warfare was limited. The Chinese people suffered less in outright destruction than in slow deterioration: dikes were not maintained to control the Yellow River, opium production made a comeback because it could be profitably taxed and/or smuggled, economic life was sporadically disrupted, long-term investment declined while disinvestment proceeded apace as in the wearing out of rolling stock on the railways and rabid inflation of the currency. Worst of all, in the land of rule-by-virtue, was the public demoralization. As Liang Ch'i-ch'ao put it almost in despair, "In China today only cunning, crooked, vile and ruthless people can flourish."[46]

To trace the politics of warlordism would be like memorizing the bus routes of a city one is never going to visit, which moreover shift

about treacherously from day to day. We would wind up confused and even more sorry for the Chinese people who had to live through it. Let us instead follow the career of one exemplar, the "Christian General" Feng Yü-hsiang (1882–1948), a big, burly leader of men, who as a peasant boy began soldiering at age eleven, rose through the ranks to attend a military academy, and became a model brigade commander in the North China Army, solicitous of his men and responsive to the ideals of the day. He became the "Christian General" when the Reverend John R. Mott, on one of his eloquent peregrinations for the YMCA in China, baptized him in 1913. Feng for a time cultivated missionaries, who saw him as a latter-day Cromwell, edifying his well-disciplined troops with the more austere teachings of Protestantism. Whether he baptized them with a fire hose has not been authenticated, but he gave them education in practical trades and sponsored road building, tree planting, and progressive reforms in areas where he was stationed. When Feng became a military governor and a principal warlord, he built up his National People's Army and began to flirt with the Soviets, who were coming into vogue, in order to get arms. Once in the big-time melee, however, he had to conscript, requisition, and tax like his rivals, and his armies scourged the countryside. His most notorious feat was to double-cross his superior (Wu P'ei-fu), ally with their erstwhile enemy (Chang Tso-lin), and so seize Peking for himself in 1924. Time wounds all heels, however, and in 1926 Wu and Chang joined forces and drove Feng out of Peking. Eventually Chiang Kai-shek, who had the wit to outdo all the warlords, took Feng into camp, made him nominally his vice commander-in-chief, and left him alone to practice calligraphy and study English in a rural cottage under guard, where some of us visited him, outside Chungking, in 1943.

What did these two hundred or so bemedaled generals and their shambling legions represent during the warlord years 1916–28? First, the potency of modern arms and militarism in a country of surplus manpower, where armament had outrun the growth of public ideology. Second, the impotence of the old gentry-merchant-official ruling class to pull itself together on a new basis of political organization at the national level. Third, a nadir of national competence just at the time when nationalism seemed to have triumphed. This was enough to stir up any patriot. A new creative era in thought and culture was obviously overdue. In fact it was already under way.

11

The New Culture
and Sino-Liberal Education

BY 1919 CHINA'S BODY POLITIC—students, educators, rural mag-
nates, city merchants, government administrators, labor unions, in
addition to the militarists just mentioned—was suffused with frus-
trated patriotism. Japan's seizure of the German position in Shantung
in 1914 and her 21 Demands of 1915 were fresh in memory. National
concern had been mounting that the Versailles peace conference
might let Japan stay in Shantung. Hundreds of groups from all over
urban China and among Overseas Chinese abroad had been tele-
graphing their protests to Paris. It was humiliating to find Japan's
claim based not only on secret wartime agreements with Britain,
France, and Italy in 1917 but also on a similar secret deal by Japan
with the corrupt Anfu Government in Peking in 1918.

News of the adverse decision triggered on May 4, 1919, a demon-
stration by three thousand Peking students from thirteen institutions
in front of the Gate of Heavenly Peace (T'ien-an men) at the entrance
to the imperial palace. "China's territory may be conquered," their
manifesto declared, "but it cannot be given away! The Chinese peo-
ple may be massacred, but they will not surrender. Our country is
about to be annihilated! Rise up, brethren!"[47] In the ensuing demon-
stration, one pro-Japanese official was beaten and the house of an-
other burned. This spark of violence touched off a nationwide confla-
gration of many elements: merchant closures and boycotts,

labor-union strikes, and a student movement that became steadily more organized, patriotic, vociferous, and active. The Peking warlords' jailing of 1,150 student agitators, using part of the university as the jail, raised the tension. When widespread public pressure got them victoriously released, nationalism was triumphant and China turned a corner.

This protean May Fourth Movement by common agreement has been given the Chinese-style numerical name Five-Four (May 4). Each observer can make of it what he will. The CCP has claimed the movement as its origin. The KMT has not. At the time, May Fourth, though certainly galvanic, was less bloody than some other incidents. What was its context as a stage in the revolutionary process?

First of all, parallel to warlordism from 1916 to 1928, China began to go through a political revolution, generally called the Nationalist Revolution. Its politics are well known, in fact stridently advertised by the two Leninist-type parties that then wanted to impose their dictatorships upon the nation. Sun Yat-sen made his comeback at Canton by reorganizing the Kuomintang in 1923 with Soviet advice, getting Communist help in a united front, and setting up the Nationalist Government in 1924. Sun's successor, Chiang Kai-shek, in 1926 led the Northern Expedition from Canton to the Yangtze, turned against the Communists, and set up the right-wing Kuomintang government at Nanking in 1928. Meantime the young Chinese Communist party, officially founded in 1921, cut its teeth competing-and-cooperating in the Nationalist Revolution, only to be all but destroyed after the split of 1927. Thus the politics of the 1920s made the news at the time and have absorbed the attention of historians as wars and murders generally do from a safe distance in retrospect.

Still another process was underway in 1916–28, however, parallel both to warlordism (mainly in the North) and to the Nationalist Revolution (mainly in the South). This was a pluralistic intellectual-cultural-academic movement based on the assumption that new ideas to create a new China could come only from hard study and thought, which must precede political action. The New Culture movement tried to avoid the corruption of politics. Its devotees pledged to have no contact with government, a very significant step in a land where top scholars had for so long become top officials almost automatically. Their new aim was to apply modern trained intelligence to China's problems. This led to the building of academic disciplines and institu-

tions as the necessary tools that could fashion a critical-minded and creative new intellectual leadership. The movement was led by several hundred young scholars who got inspiration chiefly from Western Europe and America. In this they were unlike the party organizers, who were inspired by the example of the Bolshevik Revolution and followed Soviet models.

Meanwhile Chinese conservative thinking about the salvation of China, which is only beginning to be studied, had produced certain major attitudes. One wing of the reform movement had become attached to the concept of "national character" or "national essence." Without at all denying the fact of evolution and of Social Darwinism among nations, this view focused on a national character evident in literature, language, customs, and religion, in short a Chinese value system. After the 1911 revolution, Liang Ch'i-ch'ao, as against Western "individualism" and "hedonism," offered the antidote of "familism" *(chia-tsu chu-i),* identifying the fundamental familistic values as "reciprocity" *(shu),* "respect for rank" *(ming-fen),* and "concern for posterity" *(lü-hou).* This analysis of Chinese cultural values supported and indeed was an expression of nationalism. It is inherently in conflict with modernization and has been so recognized down to the present day.

The implications of this for China were that certain Confucian principles and deep-lying values would persist in the midst of evolution and would change only gradually. In this view culture was antecedent to politics and wholesale Westernization was a great mistake, in fact impossible. China was left with the necessity to choose what mechanisms to import. Liang's cosmology took another step after his intense disillusionment at the Versailles Peace Conference of 1919, where China's rights were disregarded and wealth and power obviously triumphed over right. He returned to China feeling that the European civilization which had led to the slaughter of the World War lacked a proper sense of collectivity. The omnipotence of rational science in the West and the stress on individualism and hedonism had led the West astray.

On the other hand, K'ang Yu-wei's attempt to make Confucianism a state religion foundered on a basic cultural distinction. In brief, religion in the West under the duality of church and state had been separate from politics, whereas the Confucian state in China had

embraced and integrated literature, philosophy, politics, and a state cult of the emperor, which all held together in a unified cosmos. After the 1911 revolution Confucian societies proliferated in the provinces, seeking to perpetuate the essence of China's tradition. In one view a rational Confucianism could be compatible with modern science. But this approach tended to make it merely a useful device, not a first principle.

Another view was frankly metaphysical, arguing that scientific rationality and mechanism could not encompass the intuitive life of the mind. Here a Buddhist influence was evident and formed the basis for the opposition of the material West to the spiritual East. This argument led on into a great debate in the 1920s over science and metaphysics, which revived the stress of the Ming philosopher Wang Yang-ming on "intuitive knowledge." This stress on mind over matter carried on an old Chinese tradition, whereas the proponents of modern science as the guide to a better life, though they seemed to win the debate, were unconsciously preparing the ground for the triumph in China of Marxism as a "science of society."

Anarchism of the Kropotkin type also made a contribution in the early decades of the century because it attacked the various Confucian networks of ritual, kinship, and all manner of social duties according to status. Chinese anarchist groups were organized in Paris and Tokyo, and their journals espoused equality as the great desideratum that would free all individuals. Anarchist thinking was wide-ranging and innovative. Organization to seize power was not their line but they contributed many ideas to the New Culture movement, beginning with the attack on the family system. Though generally disregarded by later history, anarchists were the chief propagators of European socialist ideals in China before the Russian Revolution.

Because the KMT dictatorship under Chiang Kai-shek after 1928 was succeeded in 1949 by the CCP dictatorship under Mao Tse-tung, the outer world has been led to think of modern China as an authoritarian state, a party autocracy. Yet the record when scrutinized will show many bits and pieces of liberalism at work, many individuals whose humane endeavor made basic contributions. The KMT dictatorship from 1928 to 1949 was a part-way and imperfect autocracy, especially when compared with what came later. Under the KMT,

modern China's liberal tradition (let us distinguish it as "Sino-liberalism"), in the midst of shattering insecurity, did not flourish but neither did it die.

For Americans the growth of this tradition up to 1928 and afterward until 1937 lends poignancy to China's past and hope to her future. While Western liberals took due process of law for granted and sought power if at all only by legal means, Chinese liberals found no way either to create a rule of law or to control military power. They lacked the security of private property even when they came from well-to-do backgrounds. What they were able to accomplish is therefore all the more remarkable—many small achievements by gifted and devoted individuals.

These men, plus a few women, formed the academic wing of a new scholar-managerial elite. Education in Japan in the 1900s had produced the revolutionary generation active in 1911 and later. Education in the West now produced the academic leadership of the Nationalist era after World War I. Instead of passing the imperial examinations (abolished in 1905), this generation got its degrees abroad, typically the Ph.D. at Columbia University. The relation of these Sino-liberals to state authority differed from imperial times, beginning with a different view of the scholar's role. One of the oldest Confucian adages confirmed by scholar-administrators like Wang Yang-ming was the unity of theory and practice, of knowledge and action. One should "seek truth from facts," and the acquisition of knowledge should be followed by its application in practice. The statecraft scholars of the Ch'ing period had adhered to this idea. The man who knows has a duty to speak up to the authorities.

This is another way of saying that in the traditional Chinese view the scholar is a political animal. Ivory towers are for hermits only. This accounts for the split in the May Fourth Movement between the academics such as Hu Shih and the political activists such as Ch'en Tu-hsiu. Where a Western professor was generally expected to stay out of politics, in China it would have been an abdication of duty. Consequently Hu Shih and his Sino-liberal friends were following a Western model to try something new, the scholars' abstention from politics, while the intellectuals like Ch'en who joined the Chinese Communist party in 1921 and after were more in the mainstream of the Chinese tradition, in which the scholar had normally been connected with the state.

This innovation produced some ambiguity. Sino-liberals still sought the state's approval or at least tolerance of their activities. They wanted state auspices but not control. This concept was evident in the training of the returned student generation, who went abroad mainly on government stipends and usually came back to government jobs.

One factor creating this new leadership was a simple decision in 1908 by the United States Congress, inspired by missionary educators in China, to apply about half of the small ($25 million) American share of the Boxer indemnity to the educating of Chinese scholars in America. The indemnity payments to the United States Government continued but were automatically made available by it to the Sino-American board that handled the scholarships. This act was as seminal as the worldwide program of scholarships sponsored by Senator J. W. Fulbright after World War II. It led in 1908 to the opening of Tsing Hua College at Peking as a preparatory school for scholarship students to be sent to the States. By 1925 some thousand young Chinese, the intellectual or at least examination elite of the nation, had been sent on these scholarships. In the early 1920s, as Japan's aggressiveness continued to outrage all patriots, more students went on public funds to America than to all other countries combined. As this new elite began after 1914 to filter back to the political shambles at home, a new foreignized and patriotic leadership was in the making.

These "returned students," who had been abroad for study, had usually competed for their scholarships and so came from families that fostered learning. Few if any came from China's peasantry on the soil. On the contrary, they were young people of ability who had begun with the Chinese classics and by staying say four to ten years overseas had added a basic grasp of Western language and a modern discipline. Their twenty years or so of hard study in two cultures made them truly a bicultural generation, who spanned a wider cultural gap than any generation before or since. On return, they were clearly marked out by their foreign experience in dress, speech, and academic qualifications. What they had inside their heads was generally an ardent patriotism based on a new world view in which China was a backward area while Western science and learning covered the globe. Save for a few missionary Sinologists, they were the only people capable of bringing China into intellectual contact with the outer world.

Moreover, their educational experience had created personal bonds among them the same as among Chinese scholars in ages past. These bonds were formalized in secret fraternities, organized partly on the model of the Greek-letter fraternities then flourishing in American universities. For example, CCH (Ch'eng-chih hui, "the society for the fulfillment of one's life's ambitions") was formed at Shanghai in 1920 by the amalgamation of two earlier organizations: DJ (David and Jonathan), created in 1907 with nine charter members at a Chinese students' conference at Hartford, Connecticut, and C and S or Cands (Cross and Sword) founded with seven members at a Christian conference at Northfield, Massachusetts, in 1917. Thus formed, CCH expanded its activities and by 1936 had 227 members, with chapters in New York, Washington, D.C., Boston, Chicago, Shanghai, Nanking, Peking, and Canton, coordinated by a central committee of twelve, elected at a Shanghai convention in 1929. There were several other such fraternities. Brothers communed in summer retreats and helped each other's careers.

In their social functions within China the returned students found themselves in a position hardly less elitist than the old classical literati had been. They were members of an even tinier band of a few thousand who had frequented the Inns of Court or Harvard Square or Broadway at 117th Street. Those who wanted to reach the common man in China still had a long way to travel.

Right away the returned students began to offer leadership in the directions and specialties they had learned abroad, and so China received somewhat different stimuli from Europe and America. The senior statesman among them, Ts'ai Yuan-p'ei (1867–1940), for example, had risen through the old examinations and entered the imperial Hanlin Academy at age twenty-five, but later he joined Sun's Revolutionary Alliance and then studied Kant and other Western idealist philosophers during four years in Germany. For six months in 1912 he was minister of education in the Republic's first cabinet. In 1917, as the new head of Peking University (or Peita as it is generally abbreviated), Ts'ai recruited new professors and made the place over. From a routinized training school that prepared bureaucrats to hold sinecures in government, Peita became a marketplace for all the world's ideas. Ts'ai stood for the autonomy of the university— "education above politics . . . beyond political control."[48] He fostered faculty government, personal student-teacher relations, and political expression by professors as individuals. (He went on to found in 1928

the national government's research academy, Academia Sinica, on the model of the European government institutions that pursue scholarship without teaching.)

To be dean at Peita in 1917, Ts'ai invited an avant-garde journalist (Ch'en Tu-hsiu, 1879–1942) who had studied in Japan and France and who led the attack on Confucianism. At first he advocated in his journal *New Youth (La Jeunesse)* the individual freedoms—"Liberté, Égalité, Fraternité"—of the French Revolution. (By 1921 he would become the first secretary general of the new Chinese Communist party.)

In general Chinese scholars returning from Europe, with its background of feudalism and class struggle, proved more politically active. The American-returned students were more likely to be reformers than revolutionaries. The most famous was Hu Shih, who attended Cornell and Columbia from 1910 to 1917 and came back to Peita with a conviction that written Chinese must change to a vernacular style, using the vocabulary of everyday speech. Europeans had done this at the time of the Renaissance, breaking away from Latin and developing written Italian, French, German, and English as national languages. Such a "literary renaissance" was overdue in China both to create a literature that could reach the common people in everyday terms they could understand and also to make written Chinese a critical tool for modern thought.

Why was this necessary? Classical Chinese used single characters to convey ideas to the eye, but so many characters sounded the same that a classical statement often remained ambiguous or unintelligible to the ear. To get around this problem, Chinese speech generally uses two-character phrases to express an idea. Accordingly the vernacular written style used the two-character phrases of everyday speech. Because polysyllabic English is not plagued like monosyllabic Chinese by a multitude of homophones all sounding the same but with different meanings, analogues of the Chinese problem in English seem far-fetched, but let us try: an ambiguous classical statement about a "sole (soul?)" would now read "fish-sole" or "shoe-sole" or "spirit-soul" or even "alone-sole." Similarly, "Have you my all? (awl?)" could be specified as "Have you my all-everything?" or "Have you my awl-tool?" The ambiguity of "Where is the sun? (son?)" could be met by using "solar-sun" or "Mother's-son." (These examples are, of course, my invention.)

Written speech had begun to appear in the popular eighteenth-

century novels like *The Dream of the Red Chamber,* and nineteenth-century Protestant missionaries had pioneered in using it to reach the common people. There had been many precursors and they had all met the opposition of conservatives, who felt a vested interest in the classical style they had learned. But once Hu Shih and Ch'en Tu-hsiu joined forces to promote the new style, it caught on quickly. By 1920 the Ministry of Education decreed its use in textbooks.

In this way the new generation of foreign-educated scholars created a modern university and a new written language to spread learning. The New Culture movement took shape as they applied their talents to the reevaluation of China's cultural heritage. They attacked the tyranny of the old family system over the individual and its subjection of women. They reevaluated the classical texts and the vernacular novels as literature and began the scientific study of folk-lore. Most of all they pursued the vocation of most Ph.D.s—teaching —and built up educational institutions that could apply the progressive ideas then current in the West.

After 1916 not only did warlordism flourish in the provinces but also the whole structure of Confucian indoctrination broke down. In 1911 had begun an interregnum between periods of strong central power, which would last until 1949. The result was that the missionary colleges had their opportunity to train an elite of Chinese scholars in modern liberal-arts subjects without being controlled by a central government. For a few decades missionary education could try to mold Chinese students in the ideas and customs of the denominational colleges in the United States that served as the models for the Christian colleges in China.

The exact influence of Christian missions on the rise of the New Culture movement is still obscure and fraught with difficulty. Foreigners, being better informed about the missionary movement, may tend to exaggerate its influence, while Chinese patriots, being more aware of the New Culture's indigenous roots and protagonists, may give the missionaries short shrift. This will make for ongoing Chinese-foreign contention.

Because the Christian colleges were the aspect of education best known to the American public, let us pause here to look at the Chinese tradition of education and the institutional structure of which the Christian colleges formed a part.

In late imperial China there had been no government elementary

educational system. One attained literacy, such as it might be, in the home or in a village school set up by cooperating families or at a charitable school set up by a lineage that endowed it. Elementary instruction generally began with the same texts as the scholar class would follow but might stop short with the *Three Character Classic* and other preliminary works.

As we have noted, the imperial government was active only in maintaining official "schools" at the various levels of examination from the county on up through the prefecture and province. These had been nonresidential institutions that seem to have consisted primarily of a list of candidates who were entitled to receive instruction such as it was. The graduates of the imperial examinations at all levels entered the distinct upper class of the scholar-literati and thereafter avoided muscular labor of any kind. This left them fitted, if not to be officials, then to be teachers.

Thus the traditional system was largely an appendage of the state. Metropolitan graduates might collect in the Hanlin Academy in Peking, as a selected few of high prestige who were useful in compilation and handling of documents. Under the Ming and Ch'ing dynasties the institution of the academy or *shu-yuan* had grown up among scholars in the provinces, especially in the affluent Lower Yangtze area. Some academies were set up under imperial auspices, others by high officials. Some were essentially training grounds for further examinations, others began to be havens of research scholarship, sometimes not under direct official control, as described above.

The reform movement of the 1890s had set up study groups, and some reformers had been influenced by missionary educators in the small schools they established for Christian purposes. The great break came with the abolition of the examination system in 1905. From then on China followed a revolutionary course with many zigzags.

In the period of the late imperial reforms in the 1900s, Japan became a major center for training Chinese students abroad. Many of them simply became revolutionaries but most returned to teach in the new schools into which the old academies had been nominally converted. One type of Japanese-influenced new school was for law and government (*fa-cheng, hōsei*), a favorite Japanese approach to training a new elite.

However, the major influence that now set in was from the Atlan-

tic community, especially the United States. After the earmarking of the first returned portion of the United States' Boxer Indemnity Fund in 1908 helped Chinese students go abroad to the United States, American influence got in on the ground floor of Chinese modern education. Chinese upper-class students going to France and Germany often became revolutionaries, highly politicized in their interest and activities, especially after the First World War. Students to Britain and the United States, on the other hand, tended to pick up the scientific and humanistic education which seemed to be the best that these countries could offer.

As a result of these influences, the 1920s saw the growth of a number of national universities, that is, government financed, especially after 1928, in addition to the setting up of the dozen Christian colleges staffed partly by foreign missionary educators and partly by Chinese. In addition there were a few private Chinese institutions funded from wealthy sources. The 1920s also saw the beginning of foundation work in China. The Rockefeller Foundation took the lead in contributing to higher education, and in 1925 the remainder of the United States Boxer Indemnity Fund was returned to China for the specific support of the China Foundation for Education and Culture, which operated as a foundation in China. Thus when the Nationalist Government came into power in 1928 and set up the Academia Sinica as a central research agency on the European model, there was already considerable variety in Chinese education.

Also by that time the mass education movement had got started under influences from Japan and from Chinese YMCA secretaries who went to France in the First World War to help the Chinese labor corps write letters home. The illiteracy of the Chinese peasant abroad inspired YMCA secretaries as forward-looking Chinese to promote literacy movements in China. To reach the peasant masses the advocates of this movement began to work in the villages. Early reformers like Chang Chien had set up technical schools in connection with industrial development while high officials like Chang Chih-tung had created schools especially to train newly-armed forces.

Following all these traditions, the Nationalist regime after 1928 derived trained personnel from the new national universities and from the Christian colleges, which represented the forward edge of foreign influence, while at the same time experimenting with mass-education efforts in villages. Unfortunately the Nationalist Govern-

ment did not get hold of China's major problems even in the restricted area in which it operated, and so its village program remained quite limited. The theme of taking literacy to the common man and inducting him into the higher society of modern times remained to be pursued by the young CCP.

Already the student bodies at the Chinese institutions of higher education had begun to carry on the tradition of the examination candidates, who might stage a demonstration when they thronged to the examination centers under the imperial government. After May 4, 1919, student activism in the interests of saving China and pursuing revolution was thus inbuilt in the new system. It represented the modern student's recognition of his obligation, inherited from Confucian scholarship, to try to put the world in order. Of course this coincided with a European tradition also.

Thus China had seen a conglomerate accumulation of bits and pieces of an education system: For elementary and other levels of education new publishing houses like the Commercial Press now made textbooks widely available. Official translation programs provided Chinese versions of books not only from Japan but from the West. Moreover, the early returned students had worked on the problem of terminology. Beginning with Japanese terms, they had invented neologisms for the common modern ideas of economy, society, individualism, rights, etc. The natural sciences had been inducted into Chinese life in the hands of specialists originally trained abroad. A number of technical schools in China had also contributed, while the institutions of higher education in general had preserved the tradition that the educated man should contribute in the leadership of society. Beginning with missionary schools, women had been brought into the mainstream of education even before the custom of footbinding had been wiped out in the villages. From early in the century, social sciences like anthropology and sociology had found practitioners, and the scientific achievements of geology and archaeology were widely known.

Meanwhile, Protestant missions in China had learned to walk with two supports—medicine and education. Some two hundred mission schools and several colleges had been set up, and the 1920s saw the further combining of clusters of these institutions to make in the end a dozen Christian colleges. Yenching University at Peking was the leading example.

The leading spirits of Yenching were a dozen Chinese Christian

and American missionary educators who formed in 1919 a religious study group which they called the Life Fellowship. All devout Christians, they believed that bicultural education and faith in Jesus Christ could be the salvation of China. Amid the political disorders of warlordism, Yenching got protection from being an American institution incorporated in New York and largely financed from there. American money built the beautiful new Yenching campus a mile from Tsing Hua University, itself a product of the American indemnity payments. Though the nationalism of the 1920s increasingly decried a foreign faith, Yenching's Chinese Christian leadership stood firm. After 1928 a Chinese board of managers began to operate in Peking under a Chinese constitution while the trustees in New York continued to control the funds under their old charter in English.

Protestant missions in China showed a decidedly secular trend, toward dealing with the problems of the social scene rather than the spirit only. This trend was in response to the human needs of the Chinese situation. Whereas evangelism in the United States had been an ameliorating influence to improve the conduct of people undergoing the stresses and strains of modernization, in China the sense of spiritual peace and worthiness could derive more directly from a full stomach. To put it another way, while the Americans might need spiritual solace and guidance in the midst of rapid change, the Chinese had to overcome appalling conditions of poverty, disease, ignorance, and disorder. This difference in conditions was certainly as important as a cultural difference in spiritual needs. From the 1880s, when the Young Men's Christian Association began to minister to the needs of urban youth in the United States, the YMCA in China began to deal with similar problems in Chinese cities and educational institutions. Evangelism became only part of the Christian work though it remained an essential ingredient.

In 1922 an interdenominational Protestant conference organized the National Christian Council to coordinate the Christian effort among three thousand missionaries and a quarter of a million to half a million Chinese Protestants. In evaluating the influence of this community, allowance should be made for the extremely small size of China's educated elite, which consisted in the 1930s of barely 100,000 persons trained in universities. Research should show that Protestant Christianity made a broad and multifaceted contribution to China's modernization.

Roman Catholicism, mainly through Jesuits, also contributed to China's modern education, even though the Roman Catholic approach to China had been quite different from the Protestant. It had begun in the sixteenth century in the era of European exploration. Unlike the mendicant orders, the Jesuits from the first tried to reach the ruling class and found that success lay in becoming adept in Chinese language and style of civility and in interesting Chinese scholars through demonstrations of Western science. During the Ming-Ch'ing transition of the seventeenth century, Jesuits followed the lead of Matteo Ricci in acquiring official status as stipendiary scholars at Peking and then becoming officials in charge of the astronomical bureau that set the calendar. When the mendicant orders of Franciscans and Dominicans accused the Jesuits of accepting too much of Chinese culture and doctrine, the ensuing controversy over the rites of ancestor reverence finally pitted the emperor of China against the pope in Rome, with the Jesuits unfortunately on the emperor's side. After 1724 they were generally expelled from China or had to go underground except in Peking, and in 1773 the Jesuit order was abolished at Rome. Revived in 1814, the Jesuits reappeared in China in the 1840s, where Lazarists had been holding the fort for Rome.

The Catholic missionaries were less concerned with individual conversions and concentrated upon converting whole families and, in effect, villages. Unlike the Protestants, the Catholic priests wore Chinese dress and were less interested in modernization. The chief Catholic universities at Shanghai, Chen-tan ("Aurora") and Fudan, now a leading institution, were founded by a vigorous Chinese priest Ma Hsiang-po (Ma Liang).

In the 1920s Chinese-foreign cooperation flourished along many lines—in famine relief and rural development, in language reform and the creation of the new terms needed for modern science, and in financial collaboration. Typically the mission boards continued from the United States to pay the salaries of missionary educators while Chinese funds were sought to support the Chinese faculties. At the same time the Christian colleges were generally coeducational and promoted a Western lifestyle among the students, who were mainly drawn from the urban middle class. For a time the Christian colleges were pace setters for the larger government institutions. By the 1920s there was considerable interflow of personnel between

institutions like Peking National University and Yenching University in Peking and the private Nankai University in Tientsin. Missionaries were thus on the penumbra of the new order that modern China was trying to build up. For a time they played central roles.

By 1923 the rise of nationalism, sparked by the Versailles Treaty and the student movement of May 4, 1919, led to attacks on the missionary establishment as cultural imperialism. The "rights recovery" movement of nationalists included the effort to have Christian colleges under Chinese boards of trustees not headquartered in New York City. The differential treatment of foreigners and Chinese in housing and salary seemed humiliating to all patriots.

By the time the Nationalist Government came into power in 1928 two processes were underway: one was that of devolution, gradually dispensing with foreign leadership in the church as well as in other institutions. The second process, however, was the advance of the Japanese, moving toward their invasion of China in 1937. This had the effect of making the missionaries into valuable allies of Chinese patriotism because the missionaries still had extraterritorial rights and could not be coerced by the Japanese without involving their governments. This delayed the Chinese effort to abolish extraterritoriality and get rid of the unequal treaties. Foreigners who had helped reform in the 1890s could now be helpful against invasion in the 1930s.

While Peita was receiving precarious financing from warlords in Peking, a successful private university was founded in the North China port of Tientsin. Nankai University was the personal achievement of Chang Po-ling (1876–1951). A tall northerner, he had studied to enter the Chinese navy, but it was sunk in 1894–95. To save his country he turned to education, first in private schools in the homes of wealthy Tientsin backers. Chang responded to the ideals and programs of the YMCA, whose Tientsin secretaries were usually Princeton athletes, teachers, and missionaries all at once. In his school Chang stressed physical fitness, teacher-pupil comradeship, teamwork, the learning of science, and patriotism. Visits to Japan in 1903 and the U.S.A. in 1908 confirmed him in these principles. He became a Christian and his Nankai Middle School soon led the country in holding athletic meets and staging student dramatics. In 1917 Chang attended Teachers College at Columbia, which was then very much the thing to do. Two years later he set up Nankai University, later

adding a middle school for girls (1923), an experimental primary school (1928), and institutes of economics (1931) and of chemistry (1932). Under two Yale economists (Ho Lien or Franklin Ho, and Fang Hsien-t'ing or H. D. Fong) the Nankai Institute of Economics began basic studies and publications on the Chinese economy undergoing industrialization. The institute hoped to emulate the London School of Economics. In 1930 it helped a visitor from London, Professor R. H. Tawney, write his classic *Land and Labour in China*. (Chang Po-ling, Ho, Fang, and several other Nankai professors were all members of CCH fraternity). Though it secured some Boxer indemnity and Rockefeller Foundation funds, Nankai demonstrated primarily what could be done with private Chinese initiative and support.

Another institution got results in the heyday of Christian influence. The YMCA met needs for recreation, fellowship, and guidance among city youth. Exercise, discussion, and morality cultivated one's body, brain, and virtue better than Confucianism ever had. By 1920 there were YMCAs in a score of cities and in a couple of hundred schools, both governmental and private. The secretaries were predominantly Chinese, locally supported. For the eighth national YMCA convention at Tientsin in 1920 a special train brought five hundred delegates from Shanghai, and the president of China came from Peking to give a reception.

China's progressive educators found inspiration mainly at Columbia University and its graduate school of education, Teachers College. The Chinese students club there in its *Chinese Students Monthly* (founded in 1905) claimed in 1920 that Columbia's 123 Chinese students were the largest enrollment of Chinese at any institution in the country. The first Ph.D. in Education from Teachers College (P. W. Kuo in 1914, a member of CCH) went back to China's first higher normal school at Nanking and by 1921 had developed it into National Southeastern University. (Later under the Nanking Government it bore the more topographically dignified title of National Central University.) The second Chinese Ph.D. in Education (Chiang Monlin from Yü-yao near Ningpo) came back from Columbia in 1917 after nine years in the States and soon began editing the monthly *New Education*. "Children of China," he wrote later, "were to be set free of hard and fast rules of conduct . . . led to think for themselves and helped to solve their own problems."[49] He might

well have quoted the famous statement of the Ming philosopher Wang Yang-ming: "Give children a chance to develop freely. Guide them gently toward desirable ends." Within a few years Chiang Monlin succeeded Ts'ai Yuan-p'ei as head of Peita. Through such leaders Teachers College spread its influence beyond Chicago and Kansas, even into the Kiangsu Provincial Educational Association. John Dewey's pragmatic learning-by-doing rang a bell in China.

Educational innovation came with the growth of still other institutions. The most spectacular American philanthropy was the Rockefeller Foundation's $34 million or so given to house, staff, and maintain the Peking Union Medical College (later Peking's Capital Hospital). Beginning in 1915 the foundation's administrators carefully developed a first-class research-and-teaching hospital, the best in Asia. Its achievements were most notable in parasitology and in dealing with the communicable diseases and nutritional deficiencies so widespread in China. Its graduates were only a few hundred. But in aiming at quality not quantity and also building up the nursing profession and hospital social service, PUMC laid a groundwork for China's later achievements in public health.

The new institutions of science and learning in warlord China were of course European—as well as American—inspired. The brilliant and omnicompetent V. K. Ting (Ting Wen-chiang, 1887–1936) graduated in geology at Glasgow and founded the Chinese Geological Survey in 1916. It began to map China's terrain and resources and hired the retired geologist of New York State to train its staff. V. K. Ting, before his untimely death from a charcoal stove, went on to manage a profitable coal-mining enterprise, organized the Chinese municipality of Greater Shanghai, and as secretary-general of Academia Sinica coordinated its institutes' national leadership in research, all the time reporting on his wide travels in China and abroad and defending science against its humanist detractors in the intellectual polemics of the time.

The Science Society of China was organized at Cornell in 1914 by H. C. Zen (Jen Hung-chün, 1886–1961) and others. Until 1950 it published the Chinese journal *Science* and used all manner of means —monographs, translations, lectures, exhibits—to promote scientific studies. From 1929 Zen directed the China Foundation for the Promotion of Education and Culture, set up in 1925 to use the second half of the Boxer indemnity funds remitted by the American Congress.

The Geological Survey took an interest in fossils. European archaeologists were invited so their work could train Chinese co-workers. A Swede identified China's neolithic Painted Pottery, a Canadian deduced the existence of Peking Man, the French Jesuit Teilhard de Chardin helped in paleontology. The new breed of Chinese archaeologists—men who were scholars but also worked with their hands—eventually identified the "dragon bones" dug up by Honan farmers near Anyang as records of ancient auguries taken by Shang dynasty priests of the second millennium B.C. to advise the king. These "oracle bones" would lead in the decade 1928–37 to excavating the Shang capital at Anyang. This epochal project was headed (and the reports finished in the 1970s) by a Harvard-trained anthropologist, Li Chi.

These and other achievements of the bicultural generation of returned-student Sino-liberals between roughly 1914 and 1937 will someday be chronicled at length as fruits of a creative era. As in other ages of innovation, most of these leaders were personally acquainted. They contributed their policy essays and bright ideas to the same journals of discussion. Purposely standing aloof from government, they were not new mandarins but rather institutional innovators and modernizers, gradualists not revolutionists. Coming from the upper class, they dealt with their own kind. Their students were mainly city-bred children of the better-off.

While Western models had contributed to the ferment of ideas in the early twentieth century, there had been little success in reaching the Chinese villager. This was partly because the Western countries had not faced and dealt with a comparable problem. While they had a background of feudalism, few European countries had so sharp a break between the classically trained literate ruling class and the masses.

As we have noted, education for the masses got started outside Chinese society among the 140,000 or so laborers recruited by the British in Shantung province to help the war effort in France. For social work such as letter writing among this illiterate labor force, the American YMCA sent over a number of Chinese college students. Y. C. James Yen (Yen Yang-ch'u, B.A. Yale, 1918) was one who tackled the literacy problem. Soon he was in Paris editing a *Chinese Worker's Weekly,* using a selected thousand character vocabulary. Back in China the YMCA backed him to develop a mass-education movement, including a People's Library of a thousand simple book-

lets on all sorts of subjects. In 1923 Jimmy Yen, who had the charisma of a minor prophet, became the executive of a "national mass-education movement," which was soon active all over the country. Yen himself began to raise funds in America as well as China. From 1926 he worked in villages of Ting-hsien, a county southwest of Peking, confronting the peasantry's basic problems of economic productivity and livelihood, public health, literacy, and local organization.

Rural reconstruction by this time was in the air and others were active in several centers. One project in a Shantung village was led by a classically trained scholar, Liang Shu-ming, who was so conservative in trying to revive China's community life that he seemed revolutionary. Although Yen and Ting-hsien remained best known in the United States, the most creative disciple of John Dewey was H. C. T'ao (T'ao Hsing-chih, 1891–1946), who began life in poverty and did not reach Teachers College until 1915–17, long after he had found inspiration in Wang Yang-ming's philosophy. In 1921 he became head of the education department at Southeastern University in Nanking and next year succeeded Chiang Monlin as editor of *New Education.*

T'ao was a follower of Dewey, who went beyond him in facing China's problems. He became very active in the mass-education movement, opening evening schools and centers for workers and the underprivileged. He spread the "Little Teacher" movement, to have illiterates convey their new learning to others in a chain reaction. To the anti-Communists of 1927, this seemed like political dynamite. Urban mass education was suppressed as subversive and T'ao went into rural education and village renewal projects. Where progressive education in America used a well-established school system, T'ao found that the Chinese common people could only be educated *in situ,* where they lived and worked, in the village, the home or shop, wherever they congregated. Among all the American-trained educators, T'ao's origin as one of the poor made him unusually sympathetic to the needs of the common people, and this eventually brought him closer to the CCP. (In the end he died of apoplexy in 1946 before the KMT could assassinate him.)

Through this American-trained leadership, what was contributed to China by the United States of the Harding-Coolidge era? The strengths and weaknesses of the American offering were shown in John Dewey's visit to China. He reached Shanghai on April 30, 1919,

the very eve of the May 4 incident, and stayed in China for two years and two months. He was in Peking in June 1919 when the Peita students marched victoriously out of jail. His students—Hu Shih, Chiang Monlin, P. W. Kuo, H. C. T'ao, and others—orchestrated his activities in a widespread campaign to support their program for more scientific and more democratic education. Professor Dewey spoke from 78 different platforms in 11 provinces, giving well over 150 presentations. His lectures as interpreted were transcribed in Chinese and widely disseminated in books and articles. His major series of lectures on logic, ethics, philosophy, and education were given at Peking University and at Nanking Teachers College, but he lectured also in Manchuria, in Shansi, and in Shanghai and half a dozen other cities in the Lower Yangtze region, also in Hunan and at Foochow, Amoy, and Canton on the coast.

Coming as the top thinker in America, just after the victory in the World War, Dewey had a tremendous vogue in China. Partly it was engineered by his students, who held the key posts in the educational system at Peking and Nanking. Partly it was because Dewey's concern for the interconnections of modern science, education, and democracy brought a message: that modern science's experimentalism (or pragmatism), by which hypotheses could be tested to ascertain their truth, made the truth available to the common man. Using the new "Authority of Science to replace the Authority of Tradition" broke the grip of classical orthodoxy. Education was not to impart rote knowledge, but to get the student to think and so foster his "development of individuality."[50] Education should not be simply an arm of the state; it should prepare citizens to participate in representative self-government.

After Dewey's departure several of his Columbia colleagues visited China to survey school conditions, advise on teaching science, devise Chinese intelligence tests, and the like. All in all, no foreign thinker of modern times had any greater exposure of his ideas to the Chinese educated public than John Dewey. The results? Only superficial.

China was heading into a violent anti-foreign and anti-warlord revolution. First, the student movement disrupted schools and colleges. Then after 1928 the new Nationalist Government repoliticized education as a tool of the state. Dewey's precepts had assumed too much—a stable political environment, legal safeguards for individu-

als, time for gradual improvement. China wanted other things first. One can only imagine what Leon Trotsky could have accomplished in Dewey's place.

The problem-solving experimentalism that Hu Shih advocated against the ideologues of Marxism-Leninism in Peking made him an outpost in China of the kind of "cultural revolution" that Walter Lippmann was advocating in *The New Republic* in New York. But the New Culture movement had no way to deal with the brutal facts of warlord power. For example, the eight national colleges and universities in Peking received no faculty salaries after the beginning of 1921, and in the spring they went on strike. But, when the professors and thousands of students plus the acting minister of education petitioned the president of the Republic on June 3 they were beaten, shot, and bayoneted by his guards. John Dewey opined to Hu Shih that warlords and education were simply incompatible. So also, one might conclude, were American-style liberalism and China's revolution.

Anyone still myopically looking for the American "loss of China" should note that, when John Dewey left Shanghai on July 11, 1921, the Chinese Communist party was just about to be founded there. Revolutionary China had been exposed to the best of progressive education, yet it was turning to Marx and Lenin. Teachers College was about to be outshone by the Comintern. Evidently American liberalism couldn't scratch China where it itched, even though it remained in the mainstream for another fifteen years.

This becomes more striking if we consider that American influence was all over the lot in China in the 1920s while Russian influence was minimal. Sea trade and Christian missions had brought Western Europeans to China since the sixteenth century, and the Americans after World War I were rising to the top of a foreign establishment that was now expanding more rapidly into the country. The Russians on the other hand had approached China since the mid-1600s with the lethargy induced by Siberia. Their trade with China was by caravan across Mongolia, limited and controlled. In the eighteenth century the Russian Orthodox Church mission in Peking ministered only to the few Russians there, who generally immersed themselves in either the Chinese language or alcohol.

In the early twentieth century almost no "returned students" had been to Russia. Thus the Russian example in China lacked the con-

crete immediacy of the Western experience. This lack of realism was compensated, however, by the parallels between the two people's situations as backward countries oppressed by autocratic governments. The reformers of the 1890s had used the tyrant Peter the Great to symbolize how a ruler could build up his nation through Western borrowing. After 1900 Russia's revolutionary stirrings were overshadowed by her activity as the most menacing imperialist in Northeast China. Yet Russia's example of nihilist terrorism, especially assassination, had a message for Chinese revolutionaries, who on several occasions succeeded in blowing up themselves and/or their targets. From Russia came primary models of the revolutionary vocation as a romantically dedicated lifework, also the nonviolent anarchism of Prince Kropotkin's ideal of mutual aid. In short, Russia's and China's autocracy and backwardness made the one in some respects a model for the other.

Fortunately for the American influence in China, Russia did not pursue proselytism there until the creation of the Comintern after the October revolution of 1917. The Soviet Communist crusade took another thirty years to try to knock out the American influence in China in the 1950s, but the 1980s indicate it did not succeed. No outside power can dominate the Middle Kingdom. The real question is, what outside people can be more helpful in meeting China's problems?

12

The Nationalist Revolution
and the First KMT-CCP United Front

DURING THE 1920s the Chinese public were galvanized by a series
of incidents expressing Chinese nationalism. The May Fourth Move-
ment of 1919 had set a new style of student youth mobilizing urban
China against imperialism. This motif was much more vigorous in the
nationwide May Thirtieth Movement of 1925, inspired by British
gunfire in Shanghai and British and French gunfire shortly afterward
in Canton, as told below. The demand for national unity led to the
1926 Northern Expedition, mounted from Canton by the govern-
ment Sun Yat-sen had set up there in 1924.

These tumultuous events transfixed public and worldwide inter-
est at the time. Only later has the Soviet and CCP contribution been
worked out by historians.

Parallel to the American support of China's academic growth in
the 1920s, the Soviet Union had actively helped the Chinese Revolu-
tion. The Soviets approached China on several levels. They dealt first
with the Peking Government, and by treaty in 1924 got back some
of the tsarist privileges in China's Northeast—management of the
railway across North Manchuria, dominance in Outer Mongolia.
Meanwhile Comintern agents helped found the Chinese Communist
party in 1921, dealt with northern warlords, and made an alliance
with Sun Yat-sen. They left no stone unturned to accelerate China's
revolutionary avalanche.

After the dust had settled, the net result of the Soviet effort in the 1920s was to implant a structure of centralized party dictatorship and thus give China the rudiments of a new political system in place of the old dynastic monarchy. By 1928 the KMT party dictatorship would be in power at Nanking, still in an uneasy balance with warlordism. By 1949 the CCP triumph at Peking would complete the transition to the new polity, only thirty-eight years after 1911. But within this picture, so easy to see in retrospect, the way was tortuous indeed. Few things worked out as expected.

The Nationalist Revolution of the 1920s was a dual struggle to rid China of warlordism and of the special privileges of foreigners. In Marxist-Leninist terms these were twin evils of feudalism at home and imperialism from abroad. Japan's collusion with the corrupt power holders at Peking seemed to illustrate how these evils supported each other. Unity under a strong modern central government was seen as the over-riding prerequisite.

In China no socialist movement had paved the way for a communist movement, as had been the case in Europe. After the Bolshevik Revolution of 1917, Marxism-Leninism entered China as a brand-new view of the world. However, its acceptance had been prepared by certain ideas current since the reform movement of the 1890s: (1) the idea of biological evolution, which led on to the concept of social progress; (2) K'ang Yu-wei's classic doctrine of the three ages, which progressed from disorder to an eventual One World utopia; (3) the Social Darwinist idea of a struggle for survival of the fittest among nations; and (4) anarchist ideas not only of the mutual aid advocated by Peter Kropotkin (rather than terrorism) but also of liberation from the family's and the state's repression of the individual. Against this background, Marx's idea of social stages from slavery through feudalism to capitalism and then socialism was only a further step, as was also the idea of class struggle as the dynamo that led societies to progress through these stages. Taken all together the influx of Western thought in its great variety left the inherited theories of Chinese philosophy clearly on the defensive. The influence of Confucianism persisted among the revolutionaries less in literal terms than at the more general level of social values.

Marxism was first advocated at Peita by a Japan-trained political-science professor, who was also university librarian, Li Ta-chao

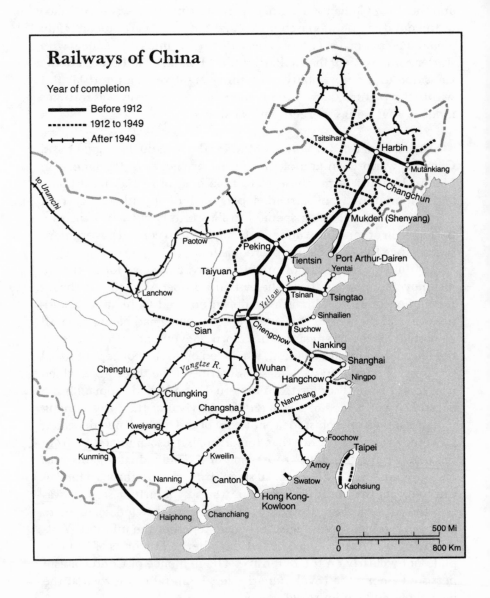

Railways of China

Year of completion

�	Before 1912
-------	1912 to 1949
+++++	After 1949

to Urumchi

Tsitsihar

Harbin

Mutankiang

Changchun

Mukden (Shenyang)

Paotow

Peking

Tientsin

Port Arthur-Dairen

Yentai

Taiyuan

Lanchow

Yellow R.

Tsinan

Tsingtao

Sinhailien

Sian

Chengchow

Suchow

Nanking

Chengtu

Yangtze R.

Wuhan

Shanghai

Chungking

Hangchow

Ningpo

Changsha

Nanchang

Kweiyang

Foochow

Taipei

Kweilin

Amoy

Kunming

Nanning

Canton

Swatow

Kaohsiung

Haiphong

Chanchiang

Hong Kong-
Kowloon

0		500 Mi
0		800 Km

(1888–1927). In mid-1918, seven months after Lenin seized power in Moscow, Li saw in the Bolshevik Revolution a promise that backward Russia could leap to the front of human progress. Implicitly he seemed to hope backward China could do the same. By early 1919, as he studied the Russian example, Li saw great value in the populist "go to the people" movement. He foresaw that China's revolution would have to be among the peasantry. At this early point Li also favored village life over the evils of modern cities. He urged students to go to the countryside and work with the peasants. In studying Marxist theory, he embraced class struggle but was less wholehearted about historical materialism; Marx's idea that the basic economic "mode of production" determined the "superstructure" of politics, ideas, and culture left Li with doubts. He felt the human spirit and "self-conscious group activity" could change things, quite aside from material changes. These early reactions of Li Ta-chao as China's pioneer Marxist are important because just at this time, in early 1919, he was the guiding light of a study group that included a young man not enrolled as a Peita student, who was working in the library for $8 a month, named Mao Tse-tung.

When the May Fourth incident took the students out of the class-room into the streets and sometimes into jail, this continual disruption of formal education appalled the educators. Hu Shih urged the students to "Study more about problems, talk less about isms."

"To talk emptily about fine-sounding 'isms' is extremely easy. Any dog or cat can do it, as can a parrot or a phonograph. . . . Not to study the actual needs of our society, but merely to talk about certain isms, is like a doctor who only knows about brews or chants but doesn't study his patients' symptoms. How useless!"

Li Ta-chao, who saw the worldwide wave of socialist revolution already coming at China, replied to Hu Shih that spreading isms was part of problem solving: "No matter how much one studies his social problems, as long as they bear no relationship to the majority of the people, then those problems will have no hope of ever being solved. . . . While we must study real problems on the one hand, we must on the other hand spread an ideal 'ism.' These approaches are mutually reinforcing."[51]

For many fervent patriots, political action superseded academicism. Advocates of the New Culture movement, like the editors of *New Youth,* split into two camps—political revolutionaries and aca-

demic gradualists. Li Ta-chao and Ch'en Tu-hsiu became progenitors of the Chinese Communist movement.

The founding generation of the CCP were mainly intellectuals. Only a very few came up from the working classes. On the other hand most of them had had at least a high school education though none of them were academic research scholars. While the CCP enlisted many intellectuals in its leadership, its historic role was to bring the common man into politics. The CCP structure assured central power to the leadership while the working masses were to be mobilized by the party organization to pursue class struggle in their own interest as defined by the party. In the original organization under the secretary, who was Ch'en Tu-hsiu, there was a Bureau for Organization and a Bureau for Agitation. The basic level was the small group or cell *(hsiao-tsu),* above whom were local, regional, and central executive committees, not elected but appointed. After the May Thirtieth Movement of 1925 the CCP grew to some twenty thousand persons and added departments to deal with women, labor, peasant and military affairs. As the central executive committee grew from three to twenty-nine members, it became necessary to set up an executive committee of it, the political bureau (Politburo). Under the doctrine of "democratic centralism," the Comintern organizers helped the CCP create a disciplined organization for class struggle.

In the same period, the Leninist strategy of allying with bourgeois elements in the emerging nations of the East led the Comintern to organize the KMT in the same Leninist fashion of democratic centralism. Russian policy was running on two tracks that were bound to cross, since both CCP and KMT by their nature aimed at total power. The Russians got into this impasse by believing that the KMT as a bourgeois nationalist movement could be helped to gain power, whereupon the CCP could take it over from within. The one thing missing from this scenario was that the CCP developed no armed force while the Whampoa Military Academy under Chiang Kai-shek received arms and training from the Soviets. This flawed strategy became evident when the Leninist democratic centralism of the KMT prevented a takeover by the CCP and the KMT military power was able to all but destroy the CCP membership, in the split of 1927 and later.

The most striking fact in the revolution in the 1920s was how far it penetrated the public scene. The middle-school and the relatively

few college students were now more numerous than ever, and many became political organizers. Merchants were more actively patriotic in boycotting foreign goods and contributing funds. Newly organized labor unions, especially in foreign-owned factories, provided the militants for strikes and demonstrations. Even farmers responded by joining in class warfare against the landlord establishment.

This greatly enlarged public citizenry provided recruits for modern armies, for administrative and tax-gathering staff, and for political organizing. Ideas of revolution penetrated often to the rice roots. Thousands of youths became activists with a new energy and dedication to ideological goals. The mid-'20s saw great excitement, turmoil, creativity, and destruction.

Historians' attempts to picture this scene face two kinds of difficulties. The first is the bugaboo of abstraction instead of immediacy. Here is the leader of the new literature of revolution, Lu Hsun, on the death of three of his girl students on March 18, 1926, when Peking police gunfire killed forty-seven people in an unarmed demonstration protesting Japanese encroachment:

> I hear that Liu Hezhen went forward gaily. Of course it was only a petition and no one with any conscience could imagine a trap. But then she was shot before Government House, shot from behind, and the bullet pierced her lung and heart. A mortal wound but she did not die immediately. When Zhang Jingshu, who was with her tried to lift her up, she too was pierced—by four shots, one from a pistol —and fell. And when Yang Dezhun, who was with them, tried to lift her up, she, too, was shot: the bullet entered her left shoulder and came out to the right of her heart, and she also fell. She was able to sit up, but a soldier clubbed her savagely over her head and her breast, and so she died.[52]

In this account the exact trajectory of the bullets through the girls is plainly Lu Hsun's artistic contribution. No autopsies were performed such as that on President Kennedy.

Such immediacy can be only selective. Most such events have to be subsumed under an abstraction like "tension mounted between patriotic students and the warlord government authorities, who shot many demonstrators."

A second problem is that of anachronism, treating past events as only preludes to what came after, not as events in themselves. Thus

the factor of chance, of accident, is filtered out and history is depicted as a series of movements bearing tags like "the rise of Chiang Kai-shek" or "the rise of Mao Tse-tung." All the many potential leaders who died before their time are thus swept away. Not the best and the brightest but only the survivors figure in history. Moreover, the judgment of the later time is anachronistically imposed upon earlier events. In the 1920s, for example, the major hope of patriots seemed to lie with the Kuomintang. Within a generation the KMT had become the problem, not the solution.

Interest in the origins of the CCP has led us to look at the 1920s as a period primarily of KMT-CCP competition. This distorts reality. The CCP in the 1920s, for all its enthusiasm, was small and had no army. Its members, only about a thousand in early 1925, before the May Thirtieth Movement, were young people fervently devoted to their cause, and they pioneered in mobilizing laborers and peasants in militant unions, on the cutting edge of a great national upheaval. But the KMT leaders around Sun Yat-sen, older and better connected with merchant money and the public press, still dominated the revolutionary movement. Sun Yat-sen's Canton Government raised the banner of nationalism by being dedicated to the reunification of China. But its task was complicated by its being the focus of several different interests—a Cantonese provincialism seeking regional strength, a Canton-city merchant element that recruited its own troops, plus South China generals who competed as warlords. In this chaotic setting the KMT's National Government was hard put to build its new political structure, develop a party army, and launch a Northern Expedition to unify China. Here is where Stalin saw his opportunity.

Soviet aid to the Canton Government in the mid-'20s included money, arms, and advisors—all the things that American aid programs got around to providing twenty years later. (The American programs were of course more overt, since they had to be debated in the Congress and therefore needed to advertise their efficacy.) Soviet advisors totaled fifty or more in Canton. Several million dollars were paid out to subsidize the KMT and buy arms for it. But the main Soviet impact was in political organization.

When Sun Yat-sen reorganized the KMT in 1923 to be a Soviet-style party dictatorship, his aim was to gain power to unify China, not to revolutionize Chinese society. "Hitherto," he said, "the influence

of our party has been mostly overseas . . . its influence in the interior of China has been very weak." The KMT had used military force, he said, to overthrow the Manchus in 1911 and Yuan Shih-k'ai in 1916. But "the revolution still had not been accomplished, because our Party still lacked power. What was the power that we lacked? It was the support of the people."[53] Dr. Sun was always too sincere to hide his simple-mindedness.

He continued, "Now we have a good friend, Mr. Borodin, who has come from Russia. . . . Since we wish to learn their methods, I have asked Mr. Borodin to be the director of training of our Party; he is to train our comrades. Mr. Borodin is extremely experienced in party management . . . all comrades [should] earnestly learn his methods." In short, learn the Soviet technology of revolution. Never mind the ideology.

Who was Borodin? He had been born as Mikhail Grusenberg in the Jewish pale in what was then Latvia. Yiddish was his native tongue but at school in Riga he became fluent in Russian. In 1903 he joined Lenin's nascent faction of about one hundred Bolsheviks within the Russian Social Democratic Labor party. He was in on the ground floor of history. But the Tsarist police picked him up in 1906 and exiled him to the West. By 1909 he was teaching English to foreign immigrants at Jane Addams's Hull House in Chicago. He returned to Russia only after the revolution (in 1918), and when the Communist International (Comintern or CI) was formed early in 1919 he became an agent for it. Linguistically fluent and temperamentally conciliatory, he carried out missions for the CI in a dozen countries. By October 1923 he was in Canton as the Soviet advisor to Sun Yat-sen, with whom he could speak English.

By the time Sun thus invited the bear into the bedroom, his group was ready to try anything. Playing footsie with South China warlords had got them nowhere. Even parading Dr. Sun in epaulettes as a "generalissimo" made the KMT no stronger. The KMT leaders, frustrated patriots of 1911, were getting middle-aged. They needed a loyal party army and a mass movement, neither of which had thus far engaged their effort.

For such things, however, as Borodin explained, they first needed a written-down ideology. And so Dr. Sun gave his discursive lectures on the "Three Principles of the People"—nationalism, centralized democracy, and something about socialism. The Nationalist Govern-

ment set up at Canton in 1924 soon had a military academy presided over by Sun's military aide (a student of the Japanese officers' academy), young Chiang Kai-shek, who spent three months in Moscow to learn about indoctrinated party armies. There was also a Political Training Institute for urban mass organizers and a Peasant Movement Training Institute in which the CCP took a special interest.

However, CCP members, under the united front agreement of 1923, had had to join the KMT as individuals (score one for Dr. Sun's practical sagacity) and so the CCP itself was only an organized "bloc within" the KMT. And Borodin's new KMT constitution meanwhile had given the KMT a network of party cells and branches, a central executive committee, and a politburo, all centralized and not easy to subvert.

Canton in the mid-'20s thus saw a new type of government take shape. The driving emotion was patriotism, the practical doctrine was party loyalty, the structure was Leninist—"all power to the center." China did indeed learn from the USSR, but Bolshevism did not triumph, for the Soviets had outfoxed themselves. Their arms and instructors shipped to Canton built up Chiang Kai-shek's KMT army, not a CCP army. The KMT's Leninist party structure proved immune to CCP subversion.

In 1925 a wave of patriotic fervor engulfed the Chinese public after British-officered police killed thirteen Shanghai demonstrators on May 30 and Anglo-French marines killed fifty-two demonstrators at Canton on June 23. The nationwide May Thirtieth Movement included merchant boycotts of foreign goods and strikes by the newly organized labor unions. It galvanized large numbers of students, among whom the CCP found many recruits. To the humiliations of all the foreign privileges in China had been added the evils of foreign capitalist exploitation of cheap city labor. Anti-imperialism swept the country in 1925–26. Revolution was in the air.

In revolutionary Canton several elements jockeyed for position. Local merchants, supporting a fifteen-month-long strike and boycott of British trade in Hong Kong, fielded their own armed forces, which the CCP infiltrated. Proponents of a Northern Expedition to unify China had to confront this leftist provincialism. Also, KMT elders like the handsome Wang Ching-wei, a veteran of the student polemics in Tokyo after 1905, regarded young General Chiang as an upstart. Wang in particular headed a KMT left wing that dominated the party

by getting CCP cooperation within the KMT. Only after Chiang's new army defeated local warlords and suppressed the Canton merchants' forces was he able to press for expanding northward as the only way to broaden the revenue base of the Nationalist Government.

During the twenty-two years from 1927 to 1949 the principal figure in Chinese politics was to be Chiang Kai-shek, a military man who became a political leader but never had a liberal education. Because he had to deal with the widespread remnants of warlordism and factionalism, to say nothing of Japanese invasion, it seems plain that the times called forth the man. A military politician was needed, and Chiang had the qualities of patriotic determination to unify China plus qualities of personal leadership, decisiveness, foresight, and chicanery that were needed in the late 1920s and early 1930s if warlordism was to be liquidated and a central government reestablished. In short, Chiang Kai-shek's strength was on the military-political plane. He had no vision of the social revolution through the incorporation of the masses in politics that was already under way in China. The question whether his weaknesses made possible his strength awaits a biographer.

Chiang belonged to the generation of Chinese patriots who felt that China could be saved from imperialism only by military strength. His origin was in the lower level of the ruling class. His grandfather had graduated from farming to being a salt merchant. His father was also a salt merchant at Fenghua near Ningpo, the treaty port in the north of Chekiang. After studying Chinese classics in middle school, Chiang Kai-shek embarked upon his military career by going to Tokyo in 1906. In order, however, to obtain military training in Japan he had to return to China and enter the predecessor of the Paoting Military Academy. Returning to Tokyo he attended a military school set up to prepare Chinese students for entrance to the official military academy. From 1908 to 1910 he formed associations with other military-minded Chinese patriots who would remain his close supporters in later years. The most important was Ch'en Ch'i-mei, eleven years his senior but also from Chekiang. After a year at the Japanese Military Academy Chiang Kai-shek came back to Shanghai in the fall of 1911 and began his rise in the military hierarchy of the Republic in the KMT's struggle against President Yuan Shih-k'ai. Chiang Kai-shek had joined the Revolutionary Alliance in

Tokyo in 1908 and he returned to Japan several times, having met Sun Yat-sen there. Japan was still the home base of the revolutionaries. After his mentor Ch'en Ch'i-mei was assassinated by Yuan in 1916, Chiang became the patron of his nephews, Ch'en Kuo-fu and Ch'en Li-fu. While biding his time in Shanghai in the late 1910s he formed relations with the underworld Green Gang (Ch'ing-pang) which would also be of use to his later career.

When Sun Yat-sen finally succeeded in getting into power at Canton, Chiang Kai-shek followed him there and served as an officer in the forces of the local warlord, who was then supporting Sun. When the warlord turned against Sun in mid-1922 Chiang Kai-shek escaped with him on a gunboat. It was only at this point that he became close to Sun and his choice as a military leader. Chiang headed a KMT military mission to the USSR during the three months September-November 1923. He came back impressed with the Soviet party dictatorship. By May 1924 he had become head of the newly-organized Whampoa Military Academy. In the next six months he led the military training of the first three classes of Whampoa cadets, some two thousand men, from whom later emerged the so-called Whampoa clique under the Nationalist Government. At the same time he became the top commander at Canton, working with the Soviet military mission and in the KMT-CCP united front.

Thus far Chiang Kai-shek had considered himself essentially a military man, but the chaotic situation at Canton after the death of Sun Yat-sen in early 1925 drew him into politics to be the holder of central power.

The Soviet investment in the Nationalist regime at Canton, supported in Moscow's councils by Stalin against Trotsky, followed Lenin's strategy of allying with nationalistic bourgeois-democratic revolutionaries in Asia against the common enemy, capitalist imperialism. Stalin was betting on one of the great causes of the twentieth century—the Marxist faith that class struggle for social revolution can be combined with simple nationalism.

Chiang Kai-shek was immune to such a faith but very conscious of the CCP infiltration of the KMT. It had proceeded so well that, at the second KMT congress in January 1926, more than a third of the KMT delegates were actually members of the CCP also. In March 1926, claiming self-defense against a plot, Chiang suddenly pounced upon the left, ousted some CCP leaders and Soviet advisors, and then

stoutly reaffirmed his devotion to the Canton-Moscow alliance. This skill in doing one thing while saying another—combining force and guile—marked him for eventual power holding. Sun Yat-sen had died untimely of cancer in 1925 and Wang Ching-wei had written down Sun's revolutionary testament to his countrymen, but it was Chiang Kai-shek who increasingly claimed Sun's mantle, leading in filial veneration of the late leader as an emperor used to do for his father, the better to demonstrate his legitimacy.

The Northern Expedition in 1926–27 from Canton to the Yangtze climaxed two years of patriotic anti-imperialism. Students, merchants, and urban labor were organized in a rising tide of demonstrations, boycotts, strikes, and incidents that led the foreign establishment to hunker down by its gunboats and evacuate all missionaries from the interior. By advance propaganda, popular agitation, and the bribery of "silver bullets," the Northern Expedition's six main armies defeated or absorbed some thirty-four warlord forces in South China. Britain, still the main power in China and so the main foreign target, gave up concessions at Hankow and Kiukiang. After the Nationalist forces took Wuhan, the Nationalist Government under the KMT left-wing leadership of Wang Ching-wei promptly moved there from Canton. In late 1926 Madame Sun Yat-sen (Soong Ching-ling), her brother T. V. Soong, Borodin, and others spent several weeks traveling from Canton to Wuhan by rail, sedan chair, boat, donkey, and on foot. Meantime the main drive under Chiang as overall commander moved on Nanking and Shanghai, where the money was. Militant CCP-led labor unions seized control of Shanghai from the local warlord in anticipation of the revolutionary army's arrival.

Chiang, however, suddenly ceased to be a revolutionary. On April 12, 1927, he coopted his friends the Shanghai underworld gangs to destroy the CCP-led labor movement there. His terror killed thousands. He set up his government at Nanking. The CCP's subversive aims became more apparent. The left KMT soon turned against the CCP connection, and joined up at Nanking. Borodin took off for Moscow, ending the first united front. As he went back to Moscow by car caravan through Mongolia, Borodin remarked that his Moscow comrades knew nothing of the conditions in China, where there was no industrial proletariat.

What had gone wrong is really a nonquestion. To be sure, by 1926 something like a third of the KMT central executive committee had

been CCP members. A left KMT had emerged under Wang Ching-wei, which was inclined to cooperate with the CCP and rival the right-wing KMT in which Chiang Kai-shek was becoming a leader. As it turned out, however, the left KMT, which had joined the CCP in moving the Nationalist capital to the Wuhan cities in 1926, suddenly began to realize that the Soviet strategy was to use them for a Communist takeover. When the left KMT defected from the Soviet-Nationalist alliance, the CCP leadership was in a small minority with no military defense, and its members had to go underground if they were not to be destroyed by the KMT terror of 1927–28. The fiasco could be attributed in great part to Stalin's being heavily engaged in his struggle to eliminate Trotsky but ignorant of China, so that he hoped a CCP success could bolster his position in Moscow. This was of course a vain hope. The CCP effort to organize militant peasants in associations for armed struggle came too late. A number of peasant associations had arisen in different areas but they generally lacked arms and overall coordination. The CCP learned by bitter experience that its only hope of seizing power was to secure a territorial base in which food and manpower could support a military effort, as it was to do in the 1930s.

By that time the CCP had found that the industrial proletariat in China could not form an organized basis for class struggle because it was too small and too dependent on a constant flow of new recruits from the countryside. The CCP also learned that one Leninist party cannot take over another from within. And finally it became apparent that the goal of social revolution through class struggle was premature, and the KMT aim of setting up a modern national government created a stronger rallying point for activists and patriots. The CCP was ignominiously defeated on all fronts.

13

Nationalists and Communists, 1927–1937

SINCE CHINESE POLITICS occur in a moral universe, a new regime while coming into power naturally heaps moral contumely upon its predecessor, which had previously of course denigrated *its* predecessor. As a result Chinese history is cluttered with moral judgments of power holders who failed to measure up. The Empress Dowager, Yuan Shih-k'ai, Chiang Kai-shek, and Mao Tse-tung, though by no means equivalent in moral stature, have each had their day, first as symbols of hope (perhaps briefly) and then as symbols of tyranny. It might even be suggested that, as modernization has penetrated the Chinese polity, each ruler has been more powerful and so in the end perceived as more tyrannical than his predecessor. This syndrome of historical judgment gives us today an onerous task of trying to judge each regime *de novo,* on its merits as now perceptible to us.

Let us begin with the startling reversal in the historical image of the Kuomintang. As of 1928 China's future seemed to be with the KMT; the CCP, always a small minority, seemed to have been wiped out, consigned to history's dustbin. How come the situation was reversed twenty years later? If the Japanese invasion after 1931 was a main factor, how did it weaken the KMT and strengthen the CCP? One answer is that the Nationalist Government of the KMT had become burdened with the problems of the old establishment, while the CCP, to survive, had to create a new order. This reflected a

temporal factor—the KMT leadership was older and had become worn out. However one strikes the balance, the outstanding fact is that the CCP was able increasingly to make itself the leader of a profound social revolution that was long overdue.

The character of a regime is even harder to delineate than that of a person. Let us look at various aspects of the Nationalist Government.

Because the KMT government after 1928 found its base chiefly in the cities, it was defined in Marxist terms as a party representing the bourgeois class. On examination, however, this analysis proves to be highly simplistic. A Chinese bourgeoisie of merchants, bankers, industrialists, and modern urban professional people was indeed emerging in the 1910s and 1920s. But it signally failed to achieve political power.

The Chinese merchant-industrial stratum in Shanghai and other major cities had its golden age in the years before and after 1920, first of all as a result of World War I. The European conflagration absorbed the attention and resources of the European powers. Chinese industries had their chance to develop production and exports with less competition from outside the country. When Japan attempted to take the Europeans' place in China as in their seizure of the German position in Shantung, this heightened the Chinese spirit of nationalism.

A second factor behind the golden age was the weakness of central government during the warlord period. Since warlords were generally excluded from the treaty ports, the nascent Chinese bourgeoisie organized in their chambers of commerce had the opportunity to promote their own interests. Foreign business in China had always relied on a large Chinese component in its activities. This component now began to compete with and supplant the foreigners.

Once the Nationalist Revolution brought the Nanking Government to power, the golden age of the Chinese bourgeoisie soon came to an end. Through its underworld allies in Shanghai, for example, Nanking was able to intimidate and coerce large donations from the business class in support of the Nationalist militarization. Abduction and assassination accompanied steadily increasing demands for merchant contributions to the government coffers. It became apparent that the Nanking Government existed not to represent the interests of a bourgeoisie but rather to perpetuate its own power, much in the

manner of dynastic regimes of earlier times.

If the Nationalist government was not "bourgeois," was it not at least "feudal"? In other words, representing the landlord interest? The answer is mixed. Nanking left the land tax to be collected by the provinces and itself lived mainly off trade taxes. The provinces, strapped for revenue, generally left the landlords in place. Central government army officers in particular might become large landowners. Nanking was against mobilizing peasants but it was for centralization, not dispersal, of power. "Feudal" may be used as a swear word, for disparagement, but it lacks precise meaning. It is more useful to see the Nanking Government as having had a dual character—comparatively modern in urban centers and foreign contact, reactionary in its old-style competition with provincial warlords. On its foreign side it could continue the effort to modernize at least the trappings of government while on its domestic warlord side it continued to suppress social change. Foreigners were more aware of its promise, assuming that in Anglo-American fashion the only way forward in China would be through gradual reform.

The Nanking Government's claim to foreign approbation lay first of all in its modernity. Nationalism seemed to have finally triumphed over warlordism. Unlike the warlords, Nanking set up the rudiments of a national administration. The big ministries of foreign affairs, finance, economic affairs, education, justice, communications, war, and navy built imposing office buildings in Nanking under the wing of the executive branch *(yuan)* of the government. Meanwhile, in addition to the legislative and judicial branches, there were established the control, that is, censorial, and auditing branch, and the examination branch for the civil service. Into these new ministries were recruited educated talent very conscious of China's ignominious place in the world. They naturally worked for rights recovery, the reassertion of Chinese sovereignty in foreign relations. They began to apply modern science to China's ancient problems. There was at first a new atmosphere of hope in the air.

The first difficulty, however, was the Nanking Government's limited scope. It was presiding over a rather small regime stretched thin over 400 million people still imbedded in traditions of manpower agriculture and transportation, widespread illiteracy that was hardly reached by the new education, and a patrilineal family system that kept youth and women in their place. The Nanking ministries had

to foster modern agronomy, railroads and bus roads, a national press and communications system, and the modern idea of opportunity for youth and women. These tasks were all but overwhelming. As a Westernizing influence Nanking found its strongest support in the treaty-port cities, its best revenue in the Maritime Customs duties on foreign trade, and its greatest difficulty in reaching the mass of the peasantry. Indeed, it was still engaged politically with warlordism and at first controlled only the Lower Yangtze provinces. It was at all times engaged in a political and often military struggle to dominate provincial warlord regimes.

At this point a second overriding factor had its influence. In an era of peace and order the Nanking Government might have ridden the crest of modernization, but its fate was determined almost from the first by the menace of Japanese militarism. After Japan seized Manchuria in 1931 important revenues were cut off, and the Chinese Government had to seek its salvation through militarism of its own. A government including many modern-minded civilians was obliged to put its revenues into a military buildup of a separate echelon under Chiang Kai-shek. The Japanese invasion when it came after 1937 was immensely destructive to a regime that was not well knit to begin with.

Third, the Nationalist Government from the start was plagued by systemic weaknesses that began with its personnel. The KMT at Canton before the Northern Expedition of 1926 had included both the surviving Revolutionary Alliance members of Sun Yat-sen's generation and younger idealist-activists who often had a dual membership in the KMT and the CCP. The Soviet input represented by Borodin had been combined with the rising military leadership of Chiang Kai-shek. Within five years, however, the vigorous Dr. Jekyll of Canton had metamorphosed into the sordid Mr. Hyde of Nanking. What had happened to change the character of the Nationalist movement in so short a time?

One factor of course was the slaughter of Communists and the rejection or suppression of those who survived. The CCP kind of youthful idealism was expunged. A second factor was the enormous influence of new KMT members from the ranks of the old bureaucracy and the warlord regimes. The careful selection of members, like the enforcement of party discipline, had never characterized the KMT. It had remained a congeries of competing factions not under

central control, and it had customarily admitted to membership any-
one who applied. Some warlords brought in whole armies. Once the
KMT was in power in Nanking, its revolutionary idealism was wa-
tered down by the admission of corrupt and time-serving officials and
the accumulation of opportunists generally lacking in principle. As
early as 1928 Chiang Kai-shek, who felt the responsibility of leader-
ship, said that "Party members no longer strive either for principles
or for the masses . . . the revolutionaries have become degenerate,
have lost their revolutionary spirit and revolutionary courage." They
only struggled for power and profit, no longer willing to sacrifice. By
1932 Chiang was declaring flatly, "The Chinese revolution has
failed."[54]

By coming to power, in short, the KMT had completely changed
its nature. After all, it had won power by using the Shanghai Green
Gang underworld against the Communists. At the beginning many
Chinese rallied to the support of Nanking, but the evils of old-style
bureaucratism soon disillusioned them. In addition to its white terror
to destroy the CCP, the KMT police attacked, suppressed, and some-
times executed a variety of individuals in other parties and the
professions. The press, though it persisted, was heavily censored.
Publishers were harassed and some assassinated. Anyone concerned
for the masses was regarded as pro-Communist. This anti-Commu-
nist stance had the effect of discouraging if not preventing all sorts
of projects for betterment of the people. Thus the KMT actually cut
itself off from revolutionary endeavor of any kind. Suppression and
censorship were accompanied by corrupt opportunism and ineffi-
cient administration. The old watchword "become an official and get
rich" was revived with a vengeance.

This disaster put a heavy burden on Chiang Kai-shek, who re-
mained an austere and dedicated would-be unifier of his country. By
1932 he was thoroughly disillusioned with his party as well as with
the Western style of democracy, which promised no strength of
leadership. He began the organization of a fascist body, popularly
known as the Blue Shirts, a carefully selected group of a few thousand
zealous army officers, who would secretly devote themselves to
building up and serving Chiang Kai-shek as their leader in the fash-
ion of Mussolini and Hitler. When a public New Life Movement was
staged in 1934 for the inculcation of the old virtues and the improve-
ment of personal conduct, much of it was pushed from behind the

scenes by the Blue Shirts. This fascist movement under the Nanking Government would have grown stronger if the fascist dictatorships in Europe had not been cut off from China.

One key to Chiang Kai-shek's balancing act on the top of the heap was the fact that he committed himself to no one faction. He claimed to be a devout Methodist and got missionary help for reconstruction. He sometimes supported his KMT organizational apparatus, headed by the brothers Ch'en Kuo-fu and Ch'en Li-fu, against the Blue Shirts. Seen close to, Chiang was less the creator of the KMT's decline than its product. Like Yuan Shih-k'ai twenty years before, Chiang found that Chinese politics seemed to demand a dictator. While he held various offices at various times, he was obviously the one man at the top, and his political tactics would have been quite intelligible to the Empress Dowager. One of Chiang's model figures was Tseng Kuo-fan, who in suppressing the Taipings had been his predecessor in saving the Chinese people from a destructive social revolution. In brief, Chiang was the inheritor of China's ruling-class tradition: his moral leadership was couched in Confucian terms while the work style of his administration showed the old evils of ineffectiveness. As Chiang said in 1932, "When something arrives at a government office it is *yamenized*—all reform projects are handled lackadaisically, negligently, and inefficiently."[55] One result was that paper plans for rural improvement seldom got off the ground while economic development was similarly short-changed.

The Nanking Government and its heavy military outlay were financed at first by borrowing large sums from the banks, which received bonds at very favorable rates of discount. By 1935, however, it was possible to reform the government's finances by taking China off the silver standard and changing to a managed currency handled by the four government banks. This reform meant that from then on the Nationalist Government could finance itself by printing banknotes. The resulting inflation at first helped the farmers by giving them higher prices.

Sun Yat-sen's five-power constitution fared poorly under the Nanking Government. The legislative branch or Yuan was overshadowed by the Executive Yuan, but the latter was rivaled by party ministries not unlike the Executive Yuan ministries. The Examination Yuan really did not function. "By 1935 for example only 1585 candidates have successfully completed the Civil Service Examinations." Many

did not receive official positions at all. Again, the Control Yuan had inherited some of the functions of the censorate of old but it was almost entirely ineffectual. From 1931 to 1937 it "was presented with cases of alleged corruption involving 69,500 officials. Of these, the Yuan returned indictments on only 1800 persons."[56] Worse still, the Control Yuan had no power of judicial decision, and of the 1,800 officials indicted for corruption only 268 were actually found guilty by the legal system. Of these, 214 received no punishment, and 41 received light punishment, yet only 13 were actually dismissed from office. Meanwhile, all of the five-Yuan government was equaled by the Military Affairs Commission headed by Chiang Kai-shek, which used up most of the Nanking Government revenues and set up a de facto government of its own.

Paradoxically, to say that China had a strong state with a final power in the chief of state is another way of saying that China had weak political institutions of the sort that could provide autonomous political influences. The imperial system had been so strong in building up the power of the emperor that no other sources of power were allowed to exist. The emperor in his conflicts with his bureaucrats resorted to willful and unpredictable decisions that broke into their routinization. Under the Nanking Government, the urban capitalists, the big landlords, the student movement, the labor unions, were all ineffective in holding the government responsible to their interests. It was a government that existed for the sake of existing and did not seek participation of other groups. As Chiang Kai-shek by degrees made himself dictator, he hamstrung the KMT and left it out of participation in administration, just as he balanced the Whampoa clique of his former students against other parts of the army or the Political Science (or Political Study) clique of administrators against the CC clique of party organizers, or the latter against the Blue Shirts. His role was such that there could be no other source of final decision, least of all through a participation by the mass of the people.

In this way the Nationalist Government at Nanking from 1928 to 1937 was undercut by several political factors. Among the mass of Chinese it was unable to penetrate the village level except superficially from the top down. Plans and legislation that tried to set up elements of local administration representing the central government turned out usually to be in competition with the provincial interests represented by warlord governors and urban chambers of

commerce. The modern reforms and improvements brought to the local scene began with the extension of roads and bus lines supplementing the telephone and telegraph. Programs and even institutions for geological survey, crop statistics, agronomic improvement, and maintenance of local order had to be paid for by the effort to collect greater taxes from the villages. The Chinese peasantry still felt that they benefited little from these modern improvements promoted by the city people and the central government. The whole idea of organizing the village for its own self-improvement was foreign to this officialism, with the result that the cause of social revolution, specifically the broadening of land ownership and the lessening of absentee landlordism, could not be pursued under the Nationalist regime.

Meantime, among the cities the Shanghai underworld and its racketeers produced a large revenue from which the government, by tacit cooperation, got a substantial rake-off. The principal activity of the Nanking Government had to be military—first to subdue or neutralize provincial warlords and second to prepare the country for resistance to the Japanese invasion. This national crisis colored the whole scene. Just as the revolution that from Canton seized the Lower Yangtze economic base in 1927 had had to be led by a commander of troops, so the continued existence of the Nationalist Government depended upon its military capacity.

As a step in Chiang Kai-shek's recourse to military dictatorship, after coming to power he naturally got rid of the Russian military advisors and soon began to substitute Germans. In 1928 the German-trained jurist Wang Ch'ung-hui helped Chiang Kai-shek establish his military echelon quite separate from the civilian government. The general staff and what became the Military Affairs Commission with its various ministries were under Chiang as commander-in-chief while the five branches of the civilian government were under him as president. German military advisors set about training an enormous military establishment for which they planned to get German industrial assistance. The German connection with Nanking was promoted by Sun Yat-sen's son, Sun Fo, as well as his rival T. V. Soong. By 1930 a China Study Commission arrived from Germany for three months and several cultural institutions were set up to develop closer relations. A Sino-German civil aviation line was started.

Spurred by the Japanese seizure of Manchuria in 1931, the Peking

intellectuals among others advocated a national industrial buildup for self-defense. Scientists were mobilized. A German-trained geologist, Chu Chia-hua, became minister of education. In 1932 began the organization of what later became the National Resources Commission (NRC) under the leadership of the geologist Weng Wen-hao, a first-level graduate of the examination system, who got his Ph.D. in geology and physics at Louvain in Belgium. Impeccably honest and highly intelligent, Weng rose in the Nationalist Government to high-level posts in economic development. The NRC was directly under Chiang and the military. Its aim was to create state-run basic industries for steel, electricity, machinery, and military arsenals. Part of the plan was to secure foreign investment, particularly from Germany. By 1933 a German military advisory commission was operating in China, aiming at military-industrial cooperation. Chinese tungsten became important for German industry. The organizer of the modern German army, General Hans von Seeckt, visited China twice and advocated building a new elite army with a new officer corps.

Thus at the time of the Japanese attack in 1937 the Nationalist Government had worked out a promising relationship with Nazi Germany. Its results, however, were hamstrung by the Japanese invasion; a parallel development of Nazi relations with Japan and the Nazi-Soviet pact of August 1939 soon left China dependent on a still-minimal amount of American aid instead of German. This suited the fact that China's foreign contact in the 1920s and early 1930s had given opportunity to Sino-liberals with predominantly American backgrounds.

While the Nationalist Government in the 1930s was struggling to build up its military power, the CCP was struggling to survive in the villages. Although the Chinese Communist party had accumulated some sixty thousand members by the time of the split in 1927, Chiang Kai-shek's white terror soon decimated it in the literal sense. Many must have dispersed into anonymity and inaction, while some of the most dedicated took off to hole up in remote fastnesses in the countryside. A dozen or so base areas thus developed, small pockets where Red Army troops in small numbers supported rebel political leaders. These base areas were typically on the economic fringe between the plains and the mountains, where wheeled vehicles

could not yet penetrate and transportation was by donkey or human carrier along flagstone paths in the valleys between sharp hills. When Mao joined up with the warlord officer Chu Te on Ching-kang-shan on the southern Hunan-Kiangsi border, they inaugurated the major base area but soon moved to the hills of Kiangsi to the northeast with Jui-chin as their capital town. Other base areas were established in the Ta-pieh Mountains northeast of Wuhan or around the marshy Hung Lake in north Kiangsu at the old mouth of the Yellow River. All these areas were relatively inaccessible and defensible. Their growth in the 1930s led to the indigenization of Marxism-Leninism in China.

The Soviet-Comintern crusade had walked on the two legs of an idealistic belief system and a technique of organization. The belief system was an entire cosmology that summed up all of human history on a cosmopolitan, supra-national basis. The organizational technique, justified by the cosmology, promoted discipline and obedience from all true believers. It was a powerful combination that promised to meet the needs of patriotic nationalism by liberation from past institutions and by industrial modernization of the people's lives.

Ideology and organization have of course been the winning combination in most revolutions. In the case of China, what came from the Soviet Union through the Comintern took a considerable time to find its adaptation to Chinese life and conditions. For example, the Marxist-Leninist analysis of history gave the key role to the urban proletariat, the industrial working class, and its urban leaders of the Communist party, but the CCP got nowhere until it substituted the peasantry for the proletariat, in effect, standing the theory on its head. Comparably, the disciplined obedience to the organization not only exalted the CCP within China, it began by accepting the guidance of the Comintern from Moscow. Once power was achieved, however, the Communist parties represented their national interests, and in the end the Soviet and Chinese parties would split apart. In time it became evident that the road to international cosmopolitanism unfortunately lay through the fulfillment of nationalism. National communism weakened and split up the Comintern strategy. Communist parties could not flourish without energizing the national culture, but once they did so their original bond was broken.

After 1927, when Ch'en Tu-hsiu was expelled for having presided

over the near-demise of the CCP, the leadership in China passed to a succession of young men put forward from Moscow by the Comintern. Their ability to wage a successful revolutionary war was severely handicapped by their having to live as underground fugitives in Shanghai and other urban centers. Their doctrinal activities contributed to the ideology of the movement in words on paper but never became a public rallying point for a mass movement. They would all have been long since forgotten had the CCP not begun to find a new organizational technique in the countryside among the peasantry.

Since the sixty thousand or so members of the CCP in early 1927 had been reduced by the Nationalist white terror to perhaps twenty thousand soon after, the remaining party members in the cities had to lead a furtive existence, but they still represented the Comintern and received directives from Moscow, which they in turn transmitted to the base areas.

At first, moreover, the Moscow influence was strengthened by the return of the famous twenty-eight Bolsheviks who took charge of the CCP in early 1931. They showed their Comintern-style ruthlessness by evidently betraying a meeting of the current CCP Central Committee, mainly local people, to the KMT police. Twenty-four were arrested and shot, whereupon the twenty-eight Bolsheviks made great propaganda over the death of five young writers, whom they dubbed the Five Martyrs, while saying nothing about the other nineteen victims, whom they now supplanted as a new Moscow-trained central committee. Their ideas and aims were highly orthodox, not closely suited to the Chinese scene. They continued to talk about the proletarian revolution and tried to seize cities in the hope of establishing independent provinces. This played into the hands of the KMT and every attempt was thwarted. There was no "rising tide" of rebellion in China. By 1933 the Central Committee was obliged to get out of Shanghai and move to the central base in Kiangsi, of which Mao Tse-tung was head. There they outranked him but became immersed like him in peasant life and its problems. From this time on the personality and mind of Mao became a central factor in the CCP revolution.

Mao Tse-tung excelled his colleagues in achieving a unity of theory and practice. As already noted, this had been a major motif in Confucian philosophy. The harmony of thought and conduct, the

interrelationship of knowledge and action—these were formulations of the great dialectic *yin-yang* principle seen throughout the cosmos. Man was part of nature and the two must interact. As his experience unfolded, man must learn from it. But what he learned must then be applied, because man being part of nature could influence the situation.

In Mao's case the unity of theory and practice led him to assume certain postures: if you can't use it, don't accept it. Book learning which could not be applied was a waste of time: ivory-tower scholarship, doctrines, and dogmas were useless if not translated into action. Accordingly he had contempt for mere scholars.

In the days of the Confucian establishment the common approach had been to learn from the established ways. For the scholar, "learning is easy, action is difficult," but in the revolution of the twentieth century the situation was reversed. As Sun Yat-sen had reformulated it after his initial frustrations: "Knowledge is difficult, action is easy." Mao agreed that if you knew something then you could and should act upon it. But your experience and the results of action should then lead to your reformulating what you knew. Mao was a creative genius, who could outthink the doctrinaire city-bred Comintern stooges who tried to mastermind rural rebellion. (This pejorative view no doubt reflects Maoist historiography, which never gives losers an even break.) As it turned out many years later, Mao's chief failing was that his unity of knowledge and action had been in the realm of concrete politics and not in the abstractions of economics.

From the scanty documentation remaining, the progress of Mao's thought can be deduced as he moved from one stage to another. Beginning as a disciple of the May Fourth Movement, he had been a gradualist believing in reform. Only after signal frustrations had he concluded that violent revolution was the only feasible course. He had begun by writing about physical fitness as an essential part of the whole person. He had subscribed like so many others to the Kropotkin form of anarchism, which stressed mutual aid and concerted efforts. In 1914 at age eighteen he made notes on a Chinese translation by Ts'ai Yuan-p'ei of the German philosopher Friedrich Paulsen's *System der Ethik.* This philosophical popularizer argued that "will is primary to intellect," and ethics are part of nature. The behavior of the universe is ethical and so is that of the individual. Subjective and objective attitudes are not at loggerheads. This attri-

bution of an ethical posture to development was particularly useful to the Chinese generation that had to reconcile history and value, the Chinese inheritance of ethical teachings with the modern knowledge of the scientific world.

From the first Mao was intensely active. He got to school later than his fellows, and at the Normal College of Hunan, where he got his principal education, he was more mature than the other students and a natural leader. He organized a workers' night school, in which he and his fellow students taught classes two hours an evening five days a week to give reading and writing to laborers. After he returned to Hunan from Peking National University just before the May Fourth Movement of 1919, Mao founded a journal of discussion named the *Hsiang River Review* (for the river that flows through Changsha). In it he put forward the dialectic view that the phase of oppression of the people would be followed by a phase of their transformation, that the humiliation and weakness of China would be followed by China's emergence as a leading nation. This expressed the theme of the unity of opposites, which went back a long way in Chinese Taoism and other thinking. His advocacy of "the great union of the popular masses" argued that unified groups in society had long had the upper hand by reason of their standing together, and it was now time for the masses to get the upper hand by doing the same. In a similar fashion the nations of the West had defined themselves by their interaction; now it was time for China, which had been isolated, to do the same.

While Mao's thinking was cosmopolitan and universal in terms, one of his first activities was in the provincial Hunan self-government movement, which tried to establish a constitution for the province as a reflection of the then popular idea of federation of independent provinces as the means to bring China into modern government. Self-government must have a popular base and participation, a mobilization of all the people. When his journal was suppressed in late 1919, Mao took another trip to Peking and Shanghai, where he found kindred spirits. But he was not yet a conspirator or a Marxist, although he organized in 1920 a Russian-affairs study group and a Hunan branch of the Socialist Youth Corps. To spread its ideas he set up a Cultural Book Shop with branches elsewhere in the province. Even after Mao went to the organizing meeting of the Chinese Communist party in July 1921 in Shanghai, he was not yet committed

to class struggle. In 1923 he organized the Hunan Self-Education College, one object of which was to use the old form of the academy *(shu-yuan)* through which to make available the new content of modern learning. His last activity in Hunan was to work in the labor movement, but he was obliged to flee to Shanghai in April 1923. Thus far he had exemplified the kind of activism that was necessary to carry through revolution—the value of ideas lies in whether they can get results. Mao was attracted to Marxism for its utility in liberating the people, but it was he who came to it, not the other way around. The ideals of May Fourth could not be made effective unless the CCP showed a way forward.

Now that the Chinese peasant revolution under Mao's leadership has occurred, it is easy to see in retrospect how unrealistic and doctrinaire was the Comintern approach to China's revolution, as a matter of organizing and leading an urban proletariat, and how essential was Mao's stress upon the mobilization of the peasantry for taking power and changing the intolerable conditions of peasant life. The young Mao of course was not the only Communist concerned about the peasantry. A half century after Ed Snow's *Red Star Over China* made Mao *numero uno* in the Chinese Revolution as seen by foreign observers, study of other early leaders is beginning to right the balance.

The most intriguing pioneer in CCP peasant mobilization was P'eng P'ai, a May Fourth intellectual from Hai-feng county, on the seacoast halfway between Hong Kong and Swatow. Returning to his ancestral clan in the early 1920s, he learned by trial and error how to get himself accepted by the villagers, how to lead them in forming a peasants' union and begin class struggle against landlords, usurers, and tax gatherers. In the united front at Canton P'eng set up and directed in 1924 the Peasant Movement Training Institute, where Mao Tse-tung would be director of the sixth and final class in 1926. Though he was a pioneer, P'eng lacked Mao's vision and remained rooted in his native county. There in time he learned how to mobilize peasant military power by means of doctrinal faith, greed, and polarization between fear of the landlords and of his own CCP terror. In late 1927 P'eng was able to set up a rebel Hai-Lu-feng (i.e., Hai-feng and Lu-feng counties) Soviet, which was not wiped out by KMT government forces until after four months of governing over Hai-Lu-feng (November 1927—February 1928). Thus P'eng preceded Mao

by several years, when Mao was still in the united front at nearby Canton.

We can see how Mao's ideas developed, after his flight from Hunan in 1923, as he worked in the united front under the KMT. For a time he was in the organization department of the KMT in Shanghai, and subsequently was made an alternate member of that party's Central Committee at Canton. There he became director of the Peasant Movement Training Institute, which provided a five-month education in the subject to a class of some hundreds. From May to October 1926, Mao directly taught the sixth class, which had 320 students from all the provinces of China. The institute program seems to have stressed an analysis of peasant problems plus an analysis of the class structure in the countryside. On the basis of Mao's own six months' experience back in Hunan in 1925 when he organized peasant unions, his articles of 1926 describe the in-built exploitation of the peasantry all the way from the working peasant landowner to the landless laborer. They are oppressed by (1) heavy rents, half or more of the crop, (2) high interest rates, between 36 percent and 84 percent a year, (3) heavy local taxes, (4) exploitation of farm labor, and (5) the landowner's cooperation with the warlords and corrupt officials to exploit the peasantry in every way possible. Behind this whole system lay the cooperation of the imperialists, who sought to maintain order for profitable trade in China.

By this time Mao had thoroughly accepted the Leninist concept of a world movement against capitalist imperialism on the basis of class struggle. But, within this generally accepted framework, Mao argued that the key to success in China's revolution must lie first in the careful intellectual analysis of the various classes in the countryside and, second, in using an intensely practical tactic of identifying those classes with whom to work and those classes to work against in any given stage of the revolution. Third, the role of the CCP in its approach to the village must be one of a guide and catalyst rather than a know-it-all, The party worker must closely examine the villagers' needs and complaints, hopes and fears; only then could the party articulate the peasantry's demands and follow its tactic of uniting with the largest possible number to attack the smallest possible target as a step in the revolutionary process.

Unfortunately while Mao was thinking these thoughts in 1926 the CCP was absorbed in its united front tactics. Its members still as-

sumed that by definition the Nationalist Revolution of the 1920s was a bourgeois revolution, a view which history was to prove quite wrong. In this misguided belief, the CCP followed the advice of the Comintern and continued the united front with the KMT at all costs, toning down its ideas of mobilizing the peasantry on the basis of their misery until such time as imperialism had been expelled from China by a new national government. Giving up the social revolution in the countryside seemed to be an unavoidable part of maintaining the united front. "Peasant excesses" were deplored by the CCP because the mushrooming of peasant associations in the southern provinces during the Northern Expedition had led to savage repression by the landlord-militarist complex still in power. The CCP had no armed forces of its own and its peasant movement was as a result quickly destroyed after the KMT-CCP split in mid-1927. Thus the CCP contributed to its own disaster.

In this period Mao had dutifully gone along with the line transmitted from Moscow, and had vainly attempted to ride the assumed "high tide" that never rose. He found the peasantry could be mobilized and even seize cities but could not fight the Nationalist Army. Mao therefore got the message that the CCP could survive and prosper only by developing its own armed forces in a territorial base where men and food supply could be combined for fighting. The "Kiangsi Soviet Republic" became the vehicle for this effort from 1931, with Mao as president.

At this time the CCP sought peasant support by land redistribution, dispossessing big landlords if any and giving hope and opportunity to the poor peasantry in particular. One of the many disputes between Mao and the twenty-eight Bolsheviks was over the treatment of rich peasants. Mao saw them as essential to the local economy and tried to give them reassurance, but the Moscow-trained dogmatists saw them as a source of peasant mentality that would destroy the proletarian nature of the movement.

Chiang Kai-shek's campaigns to exterminate this Communist cancer obliged the CCP to develop the principles of guerrilla warfare. The first principle was to draw the enemy in along his supply lines until his advance units could be surrounded and cut off. The second principle was never to attack without superior numbers and assurance of success. Eastern Kiangsi with its rugged hills and narrow valleys was ideal for these tactics. The further Chiang's spearheads

advanced, the more vulnerable they became. They were successful only in the fifth campaign in 1934, when their German advisors helped devise a system of blockhouses on the hillsides along the invasion routes so placed that gunfire from one could help defend the next. This string of strongpoints supplied by truck could not be dislodged, and Chiang's armies eventually got the upper hand. This made the third principle of guerrilla warfare, that the peasantry be mobilized to provide intelligence as well as men and food, finally ineffective. In late 1934 the CCP took off on the Long March, which began with perhaps 100,000 people and wound up a year later with something like 4,000.

The point of the Long March was to find a new territorial base, which would be on the periphery of Nationalist power, not unlike the way in which the Manchus had been on the periphery of the Ming empire. The CCP needed a haven it could organize. If Yunnan province had been available it might have served, but the local warlords in the provincial regimes had no desire to be taken over by the CCP. Instead, they were gradually taken over by Chiang Kai-shek's pursuing armies in a clever strategy by which the pursuit of the CCP justified bringing central government armies into the outlying provinces.

The Long March has always seemed like a miracle, more documented than Moses leading his Chosen People through the Red Sea. (Six thousand miles in a year averages out at seventeen miles every single day.) How did so many troops and party organizers go so far on foot so fast?

We must visualize the terrain. Southwest China is a checkerboard of large and small basins within mountain ranges. The populous plains are watered by streams from the inhospitable mountains. To cross Southwest China the Long March had to get across the rivers and through the mountains, avoiding the plains and their few motor roads. Most of the route was therefore up hill and down dale, seldom on the flat. Carrying poles substituted for wheeled vehicles and two-man litters for railroad berths.

An American example of marching was set by General Joe Stilwell after the Allied defeat in Burma in 1942. As commander he set a steady pace at the head of the column marching out to India. On the Long March the Red Army–CCP high command rode much of the way asleep on two-man litters, as the column followed the stone

paths over hills and paddy fields. Usually they had been up most of the night handling the army's intelligence, logistic, personnel, and strategic problems to prepare for the next day's march or fighting. Joe Stilwell would have let himself be carried only at the last moment before death. Contrarily Mencius said rulers labor with their minds and the ruled with their muscles. Obviously Mao, Chou, and company could survive the Long March where American leaders could not have.

The CCP leaders also preserved themselves by having orderlies, aides, and bodyguards as in conventional armies. Like the Americans against the Japanese, they had their secret intelligence sources. Their radio receiver picked up the simply encoded Nationalist military traffic. They knew more about their enemies than the latter knew about them.

One major issue as the Long March progressed was where it should go next and who should lead it. Before the march left Kiangsi, Mao had been downgraded by the Soviet-trained faction of the twenty-eight Bolsheviks and their German Communist military advisor sent by the Comintern. The facile Chou En-lai outranked Mao in the military command. But no one could break Chiang Kai-shek's stranglehold. The Comintern ideologists' recourse to positional warfare led only to certain defeat. The flight on the Long March suffered great early losses, especially at river crossings. Mao's unorthodox faith in mobile warfare was finally accepted. On the way west and northwest Mao regained the leadership of the CCP in early 1935 and thereafter never relinquished it. Chou En-lai, his former superior, became his chief supporter from then on.

Under Mao's resumed command the Red Army faced the crossing of the main tributary of the upper Yangtze, where KMT-warlord troops had garrisoned all the crossings. Mao's deceptive tactic was to march Red Army contingents around and backward till they seemed to threaten the provincial capitals of Yunnan and Kweichow. In self-defense the garrisons on the river were pulled back. The Red Army then turned and successfully dashed across.

Marching speed was so crucial that the original many-mile-long baggage train and its thousands of porters carrying heavy equipment, files, supplies, and also convalescent medical cases had to be discarded. Military personnel at the start were listed as 86,000. Those arriving a year later in Shensi were barely 4,000, even though many

new recruits had joined the Red Army along the way. From then on Long March veterans were the aristocracy of the Revolution. They provided the tangible founding myth of the People's Republic.

The Long March also helped the new leader to emerge. Mao on the March was already distancing himself from his colleagues. Once he was the One Man at the top, he preferred to dwell in separate quarters away from the rest of the leadership. Like an emperor on the make, from then on he could have no equals or even confidants. He was already caught in the trammels that beset a unifier of China. If we may look both forward and back for a moment, Mao Tse-tung's rise to power reminds us of the founding of the Han, the T'ang, and the Ming. In each case a band of leaders took shape and worked together under one top leader who was "charismatic." Once formed, this leadership mobilized the populace in their area to support a military effort and either overthrow tyrants or expel foreigners from the land, in either case, a popular cause. No dynastic founder could do the job alone. So once he was in power he had the problem of dealing with his colleagues in the leadership. The Ming period (1368–1644) is better documented than earlier times and the founder of the new regime proved to be a very suspicious and indeed paranoid leader, who destroyed one after another of his early military comrades. (He also planted millions of trees, and if he had had railroads, he would have made them run on time.)

Another development on the Long March was that Mao found his closest working colleague and future prime minister in Chou En-lai. A charismatic figure of great talent, Chou instinctively kept a middle position, trying to hold the organization together, and at the same time he had the good sense never to become number two as a rival for the top post. His forty-eight years on the CCP Politburo set a world record. Chou thus became one of the great prime ministers, devoting himself to the service of the party and its leader, just as earlier prime ministers had served the emperor and the imperial house.

This role was part of Chou's inheritance. His family came from near Shao-hsing in Chekiang south of Shanghai between Ningpo and Hangchow, the remarkable center from which so many confidential advisors and secretaries had emerged to serve high officials in the Ch'ing period. Chou had three uncles who became provincial graduates under the old examination system, and one became a governor.

From the age of ten in 1908 Chou went to elementary school in Mukden, Manchuria, and then in 1913 entered the Nankai Middle School, where he came under the influence of that extraordinary liberal educator Dr. Chang Po-ling. Chou absorbed a good deal of education but he was from the first a student leader. He spent 1917–19 in Japan, where he became acquainted with the socialism of Kawakami Hajime. When the May Fourth Movement began Chou returned to Nankai, which was now a university, and threw himself into editing a student paper. From then on his life was essentially that of an organizer and propagandist, but he moved rapidly to the left, and his revolutionary stance was confirmed by an experience of several months in jail. In the summer of 1920 he went to France.

Several hundred Chinese students were now in France, in addition to the hundred thousand or so Chinese laborers brought to help the war effort. Most of the students were on a work-and-study program, but many devoted themselves primarily to the great question of the salvation of China. Chou En-lai immediately rose to the top again as the most impressive, suave, and diplomatic, young leader among them. His specialty was not to be the top figure but to bring competing personalities into working agreement. Thus from the very beginning his role was that of a leader who kept the leadership together, not by domination but by persuasion. He visited England and spent some time in Germany organizing a CCP branch in Berlin. By the time he returned to Canton in 1924 Chou En-lai was a most accomplished practitioner of united front revolutionary politics.

In Canton he joined the staff of the new Whampoa Military Academy, headed by the rising young general just back from Moscow, Chiang Kai-shek. Chou became vice director of the political training department, in other words a leading commissar and at the same time a subordinate and therefore student of young General Chiang. He had seen the international world and at the same time worked with young people who formed the new generation of leadership in the Chinese revolution.

In March 1927 he was in charge in Shanghai when the Communist-led revolt prepared the way for the Nationalist Army, only to be turned upon by Chiang Kai-shek's split. Again, Chou was leader in the Nanchang uprising in 1928 which became the birthdate of the Red Army. Later he cooperated with the twenty-eight Bolsheviks and supported a succession of party secretaries while avoiding the

post himself. In Kiangsi he espoused positional warfare until it brought disaster.

The secret of Chou's eventual success was that he had the wit to recognize that the doctrinaire Moscow approach to China was futile and that he himself lacked the creative capacity to adjust CCP policy to Chinese conditions. Only because he knew his own limitations was he able, having been Mao's superior, to become his subordinate at the climactic Tsunyi Conference early in 1935, when Mao began to take over the CCP leadership in the course of the Long March.

Chou's international experience and finesse in dealing with people of all types provided an essential ingredient in the CCP success story. Mao could not have risen without him. Just as Mao had first learned from his military colleague Chu Te, so he profited from Chou's unusual capacities as mediator, diplomat, and administrator.

Moreover, Chou represented the continuity of a team. With him in France had been Ch'en I and Nieh Jung-chen, both of whom became marshals of the CCP forces. Later at Peking Ch'en would become foreign minister and Nieh would take charge of nuclear development. Deng Hsiao-p'ing had run the mimeograph machine for Chou in Paris. The leadership that survived the Long March was indeed closely knit. In addition to having a common faith and ideology, and accepting party discipline as the basis of their work, they were a group of long-time comrades.

Near the end of the Long March, Mao and his Red Army from the Kiangsi base rendezvoused with another part of the Red Army, who had marched from the Hupei-Honan-Anhwei base located in the Ta-pieh Mountains northeast of Wuhan. This other part of the Red Army was led by one of the founders of the CCP, Chang Kuo-t'ao, whose troops greatly outnumbered Mao's. Chang later broke with Mao and went over to the KMT. But what was the history of his Soviet base? Little has been written. The Mao group have preempted the spotlight of history.

Once arrived in Shensi province in the Northwest in late 1935 the CCP had little beyond them but desert on the west and the Yellow River on the north and east. Shensi had been carved up over the eons by the erosion of the loess plateau. The lack of motor roads made it a defensible area, but it was short of food supply and population and the Nationalist suppression campaign might have wiped it out had it not been for the Japanese invasion of 1937. In preparation for resis-

tance, the troops of the Northeast (Manchuria), stationed at Sian to fight the Communists, preferred to fight the Japanese invaders of their homeland. In December of 1936 they captured Chiang Kai-shek and before releasing him pushed the idea of a Chinese united front instead of Chinese fighting Chinese.

In 1928 the CCP had reached a low point when its sixth Congress had to be held in Moscow. While the Comintern directed its destiny for a time thereafter, by 1935 the Russian-trained element was beginning to be superseded by Mao's followers, less because of any conspiracy than because Mao had discovered the key to power in the Chinese countryside. This lay in his feeling for the mentality, needs, and interests of the common people. The "mass line" which he advocated was genuinely concerned to have the revolution guided and supported by the common people. Imported doctrines must be secondary. The people must be carefully listened to, the better to recruit, mobilize, and control them.

A comparable bankruptcy of the Comintern directives had occurred in the white areas under KMT control. Repeated attempts to organize labor unions as an urban proletariat and use strikes to get control of cities never got off the ground. The chief organizer who emerged was another man who knew how to pursue what was possible. Liu Shao-ch'i headed the Communist effort in the North China cities, where he encouraged the left-wing literary movement, the use of the arts, and the recruitment of students. By dropping the CI doctrines about proletarian revolution, Liu achieved a parallel indigenization of the CCP methods.

By the time Liu joined Mao at Yenan in 1937, the second united front had already taken shape. A united front of all Chinese against Japan became the Moscow line in the summer of 1935 in order to combat the rise of fascism in Europe and Japanese aggression in the East. Mao, however, came out for a united front in China against the Japanese but excluding Chiang Kai-shek. The key point was that the national revolution to save China from Japan now took precedence over the social revolution on the land, but Mao would not give up the latter to concentrate on the former. Instead he urged a two-front effort to combat both the Japanese and Chiang Kai-shek by developing Soviet bases in a war of resistance. To prove its sincerity the CCP from Yenan launched an eastern expedition into Shansi province in order to get at the Japanese farther east. Just at this time

in the spring of 1936 a Comintern directive ordered Mao to join a united front with Chiang. Chou En-lai went to Shanghai to negotiate the terms.

When the KMT and the CCP finally agreed on a united front alliance in April 1937, Mao began to win out against the remaining twenty-eight Bolsheviks in the CCP. Far from combining with the KMT, Mao planned to carry on the social revolution in Soviet areas as a basis for fighting Japan on the nation's behalf. If this strategy worked, the separate armed forces of the CCP would develop their own bases and popular support while also riding the wave of national resistance to the invader. The basis for Mao's national communism was already laid.

14

The War of Resistance
and Civil War, 1937–1949

DURING THE EIGHT YEARS of Japan's invasion of China, a major part of the people were in Japanese-occupied territory, mainly the coastal cities and railway towns. Another major segment were in the KMT area, Free China. The smallest part of the three divisions of China was the CCP area, with its capital at Yenan. Historians of course are genetic-minded, looking for origins, and China's future came out of Yenan. Accordingly, the defeat of the Japanese and then of the Nationalists has been less researched than the rise of the CCP. Success is creative and interesting, failure sad and dull. Who wants it? Moreover, Yenan being smaller, in size and in documentation, is easier to encompass than the vastly variegated experience of Occupied China and Free China. We begin with a bias, almost ignoring Japan's China, summarizing Free China in broad terms, and trying to zero in on CCP China.

The disaster that overcame the Nationalist Government during the eight-year resistance to Japan was man-made, most obviously by the brutally destructive Japanese armies, but also by the Nationalists' response to their bitter circumstances. Perhaps nothing could have saved the modernizing China that they represented, once Japan struck. But one factor certainly was the course pursued by the Nationalist leadership.

The removal of the Nanking Government in 1938 to Wuhan and

then beyond the Yangtze Gorges to Chungking in Szechwan cut it off from its roots. Its revenues from the Maritime Customs Service and the opium trade to Shanghai were knocked out. Its hard-won echelon of modern-trained administrators became refugees dominated by that other, domestic face of the KMT, its reactionary alliance with provincial militarists and landlords, the residue left from the old China. In West China the Chungking Government tried to keep the local warlords in line and avoid upsetting the social order under the landlords in the villages. From being the central government of China, the Nationalist regime was now a fugitive in a mountain-ringed redoubt. If Mao and his people had been in charge in Chungking they could have gradually mobilized the populace, stalemated the warlords, and done in the landlords. Szechwan province was as big as France or Germany and could have become a base for the recovery of China from the Japanese. History, however, disclosed that the Nationalist Government had too little faith in revolution to make it the leader of the Chinese people.

At first the Free China spirit of resistance to Japan, which had galvanized the world from 1937 and enlisted liberal sympathy (as did the Spanish Loyalists who were fighting Franco), provided a rallying point for the remnant modernizing sector of Chinese life. China's nascent Sino-liberal educational system suffered a grievous destruction of plant and facilities. Many students migrated to the Southwest and up the Yangtze, faculties going along with them. The Southwest Associated University at Kunming was set up by Tsing Hua University and Peking National University from Peking and Nankai University from Tientsin. Meanwhile Yenching University and other Christian institutions gathered at the site of the West China Union University in Chengtu. At the same time whole industrial plants were dismantled and shipped upriver, where the National Resources Commission had already been developing mines and industries. Intellectuals and government administrators with great patriotism put up with displacement from their homes and learned to live more primitively in the interior, without the amenities of life in the coastal cities. Unfortunately, although they were the main body of modern China's professional people, their hopes went unrewarded. This was due both to the ineptitude of their government and to the backwardness of its circumstances.

The Nationalist regime met its problems by short-term expedi-

ents that gave it little strength for the future. An exiguous flow of goods and people came out of Japanese-occupied China, mainly along the Lung-Hai Railway route north of the Yangtze and also by air from Hong Kong until the Japanese seized it in 1941. By that time the Chungking regime had succeeded in getting control of the proceeds of the land tax in grain as the wherewithal to feed its administration. Its industrial developers had arsenals at work to support the war effort. The spirit of resistance was stimulated by the Japanese bombing of Chungking, but meanwhile the spirit of the united front deteriorated. Radical intellectuals in Chungking began to drift northward to Yenan, except for those who were already outside cadres of the CCP assigned to work as ostensible liberals in the KMT area. CCP infiltration of Free China grew as conditions worsened, and the KMT organizers felt compelled to coerce the intellectuals.

Chiang Kai-shek and his regime were as unimaginatively conservative as they had been in Nanking. They felt warfare was for the big military establishment. University education was for the future of China, and therefore students were not mobilized in the war effort but given stipends to continue their studies. The peasantry were conscripted and taxed but otherwise left alone. Literacy was not especially promoted nor did public-health services reach the villages. The ruling-class stratum of the old China continued to be quite distinct from the masses in the countryside. The transplanted Nationalist Government felt besieged in a potentially hostile environment. As "downriver" people they were displaced persons waiting to get back to the coastal cities. The early Republic's structure of urban modernization overlying rural tradition was not broken up. On the contrary the KMT area as before saw the Sino-liberal wing of Western-oriented modernizers coexist with the fascist-minded party leadership most loyal to Chiang Kai-shek. As the secret police of both the party and the government tried to preserve the status quo they felt more and more compelled to keep the liberals in line as potential subversives. Their resort to training centers that processed professors, in a camp life that tried to indoctrinate them with loyalty to the Three People's Principles, only antagonized them. Strong-arm methods against students, publishers, and other seeming enemies steadily widened the split between the intellectuals and the government that hoped to rely upon them for the future.

Szechwan province, except for the irrigated rice bowl around the

capital at Chengtu, consisted largely of jagged mountains and swift rivers under an unpleasantly humid climate, chilly in the unheated winters and oppressive in the heat of summer. To the ramshackle lack of the amenities of modern life was added the all-pervasive fact of the inflation. Instead of learning to live off the countryside as the CCP was doing, the KMT lived off the printing press. This short-sighted expedient produced an inflation that steadily sapped the energy and undermined the morale of all the upper class. In short, it proved impossible for the Nationalist regime to meet its wartime fate of displacement in a creative manner. At war's end in 1945 the same party stalwarts were still being shuffled about among the ministries. A new generation had not been recruited.

The Nationalist Government during World War II displayed all its earlier weaknesses but in increasing degree. Its poor relations with local warlord power holders in Szechwan, Yunnan, and Kwangsi led to much effort to suppress or counter factionalism. Chungking's extension of local control was therefore very difficult. The governor of the key province of Yunnan, which had become the airbase doorway to Free China, was able to keep Chiang Kai-shek's secret police and troops largely out of his province until after the end of the war in 1945. As a result the Nationalist police were unable to suppress the student and faculty movement for a coalition government and against civil war at the Southwest Associated University in Kunming until the end of 1945. When a leading and patriotic faculty member, Wen I-to, was assassinated in mid-1946, the event confirmed the general alienation of Sino-liberal intellectuals from the fascist-minded KMT regime. Under Chiang the power holders simply had no concept of participatory democracy. While early in the war they had set up the People's Political Council as a purely advisory body to mobilize liberals in the war effort, the KMT soon took it over and prevented its being even a sounding board for liberal opinion.

The Nationalists fared little better in dealing with the farming population. Although the inflation at first helped agricultural producers by raising the prices of their crops, this was soon offset by a heavy increase in taxation. This was effected chiefly by a flagrant proliferation of hundreds of kinds of small taxes or fees, mainly instituted by the local government heads to finance their administration and private means. "There were, for example, a 'contribute-straw-sandals-to-recruits' tax, a 'comfort-recruits-families' tax, a 'train-antiaircraft-

cadres' tax, and a 'provide-fuel-for-garrisoned-troops' tax."[57] The imaginations of the lower-gentry tax collectors knew no bounds.

To these burdens were added the Nationalist conscription of men and grain. Corvée labor was considered at the beck and call of the army, while the central government also authorized army commanders to live off the countryside by enforcing grain requisitions. The result was that when famine hit the province of Honan in 1942–43 it meant starvation either for the troops or for the people. The requisitions continued unabated and troops were soon being attacked by starving peasants. Famine of course meant hoarding supplies for profit and an immense growth of corruption in a general *sauve-qui-peut*. The unfortunate result was that the government received little more in the way of resources while the petty officials and landlords found out how to profit in the inflation. By the war's end, peasant rebellions were incipient in several provinces of Free China.

Meanwhile, both the Nationalist Government at Chungking and the CCP at Yenan fought a two-front war, against Japan and against each other. The war against Japan that had begun outside Peking on July 7, 1937, led to the announcement in August and September of the terms of the united-front agreement between the CCP and the KMT. The CCP agreed to stop its armed revolution to change Chinese society and gave up the forcible confiscation of landlords' land, while its Red Army would be placed under central government command. On its part the KMT would let the CCP establish liaison offices in several cities, publish its *New China Daily* in Chungking, and be represented in KMT advisory bodies. From this time on, the form of the united front was maintained. The Red Army was now called the Eighth Route Army and Chou En-lai resided in Chungking to represent it. Having spent 1938 at the transitional capital in Wuhan, he was already the CCP's foreign minister and representative to the world press.

The terms of the united-front agreement remained on paper unchallenged but in fact developments were quite contrary to the alleged intention. Yenan refused to have Nationalist staff officers in its area and in effect the Eighth Route Army continued to be an independent force in spite of a small subsidy from the Nationalists. Meanwhile, the CCP in building up its base areas maintained order, encouraged economic production through devices such as mutual-aid teams, and kept on recruiting poor peasant activists, who would

eventually get the upper hand over the rich peasants. Party member-
ship grew from some 40,000 in 1937 to 1,200,000 in 1945, while the
armed forces increased from 92,000 in 1937 to perhaps 910,000 in
1945. Within this general advance, however, there was a slowing
down and some setback in the years 1941–42, as noted below.

To control and direct the widespread organization of the CCP
movement over the broad stretches of North China required dedi-
cated and disciplined party members, experienced cadres or activists
in the villages, an attempt at self-sufficiency in each base, and the use
of radio telegraphy to transmit messages. The principle of central-
ized control over a decentralized situation was exhibited in the gov-
ernment organization. Rather like the old imperial regime in its day,
the Central Committee of the party had its departments at Yenan
dealing with military affairs, organization, united-front work, enemy-
occupied areas, labor, women, and the like, a total of twelve catego-
ries. Meantime the territorial organization was divided among half
a dozen regional bureaus, such as North China, Northwest China, the
Central Plains. Within these regional bureaus were staff sections
corresponding to those under the Central Committee at Yenan. The
principle of "integration" (*i-yuan hua*) meant that all directives from
the capital at Yenan to the specialized staff sections of the regional
bureaus must go through or at least be fully known to the branch
bureau chief, as the local coordinator.

Yenan in World War II became a never-never land full of sun-
shine and bonhomie. The revolutionary morale and enthusiasm were
infectious as Edgar Snow and other American journalists reported to
the world. The homespun democracy among the CCP leaders was a
startling contrast to Chungking. In its united-front phase the CCP
was an especially attractive selection of people. Furthermore, Ameri-
can aid never really got to them and the general lack of contact
produced a mythology that captivated liberals abroad.

The secret of Mao's success at Yenan was his flexibility in combin-
ing short-term and long-term goals. In the short term he espoused in
1940 the New Democracy as a united-front doctrine that would
embrace all the Chinese people who would subscribe to CCP leader-
ship. For the long term, he steadily developed the party organiza-
tion, including its control over intellectuals. Meantime, the real
sinews of power grew up in the CCP mobilization of the peasantry
in North China.

The Japanese of course were excellent targets to mobilize against. Invading China along the rail lines, they tried to seal off the areas in between, but their rail-line blockhouses could not control trade and contact across the lines. In general their invasion cultivated the ground for the CCP mobilization. Whether the CCP success in this situation was due to a simple nationalism or to CCP doctrine is essentially a nonquestion because the CCP already represented national communism, not the Comintern, while the CCP doctrines grew out of practice in the villages or else were used to enlist intellectuals in a grand scheme of world salvation. In the Border Region and Liberated Area governments that the CCP developed in different parts of North China, the first principle was party control based on indoctrination of cadres and enforcement of discipline. The indoctrination had to combine Mao's long-term principles with his tactical flexibility, for the CCP organized regimes operating at great distances from Yenan and very much on their own except for unreliable radio communication. The second principle was to find out what the peasants wanted and give it to them: first of all, local peace and order; second, an army of friendly troops who helped in peasant life, harvesting crops when necessary and fraternizing with the villagers; third, a recruitment of local activists who might very well be found at the upper level of the poor peasantry, people of ability who felt frustrated by circumstance; fourth, a program for economic betterment partly through improved crops but mainly through agricultural cooperation in the form of mutual aid, organized transport, and production of consumer goods in cooperatives.

As these efforts went forward, they became the basis for a third principle of class struggle. This had to be approached in a very gingerly fashion because North China landlords were hardly more than rich peasants who performed functions of leadership in their communities and yet might be able to field their own local forces drawn from secret societies and mercenaries. In the early years the KMT also had its forces in parts of North China and so provided an alternative center of allegiance. The CCP dealt with this by setting up the rather persuasive three-thirds system: the Communists would control only one-third of the small congresses that sanctioned local government, leaving the other two-thirds to the KMT and independents. On this basis, of course, the CCP's superior discipline and dedication let them become leaders on their merits. As their good

repute became justified in popular esteem they could begin to pre-
pare for land reform in addition to the economic production pro-
grams that they sponsored.

Land reform could be pursued only after three ingredients were
present: military control, economic improvement, and recruitment
of village activists. In the process itself the trick was to mobilize
opinion against landlord despots, such as they were, and by denounc-
ing or liquidating them in one way or another commit the villagers
to a revolutionary course. Under the procedure, then, all land hold-
ings were evaluated and redistributed on a more equal basis accord-
ing to categories that gave each individual his status as a rich or
middle peasant or landless laborer. If this redistribution could be
made to stick, village activists could begin to be indoctrinated in the
ethos of the party's leadership. The message was simply that the
people could make a better future for themselves if they would
organize their efforts in a new unity. The leadership of this new unity
could be found in the CCP. While the individual could achieve noth-
ing alone, he could greatly contribute by sacrificing his individual
interests to that of the common cause represented by the CCP. The
principle of democratic centralism was then extolled as a means
whereby all could have their say and make their input, but once a
party decision had been made, all would obey it. This would never
have gone down in a New England town meeting, but in a North
China village, where the alternative was government by landlords
and officials from outside the region, it was properly persuasive. In
short the idea of the "mass line" was here adumbrated: the party
must go among the people to discover their grievances and needs,
which could then be formulated by the party and explained to the
masses as their own best interest. This from-the-masses to-the-masses
concept was indeed a sort of democracy suited to Chinese tradition,
where the upper-class official had governed best when he had the
true interests of the local people at heart and so governed on their
behalf.

In this way the war of resistance against Japanese aggression
provided the sanction for a CCP mobilization of the Chinese masses
in the countryside and this, once achieved, gave a new power to the
CCP based not on the cities but on the villages, where the Chinese
people mainly lived. Thus, when the showdown came in the civil war
after World War II, the CCP would be able to lead an organized

populace to support its armed forces against the superior firepower
fielded by the KMT from their city fortresses.

CCP expansion and base building across North China and even
in the Yangtze region reached a high point in 1940. The Japanese had
been extending their control over the rail lines by setting up block-
houses every one to three miles along the routes. They then sent
columns out from these strongpoints to invade the villages. Their
problem may be compared with that of the Russians in Afghanistan
in a later generation. Air power and artillery were not so widely used
as armored railway cars and machine guns. But the Japanese, like the
Americans in Vietnam or the Russians later in Afghanistan, faced the
problem of how to get control of an alien population in the country-
side where they lived, partly by the use of puppet troops and partly
by their own superior firepower. The Japanese could not be defeated
in normal positional warfare but only by the attrition of their re-
sources achievable through guerrilla warfare. To counter this the
Japanese spread their network of strongpoints and blockade lines in
the effort to starve the guerrillas by isolating them and cutting off
supplies.

To counter this Japanese pressure the top commander at the
military headquarters of the CCP, P'eng Te-huai, prepared a wide-
spread attack known as the "Hundred Regiments Offensive" that
began in August 1940. Japanese rail lines were cut repeatedly all over
North China and blockhouses destroyed. It was the primary CCP
offensive of the entire war, planned by General P'eng, possibly with-
out much knowledge of it in Yenan. After several weeks this offensive
was obviously a great victory for the CCP, but then the Japanese
retaliated in force and with vengeance. Bringing in more troops,
they mounted a "three-all" campaign, i.e., "kill all, burn all, loot all,"
and stopped trying to discriminate between the ordinary peasantry
and the Eighth Route Army but simply destroyed everything they
could reach. The number of blockhouses grew to thousands and
villages once destroyed were garrisoned. The result of this rage and
destruction was to break up the CCP position across North China,
isolate many sectors, and take over control of most of the county seats
that the CCP had acquired. It was a first-rate disaster and the CCP
did not launch another such offensive.

Meanwhile, the Communist expansion in the Yangtze region par-
ticularly through the New Fourth Army also aroused retaliation from

the Nationalist forces. Negotiations led to the withdrawal of most of the New Fourth Army from south to north of the Yangtze, but in January 1941 the headquarters unit of several thousand CCP troops was ambushed and practically destroyed in what was known as the "New Fourth Army incident." While neither party acknowledged the end of the united front, because it was advantageous to both of them in form, it nevertheless had become a fact.

These reverses left the Yenan regime facing a severe crisis. The KMT and Japanese blockades had cut off nearly all trade, currency inflation was rising rapidly, and the whole regime had to pull back to survive. While Yenan had got along with very modest taxation of the peasant grain crop, by 1941 bad weather created shortages and the government began to demand some 10 percent of the grain produced. Revenue from confiscations from landlords had dried up. The only way out was to go in for self-sufficiency, as by local production of consumer goods like cotton cloth. Cultivated land and irrigation were greatly increased, the grain yield went up, and livestock were also increased. In short, the economic crisis was met by a great effort to increase production by all possible means.

Parallel with this economic recovery, the early 1940s at Yenan saw Mao Tse-tung finally establish his ascendancy over the CCP. Partly this was based on his success in adapting Marxism to the needs of the Chinese revolution. Mao's reading of Marxist works had not been extensive until he had some leisure time at Yenan after 1936. Edgar Snow, when he interviewed Mao, saw his keen interest in a consignment of Marxist works in Chinese translation. Soon he was giving lectures on dialectical materialism and producing his essays "On Practice" and "On Contradiction." Because he had not yet eliminated the twenty-eight Bolsheviks, his lecturing on dialectical materialism was designed to show his capacity for intellectual leadership, even though the lectures were rather crude. Nevertheless, Mao showed his originality by his stress on contradictions, which was posited on "the unity of opposites." This idea of course had a long Chinese history behind it.

His philosophical concerns at Yenan led Mao to put forward his "Sinification of Marxism" in China. This involved not merely establishing a nationalistic party concerned for the Chinese nation, it also implied that Marxism might be fundamentally altered when adapted to Chinese uses. The political imperative was that the party had to

achieve disciplined organization, meaning acceptance of the party line, so that party members could be counted on to operate at a distance in conformity with their directives. The KMT had suffered from intense factionalism. The CCP at Yenan as a smaller organization moved to eradicate it with some success.

CCP success depended on consensus among party activists, who must be intellectually convinced of the wisdom of the CCP line. The line must invoke theoretical principles to sanction practical action. This was achieved by the gradual creation of the body of ideas popularly known in the West as Maoism but in Chinese more modestly called Mao Tse-tung Thought. It represented the Sinification of Marxism-Leninism, the application of its universal principles to the specific conditions of China. How Mao built it up, piece by piece, is therefore a very interesting question worth our pausing to examine. Even though an explication of Mao's Sinification of Marxism in a few quick paragraphs may require some temerity, let us try to see his situation, first of all the old problem of terminology.

Both Buddhism and Christianity when they came into China had faced a term problem, how to pick Chinese characters that would express the new concepts but keep them distinct from old established Chinese concepts expressed in the self-same characters. Japanese socialists had of course pioneered in this effort. Long before Mao, the Chinese adaptation of Marxism had begun at the level of translation of key terms. Marx's "proletariat," the key actor in his cosmic drama, was certainly associated in Western thinking with urban life, specifically factory workers in the often unspeakable conditions of the early nineteenth-century Western European industrialization. The translation into Chinese, however, produced the term *wu-ch'an chieh-chi,* meaning "propertyless class," in other words the very poor who might be either in the city or the countryside, and of course in China were mainly in the countryside. In effect, the European "proletariat" were automatically to be found in China in the "peasantry" among the poor peasants and landless laborers. Granted that Marxist terminology was used by Chinese Marxists in terms consonant with those of Moscow Marxists, there was nevertheless a subtle difference when they spread their doctrine to the Chinese students and common people.

The Chinese term used for "feudal," *feng-chien,* had referred to the fragmentation of sovereignty in the period of Warring States

before the Ch'in unification. It was opposed to the centralized impe-
rial administration designated by the term for commanderies and
counties, *chün-hsien,* and meant decentralized administration, with-
out reference to the land system or the status of the cultivators. The
term referred in classic Chinese thinking only to the structure of
central or decentralized government before 221 B.C. However, if
feudalism was identified in China with landowner exploitation, it had
gone on a couple of thousand years. Thus the periods that Marx
defined for European history could not easily be applied to China. If
all of Chinese history for its first two thousand years after 221 B.C. had
been "feudal," the term lost meaning or was humiliating.

"Proletariat" and "feudal" were only two of the key terms of
Marxism, and they obviously did not fit the Chinese scene without
being really bent out of shape.

Quite aside from this terminological problem in Sinification, the
economic foundation of Chinese life, being mainly in the country-
side, gave the Chinese revolution necessarily a rural character more
pronounced than that in the Soviet Union. The peasantry had to be
the chief revolutionists. The final factor making for Sinification was
the overriding sentiment of Chinese nationalism based on cultural
and historical pride, which meant China could not be the tail of
someone else's dog. In effect, the Chinese people could accept only
a Chinese Marxism.

In time Chinese historical consciousness would undermine the
verisimilitude of Marxism in China. But for Mao's purposes it could
be asserted that the domination of the landlord class ("feudalism")
was being modified by the rise of a merchant class centered in towns
(a capitalist "bourgeoisie"), backed by "imperialist" exploiters, and
the situation might be cured by an establishment of central state
authority ("socialism"). In other words, there was enough fit to en-
able Marxism to get on with the job of revolution by propagating its
new world-historical belief system.

Yet Sinification was still a two-front enterprise because the CCP
had to maintain its credentials as part of international Marxism-Leni-
nism by using orthodox European lingo. Thus, early on the KMT at
Canton could not be defined as representing simply a bourgeois class
trying to carry through its phase of bourgeois democratic revolution.
No, the KMT Government instead of representing the bourgeois
capitalist class was a multi-class government or "bloc of four classes,"

in which the proletariat (CCP) could participate. Mao later argued that "the Chinese bourgeoisie and proletariat are new-born and never existed before in Chinese history . . . they are twins born of China's old (feudal) society at once linked to each other and antagonistic to each other." On this basis it was appropriate for the proletariat to lead the bourgeois democratic revolution, a theory which justified the CCP in struggling for power. In China this made sense, whether or not it would in Europe.

For example, in developing his idea of New Democracy in China, Mao began with the Marxist assumption of a bourgeois democratic revolution as the transition from feudalism to capitalism, which would be followed by another revolution as the transition from capitalism to socialism. In Europe the bourgeois democratic revolution was typified by the French Revolution of the 1790s, while the socialist revolution was generally felt to have succeeded only in Russia in 1917. In other words the crowded history of the nineteenth century had represented a bourgeois democratic phase of social development. What was the equivalent in China? Chinese Marxists could only conclude that the bourgeois democratic revolution had been ushered in by the May Fourth movement in 1919, which could be characterized by Leninists as an achievement of national capitalism. Since the socialist revolution would be achieved by the triumph of the CCP at some future time, this application of Marxism-Leninism to China resulted in China's having had two thousand years of feudalism and only forty years of capitalism. By European Marxist standards, China was peculiarly out of shape.

However, Lenin argued that the bourgeois democratic revolution in a backward country could be led by the proletariat in the guise of the Communist party. When Mao picked up this view of Lenin's and Trotsky's in his essay of 1940 on New Democracy, he laid a basis for the possible collaboration of the CCP with the KMT in a second united front against Japan. Alternatively, the New Democracy allowed for the proletarian CCP to lead the nation without the KMT if necessary.

Applying his framework of theory, Mao pushed a rectification movement at Yenan which set the style for mass campaigns and thought reform in later years. This was an effort by Mao, now that he was finally in power, not only to consolidate his position but to unify the party and ensure discipline. The rectification campaign was

limited to party members, who had greatly increased in number and lacked the cohesion and discipline of the Long March generation. The ostensible targets of the campaign were "subjectivism, sectarianism, and party formalism." "Subjectivism" targeted dogmatists who could not combine theory with practice. "Sectarianism" referred to the recent factionalism and the inevitable cleavages between soldiers and civilians, party and non-party, old and new party members, and so on. "Party formalism" meant the use of jargon instead of practical problem solving. Other evils were those of creeping bureaucratism and routinization of administration. These could be combatted partly by decentralization, transferring officials down to work in villages closer to practical problems. Even so the number of officials continued to increase. Also attacked was the individualism of the many intellectuals who had come to Yenan from the coastal cities.

One principal factor made for friction in the CCP-intellectual relationship. Whereas scholars under the Confucian order had been oriented toward public service, the writers of the twentieth-century revolution had focused on evils and misdemeanors because they had grown up as a class divorced from office holding. The traditional literati, in short, had now been split into two groups, those in public service and those in public criticism. The modern intellectuals like Lu Hsun were in the tradition of remonstrance, pointing out the inadequacies of the authorities.

Since that great critic of the KMT, Lu Hsun, had died in 1936, his name could safely be invoked as that of a paragon. Because his name became so important in the CCP's cosmology, we should stop a moment to appraise Lu Hsun's actual role in history. To begin with, he became a prominent writer only at age thirty-seven in 1918. From then until his death at age fifty-five in 1936 he published only three principal volumes of short stories and essays. Yet he set a literary style and most of all an example of uncompromising criticism and satire of China's social and political evils. This strength of character led him to cooperate with the Communists after 1930 without ever becoming a party member.

Lu Hsun's unique impact on the Chinese Revolution came of course from his talent and character. He had had a broad intellectual background, beginning with a classical education followed by four years at the Nanking School of Railways and Mines, two years' study

of medicine in Japan, and an early interest in the translation of foreign literature as a means to awaken the Chinese people. For fourteen years from 1912 to 1926 he made his living as a bureaucrat in the Ministry of Education in Peking. During this time he put his Sinological competence to good use by publishing half a dozen volumes of ancient Chinese tales, T'ang and Sung short stories, an annotated edition of a third-century poet, and historical surveys of Chinese literature and fiction in particular. Moreover, he was interested in the visual arts, first collecting rubbings of early inscriptions and carvings. Later he sponsored the new art of wood engraving as a revolutionary vehicle for reaching the masses.

After his death his career was taken over by the Chinese Communist party and he was made the principal figure and shining light of the literary revolution. Lu Hsun is of course not the first hero to be traduced by history and posthumously made into a figure that in life he would have abhorred. He believed in the power of literature to change ideas and was appalled by the callous insensitivity in Chinese social treatment of the poor and handicapped. Throughout his life he was in rebellion against the treatment of individuals by his fellow Chinese. His famous and influential writings got their power from a bitter and sardonic cynicism that expressed his sense of justice. Since he was passionately opposed to KMT reaction in the Shanghai of the early 1930s he found kindred spirits among the left wing and joined in founding the League of Left-Wing Writers. The best indication of his attitude may be seen in the fact that after his death some of his closest followers became prime targets of the Maoist masterminding of literature.

In Yenan in the early 1940s the control of literature by the new state authority of the CCP became a central issue. Sino-liberal patriots of all sorts had joined up with the revolution, and their commitment to attack the imperfections of the KMT naturally led them on to criticize the emerging imperfections of the CCP. Lu Hsun had died but his closest followers had continued under the CCP to voice their criticisms. When Mao Tse-tung gave his two lectures on literature and art at Yenan early in 1942, he laid down the law that literature should serve the state, in this case the cause of revolution. It should therefore be upbeat in the style of socialist realism from the Soviet Union and avoid the kind of revelation of evils and inadequacies that had been a Communist specialty in the KMT period.

At this point another factor entered the scene: the CCP regime like earlier Chinese governments depended on its good repute. One of its sources of strength was its prestige as an idealistic, selfless organization for betterment of the common people. Criticism seemed disloyal, since the leadership was still personal and factional loyalties were still to leaders as individuals. Two elements of old-style context must be here noted: First, writing was a potent medium. The written characters had an existence of their own as well as an enduring quality. To speak evil of authority was much less serious than to publish it in print, for publication required that the authorities move to keep the record straight from their point of view. Second, there continued to be a belief in the educability of man. The doctrines of Confucius, Mencius, and other philosophers had all stressed that man was by nature good in the very terms used in the first lines of the *Three Character Classic.* This meant that individuals were evil only insofar as they were misguided or selfish, and therefore they could be reformed.

These factors provided the basis for the thought-reform movement which was carried out at Yenan in the period 1942–44. The methods of this movement became well established and very familiar in CCP history from then on. The individual who was to suffer thought reform was first investigated and persuaded to describe himself and his life experience to the point where the group could begin to criticize him. In study-group criticism the individual was at once isolated and subjected to the rebukes or admonishments of everyone else. This shook his self-confidence. As a next step, in public struggle meetings the individual was publicly accused and humiliated before a large and usually jeering audience representing the community. At this point another factor operated, namely, the dependence of the Chinese individual upon group esteem as well as the approval of authority.

As the pressure increased and the individual found no escape from the denigration of his old self, he was led into writing confessions to analyze his evil conduct and assert his desire to change. Pressure was increased if he was then isolated in jail, subjected to solitary confinement or in a cell with others obliged to wear paper handcuffs, which he could not break without dire consequences. The consequent obliteration of his personality thus prepared him for the final stage of rebirth and reconciliation. When his confession was

finally accepted and the party welcomed him back into the fold, he naturally experienced a tremendous elation and willingness to accept the party's guidance.

Whether this psychological experience did change personalities is less certain than the fact that it was a highly unpleasant experience to be avoided in future. One way or the other, the result was conformity to the party line.

Lest we begin to believe in total power and total subjection, we must give due weight to the vigor of Chinese personalities. Those who stood forth as critics were frequently obdurate and essentially uncompromising individuals who felt duty-bound to stick to their principles and criticize evils. The widespread use of thought reform by the CCP thus should not necessarily be taken to mean that Chinese intellectuals were natural slaves. On the contrary, their natural independence of judgment was hard for the party to overcome.

In one sense Mao's application of Marxism to China was a matter of pinning labels. While the early KMT had been a "bloc of four classes," in *New Democracy* Mao called the KMT a bloc of three classes. He did this by the simple device of calling the peasantry part of the petit bourgeoisie and not counting peasants as a separate class. By this simple change of labels, the Chinese revolution could seem more European Marxist in style, and Chinese exceptionalism in basing its revolution on the peasantry could be avoided. This was done by taking advantage of the Marxist custom of regarding peasants as petit bourgeois in mentality. Yet Mao felt this quite consistent with his statement that in China the armed struggle of the revolution was essentially peasant war.

Since Mao always kept theory and practice moving together, his Sinification of Marxism in the early 1940s at Yenan was in fact part of his program for getting rid of the remnant of the twenty-eight Bolsheviks and the rivals to his leadership. There is little denying that his application of Marxism to China, given the fact that it obviously had to be done or else renounce membership in the worldwide Communist revolution, was a generally successful enterprise. It had the incidental effect of making him the arbiter of thought. In consolidating his position at the head of the party after 1943 he could stress his leadership in Marxist theory. The concept of "Mao Tse-tung Thought" was put forward as the basic guidance for the revolution in China.

Mao's Sinification of Marxism may fruitfully be compared with the failure of Taiping Christianity. Hung's claim to be the younger brother of Jesus soon made him anathema to the foreign source of his vision, the Western missionaries, whom he did not even deal with in his profound ignorance. In short order he made himself both a Christian heretic and within China a foreign subversive, achieving the worst of both worlds; whereas Mao, though eventually anathematized by Moscow, succeeded for some time in cooperating with the Comintern, and when he Sinified his Marxism, he masked it in a coating of orthodox terminology. Both Hung and Mao started out with only a rudimentary grasp of the foreign doctrine and both broke free of the domination of foreigners—Hung of the missionaries, Mao of the Comintern. But of course the differences between them far outweigh such similarities.

In 1943 Mao proceeded to put forward his doctrine of the "mass line." Like many of Mao's intellectual formulations, this was double-ended and ambiguous so that it could be applied in either of two ways. While it asserted the need of consulting the masses and having a mass participation of some sort in the government, it also reaffirmed the necessity for central control and leadership. At any given time either one could be given the greater emphasis, just as *New Democracy* had provided a theoretical basis for joining with the KMT in a second united front or opposing the KMT as reactionary. Again, one's class status might be defined by reference to one's parents and economic livelihood or it could be defined by one's ideas and aspirations. Similarly, the people were enshrined as the final arbiters and beneficiaries of the revolution but some persons could be labeled as not belonging to the people and therefore fair game as enemies of the people. This could be done by administrative fiat from above.

It was typical of this line of development that Mao should define contradictions as being some of them antagonistic and some of them nonantagonistic, that is, arguable. Thus some contradictions made you an enemy of the people and some did not, depending on how you were perceived. All in all, it was a very flexible structure of ideas, as though Marx and Engels had been seduced by Yin and Yang. Once Mao had control over it, he was truly in a position of leadership. Unity resulted.

Another factor aiding the Yenan regime was the course of inter-

national relations in World War II. In 1943 the Russians successfully defended Stalingrad, the Western Allies won in North Africa, the U.S. Navy began to get the upper hand in the Pacific, and American forces had invaded the Solomon Islands on their way to Tokyo. The Japanese had to relax their pressure on the North China Liberated Areas and Border Region. For the Communists the war began to wind down when the long-planned Japanese Ichigo offensive in 1944 rolled down from Honan south of the Yangtze, destroying much of the Nationalists' best armies.

In these circumstances CCP expansion was resumed in the period 1943–45 but its policy was prudent and avoided haste and superficiality. By the time the American Army military observer group, or Dixie Mission, reached Yenan in mid-1944, the CCP was on an upswing again and preparing for the postwar showdown with the KMT. This resurgent spirit was indicated in the important Seventh Congress of the Chinese Communist Party held in Yenan from late April to mid-June 1945. It adopted a new constitution, which gave Mao more central power as chairman of the Central Committee and Political Bureau. "The Thought of Mao Tse-tung" was hailed as the party's guide.

By this time also the United States had willy-nilly become an important factor in Chinese politics. To distant outsiders like the Americans, Free China represented an outpost of modern civilization struggling to survive in a sea of antique customs and evil forces. There was no longer anything revolutionary about it, but the Americans found this encouraging and after 1941 adopted Free China as an ally. American ignorance and sentimentality reached the point where President Roosevelt pictured the Nationalist Government moving into the East Asian vacuum that would be created by the fall of Japan. A clandestine air force recruited from the American military services as mercenaries on leave came to the rescue of Chungking even before Pearl Harbor. The Flying Tigers, under a retired American airman, Claire Chennault, soon became the 14th Air Force, harassing Japanese communication lines from its base in Kunming, the capital of Yunnan. The American China missionary movement got behind United China Relief. American sympathy and largesse had a new lease on life, and General Joseph Stilwell proved that Chinese conscripts, if taken to India and properly fed and trained, could make first-class fighting men.

As Chiang Kai-shek had depended in the clinch on the Shanghai underworld, so now he began to depend on the Christian impulses and logistic supply of the Americans. Considering that the Hump airlift in the China-Burma-India Theater was the absolute end of the line in American strategic considerations and supply, this did not put the Nationalists in a strong position. By the time the U.S. Army got an observer mission into Yenan in 1944 it was too late to use the Washington-Chungking alliance to prepare the way for a Nationalist victory in the obviously coming civil war. Nevertheless, we tried. The United States Navy in its effort to keep up with the army sent a mission in 1942 to work with the Chinese secret police and get in on the ground floor of the anti-Communist crusade. But General Stilwell could not get the Nationalist forces trained, supplied, and led to fight the Japanese effectively. The American idea of using Free China as a base for the struggle against Japan absorbed the Americans' attention but at the same time distanced them from the Chinese Revolution. Like the Russian program in the 1920s, the American aid program led into ultimate disaster. For foreigners to work with the Chinese Revolution has never been easy.

The American involvement was flawed by serious anachronism. Every American who had seen warlord China and supported a Christian college had placed hope in the Nanking Government as a representative of American ideals. Unity vs. warlordism and China's equality among nations were appealing motifs. The later generation who saw the Communists were only a small group and had nowhere near the influence in the United States that had been exerted over generations by American missionaries.

These factors produced mixed counsels in the formation of American policy. The foreign service officers and commanders like General Stilwell who were on the spot saw the admirable determination and strength of the Communist movement. The home-side China constituency generally retained their image of an earlier day when the Nanking Government had seemed the last word in Chinese progress.

During the Wuhan transitional capital period in 1938, everybody had been in the same boat, with great exhilaration. But with the end of the united front in 1941 American observers could see the split widening between the KMT and CCP party dictatorships. State Department policy, however, was a small drop in the bucket compared

to the general American war effort, the logistics of transport over the Hump, the modern training and supply of Chinese troops that Stilwell effected, and his dealing with Chiang Kai-shek as a stiff-necked client who felt he was getting the short end of wartime supplies. No Americans in Washington really knew much about the North China Communist area, while they were diplomatically as well as legally compelled to support the Nationalist regime as our ally. Meanwhile, observers on the spot under the American embassy and military headquarters foresaw a post–World War II civil war in China, which held the danger of Soviet takeover of North China. The extent of Mao's Sinification of Marxism or creation of a national communism could not be adequately appreciated by outsiders who did not know the gruesome details of Mao's relations with Stalin. It therefore became American policy to head off a civil war, and the device thought of was "coalition government." This in effect would be an extension of the united front in its ideal and unrealized form, a combination of the armed forces and representation of both parties in a national assembly. Perceiving this American hope, both the Chinese parties adopted "coalition government" as a postwar aim ostensibly while privately preparing to fight it out.

The abject unrealism of the American policy was well illustrated by President Roosevelt's special emissary General Patrick J. Hurley from Oklahoma, a flamboyant and simple-minded American, Reaganesque ahead of his time. His clumsy efforts at heading off the civil war by mediation were followed by Chiang Kai-shek's taking him over. Hurley countered the entire embassy staff by plumping for American support of Chiang come what may. By the time it came, of course, Hurley was out of the picture, but his policy was still followed in Washington and led to the Americans' afterward being quite properly put out of China.

After Japan's surrender in August 1945, Chiang and Mao under Hurley's auspices met in Chungking and in October agreed upon an ideal set of principles that would gladden any liberal in the world. The KMT and CCP regimes would cooperate in a representative assembly, scrambling their armies and meanwhile guaranteeing all civil liberties and good things dear to the hearts of men everywhere. This make-believe derived simply from the recognition that neither side could take a stand against the ideal of peace and cooperation.

The hard facts in the fall of 1945 were far otherwise. As soon as

the war with Japan was ended the Communist forces moved across North China to compel the Japanese to surrender to them. The Nationalists reacted by ordering the Japanese to fight off the Communists and recover from them any territories they had gained. Soon there were numerous Communist-Japanese firefights as the Nationalist Government made use of the ex-imperialist aggressors to fight off the social revolution. Meanwhile, both Nationalist and Communist forces were moving into Manchuria (henceforth called the Northeast) in a competition to take over the area. Typically the Nationalists garrisoned the cities and the Communists mobilized the countryside.

The United States Government followed the Nationalist example by moving some 53,000 U.S. Marines into North China to hold Peking and Tientsin against a possible Soviet incursion, while transporting by air and ship complete Nationalist armies to Manchurian cities and other parts of North China. The United States thus intervened from the beginning on the anti-Communist side. Moreover, as part of the Yalta agreement of February 1945, President Roosevelt had already tried to settle China's fate by arranging with Stalin for a Chinese-Soviet treaty between the Nationalists and the USSR. The terms were that the Russians would recognize and deal only with the Nationalist Government of China, while the Nationalists in turn acknowledged the Russian recovery of their former imperialist rights in the Northeast along the railways. Stalin promised to withdraw Soviet troops within three months from the Japanese surrender. As it turned out this would be November 15, 1945, and thus the CCP would have a three-month period in which to infiltrate the Northeast as best they could in competition with the Nationalists, who would be transported by the Americans. Since the Nationalists saw that the CCP was beating them into the Northeast, they asked the Russians to stay longer, and Soviet troops did not depart until May 1946, taking with them much of the industrial equipment that could be moved from the new Japanese installations in their puppet state. Having American backing, Chiang Kai-shek fought his way into Southern Manchuria against Communist opposition.

Thus the stage was set for the frustration of the mediation effort undertaken by General George C. Marshall on behalf of Washington. As the top commander in World War II, and a devoted but savvy manager, Marshall did what could be done in the direction of coalition government. A Political Consultative Conference convened in

Peking in January 1946, and arrangements were also discussed for the combining of KMT and CCP forces. The center of the civil war, however, had now shifted to the Northeast, which was unfortunately left out of the Chungking agreements. The United States was buying Chiang Kai-shek's acquiescence by a big economic loan, and when Marshall returned to lobby in Congress and secure this part of the bargain, he lost control of the negotiations. By the time he returned, warfare was being quelled in North China by the Executive Headquarters that he had established in Peking. This headquarters used the device of dispatching American colonels with Communist and Nationalist generals to areas of conflict to stop the fighting. But meanwhile the Northeast was out of control.

Chiang Kai-shek now continued to dig his own grave by his out-of-date masterminding of the civil war. First he attached great importance to holding provincial capitals once he had seized them. Instead of waging a war from the wealthier Yangtze Valley in South China against the Communists in the North China area they had occupied, Chiang asserted his unifying power by this symbol of control in capital cities. Since most of them were soon besieged and Chiang had in fact greatly overextended his resources, it is plain that he was moved by anachronistic assumptions as to how to control China. Having committed his best American-trained troops directly to the Northeast without consolidating control of the North China area in between, Chiang had asked for disaster.

Both sides had used the negotiations as a sop to the peace movement, while preparing to fight it out. In a similar fashion the United States had demanded coalition and reform at Nanking and Yenan and yet at the same time had continued to supply the Nationalists. The end-of-war program for equipping thirty-nine Nationalist divisions plus an air force was only half complete when Japan surrendered; these supplies and equipment continued to arrive as the civil war was getting under way. Marshall's mediatory role was thereby given the lie. In fact the United States in March 1946 had already set up an American military advisory group to advise Chiang Kai-shek in his warmaking. At the same time the American contribution of $500 million to the United Nations Relief and Rehabilitation Administration in China was used mainly in the Nationalist areas. There followed in August 1946 an American agreement to sell $900 million worth of surplus war materiel to the KMT for a sum of $175 million.

This massive American support was hardly offset by Marshall's embargo on arms shipments to the Nationalists from July 1946 until May 1947.

When peace broke out in August 1945, the Nationalist armed forces were at least twice the size of the CCP's and moreover had the advantage of American equipment and supplies plus the assistance of the U.S. Navy in transporting troops and the U.S. Marines in the Tientsin-Peking area. The Nationalists held all of China's major cities and most of its territory. The spirit of the Cold War was emerging in the United States as well as China and so American backing would obviously continue. In these circumstances, for Chiang Kai-shek and the Nationalists to lose the civil war was a remarkable achievement. The reasons they lost were not only stupidity on the battlefield but incompetence behind the lines.

The Nationalists' incompetence began with their mismanagement of the economy, in which inflation was skyrocketing as note issue continued to increase. The takeover of China's coastal cities from the Japanese was characterized mainly by a corrupt seizure of assets without much attempt to put them to industrial use. Consumer goods remained inadequate. As industrial production ceased in the Free China area, it was not taken up in the recovered cities sufficiently to avoid heavy unemployment. Meanwhile Nationalists with money made a killing by using their overvalued Nationalist currency to buy up Japanese-occupation currency at its inequitable conversion rate. Starvation and profiteering continued apace in many areas of the countryside, but the return of Nationalist troops to the provinces liberated from the Japanese, if "liberation" could be applied to the situation, only increased the burden of taxation and requisition. This was one of the great carpetbagging operations in history.

Second, the Nationalist Government mishandled its citizenry and immediately alienated the major components of the Chinese people. It began this process by using the Japanese and their puppet Chinese troops to fight the Communists after the Japanese surrender. This pitting Chinese forces against Chinese at a time when everyone talked and hoped for peace was highly unpopular. Nationalist treatment of Chinese collaborators, who had functioned under the Japanese and looked forward to liberation, was generally to regard them as enemies not deserving compensation. In a similar fashion the students and faculties in reoccupied China were castigated for their

collaboration and subjected to thought reform in Sun Yat-sen's Three People's Principles. This put the blame for being under the Japanese on the student class who had survived and did nothing to mobilize their support. The government continued to tax the people while letting the profiteers and self-seeking officials remain untaxed. In effect this represented the worst form of "bureaucratic capitalism," in which officials feathered their nests at the expense of the public.

A third policy failure on the part of the Nationalists was their brushing aside and suppressing the public peace movement, which was widespread and sincere and not as the Nationalists alleged simply a Communist conspiracy. The academics wanted a shift from warfare to civilian development and an end of Nationalist reliance on the United States to promote civil war. The government repression with violence against the students successfully alienated them just as the foolish economic policies alienated the urban middle class and industrial capitalists.

In these ways the Nationalist Government lost public support and seemed to be the instigator of civil war even more than the Communists. It was evident that the Nationalist Government had become so militarized that it could think only of a military solution to the civil war without regard for its functions as a government to serve the public. Liberal Chinese critics of the KMT regime blamed it for allowing the CCP to grow into its position as a more popular regime. Whatever support of the KMT still persisted among the moneyed class was destroyed by the "currency reform" of 1948, when all holdings of specie and foreign currencies were forcibly converted into the new "gold yuan," in terms of which prices would be fixed and the inflation (somehow) would be stopped by decree. But prices soon rose 85,000 times in six months. The moneyed class had been defrauded once again. The KMT had thrown away whatever chance it had of governing China. Thus the Nationalist Government acted out with a vengeance the role attributed in Chinese history to the "bad last ruler" of a dynasty. The modern-trained Sino-liberal leadership in the Free China area did not go over to communism but rather gave up hope in the KMT.

The CCP rise to power after 1946 occurred on several fronts, first of all among the North China farming population in the villages. Here the CCP government program shifted back to the land reform that had been generally played down since the united front of 1937.

Land reform meant the dispossession and neutralization or destruction of the economic and social influence of landlords and other local magnates, with a corresponding advancement of the activists among the poor peasantry, who under CCP leadership could dominate the villages. Rich peasants were thus neutralized or reduced and the Communist leadership could proceed with further reforms. The result of this massive effort was to keep the villages in support of the Communist armies all across North China.

In an ironic fashion, the Nationalist forces now pursued a war rather similar to what the Japanese had inflicted upon China in their day. By the end of the first year of this three-year struggle the Nation- alists held all the major cities and rail lines, and their forces were still far superior in firepower. However, the CCP armies had merely withdrawn, refusing to stand and fight and so avoiding casualties. Thus they helped the Nationalists to become overextended in the classic guerrilla strategy. They fought only when they could bring overpowering force to bear on some small KMT unit. The National- ists got control both of Yenan and of the temporary CCP capital at Kalgan. The Communist leadership were refugees hunted in North Shensi by the victorious Nationalist forces. The Nationalists recaptured most of the county seats in the main theaters of North Kiangsu and the Three Eastern Provinces. The destruction of some of their base areas and takeover of the countryside in this fashion was unexpected by the CCP. Their North Kiangsu base area was destroyed, and the common people who had been under their protection were killed and abused by the returning Nationalist landlords.

The battle for the Northeast was commanded for the CCP by General Lin Piao, a master of mobile warfare. After his forces had retreated to northeastern Manchuria beyond the Sungari River, in 1947 Lin staged half a dozen raids across the river to surprise and cut up Nationalist forces. Soon the Nationalist field armies were isolated in their cities.

Recent research explains how the CCP won the Northeast—they mobilized the countryside much as they had North China. With feverish energy the North China cadres, once infiltrated into the Northeast, carried through many of the procedures of organizing local production, village indoctrination, land reform, thought reform of new cadres, and recruiting of troops and populace to unite in a patriotic war. This was a pervasive achievement, applying their skills

of social engineering under forced draft. And it worked. The Chinese of the Northeast, so long frustrated by Japanese occupation, responded to the claims of nationalism and social revolution by supporting the CCP war effort.

The Nationalists as usual assisted this process. Having come from the South they were distrustful of Manchurian leadership. The area had been under the warlord Chang Tso-lin and his son Chang Hsueh-liang and then for fifteen years under the Japanese. The Nationalists therefore brought in their own people to head up the regime they were trying to install in the Northeast while the Communists catered to the local leadership and mobilized it against the intruders from South China. As in Taiwan in the same period, the Nationalist distrust of the local leadership, together with their carpetbagging and exploitative takeover activities, turned sentiment against them. Nationalist arrogance, acquisitiveness, and corruption in both areas produced disaster, although in Taiwan, after killing many of the local leaders in the incident of February 1947, the KMT was able to survive and ultimately reform itself after its thorough defeat on the mainland. In effect the Nationalist Army suffered from all the difficulties that had plagued the Japanese: they could not get local intelligence from the pro-Communist populace, they were bogged down by their heavy equipment, and their advancing columns moved too slowly to avoid ambush or piecemeal flank attacks. The Nationalist forces were not trained to fraternize with the populace or to fight at night, nor could they move rapidly.

When the CCP began its counterattack in mid-1947 its forces were soon able not only to dominate Shantung but also to recover the base area between the Yellow River and the Yangtze stretching between the Peking-Hankow Railway on the west and the Peking-Nanking Railway on the east. This gave them a strategic position to menace the whole Yangtze Valley. As the strategic balance shifted, the Communists were more able than ever to capture the Nationalists' American equipment and recruit their surrendered troops into new Communist armies.

On the Nationalist side Chiang Kai-shek refused to evacuate garrisons in major cities while there was still an opportunity to do so. The result was that his best troops, after being besieged and isolated, surrendered with their equipment. By these superior tactics and strategy, the CCP forces not only overwhelmed Nationalist defend-

ers but demoralized them as well. When they finally encircled Peking in January 1949 the Nationalist commander decided to surrender with all his troops and later had a trusted position in the new regime.

When Mao entered Peking his troops were riding in American trucks led by American-made tanks. The American supply of hardware to Chiang Kai-shek had been accompanied by professional military advice. But Chiang took the one and not the other. The Americans advised him not to get overextended, but he did so. They advised him to use his planes and tanks and not hoard them as symbols of firepower, but he did not succeed in doing so. They also advised him to let local commanders make tactical decisions, but the Generalissimo persisted in acting like a generalissimo and sending down orders to the division level. Perhaps it was correct that Chiang knew his division commanders were stupider than he, but from Nanking he lacked the intelligence facilities to mastermind the battlefield. He had risen to power, after all, as a military politician and not a field commander. His generals had to be loyal even if they were not smart, and sometimes it seemed that they were indeed loyal because they were not smart. The payoff came in the fact that the civil war was fought necessarily in the countryside, where CCP mobilization of the populace gave them both intelligence and logistic support. Thus in 1949 in the climactic battle of the Huai-Hai region north of Nanking, the Nationalist armored corps, which had been held in reserve as a final arbiter of warfare, found itself encircled by tank traps dug by millions of peasants mobilized by party leaders like Deng Hsiao-p'ing.

The Americans, after all their investment in troop training and supply of equipment, were disgusted with the outcome. Fortunately General Marshall had spent a year trying to head off the civil war as a mediator in Chungking and Nanking after the Japanese surrender. He knew the score, and when he returned to the United States as Secretary of State in 1947 he succeeded in preventing the Americans from going into a super-Vietnam to quell the Chinese Revolution. American supplies continued but the marines sent into North China to protect it against the Russians were withdrawn. The CCP eventually won the war by using surrendered Japanese arms secured through Russian benevolence in Manchuria and American-supplied arms captured from Chiang's armies as they surrendered. By 1949

nobody could deny that the Chinese Communist party under Mao Tse-tung had conquered China fair and square.

The epitaph for America's China policy in the 1940s should begin by noting the Americans' profound ignorance of the Chinese situation. They were preoccupied with their official contacts with the Nationalists and their own logistic war effort in China. They sensed the Nationalist deterioration but had little detailed knowledge of it. The CCP side of the picture was meanwhile almost entirely blank to the Americans. The few observers who got to Yenan responded to the upbeat optimism and determination of the CCP, but there were no American observers in North China except for a very few journalists, who however had very limited observations. The result was that CCP power was completely underestimated. In 1948 the American estimate was that the Nationalists could not defeat the CCP, but neither could the CCP defeat the Nationalists. This view showed a total incomprehension of reality in China.

To this was added the American preoccupation with anti-communism, which in Europe was a matter of power politics. In China, however, it was essentially a sentiment motivated by the Americans' distaste for totalitarianism that had moved them in the war against the Nazis. In this befuddled situation, most of the American public did not even realize that there was going on in China a revolution which had its roots in the past and would dominate the future. Seldom has a national posture been more ineffective and unproductive.

Only in one small area did the Americans seem to do something right. This was in aiding the development of Taiwan, the island refuge of the defeated Nationalists. Taiwan after 1949 harbored that part of the Chinese Republic's Sino-liberal leadership that chose not to take its chances with the CCP. Although the warlord wing of the Nationalist regime began by slaughtering the Taiwanese Chinese elite in February 1947, the Sino-liberal wing thereafter had its chance. Here we can note only the end results and some of the factors contributing to them, such as a genuine land-to-the-tiller reform accompanied by improvements in agronomic technology under the Sino-American Joint Commission on Rural Reconstruction funded by the American Congress in 1948. The industrialization and export trade that gradually followed were aided by several very concrete factors. First of all was Japanese colonialism, which had left satisfactory conditions of local order and public health, railways and

other material underpinnings, general literacy (but not higher education) and farmers' associations to increase production. Second was American economic aid and (after 1954) military alliance. Third was a concentration of refugee talent from the mainland in an area not yet overpopulated. Fourth was a reform of the KMT under Chiang Kai-shek and its gradual cooperation with Taiwanese-Chinese in business and government. On Taiwan the Nationalists modified the socialist-minded state control of industry that the National Resources Commission had been pursuing on the mainland. Many other circumstances of course also contributed, such as the Cold War of the 1950s and '60s.

The survival of the Nationalists' Republic of China one hundred miles overseas on Taiwan of course impaired the CCP's claim to legitimacy as the unified government of all China. De facto independence of the province of Taiwan could not be acknowledged, especially when the Nationalists proclaimed their face-saving determination to fight their way back to the mainland. Suffice it to say that Taiwan's autonomy continues to this day in a well established stalemate of China's civil war.

Historians' appraisals of the KMT record in China have made use of the extensive criticism of both Sino-liberals and of the CCP propagandists, who were making a play for Sino-liberal support and therefore quickly denounced all KMT corruption and infringements of human rights. The fact was that the KMT walked on two legs which unfortunately went in opposite directions, one modernizing and one reactionary. Thus the KMT's evils could be recorded in a partly independent press and by foreign journalists while the secret police, not having total power, often succeeded only in adding to their record of dirty work. Although totalitarianism had its activist supporters under Chiang Kai-shek, they could not dominate the Chinese scene in the way that CCP totalitarianism, once in power, would be able to do. As a result the images of the KMT and CCP as governments of China derive from very different data bases and are not really comparable. The CCP's executions, for example, were generally unknown to outsiders at the time.

PART IV

THE CHINESE
PEOPLE'S REPUBLIC,
1949–1985

15

Creating the New State

ONCE WE REACH the People's Republic of China in 1949 the scholarly literature on China changes remarkably from historical studies to social-science studies. China's going communist spurred a great Western effort to understand the new enemy. The means adopted was interdisciplinary area study, which had begun during World War II with the mobilization of academic talent in all relevant fields, beginning with geography, economics, political science, sociology, anthropology, and social psychology, in order to know the enemy. The Cold War called forth similar studies of the Soviet Union. After 1957, when the Soviets orbited their Sputnik satellite, federal funding of area studies plus the aid of the Ford and other foundations inspired a decade of new effort to apply the major disciplines to understanding China. The result was a new ballgame.

Being or trying to be scientists, social scientists are interested in universal phenomena and naturally pursue comparisons among countries. They had scores of fruitful new questions to ask about China. After thirty years of recruitment, training, field research, and hard work, we now know more about the PRC than about any earlier era of Chinese history.

For our purposes here, social science is more concerned with analysis of events than with simple narrative. Although "modern history" is becoming properly suffused with social-science analysis, it

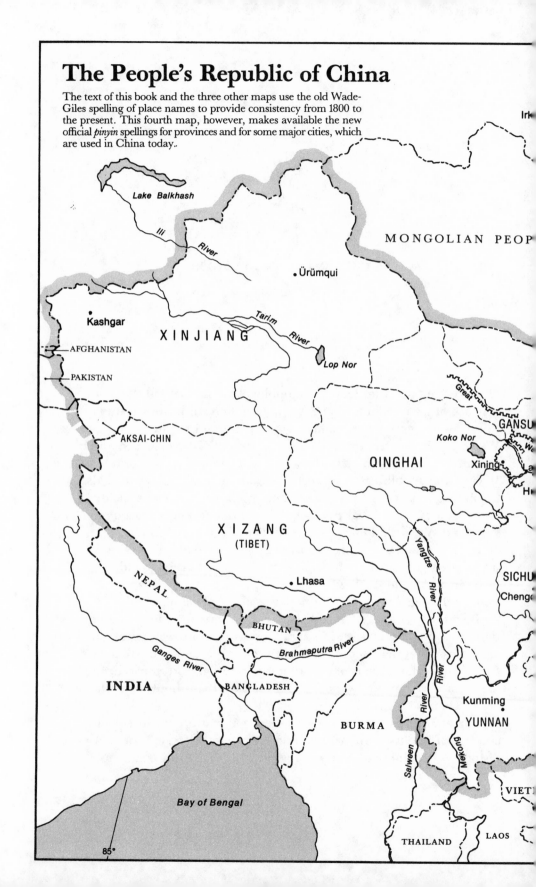

The People's Republic of China

The text of this book and the three other maps use the old Wade-Giles spelling of place names to provide consistency from 1800 to the present. This fourth map, however, makes available the new official *pinyin* spellings for provinces and for some major cities, which are used in China today..

Irk

Lake Balkhash

Ili

River

MONGOLIAN PEOP

•Ürümqui

•Kashgar

XINJIANG

Tarim River

Lop Nor

Great

AFGHANISTAN

PAKISTAN

GANSU

Koko Nor

Xining•

QINGHAI

AKSAI-CHIN

Wa

La

H

XIZANG
(TIBET)

NEPAL

•Lhasa

Yangtze River

SICHU

Cheng

BHUTAN

Ganges River

Brahmaputra River

INDIA

BANGLADESH

Salween River

BURMA

Mekong River

Kunming
•

YUNNAN

Bay of Bengal

VIET

85°

THAILAND

LAOS

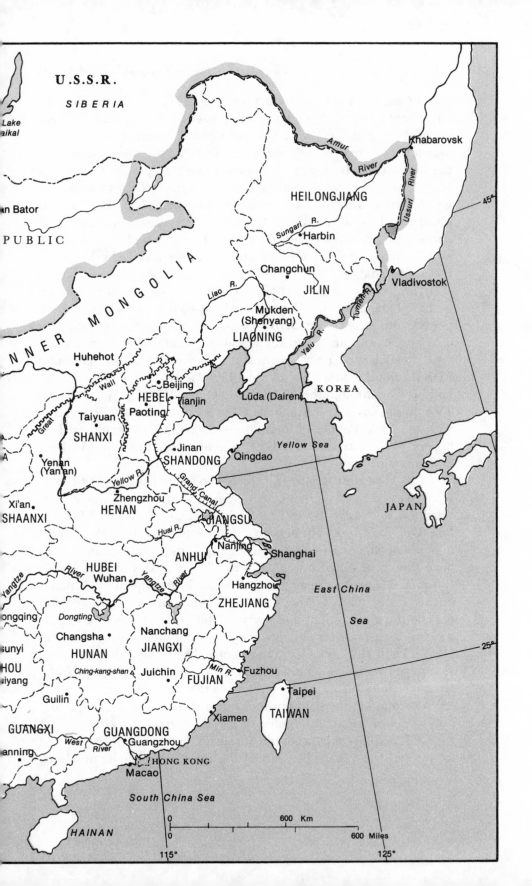

has not commanded great research support. The result is that the final chapters of this book have to represent a great wealth of social scientists' studies of "contemporary China," much more than one individual can master. I therefore suggest that the reader scrutinize the list of contributions to Volumes 14 and 15 of *The Cambridge History of China* (see Appendix) to note the magisterial surveys from which the following narrative chapters have benefited. It will also be noted that I make references to China's past history in the hope of encouraging the miscegenation of social science and history that is already under way. To reduce confusion I have inserted subheads in these final chapters.

In order to get some idea of the Chinese experience of revolution we have to begin by dividing the era 1949–85 into periods and within periods into aspects, topics, or factors. One chief problem is the host of named events and agencies as well as people. They form an esoteric vocabulary of special terms and acronyms not unlike that under FDR during the New Deal of the 1930s. However, anyone who can find his way through the FBI, AFL-CIO, ILGWU, UMW, NRA, and TVA, to say nothing of the Smoot-Hawley tariff, can get acquainted with the PLA (People's Liberation Army), APCs (Agricultural Producers Cooperatives), and GLF (Great Leap Forward) without undue strain.

In the broadest terms, the thirty-five years from 1949 to 1985 were marked by two great cycles or spasms, Mao's Great Leap Forward (GLF) of 1958–60 and his Great Proletarian Cultural Revolution (GPCR) of 1966–76. In each case he mobilized popular support in hopes of effecting revolutionary changes in Chinese society. Some have therefore called him a "populist," though this term if simply transposed from American politics may mislead as much as it enlightens us. Each spasm of "populism" (or mobilization of people from outside the government and party establishments) was followed by a swing back to systematic economic development, respectively in 1961–65 and 1976–85. Overall some may like to see this alternation as one between "social revolution" and material "development," although these terms are so ambiguous that they may take our feet off the ground in the kind of simplistic levitation that too frequently puts us out of touch with reality. It is really too soon to characterize the CCP revolution by a couple of slogans, however fancy. Suffice it to say that the first eight years of the People's Republic of China,

from October 1949 to early 1958, were followed by two periods of great disorder among the people—first the Great Leap Forward of 1958–60, followed by years of economic recovery, 1961–65; and second the Cultural Revolution of 1966 to 1969, or, most now agree, to Mao's death in 1976. In this sequence of five phases the first, third, and fifth saw economic progress under leadership of able CCP organizers and administrators. The second and fourth periods, however, were dominated by Mao Tse-tung's leadership and their significance will be debated for a long time to come.

The present chapter recounts the takeover and consolidation of political control from 1949 to 1953, then the economic transition to "socialist" (collectivized) agriculture and Soviet-style industrialization from 1954 to 1957, and finally the social problem of the relationship between the party dictatorship and China's thin stratum of intellectuals.

THE INITIAL PERIOD, 1949–1953

The Chinese Communist party's takeover of China after 1949 and the establishment of a new comprehensive government was a great creative achievement. Just as the Manchus had established their kingdom in southern Manchuria and coopted Chinese administrators before they took over China, so the CCP had created a government in North China and the Northeast while in the process of winning the civil war. Under Mao as the undisputed leader in both theory and strategy, the CCP leadership worked as a team, debating policy issues in the Politburo and adapting central directives to local conditions. Leading field commanders like P'eng Te-huai, Lin Piao, Nieh Jung-chen and Ch'en I had all worked with Mao and Chou for many years. Party builders like Liu Shao-ch'i and Deng Hsiao-p'ing had been part of the Yenan organization. It was a tested and close-knit group.

The CCP was unexpectedly assisted by the operation of Heaven's Mandate. They expected to have several years of further fighting before they could control all China. But in fact, once they had defeated the KMT armies, the whole country suddenly accepted them as the new authority. Not only was the craving for peace widespread, the general acknowledgment of CCP victory ended the resistance. The remarkable thing is that the CCP leadership was able to do so

many things at once. Chairman Mao was conducting a symphony but our analysis of it has to be by instruments as well as movements.

First of all, the People's Liberation Army spread over South and Southwest China as newly liberated areas. Six military administrative regions divided up the country, and military commissions administered them in the initial period until they finally became vestigial and were abolished in 1954, when civil control had long since been established.

The CCP generally felt that the first three years of their rule would be required for rehabilitation of the economy and mobilization of the people before they could begin a transformation of society. But here again events went faster than they expected.

Their first move in local government was to leave the KMT officials largely in place. These retained personnel continued to receive their salaries and perform their functions. After all, they totaled some two million persons, whereas the CCP had at most three-quarters of a million cadres to take over their jobs.

Meanwhile, the rehabilitation of the economy rapidly proceeded. First of all the inflation was brought under control by the concerted use of several devices: control of all credit by taking over all the banking system, control of major commodities by setting up nationwide trading associations in each line, and assurance to the public by paying all personnel in market-basket terms, that is, calculating salaries not in money but in basic commodities—so much grain, so much oil, so much cloth, and the like. This made individuals' salaries independent of the inflation and created a stable basis for commerce. The flow of goods and of money was thus brought into balance and the inflation reduced to about 15 percent a year. This was literally the salvation of the salaried class.

Rebuilding the railways and reviving steamship lines presented no great logistic problems, but the CCP's plunging into the Korean War after only one year in power seemed at the time like a risky gamble. The Chinese "volunteers" when they entered Korea in October 1950 faced American firepower that eventually gave them a million casualties. While some aid came from Moscow, the war was a serious drain of resources. On the other hand it was useful in the reorganization of society. The public campaign to "resist America, aid Korea" provided a wartime sanction, as had the Japanese war and

the civil war earlier, in terms of which the populace could be orga-
nized.

The initial phase of public sentiment in the cities after 1949 was
one of euphoria, based on growing confidence in the CCP. Here was
a conquering army of country boys who were strictly self-disciplined,
polite and helpful, at the opposite pole from the looting and raping
warlord troops and even the departing Nationalists. Here was a dedi-
cated government that really cleaned things up—not only the drains
and streets but also the beggars, prostitutes, and petty criminals, all
of whom were rounded up for reconditioning. Here was a new China
one could be proud of, that controlled inflation, abolished foreign
privileges, stamped out corruption, and brought the citizenry into a
multitude of sociable activities to repair public works, spread liter-
acy, control disease, fraternize with the menial class, and study the
New Democracy and Mao Tse-tung Thought. All these activities
opened new doors for idealistic and ambitious youth. Only later did
they see that the Promised Land was based on systematic control and
manipulation. Gradually the CCP organization would penetrate the
society, set model roles of conduct, prescribe thought, and suppress
individual deviations.

In similar fashion women were liberated from family domination.
The new marriage law made wives equal to husbands. It was a new
day for women. Only later was it seen that women's emancipation
had made them full-time salaried workers though still responsible for
the home and with little access to contraceptives. Thus, having few
refrigerators, they would have to queue up endlessly to buy daily
necessities.

Long before the CCP could try to transform the economic and
social life of the Chinese masses, they faced the problem of creating
a new administration that could be relied on to carry out the revolu-
tion. Since businessmen as well as KMT officials had been left in place
while new CCP cadres had been infiltrated into the government
administration, the most urgent task was to weed out and streamline
the government apparatus itself. The Three-Antis Campaign of
1951–52 (against corruption, waste, and bureaucratism) was targeted
on officials in government, industry, and party. The concurrent Five-
Antis Campaign attacked the capitalist class, who at first had been
left in place. Under charges of bribery, tax evasion, theft of state

assets, cheating in labor or materials, and stealing of state economic intelligence, nearly every employer could be brought to trial. Many were eliminated and some were left to function as government employees.

Two mechanisms made these movements possible. The first was the new united front, which had been created in 1949 by setting up the Chinese People's Consultative Conference as the top organ of government to include both CCP members and non-CCP leaders. The Common Program, which it adopted in 1949, called for gradualism. The government when first set up had a majority of its ministries headed by non-CCP personnel. This represented a mobilization of talent that could be gradually supplanted as CCP personnel became available.

The other device was the mass campaign, which made use of the structure of mass organizations. Labor, youth, women, and professional bodies were all enrolled in these organizations. A nationwide administrative structure in each organization could reach its membership when a campaign was put on. Thus the early campaigns to eliminate counterrevolutionaries, resist America and aid Korea, and the Three-Antis and Five-Antis Campaigns provided an expanding framework for reaching the great mass of the Chinese people who lived in cities. Campaigns not only uncovered and knocked off victims who were of doubtful use or loyalty, they also uncovered activists of ability who could be recruited into the CCP, which had 2.7 million members in 1947 and 6.1 million by 1953.

While this gradual and piecemeal, though sporadic and often terrifying, process of consolidation was going on in the cities and the modern economy, a parallel procedure headed up in the land-reform campaign. Of course this campaign to give all villagers their class status, pull down the landlords, and raise up the landless laborer had been largely carried through in the North China and Northeast areas under Communist control before 1949. To spread land reform to the larger body of Chinese south of the Yangtze was a daunting task. After military pacification, work teams entered the villages and organized the peasantry to attack and destroy landlords. At this point the rich peasants were not attacked but rather catered to. Since their status shaded off into landlordism above or poor peasant below, the atmosphere of terror, public trials, mass accusations, and executions provided what one might call a "stimulating" atmosphere.

By moving on all these fronts simultaneously and systematically, the CCP was ready by 1953 to begin economic planning and the further systematic transition to socialism.

THE TRANSITION TO SOCIALIST AGRICULTURE

One preparatory step in 1954 was the establishment of a state constitution, which superseded the Common Program and brought the New Democracy phase of China's development to an unexpectedly rapid end. The constitution was based fundamentally on the Soviet constitution established by Stalin in 1936. The net result was to strengthen the Government Administrative Council and its fifty-odd ministries. The administration became the executive arm of the party. Coordination was provided by dual membership. Thus Chou En-lai was both premier and a Politburo member, number three in the hierarchy, after Mao and Liu. The new government may be fruitfully compared not only with the Soviet government but also with that of the Nationalists in the 1930s and the late empire before it. One non-Soviet feature was the establishment of the state chairmanship, held by Mao, which was undoubtedly an echo of the emperorship of old. The state cult of Mao was already beginning in order to meet the Chinese need for a single authority figure.

In contrast with the Soviet Union, the military and public security forces were kept under strict party control. The armies were under the Military Affairs Commission headed by Mao Tse-tung, while public security was controlled by the party as well as a ministry. In other words, the secret police were not permitted to become a separate echelon of government or independent kingdom as they did under Stalin, able to terrorize the rest of the administration as well as the people. Likewise the military had no separate echelon as had happened under Chiang Kai-shek, when the Military Affairs Commission had developed ministries that rivaled both the party and the government. Final power remained firmly concentrated in the Standing Committee of the Politburo of the Central Committee of the party.

On the principle of vertical rule the ministries controlled subordinate agencies at the lower levels of government, while horizontal coordination was worked out at each territorial level. Meanwhile, a series of People's Congresses on the Soviet model was established at

the level of the province and below, elected from a single slate of candidates and responsible more to those above than to those below. This echelon headed up in the National People's Congress, which met from year to year to hear reports and confirm policies. Non-CCP personnel were still prominent in it, but it had no power except as a discussion body. Control was mainly exercised by party committees at all levels of the government.

The next achievement was the collectivization of agriculture. In the Soviet Union in the early 1930s the city cadres had entered the countryside to attack and destroy the rich peasantry (*kulaks*), who fought back by destroying livestock, fomenting opposition, and generally refusing to go along. The Soviet collectivization had been immensely destructive. In China, however, the CCP had from early on been a rural organization, close to and dependent upon the villages, and it knew how to take gradual steps toward its eventual goal. Thus the first stage was to get the peasantry into mutual-aid teams and the second stage was to set up Agricultural Producers' Cooperatives of the lower level, in which the farmers not only pooled their land and equipment but got a return in proportion to them. This step kept the rich peasant community from fighting back because its position was not destroyed but at first improved. While this land reform shifted landholding from the small 2.6 percent of landlord households, the situation was not stabilized. Private ownership was simply strengthened by the distribution of landlord land to former tenants and landless laborers. Land could still be bought and sold privately, and so a rich peasant class became more prominent.

The third stage of cooperativization was to move from the APC lower level to the higher stage of APC, which was truly collective and in which all peasants worked for wages with no further return from their input of property, tools, or land. One should note that cooperativization had been preceded by land reform, in which the distribution of landlord holdings had involved community action and local activists had been spotted and recruited. The result was that in 1954, '55, and '56 the program for collectivization went faster than planned or expected and embraced the whole country by the end of 1956. Since the physical plant of village roads and houses remained much the same, the chief change was in the labels of status applied to individuals and their participation in meetings and other new developmental activities. (Note: An Agricultural Producers Coopera-

tive or APC was usually part or all of a village. In 1958–78 these units were called "production teams." They were the bottom layer of a three-tiered structure: production teams forming brigades and brigades forming communes. After 1978 the production team continued to be the basic unit.) The PRC had created a rural apparatus such as the Nationalist Government had never even envisaged. The party membership had been largely recruited from the peasantry and remained accessible to peasant opinion, while agriculture was recognized as the basis of life for the Chinese masses.

Since the PRC state penetrated the populace to the level of the family farm, which now became part of an APC or later a production team, this organization of the countryside was far more complete than anything previously attempted in Chinese history. Mao's intense personal interest as well as the collective spirit among the Chinese people, to say nothing of their inveterate readiness to accept the demands of authorities, seem to have been factors in the rapid success of collectivization. These tendencies could be utilized and also led astray by overeager CCP members "dizzy with success."

One of the shibboleths of the CCP was that collectivization of land in big fields would raise output and peasant income. Unfortunately the outcome of this policy and the evidence of other countries cast doubt on this theory: smaller farms were likely to achieve higher levels of output per unit of land area. This economic aspect was of course only part of the story: collective effort could create a society of greater egalitarianism, capable of pursuing new and broader goals.

BEGINNING INDUSTRIALIZATION

The Stalinist model of industrialization through emphasis first on heavy industry at the expense of agriculture was inapplicable to the Chinese case because of the great preponderance of the countryside in the economy. Nevertheless, early industrial targets were achieved and the control over the countryside produced revenues that could be used for industrialization. Indeed the "leap forward" mentality had already appeared in the effort to socialize industry. State monopoly of industry was helped by the fact that the Nationalists' National Resources Commission (NRC) had already controlled two thirds of China's industrial investment. Instead of moving over the space of several years to a combination of capitalist and state management,

the CCP leadership followed the example of the collectivization in agriculture. Quickly its campaign took over industrial management in name, although in practice the capitalist element had to be left to function. The fact was that the CCP cadres across the land had backgrounds and experience in problems of agriculture much more than they did in problems of industry. The targets set for increased production became unrealistic, but the spirit of patriotism and emulation as well as personal ambition brought the local organizers of the CCP to set high goals and report them overfulfilled, at least in form, without regard for sound and gradual development. Thus the activist ambitions of government and party personnel could become unrealistic.

Since the PRC after 1976 moved back to a family-farm system and production for a free market, together with small-scale enterprises and other features less rigid and austere than the Mao dispensation of the 1950s, the question is sometimes asked whether the CCP revolution might not have gone forward as rapidly in the modernization of the Chinese economy if the Maoist era had never occurred. Evidence can be adduced, for example, to show that the growth rate of industry from early in the century was maintained at a relatively steady pace. It can also be argued that the imposition of the CCP cadres and government as a new ruling class was hardly anything new in Chinese experience except for its much deeper penetration and tighter control over everyday life. Experience suggests that regimentation was counterproductive in producing economic development, so all that happened in the Chinese revolution was the getting back to the structure of the late empire with a modernized technology and mass patriotism.

The difficulty with all such attempted revisions of history is that they are based largely on outsiders' assumptions. For example, it is not easy to show that the landlord dispensation in the villages could have been eliminated by gradual evolution and without violence. It is also doubtful whether mass literacy (estimated by the World Bank at 66 percent in 1978) as well as political organization could have been achieved with equal rapidity in the absence of party control.

We are left with the platitude that the Chinese Communist revolution was bound to be in the Chinese style. It accomplished tremendous changes but along lines that showed some continuity with the past. On the whole it did not make China more like the USSR or

Japan or the United States, except insofar as China participated in the technology of the modern world.

The economy that the PRC inherited had been fragmented into at least three sectors—Manchuria, which had been under Japanese control after 1931 and was now known as the Northeast; the treaty-port cities, where foreign trade and modern industry had got their start; and the Chinese countryside, which was as yet little affected by modernization except for the commerce facilitated by railroads and steam vessels.

After the PRC was established and inflation began to come under control, the tax base was broadened and government revenues rose from 6.5 billion yuan in 1950 to 13.3 billion in 1951. The continuing deficit was financed about 40 percent through bond issues. The bonds were not in currency units but in commodity-equivalent units. They could be bank deposits. Where the Nationalist Government revenue had been somewhere around 5 to 7 percent of gross domestic product, the PRC tax share of economic output was estimated at 24 percent in 1952 and 30 percent by 1957. The process of combining private capitalist industry with state industry made use of discriminatory tax and credit policies, with the result that the private sector, which amounted to more than half in 1949, was reduced to less than a fifth. Local handicrafts, however, remained largely private.

The First Five Year Plan of the period 1953–57 proved to be on the whole a great success. National income grew at an average rate of 8.9 percent. Agricultural output expanded about 3.8 percent as against population growth of about 2.4 percent. This may be compared with other developing countries, where growth averaged only about 2.5 percent. India was under 2 percent during the 1950s. As another indication, life expectancy rose from 36 years in 1950 to 57 in 1957. The proportion of primary-school children enrolled in schools jumped from 25 to 50 percent. In general, urban wages rose by almost a third and peasant income by about a fifth.

The PRC record in investment was almost like that in the Soviet Union during the forced industrialization begun in 1928, even though China confronted the fact that per capita national income was only about one-half to one-quarter that of the Soviet Union in 1928. In adopting the Soviet model for rapid industrialization, for heavy industry at the expense of agriculture, the CCP was misled by the fact that in the USSR the ratio of population to resources was

much more favorable and industrialization far more advanced before the revolution. About half the total industrial investment was given to 156 Soviet-aided projects that were large-scale and capital-intensive. Of the 156 Soviet plants, nearly all were in heavy industry and located in inland centers like Wuhan or Paotow in the North so as to get away from dependence on Shanghai and Tientsin on the coast. But the dependence on Soviet aid came at a high price. While the PRC was investing some 25 billion yuan in the First Five Year Plan, the Soviet contribution was not in the form of grants but only of loans, at the rate of about 60 million yuan a year, all to be repaid. While some 10,000 Soviet specialists came to China and 28,000 Chinese got training in the USSR, these Soviet credits totaled only 4 percent of China's total investment in industry. To be sure, the Soviet technology was more advanced than China's, but on the whole the Soviet relationship proved of questionable value.

All these factors led the planners of the Second Five Year Plan in 1956 to agree that heavy industry must receive less stress while agriculture and light industry should receive more. Progress in the countryside would be essential to long-term progress in the cities. The planners also felt that large-scale plants would be less effective than smaller-scale in the interior. Small local plants though less advanced in technology could use labor and materials on the spot, reduce transportation costs, and begin the industrialization of the countryside. Meanwhile the planners wanted to be less dependent on Soviet aid. A final incentive arose from the fact that collectivization of agriculture had not noticeably increased production of grain and other farm products. Along with this it seemed that the growth of the enormous state bureaucracy had reached a point of impeding economic growth, and there was a strong sentiment in favor of less centralization. However, the Second Five Year Plan discussed in 1956 was never worked out to the point of publication because it was superseded in the spring of 1958 by the Great Leap Forward (GLF).

THE PROBLEM OF THE INTELLECTUALS

In the background of the GLF, quite aside from the economy, was another problem, that of the intellectuals and education. How could the revolution succeed if intellectuals were still following the Confucian model of censorial remonstrance and students were still learn-

ing classical and liberal stuff in the schools? Mao had not had much of a liberal education but he knew what he wanted—intellectuals that would support the regime and education that would reach and remold the peasant masses. Since this was one area where he, a bit like Chiang Kai-shek, eventually met defeat, let us pause to look back over China's educational experience.

The relationship of intellectuals to the state authority has been a long-term protean topic both East and West. Recalling how complex and diverse has been the Western experience, we can expect to find a similar complexity and diversity in the case of China. If we do not, it may simply be due to our ignorance.

It is often said that the absence of central power during the warlord era of the 1910s and '20s set the stage for a great flowering of the Chinese intellect. This generalization is incomplete. It overlooks the fact that the twentieth century also brought into China the tremendous stimulus of foreign thought. Mere disorder as in previous interregnums in China had not necessarily produced innovation. The interregnum between the central power of the Ch'ing dynasty to 1911 and the central power established by the CCP in 1949 was the period of maximum susceptibility and response to foreign theories of social order. Mao's generation, indeed, had run the gamut from the breakdown of Confucianism to the acceptance of progress, evolution, and social Darwinism, combined with the rise of fervent nationalism and reappraisal of Chinese tradition in order to save the nation. The thought of Mao was in fact a culmination of the Soviet influence.

One salient feature of the old Chinese social structure had been the close identification of the scholar with the state. As I have argued above, this close relationship can be traced back to the prehistoric polity of the Shang dynasty, where literacy emerged as a prerogative of the ruler, and the literate person or scholar was by nature and tradition oriented toward state problems. If we look at the early West we note that the Phoenician alphabet spread through channels of trade, while Greek and Roman literature was only in small part devoted to affairs of state. Here is still another case of Chinese exceptionalism. In short, the Chinese intellectuals of the twentieth century could trace their origins back to the emergence of *wen*, which had originally meant lines or writing and so literature, culture, and civilization. *Wen* translated as "civil" was opposed to *wu*, "military force

and brutality." *Wen-jen* were men of letters and therefore of superior refinement.

As the Chinese state had developed its strong central authority, men of letters had come to be almost universally examination graduates and therefore classicists and conservatives. The great achievements of Chinese literature had come within this framework of acceptance of the social order and central authority. No monastic sanctuaries, no clash of sectarian faiths, no division between church and state were allowed as in Europe to spawn diversity. Scholarship remained largely in official channels, and the great protagonists of schools of thought like Chu Hsi and Wang Yang-ming had had official careers.

Two things had happened in modern times to illustrate this situation. First, Chinese scholars of the nineteenth century were slow indeed to embrace foreign ideas and begin the process of reform. Second, when the old order collapsed, the spirit of nationalism was so strong among them that both reformers and revolutionaries were mainly devoted to "saving China." They were still oriented toward the state.

This orientation of course had its contradictions because the role of the scholar-official had always been a dual one—not only to carry out the imperial administration but also to advise the ruler about it and in time of need remonstrate with him as to policy. The idea that scholars knew what to do and had an obligation to offer their advice became enshrined, for example, in the doctrine of the unity of knowledge and action, that scholarly knowledge should eventuate in action and action should influence knowledge. When Hu Shih and his colleagues in 1919 urged the divorce of scholarship from politics, they were being truly revolutionary. But after 1931, under Japanese attack, even they made their contribution as official advisors and administrators. The great critic of China's decay, Lu Hsun, took action to found the League of Left-Wing Writers. His encouragement of criticism and publication had been oriented toward the improvement of the social order and the exercise of state power, not at all a withdrawal from politics.

Once the party was in power after 1949 its need for thought reform greatly increased. In theory the transition from revolutionary war to administering a new government required that militant activity shift to the pursuit of revolutionary goals through persuasive

means rather than violence. Nevertheless, Mao once offered the estimate (completely unauthenticated) that 800,000 people were killed in the early 1950s, some as KMT spies, some as landlord despots, and a few as recalcitrant opponents of party dictatorship.

The thought-reform approach now grew to major proportions. In nationwide campaigns certain evils of conduct were targeted in the abstract and then found in individuals who were victimized in a massive procedure. In each case a campaign was nationally organized and promoted by activists in each locality, who were sometimes instructed to find a certain quota of victims. Public struggle meetings and humiliation were on a massive scale, with thousands of participants in the audience who were set a warning example of what not to be and do.

The next problem that arose was how to reform education so as to produce students devoted to the party line. Since intellectuals were in large part teachers, the whole educational system became an area for revolutionary remaking.

When the CCP came to power there had already been a great deal of variety in China's educational inheritance. The late imperial academies *(shu-yuan)* and their currents of thought have been noted above. After 1900 there had ensued a period of influence from Japan during the first decade of the century, followed by influences from the Atlantic community during the first four decades of the Republic of China. Meanwhile, mass education got its start in the 1920s and '30s with a special contribution from the CCP in the 1940s.

Among China's three distinct eras of educational policy, in the first, the old classical education, lasting until 1905, had trained generalists to be like Oxford and Cambridge graduates—broad-gauge administrators, not technical specialists. In the second era, until the 1940s, the Western liberal arts were used to produce a modernized elite. The common people were reached only in a preliminary way. In the third era, after 1949, the masses, Mao hoped, could finally become a major focus of educational policy. He therefore tried to use the Soviet system to produce ideologically sound technocrats. But the actual system still faced in two directions: to give a modern education and skills to the whole people and to train up a broad-gauge elite able to take the place of the old Confucian literati-administrators. But how do you, given the PRC's limited resources, bring the masses into the literate life of modern times while continu-

ing to produce a highly trained elite?

After 1949 the CCP began a vigorous imitation of the Soviet model of education. This model stressed the specialized training of scientific personnel in practical subjects, especially the natural sciences. Accordingly the CCP dismantled the liberal-arts programs inherited from the Christian colleges and national universities. Instead it created twenty new polytechnic colleges and twenty-six new engineering institutes. Out of some two hundred institutions of higher education only thirteen were designated as comprehensive universities that included both arts and sciences. This reorganization in the early years of the People's Republic had the effect of shifting the majority of students into technical subjects, rather than the liberal-arts curriculum, which had previously produced graduates with political ideas but few skills, especially in politics and economics. The main shift, in other words, had been from higher education's producing people for top government jobs to a more practical program of producing technicians. The CCP of course could through its own channels find administrators. This may be seen as an attempt to cut the linkage between liberal education and public policy.

The Soviet example also led to the regularizing of teaching plans, materials, and textbooks, so that training programs in all specialties were prescribed from the center. A Soviet-type Ministry of Higher Education was set up in November 1952. A large translation program secured Chinese editions of Russian specialized textbooks, which accounted for a third or more of books published. The teaching of English as a second language gave way to the teaching of Russian. Grading and oral-examination procedures followed Soviet practice.

In this way the inheritances from the Nationalist period and from the CCP Border Region were combined with Soviet influences in a system that had many unresolved problems. For example, the highly trained Western returned students, who were now professors in the social sciences, had to be reconditioned to carry on under communism. Professors were prime candidates for thought reform in the 1950s. Yet the fact remained that the teaching staff on the whole had not adopted communist methods and viewpoints. They were democratic socialists more than totalitarian communists.

Despite their experience of thought reform and many conscious efforts to imbibe the new principles of the revolution, the inherited faculty members were up against the problem of standards in their

fields. The CCP aspired to create intellectuals out of workers and peasants without delay, but the professors found that the best students still came from families with educational backgrounds and that workers and peasants who had had only a few years of schooling were simply not capable of university work. The regime could encourage the activity of people's schools *(min-pan)* at the village level but it proved impossible to make them a pipeline into modern education at the higher levels. Because popular education had to be guided by uneducated party members, it had little chance of achieving the levels of the university.

Most of all the Chinese system of higher education remained quite limited in quantity. A nation of 400 million people had produced only some 185,000 college graduates before 1949, and as the population rapidly increased after that date, the proportion of highly educated personnel did not improve. College graduates thus comprised somewhere around one-tenth of 1 percent of the population. How could one hope to create a modern country with that cadre of trained personnel? As the 1950s wore on, the goal of a people's school in every village had to be given up. The excess number of middle-school graduates competing for college entrance could not be usefully increased lest it create a frustrated class of intellectuals without jobs adequate to their self-esteem.

China still suffered, in short, from the inherited division between the muscle-worker masses and the brain-worker ruling class. Middle-school graduates felt it was demeaning not to be in white-collar jobs. In 1956 only about a third of all undergraduate students in universities were of worker-peasant origin. The revolution in education had begun but was far from complete or successful. Combined with the economic inadequacies of the Soviet model of development, this set the stage for a new phase of revolutionary effort to secure the more active support of intellectuals.

Mao began with the premise that the intellectuals' work was essential to the revolution. "We can't get along without them." In early 1956 the position was that just as peasants were amalgamating with workers, so they were both becoming party members, and the same applied to the intellectuals. As people doing labor they were all members of the proletariat. Class struggle was dying away. This was the view of Deng Hsiao-p'ing, one of Mao's most loyal followers, who was general secretary of the CCP. Evidence indicates that Mao be-

lieved, in early 1956, that the intellectuals, while undoubtedly expert, were also Red in their outlook.

In intellectual-educational circles the new phase was ushered in by the Hundred Flowers campaign of 1956–57, so named for the phrase "Let a hundred flowers bloom together, let the hundred schools of thought contend." As part of a general improvement in their working conditions (more access to foreign publications, more free time and scope for initiative), intellectuals were urged from May 1956 to voice criticisms of the cadres who had been lording it over them. Mao estimated that among a total of at most five million intellectuals, i.e., middle-school (high-school) graduates and above, not more than 3 percent were by this time hostile to Marxism. So the Hundred Flowers criticism of the party's bureaucratic style and methods would be constructive, representing a "non-antagonistic contradiction" among the people, arguable within a context of complete loyalty to the Communist system.

Of course China's intellectuals well knew that if you stick your neck out you may lose your head. For a year they said nothing. But then in May 1957 the CCP launched a campaign for Rectification of working style among the bureaucracy. Once the cadres were under attack, the intellectuals who had suffered under them proceeded to let fly. In May 1957 they began to criticize the CCP regime in rapidly escalating terms—its basic premises, working style, doctrines, and practices suddenly came under attack—so severe that within five weeks the Hundred Flowers campaign had to be closed down.

THE ANTI-RIGHTIST CAMPAIGN

Once the Hundred Flowers movement in mid-1957 showed the considerable disenchantment of the intellectuals with the CCP regime, Mao then shifted to the principle of class struggle against recalcitrant intellectuals by making them the targets of an Anti-Rightist Campaign from June 1957. In other words, while contradictions existed as the motive force of history, they need not lead to class struggle unless they became antagonistic. The Rectification campaign was necessary because so many CCP bureaucrats were slack and self-seeking. Some were developing ties with unreliable intellectuals and so many intellectuals were refusing to become Red in their hearts. Once the intellectuals had been shown by the Hundred Flow-

ers fiasco to be of dubious loyalty, Mao moved to the idea that a new generation of intellectuals should be trained up verily committed to the party because they were of good proletarian-class background. In the contradiction between merit and class status, he saw it necessary to emphasize the latter. He warned the intellectuals that they were simply teachers employed by the proletariat and laboring people to teach their children. They should not venture to have their own ideas separate from the party.

From 1957 on, because Mao had lost face by his trust in Redness of the intellectuals, he remained vindictively opposed to them, regarding them with disdain as mere word users and, with some fear, as people he could not control. This reaction led him to many wild statements: that the intellectuals were the most ignorant of the people, that all great intellectual achievements had been made by relatively uneducated youth, that worship of technology was a fetish. In this way he was thrown back upon the source from which he had emerged, namely the Chinese peasantry as the fount of wisdom and the hope of the future.

Emperors had occasionally opened the path for words of criticism *(yen-lu),* but they often got more than they expected. Mao and his colleagues were appalled and disillusioned. When they quickly retaliated by making intellectuals, including many CCP members, targets of the Anti-Rightist Campaign, somewhere between 400,000 and 700,000 and perhaps many more skilled people were thus removed from their jobs and given the devastating label of "rightist," an enemy of the people. The effect was to decapitate China, inactivating the very people in shortest supply. It was in this atmosphere of accusation and anti-intellectualism that the Great Leap Forward got started.

Since the history of a revolution is replete with figures totaling the victims of one aspect or another of the violent and sudden changes, one has trouble identifying with the situation. Let me therefore present thumbnail sketches of three cases well known to me.

The first is of a professor of political science (Ch'ien Tuan-sheng), who got his Ph.D. at Harvard and became a vocal and fearless critic of KMT and other evils in the 1930s. He was a man of such intellectual and political stature that he became head of the Foreign Affairs Committee of the People's Political Council, that powerless body set up in 1938 to appease the Sino-liberal sentiment of the time. As a

professor at the Southwest Associated University he led the student movement in criticism of the police efforts used by Chungking to dragoon the intellectual community. Living on a pittance in a farmhouse, he survived the war years and in 1948 returned to Harvard for a year's writing. When he returned to China in 1949 his chief expectation was that he would be killed in a last-minute bloodbath by the KMT as it went down to defeat. Instead, he was welcomed by the CCP as part of the united-front effort to rebuild China. Soon he went on delegations to foreign countries, speaking for the new China, and finally was made head of a college of law and government for training officials. There he found, as time went on, that he was a figurehead and power was held and used by a couple of CCP commissars who knew nothing of the subject and less of the outside world. When the Hundred Flowers Campaign finally erupted he criticized the effort of nonintellectuals to mastermind college work and was promptly denounced as a rightist in 1957. For the next twenty-two years he was out of action, mainly under house arrest, although like Peking houses his had a courtyard where the sun could shine. Eventually in 1979 he was rehabilitated, but at age eighty it was too late for him to train the generation of academic specialists in international relations that China needed.

Another case is that of an able journalist (Liu Tsun-ch'i) whom I knew as head of the United States Office of War Information Chinese staff in World War II. He seemed to have no CCP connection. His sentiments were those of a Sino-liberal and he collected a staff of able people. Having joined the CCP as an undergraduate in 1931 and been imprisoned by the KMT, he was working as an outside cadre rising to prominence in Free China, but devoted to China's salvation through the CCP. In 1957 he was attacked as pro-foreign and as having been too close to the KMT. He spent the next twenty years in captivity and out of action. He was rehabilitated in the late 1970s and became editor for a time of the new English-language *China Daily,* which began to practice Western-style journalism in Peking.

The third case is that of a young woman (Yang Kang), a graduate of Yenching University in English literature who joined in the student movement of 1935 and became a leftist opposed to the KMT appeasement of the Japanese invasion. She joined the CCP but was assigned to work as an outside cadre. She determined to use literature to awaken the Chinese masses. By World War II she was editor

of the literary page of the leading newspaper in Chungking, protected by the head of it, who was a member of the so-called Political Science Clique within the KMT. Her specialty was to travel in the provinces and report conditions and people's sentiments and feelings in an effort to keep the Chungking leadership aware of conditions elsewhere. Come the revolution, she rose to become assistant editor of the *People's Daily* in Peking. But when the Anti-Rightist Campaign began in 1957 she found herself suddenly vulnerable from having spent a year in the United States in 1946–47 and having recorded liberal sentiments in her journal, which had been seized. Under attack, her faith evidently was shattered and she killed herself.

No doubt it was natural that outside cadres assigned by the CCP to work as ostensible liberal individuals in KMT China should develop liberal sentiments. The ideal of the revolution was to emancipate people, not control them. Such idealists would suffer only after the revolution succeeded.

In the tens of thousands of such cases, we see the revolution beginning to devour the revolutionaries. By 1957 a new crowd were coming into power, arising from peasant ranks, not well educated, ignorant of the outside world, and suffused with both xenophobia and anti-intellectualism. The general secretary of the CCP, who took an active part in the Anti-Rightist Campaign, was Deng Hsiao-p'ing.

One way to try and understand this grim story is to see it as a manifestation of class struggle between newcomers, who felt they represented the masses, and the remnants of the modernized ruling class, who had joined in the united front and rendered highly skilled service to the new state. Peasant attitudes that had accumulated over the centuries were not full of good will and magnanimity. On the contrary there was a vengeful anti-intellectualism abroad in the land, which seemingly expressed the accumulated hatred for the small elite. The new ruling group coming into power in the CCP were contemptuous of learning and capable of fanatic destruction now that they had the chance, with only a minimal grasp of China's problems of modernization and how to meet them. In short, China's political life, by including the peasantry, was brought down to the harsh and ignorant peasant level. This has occurred in other revolutions as one of the costs of social change.

16

The Great Leap Forward
and Its Consequences

THE NATIONAL CATASTROPHE of the Great Leap Forward in
1958–60 was directly due to Chairman Mao. In the end some twenty
to thirty million people lost their lives through malnutrition and
famine because of the policies imposed upon them by the CCP.
Measured by the statistics showing an increase of mortality, this was
one of the greatest of human disasters. Yet its rationale seemed quite
sound to most of the CCP leadership at the time. What went wrong?

A moment's reflection shows that the GLF was not a unique event
but part of a pattern. The first eight years of the People's Republic
of China had impressed the outside world as comparatively smart
and orderly, compared that is, with what came after. This orderliness
was due in part to the unity of the leadership.

BACKGROUND FACTORS

In the background of the GLF we can see several factors and
chains of causation without being able to assign them their ultimate
influence. One superficial observation may come first: after 1921 the
first decade or so of the Chinese Communist party's revolutionary
effort in China had been largely dominated by Soviet models and
Comintern advisors. Only in the mid-1930s and the 1940s did the
Sinification of Marxism-Leninism lead to a national Communist

[296]

movement under the leadership of Mao. Somewhat similarly, the first eight years of the PRC from 1949 had seen again a reliance upon the Soviet model in the field of economic development, at which the PRC leaders were relatively less experienced. Only in 1958 did the CCP under Mao strike out on its own version of economic development through the GLF. Such a comparison, though very general, suggests that the CCP adaptation of Marxism-Leninism to the Chinese countryside had seemed at first successful while finding a Chinese road to industrialization seemed harder. Social-political strategies that had worked in the CCP's rural experience were not always suited to the cities.

The GLF cannot be understood without going back to note certain aspects of the Chinese inheritance, as well as the circumstances of the 1950s. In China's inheritance was the tradition that the state authorities had unquestioned control over the populace in the villages. For example, they customarily combined households into five- or ten-unit groups and combined these to make larger groups until a *pao-chia* structure might contain a thousand households for purposes of registration and mutual surveillance. Similarly, households under the *li-chia* system for labor service and tax collection were grouped in an ascending hierarchy of mutually responsible units. Using these structures, emperors from early times had pursued public works using labor conscripted from the countryside. The ruling class in short could tell the peasant what to do with himself and his belongings at the same time that they taxed him.

This bifurcation of society into the rulers and the ruled, the managers and the producers, could now be used by the modern state more intensively and completely than ever before. Mao and the CCP had inherited the role of blueprint artists capable of laying out plans and getting results. By using the persuasive methods they had developed at Yenan, once they had set up a Stalinist command economy they could really order the peasantry around.

All central orders, however, had to be applied by the local authorities. Part of China's inheritance was that their state of morale, their loyalty to the center, was a key determinant of the results achieved. The CCP activists and cadres in the local scene had now in a general way succeeded to the leadership position of the lower gentry of imperial times in the local communities. They could reassert the old practices of officialism, oriented upward toward seeking

approval from their superiors rather than downward to serve the people. Of course the terms used at the time promoted an atmosphere of greater egalitarianism and appearances of official humility. Yet the overall pattern seems clear, that there was still a local managerial elite which gave the orders for the masses to follow out. The set-up of local territorial congresses looked fine on paper, but as in other totalitarian states, one has to doubt that they were an effective part of the power structure.

When morale was high, local authorities might get into a zealous competition to report how well they had carried out the center's orders. Aside from overoptimistic false reporting, they might coerce the populace to get results. When the collectivization of agriculture in 1955–56 had gone much faster than foreseen, it had at least nominally brought the rural people into a new form of economic organization, in which tools and land were used in common and the proceeds shared with the state. But the rush toward creating Agricultural Producers Cooperatives had been partly a change of blueprints on paper. The party cadres who staffed these political echelons could report success as their patriotic as well as self-serving duty. In fact it was later disclosed that many APCs had been inaugurated too quickly and were not really able to function as claimed.

Underlying this situation was another inherited factor, the docility of the Chinese peasantry, who were remarkably inured to following the dictates of authority because it represented the peace and order on which their livelihood depended. The vision of the leadership could be imparted to the populace because in the early 1950s the CCP and the Chinese people generally still felt united in a common cause of building up China. The people trusted Chairman Mao. This at once opened the door to utopianism and illusion because the party cadres, drawn increasingly from the upper ranks of the peasantry, were fervently ready to go along, follow the leader, and bring the masses with them. Thus the local obedience to the state and party authority, plus the personal charisma of Mao Tse-tung, could create situations of mass hysteria where people worked around the clock and abandoned established ways, almost like anarchists seeking freedom from all constraints.

MAO AND THE GLF

The immediate occasion for the GLF was the CCP Central Committee's realization that the Stalinist model of industrial growth was not suited to Chinese conditions. To begin with, the Chinese population in 1950 was four times as big and their standard of living only half as high as that of the Russian population in the 1920s. In spite of the universal establishment of APCs, the farm product had not noticeably increased. Agricultural production at the current level could not be relied upon to finance both industrialization and foreign trade to buy machinery plus feed swollen urban centers.

The economist's remedy for this problem, instead of the GLF, would have been to slow down the rate of investment in heavy industry, which at first had reached 48 percent, and direct some of it to light industry, which could produce consumer goods. The availability of consumer goods in turn would provide a material incentive for the peasants' productive activity. By this approach the central government ministries would also play a greater role, and expertise would take precedence over zealotry. The effect would be to carry through an agricultural revolution, which has preceded industrialization in most cases of successful economic development.

This slow approach did not suit Mao Tse-tung's frame of mind, and he persuaded his colleagues that the countryside could be made over and produce more by a massive organization of labor power. The incentive would be revolutionary determination such as had brought the CCP leadership to success. Economic betterment could be promised but the material incentives for the individual's work would be reduced, while ideological ardor and self-sacrifice would take their place. This involved a very big and uncertain assumption about peasant psychology.

One obvious cause of disaster was the romantic notion that the clever organization of people could increase their productivity, that the spirit was more effective in production than the economic factors, and that an inspired populace simply by combining their labor power could achieve more. To a group of leaders who had overcome seemingly insuperable obstacles to attain central power in China, it stood to reason that a militant attack on an economic problem, in the spirit of the Long March, could achieve unprecedented wonders. The major fallacy in the GLF was the assumption that socio-political

mobilization could help the economy. In other words, the massive application of manpower could improve the economic situation.

It is true of course that manpower applied to dike building and irrigation channels, together with the damming up of water and water power and the further reclamation of land, did get results. The Chinese countryside is still dotted with the lakes and water channels constructed by back-breaking labor in 1958–59. One has only to walk through a quarter-mile tunnel built of hand-hewn stone under the surface of a new field as a means of draining off the water that might otherwise erode the land to realize what a massive application of muscle power was achieved in the GLF. But all this did not add very much in improved skills, available resources, and capital equipment that could have increased productivity per person. Above all, the mobilization of labor should have been carefully calculated and organized to serve economic ends.

Several notions seem to have contributed to the CCP leaders' fallacious thinking when they launched the GLF. One element in the background was the egalitarian ideal of their Yenan experience. Egalitarianism in the Chinese revolution is of course an ambiguous term. It could mean the uplifting of the downtrodden and the down-treading of the upper-upper strata, a mere leveling for purposes of totalitarian control. But in a historical context it could also represent an effort to break out of the ruling class–common people bifurcation of Chinese society. Thus one motif of the GLF was the downgrading of the intellectuals. They had not joined up with the CCP crusade, so they could be dispensed with. It was proclaimed that books were useless, expertise was not essential, every man could be his own expert, a specialized elite was not necessary, and the Chinese people could solve their own problems. This was quite acceptable to newly liberated peasants.

The GLF was also skewed fundamentally by a cognate factor. Mao's dislike of bureaucratic centralism and the desire for decentralization of the economy led to the actual dismantling of the Central Statistical Bureau, so that the leadership began to fly blind amid the wishful and exaggerated reports of ambitious local managers. Soon they could have little idea of what was really going on. Seldom has a sentiment been so misplaced. The idea of decentralization reached the point where the comparative advantage of areas' producing what they could do best was sometimes given up and provinces tried to be

self-sufficient, as for example by making their own steel in backyard furnaces. Another effort at decentralization was the setting up of the communes as all-purpose, self-sufficient administrations capable of supervising the productive efforts of their brigades and within them of the production teams. From their inauguration in 1958 the communes were supposed to handle local finance and investment, health programs, cultural life, and many other aspects of peasant society.

Decentralization was another way of saying that local cadres were restive under central orders and welcomed the opportunity to manage the masses in the new projects. The GLF greatly enhanced the importance of the party as leader of the society and reduced the role played by central government ministries and their expertise. The political result was to give opportunity to the ideologically zealous organizer of mass enthusiasm, the revivalist type rather than the trained expert. The GLF attempt to use mass mobilization to achieve a Chinese type of economic development made it very difficult for the center to rein in the local activists and get back to an orderly program of central direction, such as economic management requires.

Looming behind the many factors at play in the GLF was the personality and ego of Chairman Mao. Judging by what he did later in the Cultural Revolution, one can only conclude that his great strength was his great weakness. He had spent all his life since the 1920s organizing by word and deed a rebellion against the established order. His targets before 1949 were plain in history, but after that date he continued to target established groups within Chinese society, and eventually he would break with the Soviet Union as an establishment gone astray. The principal motif of the Maoist style of rebellion was mobilization of the masses and suppression of the intellectuals who formerly had managed them. Time after time he had shown what a determined will and the inspiring of the masses had been able to accomplish. When he found his great enterprise in difficulty in 1958 he resorted to the tried-and-true formula of a Yenan-type mass campaign.

How campaigns were orchestrated in the PRC is still not clearly documented, but it takes no feat of imagination to assume that Mao had his personal secret communications network in addition to the news media that the CCP controlled. In form the next move seemed always to spring spontaneously from "the masses," with Mao and the

Central Committee responding to it in the style of the much-touted mass line. In fact we can assume that the real spontaneity lay with Mao and the CCP, who in effect inspired or directed it to enter the public scene and become newsworthy. This could be done in the U.S.A. only if the news media were under central control.

In the GLF of late 1958 companies and whole regiments of farmers with their hoes and carrying baskets marched into the fields in military formation with drums and flags to make war upon recalcitrant nature in a military fashion. The logic of mobilization involved the creation of the people's communes, organizations as big as central marketing areas, under which, as noted above, the benefits of modernization in health care, education, large-scale production, and the amenities of life were supposedly to be distributed equally through their concentration of power and overall planning. Villages were now called production teams and a group of teams became a brigade, forming part of a commune.

It would be quite unfair to Chairman Mao not to recognize his determination to liberate the peasantry from their limitations of illiteracy, disease, malnutrition, and social fragmentation. Mao's idealism in this respect resonated with the utopian goals of most great revolutionary leaders. When Mao assumed that the common man and woman could be motivated less by material incentives of a selfish nature than by the ideal of selfless service to the community, the mass enthusiasm of the GLF seemed for a time to bear this out. Human nature could be transformed to function on a higher social plane. In short, mass mobilization came naturally to Mao as the means for social and even material transformation of China.

OUTCOME OF THE GLF

Seldom has the willful pursuit of an ideal led to such devastating results. Where 1958 had been a good crop year, 1959 had less helpful weather. The farmers marching about to win the revolution on the land had been unable to harvest all the crops, yet the statistics sent in from the provinces and their localities added up to an enormous increase in production, more than a doubling of output. The result was that government requisitions continued high even while production was actually dropping. This led to an all-time first-class man-made famine.

In early 1959 there was a retreat from the GLF program, but the retreat was halted when objections were raised to Mao's course. In July 1959 there was a climactic meeting at Lushan, a mountain retreat in the Lower Yangtze. One of the top army commanders at Yenan and in Korea, who was one of the ten marshals of the People's Liberation Army and currently defense minister, P'eng Te-huai (who had been with Mao for thirty years, since the very beginning on Ching-kang-shan), tried to report to Mao the actual deterioration of peasant life, but Mao took it as a personal attack and had P'eng thrown out of power. In retaliation the GLF proponents and Mao as their leader persisted in continuing the GLF program. After the Lushan meeting in 1959 another Anti-Rightist Campaign was mounted against critics of the GLF strategy. This in turn fired up a renewal of the GLF in 1959, with an exacerbation of the disastrous consequences. The rural zealotry of the GLF managers in the party apparatus continued to oppose the technical economic views of the urban central ministries and administrators. This prolongation of the GLF led to another fall in production both in heavy industry and light-industry consumer goods. The famine of the 1870s in the Northwest, where no rain fell for three years, had been beyond reach of railways or waterways. Corpses dotted the roadsides. In 1959–60 China was better organized and famine areas full of corpses were not seen. But the malnutrition due to thin rations made millions more susceptible to disease. The higher-than-usual mortality became obvious when the statistics were worked out. Not until 1960 was it finally realized that many peasants were starving and the whole economy had been thrown into a shambles. China had slid into an economic morass and Chairman Mao had been shown to have feet of clay. He even had to admit that he knew almost nothing of economics. The GLF had played itself out as a Mao-made catastrophe.

Along with economic catastrophe had come an ominous political turn. Until this time the top CCP leadership in the Politburo had held discussions every few weeks or months in various parts of the country in order to thrash out their policy decisions. The merit of this system had always been that alternatives were vigorously put forward but after a decision had been taken everybody went along. Now, however, for the first time Mao had transformed the policy argument put forward by Marshal P'eng into an illegitimate personal attack on himself. For the moment Mao won the day, but it was a Pyrrhic

victory that opened the door to factionalism rather than honest pol-
icy discussion. Mao's headstrong denunciation of P'eng destroyed the
unity of the CCP leadership. Initially nearly everyone had gone
along with the GLF strategy, but its failure demonstrated Mao's
fallibility and destroyed the solidarity among the leaders.

One of the bones of contention between Mao and Marshal P'eng
lay also in the latter's desire to make the People's Liberation Army
more technically competent, like the Red Army of the USSR. Mao on
the contrary had been developing the idea of using nuclear bombs
as a counterpart to guerrilla warfare without building up the profes-
sional army on Russian lines.

By concentrating on Chairman Mao as the leader we cannot con-
vey the GLF national mood of fervent self-sacrifice and frenetic
activity. Peasants worked around the clock to break their own work
records, cadres in charge locally kept on reporting totally unrealistic
production figures, and Mao's colleagues like the economist Ch'en
Yun and Premier Chou En-lai found no way to stop the fever. The
backyard steel furnaces, which were supposed to bring industrial
production to the village level, were fed with pots and pans needed
in households, but their steel proved generally worthless.

The greatest crime of this period, in addition to refusing to recog-
nize reality in 1959, was the maintenance of grandiose plans for
raising the amount of investment funds that were to be derived from
agriculture and put into industry while also using agricultural pro-
ducts to pay off debts to the Soviet Union. The result was that requisi-
tions of grain from the villages were increased and collected just at
a time when the villagers had had trouble getting their harvests in
because of the diversion of labor power to public works and also
because of poor weather. The net result was to leave the populace
in some areas with only half or one-fifth of their usual subsistence
grain supply.

The extent of the disaster, in addition to not being recognized by
the leadership, was also hidden from outside observers by the fact
that city populations received rations from the countryside and in-
dustrial construction continued. But eventually the hard facts could
not be escaped. All the marching about with drums and cymbals,
carrying flags, and attacking targets, plus the utopian idea of com-
mon mess halls for production units and the addition of women to the
labor force outside the family farms, had led only into a blind alley.

In effect, the Chinese path to socialism had led over a cliff. Several years of saner economic policies in the early 1960s were necessary to get back to the levels of livelihood of 1957.

MAO'S MOTIVATION

In retrospect it seems quite incredible that Mao, who prided himself on knowing the peasants, could have led so many of them to death and disaster. Perhaps we can conclude that the GLF demonstrated the lack of economic understanding on the part of the Yenan leaders; that it revealed an old Chinese custom of blind obedience to authority, which could therefore be tyrannical; and that it showed how the fever of revolution could unhinge the commonsense of both leaders and led.

Historical comparisons should indicate that Mao was no more a megalomaniac than many emperors, who used to accept their unique semi-divinity. Along this line of thought, the growth of Mao's megalomania can be charted from late 1957, when he put out of the way so many intellectuals and party bureaucrats who seemed not to accept his leadership and vision. From then on he was not a man above the battle and able to hold the balance as formerly. He became an embattled partisan on the narrow field of his own domination or rejection. Whether this should be defined as premature senescence in his sixties, he seemed from then on to regard himself as the fount of wisdom and authority.

Part of this grandiose posture was his assertion of the supremacy of the Chinese Communist Revolution over the Soviet model and its antiquated revisionist tendencies. Having got to the point of breaking with his colleagues, it was only a further step to break with Soviet Russia. This resulted in a "nativism" in which Mao stressed the Chinese cultural heritage from her long history as more important than the Soviet teaching and model. In this way he represented in himself the spirit of national communism, which was capable of becoming even more national than communist. By 1960 came the split with the USSR, a subject so complicated that we discuss it separately below.

Two things followed from the GLF. One was that the Politburo leaders like Liu Shao-ch'i and Deng Hsiao-p'ing went back to programs of planned development on the basis of factual appraisals. During 1961–62 reports were produced at length on the communes,

industry, science, handicrafts, finance, literature and art, and commercial work. Prepared by working groups under different party leaders, these policy reports amounted to a program for economic rehabilitation. In general they followed the long-term recommendations of Ch'en Yun, who stood fifth in the hierarchy and had specialized in economic administration. As part of the rehabilitation program Liu and Deng supported the idea of "individual responsibility," which would increase the incentives for agricultural production. Mao countered this trend by a vigorous call for class struggle. This signaled the beginning of what became known as the "two-line struggle" between Liu, Deng, and others on the side of expert management and Mao and his supporters on the side of a romantic rural-based mobilization for meeting China's problems.

One of the results of Mao's attack on Marshal P'eng was that he was succeeded as defense minister by Marshal Lin Piao, a brilliant tactician, who now rose to power and pushed the politicization of the army. Lin pulled together the "little red book" of quotations of Chairman Mao as part of his indoctrination program and proved ready to take Mao's side in the developing controversy. Soon he had abolished insignia among army officers and revived the political commissar system, thus downgrading the professional military that Marshal P'eng had represented. A campaign was pushed to "learn from the People's Liberation Army (PLA)," as though its military politicization could be a model for the whole society. This of course broke with the precedent in the CCP that militarism must be kept subordinate.

To make a long story short, Mao Tse-tung now became head of a faction. He had lost much face in the GLF. Even before that, he had decided to take a back seat in policy formation, passing upon CCP decisions in a position in the "second line," while Liu Shao-ch'i became chief of state. Why Mao should have pursued factionalism that practically destroyed the party he had built up and endangered the whole revolution is a very complex question that must be approached along several lines of analysis.

Initially Mao's rural aversion to city bureaucratism had expressed his faith that the countryside must be the chief beneficiary of China's revolution. His long experience had made him well aware of the impediments to the good life among Chinese peasantry. However, the ideal of their "liberation," once Mao was in power, seems to have

been submerged under the effort to build up China's national wealth and power under CCP leadership and control.

As this effort continued, however, Mao became concerned about the seemingly inevitable buildup of the institutions of the central government and its many levels of officials, who seemed to be taking the place of the administrative elite of imperial times. He feared a revival of the ruling-class domination of the villagers. Given the modern necessity for expert management, and the irrepressible tendency toward personal privilege and corruption among the new ruling class, it would be hard to prove him wrong.

One immediate cause of Mao's concern in the early 1960s was the CCP establishment's widespread and persistent denigration of his record and policies. In a state based upon the ideals of harmony and unity, leaders of factions could not attack one another directly and by name lest they seem to be spoilers and troublemakers. The ancient recourse of Chinese officials had therefore been to use the penumbra of establishment intellectuals who formed the outer and vocal fringe of their factions. While the Sino-liberal remnants among the intellectuals had generally been purged as rightists, their places as editors, writers, journalists, and organization men of the intelligentsia had been taken by a somewhat younger generation who were inheritors of the intellectuals' tradition. Allied with political leaders, they expressed their attitudes in editorials, essays, commentaries, plays, and other literary productions. In the early 1960s a group of gifted intellectuals representing the CCP establishment used the indirect methods of Aesopian language, indirect allusions, and historical examples to sustain a drumfire of criticism of the errors of the GLF and of Mao's mass-mobilization tactics in general. Some went further and questioned Mao's 1942 dictum that all literature should directly serve the revolution. This critical opinion was generated mainly in Peking, where P'eng Chen was the top man heading the Peking Party Committee.

Finally, Mao's fear that the popular revolution was going astray in China was inspired partly by the spectacle of the USSR. He resented the heavy-handed ways of Nikita Khrushchev as the Soviet leader, and they soon were enemies. In the USSR Mao saw "revisionism" at work, that is, a falling away from egalitarian concern for the people and their collective organization and instead the growth of a new ruling class of specially privileged, urban-centered, and techni-

cally educated people who were kept in line, like the populace in general, by the powerful secret police. Given our general Western appraisal of the Soviet party dictatorship, Mao's distrust can hardly be faulted. In any case his personal motive was to regain control of the CCP by bringing his own like-minded followers into power.

The unfortunate fact, however, was that, once Mao began to build up a faction to oppose the "revisionism" that he saw headed by the other CCP leaders in their economic revival efforts, he showed all the skill and chicanery of a master politician. During the period of realignment from 1962 to 1965 Mao collected his adherents.

THE TWO-LINE STRUGGLE AND EDUCATION

Mao first tried to lead a rectification among the party cadres in the countryside. This would have enabled Mao to create a network of temporary organs in a campaign style, and so the Socialist Education Campaign in 1963 became a battleground in Mao's two-line struggle with Liu as state chairman and Deng as general secretary of the party. Both sides had to agree that the party had suffered badly in its prestige among the people, that corruption had increased and morale was low. They differed whether to conduct rectification by a new mass movement at the lower levels of the countryside or to keep it within the CCP organization.

In 1964 the CCP mounted a mass campaign for class struggle to rectify the village cadres. In practice, the new committee chairmen, secretaries, accountants, warehousemen, and others of the village managerial level had soon begun to lord it over the peasantry from whom they had so recently emerged. They indulged in small peculations, played favorites, did less manual labor, and in general asserted their authority by giving arbitrary orders and making a better life for themselves. The "four cleanups" therefore targeted cadres whose attitudes (not class origin) had made them exploiters.

To combat these evils the CCP used the device of sending work teams of outside cadres to rectify the conduct of local cadres. The procedure was reminiscent of the original land-reform measures against landlords, local bullies, and small-time despots. Work-team members settled in the village for some weeks, cultivated relations with the poor who had grievances, compiled charges and evidence against the local cadres, and then used endless interrogation, physical

exhaustion, and forced confessions as a basis for struggle meetings. These were in the same style as struggle meetings against intellectuals and bureaucrats. They became the chief form of the peasant's participation in political life, manipulated by the CCP on a vast scale. Instead of watching an execution in the old style as passive observers, they now became vociferous accusers of victims targeted by the authorities.

Disillusioned by the party officials' reluctance to go along with his approach to rectification through a mass campaign, by 1965 Mao evidently began to look outside the party to find a means for its rectification.

Meanwhile Mao's wanting to liberate China's peasants and through education make them knowledgeable citizens—an ideal that Western liberal reformers could readily accept—had also been frustrated. Education had always been a major concern of Confucianism. The GLF had faced a double problem—how to bring education to the common man through new arrangements while continuing to train the necessary elite in the established system of middle schools and universities. The new effort centered on the creation of work-study schools like the "people's schools" *(min-pan)* used in the Yenan period. Thousands of middle schools, it was claimed, were established on a work-study basis, while the regular curriculum was reduced from twelve years as in the American system to ten years as in the Soviet. To reach the common man it was also essential to simplify the content of education; textbooks were consequently rewritten. The bottleneck was in personnel who were adequately trained in special subjects. They were simply unavailable. The makeshift of hailing peasants as "scientists" and bringing them into teaching positions proved to be ineffective. There was no getting around the fact that the work-study schools were inferior to the regular schools.

This palpable fact gave the work-study schools a bad reputation as inferior channels for advancement. Peasant families realized quickly that their children could advance into the upper class only through the regular school system. Instead of entering a work-study program that could lead only to the status of an educated peasant, they preferred to keep their children at home for work on the farm.

Educators in the regular system, when it was watered down to accommodate relatively untrained worker-peasant students, re-

sorted to a special device in the effort to maintain standards and produce a trained elite. This device, which had been used at Yenan, was the key-point school, where the best students, teaching staff, and equipment could be concentrated. Since a national examination system was again functioning, the percentage of graduates who passed on from senior middle school into universities became the hallmark of excellence. In the pecking order thus established, the key-point schools were at the top and work-study schools at the bottom. Moreover, the work-study schools had the largest proportion of worker-peasant children while the children of political activists or "revolutionary cadres" in the official structure were dominant in the middle schools. However, the winners at the top level in the key-point schools were likely to be the children of old intellectuals, whose family tradition had given them a head start in education.

Considered as a social program, the educational reforms and innovations of the GLF period directly attacked the old split between upper class and commoner. Mao's dictum "Never forget class struggle" put the children of intellectuals at a disadvantage. As a consequence, students with a bad class background were often penalized or even excluded from the system. Nevertheless, a competition was set up for entrance to college on the basis of examination grades much the same as in earlier times. The result was that by the mid-1960s China's new educational system was bifurcated into two tracks and the upper track still led into the elite. It had not been possible to change China's class structure through education.

On the contrary, the emergence of elites left a majority outclassed and dissatisfied. When entrance to higher education was restricted in the 1960s for reasons of cost to the state and fear of oversupply of graduates, greater numbers of young people remained unemployed in the cities. In the labor force a similar restiveness was due to the higher wages and more secure jobs for skilled workers, while the majority were plainly expendable. Tensions were growing in major areas of Chinese society as well as within the CCP.

THE SINO-SOVIET SPLIT

Looking back twenty-five years to 1960 it may seem to us now perfectly obvious that the Chinese and the Russians would split up. The fact was that the American contact with China across the Pacific

had been much more extensive and long continued than the Russian influence from across Siberia and Mongolia. There had been no Russian Orthodox Christian colleges educating Chinese youth. English not Russian was the second language of the Chinese upper class. The Chinese link with Russia had come through the Communist movement and the few thousands of Chinese that it sent to Moscow. This influence did not begin until the 1920s, and as the Chinese and Russian Communists got to know each other they did not necessarily become greater friends. The CCP leadership could not forget that Stalin had given them wrong advice in the 1920s, and as late as 1945 he had made a treaty with Nationalist China to serve Russian national interests in Manchuria. In short the Sino-Russian linkup was tenuous and could dissolve as soon as the CCP began to develop its own style of national communism. One solvent would be the fact that, when China again recognized the need for outside aid in economic development, the United States and its allies could supply much more than the Soviet Union.

This being the view from twenty-five years later, we are left to contemplate how the United States could so signally have failed to see the possibility. In the days of John Foster Dulles's Presbyterian crusade against "monolithic atheistic communism," which headed up in Moscow while stretching its tentacles around the world, there seemed to the ideological cold warriors of the day (who included a great part of the American public) to be no way that the Chinese could break free of Russian totalitarian control. For that matter we saw no possibility that the Vietnamese Communists could be at odds with Chinese Communists, because we knew that all Communists anywhere were part of a great world conspiracy.

By suggesting that our understanding was completely wrong, in fact stupid and not well based, I do not mean to claim that we may be smarter and better informed today, but I hope so.

The Chinese-Russian split developed in the late 1950s in a series of stages. For the fortieth reunion of the USSR, Chairman Mao went to Moscow for the second time, in the winter of 1957. He said fulsome things about Soviet supremacy in international communism and even went farther than the Russians would have liked in claiming that the Soviet orbiting of Sputnik had just shown that "the east wind was prevailing over the west wind" and the days of capitalistic imperialism were numbered. At this time various Sino-Soviet agreements

for technical exchange, including assistance in making nuclear bombs, were worked out and China continued to have the help of some ten thousand Soviet experts in its industrial development. Meanwhile, China's intellectuals had been profoundly influenced by the Soviet example in education and culture. Russian was now their second language. Russian literature, art, and architecture were emulated.

The relationship began to come apart when Khrushchev became an outspoken critic of the Great Leap Forward. On his two visits to Peking, in 1958 and 1959, he and Mao did not get along. The Russian leader thought the Chinese leader was a romantic deviationist whose judgment could not be trusted. Khrushchev was incensed at Mao's claim during the GLF that through the commune system China would reach communism sooner than the USSR. Khrushchev was also incensed that in 1958, when Mao was planning to bombard Quemoy Island, garrisoned by Nationalist troops, just outside the port of Amoy, Mao had told him nothing about it on the grounds that it was a purely domestic matter. This overlooked the fact that the United States was allied with Taiwan, as was the PRC with the USSR, and so this move in an alleged civil war might trigger a superpower, and therefore nuclear, confrontation. Khrushchev was just in the Camp David phase of working out a modus vivendi with President Eisenhower. In the Taiwan Straits crisis of 1958 with the United States, the Soviets refused to back up China, and they then reneged on the promise to give China an atomic weapon. This falling out reached the point in mid-1960 where Khrushchev suddenly withdrew all the Soviet technicians from China together with their blueprints. The CCP was soon sending ideological blasts against Soviet revisionism to the Communist party of the Soviet Union and being paid back in kind. By 1963 this altercation between the two parties was being made public to the world. The falling out was all the more bitter because as sectarians the CCP and CPSU had once shared a common faith and each saw the other as now traducing it.

THE GLF IN HISTORY

The history of the great Chinese Revolution is still at the great-man stage. In the center stands Mao Tse-tung and his interaction with others in the leadership. Off in the wings are the many million

activists who helped him make history, while still out in the street are the hundreds of millions of the Chinese people. This is of course an inevitable progression in history writing, especially when research has to begin from outside the country with the leader's pronouncements. Several breakthroughs have been made ahead of their time, and studies are accumulating of other individual leaders and of unnamed followers in various parts of the national scene. In time we may expect a reconstruction of local moods, peasant discontent, cadre sentiments, and small projects that represented the real, extremely varied experience of the Chinese people. Some of this will have to be done by a combination of field research and personal reminiscence on a massive scale.

Mao's present dominance in revolutionary history does not even accord with his own mass line. His wide trips around the country during the era of agricultural collectivization in the mid-1950s were touted as letting him keep his finger on the rural pulse. Yet, when Mao made his rural investigations at any time, we may be sure that he was talking with the local cadres and not with peasants alone. He was no more able than a foreign tourist to talk with people out of the presence of the local authorities who accompanied him. Yet he was certainly capable of sensing and responding to the popular feelings of the moment. We are therefore justified in trying to reconstruct a theory (or "model") of the popular ingredient in the revolution. How far was Mao simply staying out in front of his troops?

In the first place the GLF came after the years of collectivization of agriculture, which had been marked by the determined and wholehearted activity of the local cadres who managed the process. These many millions of people, both men and women, were political activists and managers, including both party members and candidates. They were certainly ambitious to carry through the revolution and at the same time rise in the world with it. They had emerged from the rural masses by their own responsiveness to the opportunities of the revolution. In terms of social structure, they corresponded in a general way to the lower gentry of late imperial and early Republican times—the followers of patrons higher up, managers of bursaries and the affairs of the absentee landlords, local officials, heads of local gangs and peasant associations, military men, and others in a position to tax, conscript, organize, and tyrannize over the farming population. We have recounted above how this lower gentry

at the end of the imperial Confucian order had become petty local despots on their own, no longer tied in with the upper gentry who were then in the cities and towns.

Indeed, the whole process of land reform had been one in which the CCP cadres supplanted the old remnants of the lower gentry. In probity and vitality they represented a new regime, but in structural terms they penetrated much further into village life and moreover represented the authority of the party. Where the lower gentry had arisen locally with some degree of spontaneity, the CCP cadres achieved their dominance by representing higher authority.

Another observation must be that, once they had been called into being and had found their way upward in society through the collectivization of agriculture, this new stratum of activists in the countryside needed things to do and were ready to go further. The GLF was hard to rein in because once the activists got started reorganizing the villages they tended to keep on going. "Liberation" in effect had produced a new class who wanted to keep on liberating.

Part of this scene must have been the opportunity for youth to rise in the world. By the late 1950s and early 1960s China was becoming a nation of young people, many of them uprooted from the past and avidly in competition to gain preferment. One may imagine other motives, not necessarily selfish or materialistic. The elimination of the old constraints on peasant life, the spread of literacy and organization, the doctrines of equality and opportunity for all must have inspired many peasant youth to join a noble cause and sacrifice for it.

However, in the perspective of Chinese history the GLF appears as an updated form of the enormous public works built in earlier times. Rebuilding the Grand Canal in the Ming, like the constructing of Chengtu airfields for American B-29 bombers in World War II, was done by labor conscripted from the countryside. Typically a village headman would be ordered to provide so many bodies at the work site over a certain length of time, say ten days. The villagers would bring their food supply and erect mat sheds to sleep in. They worked as a group and after fulfilling their stint would march home again. There were of course many variations in such arrangements of labor service, but they all added up to tremendous feats of earth moving in baskets balanced on shoulder poles and of rock cutting to provide masonry. The GLF's achievements in building dams, dikes, and irri-

gation channels was the latest version of an ancient practice that had, for example, erected prehistoric capitals at Anyang and Chengchow with walls of earth so well tamped (beaten down within a movable frame) that they are still identifiable. To command such labor power was the ruler's prerogative. Mao's use of it was quite natural.

Its direction, moreover, by minor authorities in impractical ways, such as to cultivate the soil too deep (so salts rose to the surface) or interplant one crop with another (difficult to harvest), similarly harked back to statecraft theorists of the upper class telling farmers how to farm.

Nor was the reorganization of peasant life under brigades and communes entirely a Maoist invention. The GLF merits comparison, especially in its invasion of the rural scene, with earlier agrarian reforms, such as those of the Northern Wei, Sung, and early Ming. We still have much to learn from history.

After some economic recovery in the early 1960s, the next phase of the revolution saw China turn inward again. To be sure, in the 1962 Sino-Indian boundary dispute, after long provocation the PLA forces had scored a quick and spectacular military victory. But as the Sino-Soviet dispute became more vitriolic, Chinese efforts to organize the underdeveloped Third World countries of Africa and Asia against the USSR met frustration. Chou En-lai's touring Africa got nowhere. Meantime as the United States intervened massively in Vietnam in 1965 it promised not to invade North Vietnam on the ground, and so to avoid a Korean-type Sino-American conflict. Frustrated in foreign relations, Mao evidently felt the times propitious for another great effort to remake the Chinese people.

17

Mao's Great Proletarian
Cultural Revolution

To OUTSIDE OBSERVERS the Cultural Revolution was a weird happening. One never knew what would come next—Chairman Mao suddenly swam the Yangtze, teenage Red Guards rampaged through the cities, yesterday's top officials were paraded as criminals, and then the subsequent horror stories of harassment, brutality, and torture began to come out. The decade 1966–76 became China's "Ten Lost Years."

The Great Proletarian Cultural Revolution was from any point of view one of the most bizarre events in history. To Western observers it made China even more mysterious than usual. Something like one hundred million people were active participants in it, many of them as victims, while at least five hundred million can be said to have been significantly affected by it. How could it have been on such a super-massive scale and yet be, at least in the early stages, under central direction?

This gigantic upheaval is too recent to be fully known, much less comprehended. However, brilliant and painstaking studies have made a start. Our tack in this chapter is to sketch in the course of events, mainly political history, but we must also analyze certain background factors to keep in mind if one is to make any sense of what happened.

PRINCIPAL PHASES OF THE GPCR

The Cultural Revolution proper lasted three and a half years, from late 1965 to April 1969. Let us first note principal phases and then go back over them. The phases analyzed by leading political scientists were:

First, until the summer of 1966, an increasing tension between Mao's faction and the CCP establishment. Mao showed his teeth and secured the dismissal or demotion of certain outstanding "revisionists" (opponents) in party, government, and army. This led to a decision by the Central Committee at its Eleventh Plenum (full meeting) in August 1966 to mount a broad attack upon "revisionism" wherever found.

Second, from then until the end of 1966, Mao's group fielded the Red Guards. There was an open season on intellectuals (meaning middle-school graduates or above), which shut down the educational system, and on party functionaries, which practically dismantled the CCP organization. This period featured six rallies which between August and November 1966 brought to Peking ten million Red Guards, with the logistic support of the People's Liberation Army and free rides on trains. Red Guards rampaged through the cities, destroying the "Four Olds" (old ideas, culture, customs, and habits) with impunity. This assault hamstrung the government, yet did not create a unified mass movement to take its place.

In the *third* period, from January 1967 to mid-1968, a "Seizure of Power" was organized in which Red Guards took over many parts of the establishment. The government having in effect been put out of action, Mao tried to set up three-in-one committees representing the mass organizations, surviving cadres, and the People's Liberation Army. But this kind of organization could not control the country; factional feuding among Red Guards escalated into open and armed warfare between radicals and conservatives. The period ended in mid-1968, when Mao demobilized the Red Guards and called in the PLA to restore order.

Fourth, there then followed, from the summer of 1968 to April 1969, an attempt to rebuild the party and the government, in which military influence was now preponderant. Finally at the Ninth Congress of the CCP in April of 1969 the Cultural Revolution was declared to have ended, but in fact some of the worst excesses occurred

under the military in 1970–71, and Mao's faction (later stigmatized as the Gang of Four) remained in power until his death in 1976.

The scholarly unraveling of the many cross-currents in these four successive phases is achieving significant results, but to try to summarize them here would be a work of supererogation, not feasible. The record of the CCP's internecine conflict is littered with esoteric terms—the Early Ten Points (May 1963), the Twenty-three Articles (January 1965), the Sixteen Point Decision (August 1966), the January 23 Directive (1967). These form a shorthand that denotes stages in the factional struggle. Instead of plunging into this quicksand of confusing minutiae, let us begin with certain background considerations: namely, Mao's unique status and personal power, his reliance on the repoliticized PLA to back him up, and the unexpected fission among the Red Guard teenagers whom he fielded as a mass movement.

MAO'S PERSONAL POWER

Our American understanding of Mao requires a feat of imagination. First we have to recognize the nature of his supremacy. The secret of this primacy was that Mao had had two careers, one as rebel leader, one as an updated emperor. He had gained the power of the latter but evidently retained the self-image of the former. Briefly put, authority in China came from the top down as was recognized even in the mass line, and once the CCP had taken power its leader became sacrosanct, above all the rest of mankind, not only the object of a cult of veneration but also the acknowledged superior of everyone in the organization. So much of the CCP had been put together by Mao that it could be regarded as his creation, and if he wanted to reform it, that was his privilege. Only if we regard him as a monarch in succession to scores of emperors can we imagine why the leadership of the CCP went along with his piecemeal assault and destruction of them.

This unique position in people's minds made it possible for Mao, who was also entranced by himself, to regard the emergence of elites as a failure of the revolution, the cure for which must be a revival of egalitarianism, even though this could be attempted only because Mao was so unequal himself. This benevolent despotism was just the opposite of the politics familiar to the Atlantic community, where the

chief power holder is normally the chief object of criticism. In other words Mao was in such a unique position of acknowledged power that he could do practically anything he wanted to, even though he had to make use of the usual procedures in meetings of the Politburo and Central Committee. It was like God playing politics. The cards were stacked on his side.

But what did Mao think he was doing? Perhaps it can be summed up as an effort to make "democratic centralism" more democratic and less centralist. He saw the new bureaucracy following the ancient pattern of autocratic government from the top down. This would leave the peasant masses where they had always been, at the bottom of society, being exploited by a new elite. To combat this tendency Mao wanted to use the mass-line approach by which the party should elicit and respond to peasant concerns. This new downward-oriented style of government could be aided by decentralization of administration. Local decisions should not all depend on Peking bureaucrats. The aim of government should be the welfare and education of the local peasant masses, not merely the old shibboleth of a "wealthy state and strong army." To pursue such a goal would defeat the revolution.

This flatly denied one of the basic tenets of the Chinese political tradition, namely that the masses must be governed by a carefully trained and loyal elite of ministers and subordinate officials, of army officers with commanding rank, and of party organizers with special prerogatives. "Revisionism" Mao defined as an abandonment of the goals of the revolution, and acceptance of the evils of special status and special accumulation of worldly goods, which could be called a restoration of capitalism.

In promoting and manipulating this social convulsion, Mao staged an instinctive attack on the establishment, even though he had helped set it in place. His rationale centered upon his analysis of class struggle, which he felt still continued under socialism. A struggle against "revisionism" in China was suggested by the example of the Soviet Union, where the ideal of socialist government had been subverted by a corrupt bureaucratism.

He also seems to have had in mind the idea that student youth could be mobilized to attack the evils in the establishment and purge China of revisionism. It would be a form of the manipulated mass movement, which his experience told him was the engine of social

change. To be sure, by arousing and giving a lead to urban young people Mao flouted all the principles of party rectification within party ranks. In effect, he declared war on the leaders who had come with him from Yenan. By manipulating the situation to get the Central Committee's and other directives approved as he wanted, Mao had the party leaders hog-tied by use of their own tradition of disciplined obedience to party commands. This included at certain key points his securing the support of Chou En-lai, who was evidently performing his usual function of trying to ameliorate the injustices and impracticalities in Mao's attempt to purge his party colleagues. In effect the CCP leadership, intensely loyal to the party, could not foresee what was going to hit them.

To be sure, as the situation got increasingly out of control and into violence, Mao made various efforts to rein it in, but seldom successfully. The Cultural Revolution turned out to be something he had not envisioned. Allowing for many variations, the purge rate among the party officials was somewhere around 60 percent. It has been estimated that 400,000 people died as a result of maltreatment. In the eventual trial of the Gang of Four in 1977, those culprits were charged with having framed and persecuted more than 700,000 people, of whom some 35,000 were persecuted to death. Many more were physically and mentally crippled, and a greater number committed suicide.

THE ROLE OF THE PEOPLE'S
LIBERATION ARMY

Because the main background factor in Mao's ability to instigate the Cultural Revolution was the support of the armed forces, let us pause next to note the long competition within the PLA between military professionalism and ideological politics. Looking way back, we can note how the Red Army of the USSR had worked out the party-army relationship first by putting "politics in command," i.e., military professionals should be subordinate to political commissars. Gradually, however, military professionalism gained the upper hand in the USSR, along with the growth of the Soviet general staff.

A comparable progression had occured in China. The Whampoa Military Academy under Chiang Kai-shek at Canton had created a party army to spearhead the Northern Expedition, but after the split

in 1927 Chiang built up professional forces with no reliance on the masses' help for guerrilla warfare or "people's war." Meanwhile, the CCP in the boondocks had to fall back on the ancient Chinese peasant-bandit techniques—small-unit mobility, deception, and union with the rural populace within a given region. Even in Kiangsi, however, the control group of about a dozen CCP commanders showed a firm belief in professionalism. Several had studied warfare in Moscow and the rest had absorbed Soviet ideas. The main holdout against them all was Mao Tse-tung, who believed fervently—then as always—in mobilizing the rural masses in "total war."

In sum, the CCP from the start had had a trained and sophisticated group of central commanders who were intent on the specialization, organization, and discipline of a truly professional army. They held political or military posts as required. During the CCP rise to power some of them headed field armies, of which there were eventually five: the First Field Army, mainly in the Northwest under P'eng Te-huai; the Second in Southwest and Central China; the Third in East China under Ch'en I; the Fourth in the Northeast and also South China under Lin Piao; and the Fifth, also called the North China Army, under Nieh Jung-chen, in the Peking-Tientsin area. Each of these armies had some local roots, some continuity of command, and certain shared experience, all of which might have led to regionalism and rivalries. But the central military leadership (Mao, Chou, P'eng, and others) carefully transferred personnel and units to avoid factionalism. The political leaders, having been commanders themselves, knew how to preserve unity.

By the 1960s the important point to note is that while the PLA was essentially defensive concerning foreign powers, it played a basic role within the country as a support of the political establishment. There were about thirty-eight "main-force" troop units or "armies," which were deployed around the country in eleven military regions. These main-line forces may be contrasted with the regional forces, which were divided among twenty-eight provincial military districts. The regional forces were less well armed and were trained only for local defense work (including for example the mobilization of the People's Militia and production-construction corps, who numbered in the tens of millions as part-time soldiers). They were widely dispersed in small commands scattered over the landscape and not trained to be unified field armies. One is reminded of the late impe-

rial system under the Ch'ing, in which the Lü-ying or "Army of the Green Standard" served as a constabulary dispersed in small units to maintain local order but seldom mobilized as unified striking forces. The latter "main force" function was left to the garrisons of Manchu, Chinese, and Mongol bannermen, who were nominally kept out of civilian life and figured, for example, in Ch'ien-lung's "Ten Great Campaigns" against rebels on China's frontiers.

Just as military control had headed up in the emperor, so in the PRC the commander-in-chief was the chairman of the CCP, who usually had a concurrent appointment as chairman of the Military Affairs Commission (MAC). Under the MAC were three basic command structures to control the military, to command the CCP political apparatus within the military, and to handle administrative and logistic functions. Another echo of the imperial system was the arrangement for troops to grow their own crops and have their own small-scale local industries in order to make them, to some degree, self-supporting, similar to the ancient *t'un-t'ien* system of semi-self-sufficient frontier outposts.

Balance and control were maintained under the MAC through the General Political Department, which functioned throughout the military; the General Staff Department, which headed the command structure; and the General Rear Services Department under the Ministry of National Defense, in charge of logistic and administrative matters. Political control was thus built into the system. This was exemplified in the fact that Prime Minister Chou En-lai, having been in the Political Department of the Whampoa Military Academy under Chiang Kai-shek, was the teacher and senior of a number of CCP military officers, several of whom were among the ten marshals at the top of the organization. The result was that the party penetrated the army at all levels, many of the military being party members.

We have noted in the preceding chapter how the armed forces under General Lin Piao as defense minister were fairly thoroughly politicized and served as the main base of support for Mao's revolution from below. The essential point in this situation was that, while the main-force armies were guided by their own internal Political Department, the *regional* armies of the PLA in provincial commands took their orders from the local party secretaries and other party authorities. Thus the first party secretary of a province usually

served concurrently as the first political commissar of the military district. This political-military web of control operated in several ways: one was to handle conscription from the millions of applicants each year, the PLA having become a principal channel for upward mobility from the countryside. The recruited soldier, if accepted after strict physical and political examinations, had a chance to get training and even become a party member, so that after his three or four years of service he could become a leader in his home community. Recruits came from all parts of the country on a quota basis, and many were middle-school graduates. Only about 10 percent of the eligible males were inducted into the service. The army was a great political training ground to produce supporters of the CCP. Since 1949 about fifteen million men had been released from the PLA, and the half million or so discharged each year had usually been given good jobs in addition to acquiring social prestige and being regarded as politically reliable. Thus the regional PLA interpenetrated local government and public security services, including the organization of the militia. The armed militia was only seven to nine million persons, who received three to six weeks of military training annually. Behind them were the fifteen to twenty million of the basic militia, who received only a few days of training each year and not ordinarily with firearms.

This was the military setup that was brought into play in the Cultural Revolution. After the Great Leap Forward had produced economic disaster and a decline of morale among the populace as well as the party, the regional PLA under Lin Piao became both Red and expert, that is, still devoted to the revolution and using its skills for the purpose. This provided Mao's power base. The thirty-eight or so armies of the professional main-force troops were at first not involved.

THE ROLE OF STUDENT YOUTH

As a final background factor we must note that Mao's mass movement in the GPCR consisted primarily of teenage student youth, a very different kettle of fish from the peasant masses who had been activated in the agricultural collectivization of the mid-'50s or in the GLF of 1958-60. The GPCR at first did not greatly affect the peasantry except in communes near cities. Until its later stages it did not

lower China's agricultural and industrial output as the GLF had done: they continued at first in rather normal progress. As an essentially urban movement the GPCR featured the Red Guards from mid-1966 until they were abolished in mid-1968. These inexperienced youth, trying to "learn revolution by making revolution," were immensely destructive. Their suppression finally required action by the PLA. While Mao was basing himself on a triad of organizations—the PLA, radical party intellectuals, and mass organizations—the last-named remained the least institutionalized and the hardest to control.

The Red Guard factionalism, which led to open and active warfare between organized groups in the cities, had a complex origin. One factor we have noted was that in the educational system of the 1960s two types of students vied for the top standing and entrance to the university from the middle school. One group was composed of children from intellectual families, who had a head start in their education at home and were capable of doing high academic work. They gained merit on examinations which could not be denied. The other group was composed of children of the new ruling class of party members, officials, and cadres, whose class background was considered revolutionary and first rate. They were a rising generation and would have the inside track for official employment. Their level of scholarship, however, was not as high as that of the children of intellectuals, even though the latter's class status was declared to be very low. This difference in class background would help produce the animus and rivalry evident in Red Guard factional fights.

Having noted certain contributing background circumstances affecting the GPCR, let us now follow its phases as acts of a drama, necessarily a great tragedy but not lacking in color, excitement, and great hopes along the way. No doubt it is typical of genuine revolutions, when the state power dissolves and factions are engaged in mortal combat, that the progress of events comes to be marked by a series of shorthand terms like the Rump Parliament, Thermidor, or the NEP. The historian has to impose upon the chaos of events a structure of turning points or milestones.

THE GPCR: THE PREPARATORY PHASE

Going back over the four phases listed above we begin with an introductory period from late 1965 to the summer of 1966, which saw tensions rise between Mao's faction and the CCP establishment. To his support from the repoliticized PLA under Lin Piao, Mao added through his wife Chiang Ch'ing a group of radical Shanghai intellectuals, who later would form his Central Cultural Revolution Group.

Mao was beginning with a rather nondescript team. Lin Piao had, to be sure, proved himself a very able field commander, but in appearance he was a thin and rather quirky, certainly uncharismatic individual, who was always seen with his cap on (he was bald). No doubt Lin was a gifted infighter and crafty like a fox, but where Mao's being overweight simply added to his magnificence (in the Chinese style, where being thin is not prized), Lin appeared small and unimpressive.

Mao's wife, Chiang Ch'ing, had been a two-bit and not very successful movie actress before she went to Yenan and captivated the chairman. However, she proved herself a very competent politician. She wanted to take over the cultural establishment in order to make radical reforms under the guise of getting back to first principles. She was no diplomat, however, and nursed grudges against practically everyone she had met up with. She got into power partly by joining Lin Piao as head of his Cultural Department for the PLA. She also teamed up with undistinguished radical intellectuals from Shanghai, which became the cultural power base for attack on Peking.

As a final move in cementing Mao's combination of forces, a principal officer of the PLA (Lo Jui-ch'ing) who disagreed with Marshal Lin Piao was seized late in 1965, accused, interrogated, and dismissed from all his posts in April 1966. The effect was to suppress dissidence in the army. Among the intellectuals a comparable attack was launched on one who was the vice-mayor of Peking (named Wu Han) for having published a play in which an ancient emperor was rebuked for having wrongfully dismissed an official. Mao was said to be convinced that this was an attack upon him for having dismissed Marshal P'eng Te-huai at Lushan in 1959. The top party official in Peking was a stalwart of the inner group, P'eng Chen (no relation to the general), who naturally saw the attack on his vice-mayor as an

attack on himself. A Peking investigation cleared the man of evil intent but Mao then engineered a Shanghai forum at which P'eng was scathingly denounced, and in April 1966 he was removed from power by the central authorities. This incident showed everyone which way the wind was blowing.

In these preliminary moves Mao knocked off certain officials who were unresponsive to his programs and secured the acquiescence of the party establishment as represented by Chou En-lai, Liu Shao-ch'i, and Deng Hsiao-p'ing. They were all accustomed to going along with the great man and leader. They did not know that they were being led up a mountain and into a volcano. These first moves were approved by the Politburo in May 1966. After all, they were children of the party and ready to knuckle under to its constituted authority. The Politburo now established a Central Cultural Revolution Group that would report directly to the Standing Committee. It was packed with Mao's supporters. Meanwhile, reorganization of various departments infiltrated Mao's supporters into key positions.

The attack on revisionism and on unnamed members of the party who were "taking a capitalist road" was then heightened during a sub-phase known as the Fifty Days, from June to August 1966. In this period radical students were mobilized to attack university authorities in wall posters, but Mao stayed in retirement in Central China, leaving his deputy and chief of state, Liu Shao-ch'i, the urban organizer of the CCP, in charge at Peking. Always the party builder, Liu could hardly give precedence to mass organizations. He tried to quell the agitation by dispatching work teams to scrutinize the lower levels of the party in major institutions, both universities and factories. Something like four hundred teams with about twenty-five persons each, which would total ten thousand in all, were dispatched to work within the party organization. This thwarted Mao's effort to work through mass organizations. While they were slow to rally to an anti-CR position, the party leadership tried in various ways to throttle it down.

The role of Chou En-lai in the GPCR is not easy to evaluate. As a member of the party Politburo and as chief administrator of the government Chou was involved in practically everything. There is little evidence that his loyalty to Mao ever wavered, but he acquired a wide reputation as a humane official who tried to palliate the excesses of the time. Thus he repeatedly intervened to protect specific

individuals, and as the radical and conservative sides became more embittered, Chou performed his usual function of trying to bring them together. As late as February 1967 Chou presided over a meeting between the Central CR group on the one hand and an array of military and State Council leaders that included three marshals of the military and five vice premiers. Castigated by the radicals as the "February adverse current," this meeting represented a recurrent theme of opposition to the worst tendencies in the GPCR.

THE GPCR: MAO'S SUDDEN EMERGENCE

In the second phase, from August 1966 to January 1967, Chairman Mao was a great showman. The dutiful Liu Shao-ch'i, no doubt already doomed for destruction, was orchestrating the anti-revisionist movement among the party faithful. He was conducting it as an intra-party reform, not a public mass movement. This, of course, was not what Mao, who was resting out of sight in Central China, wanted to do. In July 1966 the Chinese public was electrified to learn that Mao had come north, pausing on the way to swim across the Yangtze. Since rural Chinese generally could not swim, and few adventurers had ever tried the Yangtze, this was like news that Queen Elizabeth II had swum the Channel. He was obviously a paragon of athleticism, capable of superhuman feats. (Photos showing his head on top of the water suggested Mao did not use a crawl, sidestroke, backstroke, or breaststroke, but swam instead in his own fashion, standing upright in (not on) the water. He was clocked at an unusual speed.)

Meanwhile at Shanghai he pulled together in August 1966 the so-called Eleventh Plenum, actually a rump session of the Central Committee packed with his supporters. In short order it demoted Liu Shao-ch'i from number 2 to number 8 in the CCP hierarchy and promoted General Lin to number 2, which made him Mao's putative successor. The Plenum also put forward Mao's general vision of the movement against revisionism, which was intended to achieve a drastic change in the mental outlook of the whole Chinese people. Spiritual regeneration, as he put it, was to take precedence over economic development. The principle of class struggle was to be applied to all intellectuals, bureaucrats, and party members in order to weed out "those in authority taking the capitalist road." As yet nobody knew exactly who these evil people were.

By these maneuvers Mao got nominal legality for the stirring up of a mass movement against revisionism in the party establishment. This soon took the form of the Red Guard movement. For this Mao energized the radical students by putting out such slogans as "Bombard the headquarters" and "Learn revolution by making revolution." Youthful support was mobilized in six massive rallies between August 18 and November 26 at Peking. (Their fanatical enthusiasm calls for comparison with Hitler's rally at Nuremberg.) To these rallies, which were organized by the PLA and the Cultural Revolution Group, some ten million youths volunteering as Red Guards from all over China were transported free on the railways and housed in Peking. They waved aloft the little red book of *Quotations from Chairman Mao* which General Lin had compiled for indoctrinating his troops. Classes were meanwhile suspended and the universities soon closed down.

Whatever may have been Mao's romantic intention, the Red Guards turned to destructive activities that have since been called hooliganism, breaking into the homes of the better-off and the intellectuals and officials, destroying books and manuscripts, humiliating, beating, and even killing the occupants, and claiming all the time to be supporting the revolutionary attack on the "Four Olds"—old ideas, culture, customs, and habits. These student youths, boys and girls both, roamed through the streets, wearing their red armbands, accosting and dealing their kind of moral justice to people with any touch of foreignism or intellectualism.

By late 1966 Mao's Central Cultural Revolution Group manipulating the situation escalated the depredations of the Red Guards from mere attacks on all persons alleged to have a "bourgeois" taint to a heightened phase of "dragging out" party and government officials for interrogation and punishment. They soon settled on the former chief of state Liu and the secretary-general of the party Deng as the number 1 traitors "following the capitalist road." They and many others were denounced, detained, and publicly humiliated. By mobilizing a mass attack of urban youth on the central establishment of state and party, Mao and his followers were able to achieve a chaos which they evidently hoped would be a salutary revolution. Confronted with the loosely organized Red Guards in the summer of 1966—student political activists of both sexes, age nine to eighteen, drawn from schools—the CCP leaders who were under attack fought

back by fighting fire with fire and fielding their own Red Guards. The party establishment was of course strongly structured and not easy to break down, but it was a forlorn hope. Mao had the levers of power and finally emerged as clearly bent on the destruction and rebuilding of the party.

THE GPCR: THE SEIZURE OF POWER

The third phase began with the movement for "Seizure of Power" in January of 1967. Seizures were authorized from Peking and carried out by Red Guards and others all over China's cities. Officials were ousted from their offices, their files examined and often destroyed, and their places taken by young people without previous experience in administration or leadership. Already these young people were breaking into factions, which began to fight one another.

During all this time the People's Liberation Army was kept on the sidelines and so let the destruction go forward. In January 1967, however, the army was directed to help the anti-revisionist revolution against the conservative counterrevolutionaries. The situation had got out of Mao's control, the PLA remained the only unified force in the society, and it now increasingly had to take power in the local scene. Although thus far only the regional forces, not the main-force units, had been concerned with the GPCR, they were so intertwined with the CCP local organization that it proved difficult for them to join in the three-way "Revolutionary Committees" that were expected to create new provincial governments. The regional forces of the PLA became a weak reed to lean upon. They were supposed to maintain order and protect public services through "Military Control Committees." But, when the regional military garrisons and districts in the provinces were ordered to support the left against the right, they found it impossible to get control over the situation. Only in four provinces did the setting up of Revolutionary Committees proceed effectively. One result was an attempt by the Central Cultural Revolution Group to purge the PLA of recalcitrant officers in the provinces. Even so, the Wuhan Incident of July 1967 showed how ineffective the regional forces had become as a GPCR tool: an independent division of the Wuhan garrison command helped kidnap two members of the Cultural Revolution Group of the Central Committee from Peking. Peking had to bring in main-force units to control the

situation and set up the Revolutionary Committees.

After Mao ordered the Red Guards to take on the job of dragging out the "capitalist roaders" in the army, the situation soon became violent. China was falling into civil war, in which Red Guard factions battled each other and the regional military joined in and took sides. While the attack on the regional forces' commanders slacked off after September 1967, the spread of factionalism was contagious, and friction developed between regional and main-force units. Peking dealt with this crisis by ordering the PLA to stop supporting either side and to undergo political training. However, by 1968 factional rivalry was becoming evident even within the main-force units. If this developed further, Mao's last card would have been played and he would have lost control of the situation completely. Under these pressures Mao, in July 1968, finally disbanded the Red Guards, who he said had failed in their mission, and ordered the PLA to carry through the formation of the Revolutionary Committees in all the provinces. The dispersal of the Red Guards led to their being sent down in large numbers to the countryside, casting them from the heights of political importance to the depths. The activists who now took the place of the Red Guards were called Revolutionary Rebels, and their depredations were equally cruel and fearsome. At the same time main-force units were moved about, while the disbandment of the mass organizations relieved the pressure on them to take one side or another. The final result was that the Revolutionary Committees were dominated by military men. Most of the party first secretaries were PLA officers. Premier Chou was quoted as saying that the two million or so of the regional forces of the PLA had suffered "hundreds of thousands" of casualties.

THE GPCR: FOREIGN RELATIONS

In the fourth phase of the GPCR from July 1968 to April 1969, when Mao attempted to put a new state together, the leadership consisted of two-fifths or more of military men, two-fifths of new or old party and official functionaries, with only a slight representation of mass organizations. Military dominance in 1969 was ensured by the low quality of party and government officials brought into power, who generally could not compare in ability with their predecessors.

The climax of the Cultural Revolution was reached at the Ninth

Party Congress in April 1969. Lin Piao gave the political report. The new constitution, adopted to supplant that of 1956, stressed Mao's Thought and the class struggle. Party membership was limited by class origin. The new constitution was much briefer than the old, and left party organization obscure, but General Lin Piao as vice chairman to Chairman Mao was stated to be "Comrade Mao Tse-Tung's close comrade-in-arms and successor." Of the fifteen hundred delegates, two-thirds appeared in military uniforms, while in the new Central Committee 45 percent were military (in 1956 it had been 19 percent). On the other hand the representation of the masses and mass organizations did not include many radical student youth. Two-thirds of them were from provincial positions. The great majority were newcomers to the Central Committee, yet their average age was about sixty. The Central Committee was not only more military but less educated and less prepared to deal with foreign affairs.

China's foreign relations during the GPCR had suffered from the same mindless zealotry, for the animus of the time was not only against things old but also against things foreign. Anti-intellectualism was accompanied by xenophobia. In 1965, when Chou En-lai as China's ambassador of good will went on extended tours in Africa and Asia, the Chinese program of extending its aid programs, such as building the Tan-Zam Railway in Africa, became intermixed with revolutionary incitement and espionage. The Chinese attempt to set up a Conference of Third World Countries in Algiers, excluding the Soviet Union, was a fiasco. Meanwhile the Communist party of Indonesia staged an attempted coup and was quite thoroughly destroyed by the Indonesian government. Such failures set the stage for China to pull in its horns during the Cultural Revolution. Nevertheless, the rampaging style of Red Guard attacks damaged the PRC's foreign relations, especially after Red Guards took over the Foreign Ministry in June 1967. Their squads systematically destroyed records and thoroughly disrupted the continuity of foreign relations. The foreign minister Ch'en I was forced to make self-criticism several times before thousands of jeering students, with Chou En-lai presiding. What foreign policy could be pursued had to be done through Chou's office.

As the Red Guard spirit of making revolution on all fronts spread into foreign relations, Chinese embassies abroad became centers of revolutionary proselytism and nondiplomatic incitement of local

Communists. From September 1966 to August 1967 this subjective and emotional approach to foreign contact led to the breaking off of relations with several countries, the recall of all but one of the PRC's ambassadors abroad, and a decline of foreign trade. As part of China's domestic disorder, Red Guard mobs invaded the Soviet and British embassies and in fact burned the British Embassy to the ground, as well as the Indonesian Embassy later on. Enormous denunciatory mass meetings were a poor substitute for diplomatic relations.

The Cultural Revolution period wound up with a significant shift in the PRC's relations with the United States and the Soviet Union. As the American ground and air war escalated in Vietnam after 1965, both the United States and China took measures to avoid a direct confrontation. As noted earlier, the American crusaders stopped short of fighting China again. They explicitly promised that their planes would try to avoid penetrating Chinese air space. The threat of war with the Americans, who were making war so close to China's borders, was damped down and Mao concluded he could proceed with his domestic revolution. The PRC's relations with the Soviet Union went in the opposite direction. The split, begun in 1960 and continued in polemics and exchanges of denunciations between the two parties, steadily intensified the Soviet-Chinese hostility. Border incidents began to occur along the four-thousand-mile frontier, and Soviet forces were built up accordingly. When the Soviet Red Army took over Czechoslovakia in August 1968, the Brezhnev doctrine was soon propounded, that where a Communist regime had been established it could not be allowed to be subverted. To the Chinese this sounded rather aggressive. Red Guard attacks in mid-1967 provoked a crisis in Hong Kong, but this tapered off after the PLA took power and curbed the Red Guards in 1968. Revolutionary activity through the Chinese embassies in Burma and Cambodia led to violent incidents and a breaking off of relations. Peking's mindless revolutionary policy encouraged the Japanese Communist party by accusing Japan of rearming, and it led to a clash with Indian patrols on the Sikkim-Tibet border. This time the Indians were better prepared, and a week's fighting ensued with no outcome. When North Korea went over wholeheartedly to collaboration with the Soviet Union, Chinese-North Korean relations worsened.

The Cultural Revolution's truculence toward the outside world came to a head on March 2, 1969, when the Chinese sent an ambush

force onto a disputed island in the Ussuri River, the main tributary of the Amur on China's northeast boundary. The Chinese in their white uniforms overwhelmed the Russian border patrols. Russian retaliation was vigorous, not only at that site but in the following year or two at many points along the Sino-Soviet border where incidents erupted, and the Chinese were thus put under pressure. By the end of 1969, as relations with Russia worsened, they began to improve with the United States.

In the United States the initial impression of the Cultural Revolution had reflected its propaganda. It was seen as Mao's effort to preserve egalitarian populist values and avoid bureaucratism and statism in the course of China's economic development. However, as news of the Red Guard excesses and the maltreatment of intellectuals gradually came out, the movement seemed more like totalitarian fanaticism under dictatorial leadership. The Nixon-Kissinger policy of seeking normal relations with the PRC had to go slow, even though led by a right-wing Republican.

Though the GPCR was officially ended in April 1969, many forms of its terrorism continued. During 1970–71 the military security personnel were particularly ruthless in searching for former members of a perhaps fictitious "May 16 Group." Innocent people were tortured into confessing membership and naming others. Several thousand were executed although it is uncertain whether any "May 16 Group" had really existed as charged.

In the 1970s, moreover, the GPCR spread its coercion into the countryside, where, for example, peasants were required to abandon all sideline occupations such as raising pigs, chickens, and ducks in order to "cut off the tail of capitalism." For many this meant starvation. All in all, the witch-hunt fever did not run its course until after Mao's death in 1976.

THE SUCCESSION STRUGGLE

Under way from 1969 there was a power struggle to secure the expected succession to Chairman Mao. The competition was to get the number 2 spot, which would give the holder a presumption of succession in due time. General Lin Piao had reached a high point at the formal conclusion of the Cultural Revolution in 1969. He brought his military people into increasing prominence in both party

and government. While the military continued to be divided in their orientations between the Central Military Command at Peking and the regional commanders in the provinces, General Lin nevertheless had a commanding position, in addition to having been designated Mao's chosen successor.

From 1969 to 1971, however, Lin's leading position began to deteriorate. For one thing, Mao wanted to reduce the role of the military in the political system. Consequently an attack on Lin was orchestrated by Mao, who had no further use for him, and apparently it was supervised as usual by Chou as premier. It was pursued on many fronts through the arcane and Aesopian use of words and symbols that are a specialty of Chinese politics. For example, when an anti-Lin man was put in the Central Military Headquarters under Lin, he was ostentatiously accompanied by Premier Chou and two leading generals of the old guard. Instead of Mao and Lin appearing side by side in widely disseminated photographs, Lin now appeared in the background. Again, a one-time aide of Mao, who had developed close relations with Lin, was accused and in the usual fashion required to give a self-criticism. All these were signs and symbols by which the ultimate power holder showed which way the wind was blowing. In short, General Lin had been of great use, but his usefulness had passed, while Chou En-lai in the number 3 post continued to work closely with Mao, especially on foreign relations and the rehabilitation of the government.

A final trick of Chairman Mao was to travel around, talk to regional military commanders, and criticize Lin. As this news was relayed to him by the bamboo telegraph, Lin realized that his days were numbered, and he became involved in a conspiratorial effort masterminded by his son who was in the central command. The alleged aim was to assassinate Mao and by a military coup take power in his place, as the only alternative to personal disaster. Lin's son made extensive preparations secretly but someone evidently kept Mao and Chou informed. In desperation Lin and his wife tried to get away by air, but their plane was destroyed far out in Mongolia as it evidently headed for Soviet territory.

In totalitarian fashion this top news of the day was unreported in the official press for more than a year, when a full story was finally released with documents and circumstantial evidence. Exactly what happened is still a mystery, but scholars in the West seem pretty well agreed on the above account.

The last five years of Mao's life and thought are highly enigmatic because he put forward almost no statements or policy pronouncements beyond a few paragraphs. In 1971 and 1972 he seemed to be working out with Chou a program for China's further development, but in 1973 the Shanghai faction of the Central Cultural Revolution Group or "Gang of Four" seems to have acquired greater influence over him. He grew infirm, and in his meetings with Nixon, Kissinger, and other foreign dignitaries seemed physically feeble, although his thinking seemed as sharp as ever. We know, for example, that when a photograph was taken showing Mao standing, supported by a nurse on either side, the photograph that came out for public consumption showed Mao alone with no nurses. About this time Chou on his part was becoming ill with cancer. Soon the Gang of Four used a major campaign to "criticize Lin Piao and criticize Confucius" as an indirect attack on Chou En-lai. The palace politics and power struggle confused most observers. While Chou was under attack, it is not certain that Mao was ready to destroy him. In any case Mao had come to the end of the line. In his last years he was as much a wreck as the country and party he had twice led to disaster. The GPCR is now seen, especially by its many victims, as ten lost years in China's modern development.

THE GPCR IN RETROSPECT

Statistics used in a short summary do not convey the experience of revolution—neither the heady though transient exhilaration of Red Guards in power nor the bitter suffering of their victims. A "literature of the wounded" soon began to report individuals' disasters—the scholar whose manuscript of an unpublished lifework is burned before his eyes, the husband who tries in vain to save the class status of his children by divorcing his wife, who has been labeled a rightist, the famous novelist who is simply beaten to death, the old school principal who is set to cleaning the latrines.

Since urine and feces (or, in nonliterary parlance, shit) form an essential Chinese fertilizer, it was much easier in China than it would be in the United States to give the upper class some experience of the life of the masses. For intellectuals to clean latrines was not simply a matter of a mop and detergent in a tiled lavatory, even a smelly public one. On the contrary, the cities of a rapidly developing China have both modern and early modern plumbing,

but their outskirts as well as the vast countryside have retained the old gravity system. The custom, so admired by ecologists, was to collect the daily accumulation, almost as regular as the action of the tides, for mixture with other organic matter and to develop it through composting to fertilize the fields. In fact, one noteworthy sight in any Chinese rural scene is the field latrine, where men and women on opposite sides of the central wall take care to deposit both liquids and solids during the day. The cleaning of latrines was therefore not simply a hygienic task to get rid of unwanted matter, but a fundamental supply question, to conserve a nutrient. When ten million or so Red Guards, after they got out of hand, were "sent down to the countryside," they also handled night soil, but they found black pig shit a richer product.

Yet even such labor was far less devastating than public humiliation in "struggle meetings." Targets might be required to stand on a platform, heads bowed respectfully to the masses, while acknowledging and repeating their ideological crimes. Typically they had to "airplane," stretching their arms out behind them like the wings of a jet. In the audience tears of sympathy might be in a friend's eyes, but from his mouth would come only curses and derisive jeering, especially if the victim after an hour or two fell over from muscular collapse. Lu Hsun's stories had been especially bitter at the Chinese sadistic laughter over the misery of others. Now Mao's revolution organized it on a massive public scale. Some preferred suicide.

To Chinese, so sensitive to peer-group esteem, to be beaten and humiliated in public before a jeering crowd including colleagues and old friends was like having one's skin taken off. Generally the victim felt guilty, as anyone may under attack, but especially because they had so venerated Mao and the party. When the charges against them seemed overblown, their experience became meaningless, especially when they so often saw their erstwhile torturers by a sudden shift of line become the tortured. For what cause were they suffering? Very often they wrote false confessions.

A salient thing that strikes one about the GPCR is its massive size. The record is far from fully compiled but estimates of victims now hover around a million, of whom a considerable number did not survive. The amount of witless destruction of the paraphernalia and institutions of Chinese civilization—books, temples, art, modern

"things" in general, stigmatized as "foreign"—has still not been estimated.

Another factor is the systematic cruelty of struggle meetings and the passivity with which Chinese audiences accepted this cruelty and the dictates of higher authority, even when represented only by ignorant teenagers. Many people had no other faith than in Chairman Mao. This put them in an unusual spot. The moral principles of Confucianism had been eroded away, but the Maoism put in its place could not be given an interpretation not sanctioned by Mao himself. It was as though Confucius and Mencius were currently alive and the reader of their works had no way to make an independent judgment on their application to the social scene. Confucian-type remonstrance with the power holder in the name of eternal truths from which he might have strayed was not possible when Mao was still in power and changing his mind from time to time. Intellectuals were left with no inner sanction great enough to overcome the hysteria of the crowd and their fear of it. The GPCR of course fed upon this public dependence on, and blind obedience to, authority. There was no idea of morality's being under the law.

Several other features strike one. First, the GPCR's original idealism, which inspired Red Guards and others, was at first quite genuine. Only by degrees did disillusion, hypocrisy, and corruption supervene, along with personal ambition and cynical opportunism.

But opportunists were even more susceptible to being orchestrated by Mao. We have no reason to believe that he was not the creator of the Red Guards, who followed his instruction, or the instigator of the attacks on the universities and the subsequent "Seizures of Power," or the final use of the PLA both to restore order and to continue the terror. The GPCR committee, Chiang Ch'ing and her colleagues, may well have manipulated a senile Mao, but the main decisions bear his stamp.

Mao was able to do this because of the imperial prerogatives that he had accumulated as the charismatic and sacrosanct great leader, above the law and unbound by precedent or custom. This in turn was possible because he presided over a regime based on his personality and ideology, not on law. Senator Joe McCarthy had persecuted Americans in the early 1950s but he had no police power. The law would let him subpoena and vilify people but not arrest and torture them. The Salem witchcraft trials of 1692 no doubt shared some of

the GPCR spirit, but to find analogies we have to turn back to Europe's sanguinary wars of religion, including the institution of the Inquisition, which was alive and well at Rome as late as 1814.

The most frequent comparison, between the GPCR and the Nazi holocaust, brings out the fact that the Nazis' genocide had relatively identifiable targets whereas Mao's GPCR found shifting targets and used ad hoc methods. Where the Nazi program was planned and systematic, the GPCR was improvised and sporadic.

To see the Cultural Revolution as a struggle of populace against intellectuals would be highly simplistic. To Western writers and historians, most of whom claim to be intellectuals, their counterpart types in other countries are ipso facto good guys. We have a predisposition to support intellectual freedom and human rights all over the world.

The first fly to be found when this ointment is applied to the Chinese revolution is the fact that most intellectuals are part of the establishment just as in earlier times. They seek to function within the establishment, not in opposition to it. They are seldom alienated but on the contrary likely to be quite Leninist, believers in central CCP control. Thus in most cases where Mao's Cultural Revolution in 1966 attacked intellectuals in the government, including the educational system, a great many of the victims were not averse to state tyranny but rather to Mao's populist methods. If one looks back one finds that these prominent victims like Deng Hsiao-p'ing had been full and active supporters of the Anti-Rightist Campaign of 1957–59. They had attacked many of their kind in the course of throwing 400,000 to 700,000 educated people out of power and denying them freedom to use their abilities for the state. We may therefore too easily idealize the prominent individuals whom Mao destroyed. Given a chance they would have destroyed Mao as the leader of a populist faction against the establishment faction. Intellectuals were a necessary part of the establishment for administrative, scientific, educational, and many other purposes. They were caught in a gigantic factional struggle for power.

It was apparent to Mao that most of the Sino-liberals from pre-1949 were still being liberals. Meantime the "establishment intellectuals" were a new class of scholar-officials. Graduates of the Higher Party School or even Moscow-trained, they were firm believers in the ideology of Marxism-Leninism and yet might have their own private

views on Mao's innovations. Among the government and party offi-
cialdom, these men were editors, writers, educators, and ideological
theorists capable of long disquisitions about the divagations of the
party line. Some among them cultivated the old scholarly arts: callig-
raphy, poetry, writing of essays, connoisseurship of art, historical
research. Moreover like true scholar-officials of old, they formed a
highly select and mutually acquainted group, given to ambitious
rivalries for power and position and therefore naturally members of
factions as factions developed.

Mao's defiance of his colleagues over the case of P'eng Te-huai
brought back factionalism in all its guises. Major officials became
patrons of minor officials and they all worked together to keep an-
other group out of power. Typically the occasion for their factional
organization came ostensibly from differences over theory and the
application of ideology. This new scholar-official class had the usual
esprit de corps and self-image as a selected elite. Their knowledge
of and concern for the peasantry became largely theoretical as they
had among the officials of the Ming and Ch'ing. Social revolution
might not continue in their hands, but they might form a new hard
crust of bureaucracy and privilege over the people. (As of 1985 it
must be confessed that some of these traits seem to have survived.
After all, the role of a Chinese scholar-official has more history and
practice behind it than almost any other role in history.)

THE DENOUEMENT

In the early 1970s, although the Shanghai element headed by the
Gang of Four continued to dominate the media of communication
and of culture, they had no way, even though backed by Mao, to take
over the administration of the government and economy. The ad-
ministrative establishment who were intent on economic develop-
ment gradually coagulated under Chou En-lai. When Chou, after
1973, became ill with cancer, he moved to make Deng Hsiao-p'ing
his successor. Though Deng had been targeted for destruction by the
GPCR, he was an experienced old-timer too well connected, espe-
cially with the military, and too able and dynamic to be cast aside as
Liu Shao-ch'i had been. Just before the Fourth National People's
Congress of January 1975 he was made vice chairman of the party
and a member of the Standing Committee of the Politburo at the

center of power. The National Congress next made Deng the first vice premier, number 3 in the hierarchy behind Mao and Chou, and Deng also became chief of the army. The Congress heard Chou En-lai put forth the call for the Four Modernizations, one of his last public acts.

After Chou En-lai died in January 1976, the Gang of Four banned any mourning, but on the annual day for mourning the dead in April they could not prevent a great crowd of hundreds of thousands gathering around the Martyrs Memorial in the T'ien-an-men Square to express their love and veneration of the dead premier. This became the April Fifth (4–5) incident, historically parallel to May Fourth (5–4). Orchestrated by the opposition to the Gang of Four, it represented a pervasive disillusionment at the popular level. The demonstration was suppressed, and Deng Hsiao-p'ing in the spirit of the GPCR was for a second time removed from power.

But the Gang of Four could not suppress the great T'ang-shan earthquake that in July suddenly killed half a million people east of Peking, and forced Peking residents to move into the streets. Of course every peasant believed in the umbilical relationship between man and nature, and therefore between natural disasters and human calamities. After such an overwhelming portent, Mao could only die. He did so on September 9, 1976. He left the succession to his thoroughly unmemorable look-alike, Hua Kuo-feng, a security chief from Hunan. In October the Gang of Four, consisting of Mao's wife Chiang Ch'ing and three of her colleagues in the Central Cultural Revolution Group, were arrested and held for trial. In the complex maneuvering for power, Deng Hsiao-p'ing won out in late 1978.

Meantime, it became obvious that the appraisal and reappraisal of Mao would continue for generations. As analysis of his record continued, his once-hallowed image began to shatter into fragments. For example, if Mao really aimed to "liberate" and benefit the rural masses, how could he preside over the starvation and death of so many of them? One answer may lie in the nature of what he was after. If collectivization of agriculture actually failed to improve production, this could be put down to his economic ignorance with "politics in command." But this suggests Mao's aim was more political than economic, organization rather than betterment. This in turn suggests that the CCP revolution, like a takeover by any new dynasty, was a drive for power by a group dedicated to unifying and

controlling China. On their way up their conscious or at least publicized aim was liberation and New Democracy. It was like an American campaign platform. Once in power, however, the CCP's aim subtly began to shift toward holding on to power. Eventually this led to a factional power struggle. By that time Mao's class-struggle ideology had become a visionary's abstraction not connected with human flesh and blood. Peasants, like intellectuals and officials, were expendable in the service of an ideal. Such a corruption by power holding is of course one of the oldest political phenomena, often rationalized as *raisons d'état.* Some argue that by putting politics in command the CCP under Mao turned its back on the cause of rural economic betterment in favor of a controlled and egalitarian collectivization— in effect, all sharing the poverty.

Among most Chinese, those in the villages, the final effect of the GPCR was disillusionment with socialist government and a renewal of reliance on the family. Consider these anomalies: Class status, once ascribed in the 1950s, had been inherited by the succeeding generation and now amounted almost to a caste system. Offspring of the 6 percent who had been classified as of the "four bad types" (landlord, rich peasant, counterrevolutionary, and bad element) lived under a permanent cloud. Meanwhile mobility from city to countryside had continued to be cut off and peasant life was disesteemed as inferior, uncivilized, and to be avoided. The "sending down" to the villages of some 14 million urban youth had done little to change this image. The collectivized rural economy had signally failed to produce more, and highhanded but ignorant cadres had intervened in it destructively. In the 1960s the cult of Mao had supplanted the local gods and other figures of the old peasant religion, but by the mid-1970s the GPCR violence and Lin Piao's fall had tarnished Mao's image. Public health successes had doubled the population. Even the great achievements of the revolution in spreading primary school literacy, road transport, and communication by press and radio had partly backfired by revealing how much farther China still had to go. Imperialism was ended but so were foreign stimuli, while the old "feudal" values and corrupt practices remained still embedded in Chinese society. By the time Mao died, his revolution was dead too.

18

New Directions:
Deng Hsiao-p'ing's Reforms

CHINA NOW TURNED A CORNER. The era of revolution and violent struggle was followed by an era of reform and consolidation. The contrast between the two periods could hardly be greater. Chou En-lai had first proposed in 1964 a program for the Four Modernizations (anything significant in China needs a number) in the areas of industry, agriculture, science-and-technology, and defense. He renewed the proposal in 1975. This now took the place of class struggle, which was abandoned. The Maoist "politics in command" and "red over expert" were supplanted by the ancient statecraft slogan "seek truth from facts."

From China's having a supreme leader in the person of Mao, the leadership now became less obvious. Deng remained only a vice premier, making use of his long experience and seniority informally and working through others. The ideas of the economist Ch'en Yun were resurrected. Prominent earlier leaders like P'eng Chen, who had been chief man in Peking but an early victim of the Cultural Revolution, were brought back into action. Conservative versus reformist policy conflicts were still mixed in with personal power struggles. (The reform group someday may be compared to the Japanese Genrō who built the modern Japanese state and economy one hundred years ago.) To be free of the cantankerous unpredictability of Mao smoothed the path for the Deng reforms. They won public

acceptance like those of the Han after the Heaven-storming tyranny of the Ch'in First Emperor or of the T'ang after the grandiose excesses of the Sui.

The about-face in CCP policy from class struggle to economic reform was a startling change in the means, if not the ends, of the Chinese revolution. The transition took two years until late 1978 to establish Deng Hsiao-p'ing in power as China's "paramount leader." What was the context in which Deng's reform program got started?

In the 1970s the PRC was plodding along in the centralized muscle-bound totalitarian fashion of the USSR. Bureaucratic controls stifled initiative but some progress still occurred. Deng's motive, in the 1980s, must therefore be seen as very similar to Mao's (and his) in the GLF of 1958–60—to speed up China's growth to wealth and power. Mao, and Deng with him, had been averse to centralization, which produced a stultifying bureaucratism. The difference after 1978 was that Deng was now trying to advance by a new route of fostering initiative but at the same time rebuilding the party and government. He realized that China's growth had to be engineered *through* a trained bureaucracy, not by trying to go around it. This was more practical than Mao's moralistic, willful approach but also was a far more complex task.

The first reform was in foreign relations. The PRC turned outward again, welcoming foreign contact. Normalization of Sino-American relations, begun in 1972, was completed in January 1979. Vice Premier Deng toured the United States, demonstrating that any survivor of the Cultural Revolution would have no trouble with the corny shenanigans of American politics. Soon ten thousand Chinese academic-technical specialists were studying in the United States while a hundred thousand American tourists were taking their dollars to China. In some ways it seemed like old times.

Deng's "open door" policy acknowledged that the Chinese economy could progress only with a greater infusion of technology and capital, both of which could be obtained abroad. Technology transfer became a major objective. Contracts with foreign firms for the installation of new machinery, factories, production processes, tourist hotels, and the extraction of coal and oil, to name but a few, would simultaneously bring in both capital and technology.

To get some flavor of the new China emerging in the mid-1980s, let us note developments in certain sectors such as the CCP, its

legitimacy and personnel, economic management, and the intellectuals.

REBUILDING THE PARTY

One of the Deng regime's first needs was to reestablish the CCP's legitimacy, its right to rule, by acknowledging its errors. As a first step it reappraised the careers of several hundred thousand "rightists" put out of action in 1957 and later, and rehabilitated them. Liu Shao-ch'i had died neglected in 1969, so his rehabilitation like that of many others had to be posthumous. This better-late-than-never approach expressed the Chinese concern for the historical record.

Mao was a problem. Having been both Lenin and Stalin in China, he could not simply be denounced without pulling down the temple. The solution was to divide Mao into his good early phase and his bad last phase. This by and large added up to 70 percent good and 30 percent bad—fair enough, from the CCP viewpoint. Mao's Thought, from the early phase, could still be the guide to China's future, especially when interpreted by skillful dialecticians. The resolution "On questions of Party history" by the CCP Central Committee in June 1981 also acknowledged that the Central Committee had been "partly responsible" for the breakdown of collective leadership. This was reminiscent of an emperor's penitential edict which took responsibility for untoward events to prove that he was still doing his job. As part of this effort, the Cultural Revolution was held up as a comprehensive disaster, both unnecessary and destructive. To promote the legitimacy of the Four Modernizations, the party harked back to Li Hung-chang's Self-Strengthening movement of the late nineteenth century and extolled the efforts of Sun Yat-sen. Both had stressed the importance of foreign technique as well as machinery.

To regain public confidence the party membership also had to be sifted out and upgraded. Of the forty million party members only 4 percent were estimated to have a college education and only 14 percent a middle-school (high-school) education. The half of the forty million who had come into the party during the Cultural Revolution were weak in expert training and even in literacy, while still strong in the ideology of mass movements in the Maoist style. After all, their principal experience in the party had been to attack the establishment. They could hardly be relied upon now. To reestablish party

discipline and obedience to its directives was a first necessity, but this party reform was a delicate matter. The Deng regime tried to head off factionalism by stressing regularity of procedure and a revival of democratic discussion within party councils.

The Twelfth Party Congress of September 1982 inaugurated an extensive rectification movement, which, however, was kept an intra-party matter without attention to mass opinion. Simultaneously an effort was made to recruit intellectuals and skilled technicians into party membership. Naturally this reversal of the Maoist tradition met resistance, but in the end, the drive for production and modernizations had such an immediate effect in material terms that the old-line ideological opposition gradually became quiescent.

During the five years to 1985 more than a million senior CCP cadres were pensioned off. In September 1985, 131 high-ranking veterans resigned. Generally they retained their perquisites as members of a new Central Advisory Commission of the CCP headed by Deng.

Pruning the military was slower work, but by 1985 budgets and manpower had been significantly reduced, forty general staff officers had retired, and 10 percent of the officer corps began to follow them. In June 1985 the PLA's eleven military regions were reduced to seven, losing half their senior officers. The military also lost their prominence in the CCP Central Committee.

ECONOMIC DEVELOPMENT: AGRICULTURE

The Maoist era had left behind not only over-age leaders but also many economic problems. For twenty years the growth of agricultural product had lagged behind. The amount of arable land had declined by 11 percent or more owing to the take-over of land for new construction. Population rose from a census figure of 586 million in 1953–54 to an estimated 630 million by 1957, 820 million by 1970, 880 million in 1974, over one billion in the early 1980s and still growing. This growth was only partly compensated by the increase of night soil fertilizer. The tendency was to eat up the production gains of the revolution and strain the resources of space and housing as well as the public services. Moreover, the overabundant manpower was undertrained and some quarter were illiterate. Meanwhile the guarantee of jobs and livelihood had inhibited the increase

of productivity. The emphasis on heavy industry and elimination of sideline enterprises in the countryside had left somewhere between forty and ninety million unemployed in rural areas, and between ten and thirty million in the cities. In spite of (or because of) the heavy investment in industry, the standard of living had stagnated. A reassessment of Maoist economic policy was in order.

The original strategy for agricultural development under the PRC had assumed that China's labor force could be mobilized and itself provide the infrastructure of irrigation, roads, and fields, if it could be properly motivated. Cooperativization and rural communes in the 1950s did indeed make available a great deal of unused rural labor power. Although the labor invested in earth moving and rock cutting was at the time very expensive, it was argued that thereafter there would be greater production and productivity per person. Unfortunately this self-sufficient strategy in agriculture, although widely advocated for developing countries, had seldom worked out. Improvement came from tube-well water pumps more than from irrigation channels, and from fertilizers, insecticides, and better strains of crop rather than from large, level fields. On the whole it is dubious that labor mobilization through the cooperatives and communes had improved production.

In order to provide consumer goods, small-scale plants in rural areas had begun an industrialization of the countryside *in situ,* which had been more successful as an inaugural stage. Small-scale plants avoided heavy transportation costs. For cement, the ingredients could usually be found locally. Similarly, repair of machinery, so unavoidable in their rural use, could be combined most efficiently with small-plant production of machinery. Chemical fertilizer could also be locally made, but the steel industry was out of place in the countryside and textiles were more efficiently produced in city factories.

As to rural income becoming equalized and the inequality of standards of living being reduced, these had plainly been achieved in spirit by the destruction of the landlord class and the bringing of landless labor into the cooperative community. However, aside from the egalitarian spirit so achieved, it is not at all certain that equalization of income had made much progress. One main reason was that different areas had different resources and different capacities for growth and improvement. Farmers in a poor, rocky, mountainous

region with little irrigation were condemned to poverty unless given a handout from outside. Farmers in the Lower Yangtze rice and irrigation system were likely to continue to have a higher living standard. Another factor making for inequality was the prohibition of rural migration to the cities. As a result, the city work force became more fully employed and better off. This betterment spread to the countryside round about, but not to a great distance.

In approaching the reform of agriculture after 1976 planners recognized that rural management had been faulty, first of all in the motivation of the farmer. A principal move therefore was to encourage by-product or sideline production on farms, in addition to grain production. The farmer's by-products could be sold on free markets locally, which would raise his income. Another change in management was the "production responsibility system." This mouthful of a term included half-a-dozen or more variations but they all were based on contracts. We might better think of it as the "contract system." After various stages of experimentation the contracts generally were made between the production team (usually a village) and the individual household. The team managers (cadres) made an overall plan and then contracted with households for them to use certain plots of land. Contracts stated the output targets and compensation to be paid the household. The result was to take the bookkeeping of accounts out of the big organizations like brigades and bring it back to the production teams of, say, twenty-five families.

To move responsibility down to the individual farm family provided a great incentive, because it meant that the more they worked the more they could produce for themselves and not see it pooled in the local pot. Land could not be purchased, but it could be used on this basis. Instead of meeting grain payments to a landlord state, the farm families now farmed certain parcels of land and returned certain quantities of crops to the team. This was the "full responsibility to the household" *(baogan)* system, which became almost universal. The earlier Maoist system of the GPCR had used moral exhortation as an incentive, had demanded grain production only, and had banned sideline production as incipient "capitalism"—a triumph of centralized blueprint ideology over reality.

This change of system now made a big difference. Instead of the local authorities concentrating on their grain-quota collections from the farmers, and the farmers having to fend for themselves in their

sideline occupations like the sale of pigs and chickens, now the whole community could join in planning to maximize production and income. Farmers found that sideline products were more profitable than grain production, and planners therefore began to import grain supplies on the basis of comparative advantage, although this could not go very far without becoming an insuperable burden for the government.

Anyone who concludes that Chinese agriculture, having seen the light and wanting to be more like us, has gone "capitalist," is making a grievous error. The contract system must be seen as the latest phase of statecraft, how to organize the farmers in order to improve their welfare and strengthen the state. China's ruling class had dealt with this problem century after century since the beginning of the historical record. They found that contracts in a semi-commercialized agriculture increased incentives and therefore production. It was as simple as that. Wei Yuan and other statecraft scholars of earlier times would undoubtedly have understood and approved these new methods of organizing the farming masses on the land.

So what had the revolution achieved for the farm family? The pressure of numbers and scarcity of land were greater than ever. The workload had hardly diminished. Landlords had been supplanted by the cadres in charge of production teams. The difference was in peasant mentality, behavior, and opportunity. In the Maoist era the door had been opened to education, public health, and improved technology. The doctrine of egalitarianism had given the peasant a new view of himself and his potentialities, even though the 1980s brought decollectivization and more rich peasants.

ECONOMIC DEVELOPMENT: INDUSTRY

Deng's most spectacular reversal of economic policy was his "open door" for foreign trade, technology, and investment. In the perspective of China's foreign relations since 1800, this was a swing of the pendulum. Before the unequal treaties of the 1840s and '50s Ch'ing policy had ostensibly regarded foreign trade and contact as inconsequential. The Canton trade exports of tea and silk were occasionally stopped in order to coerce the foreigners. But meanwhile Chinese labor-intensive handicraft products, primarily teas and silks, became staple export goods in the newly-opened coastal emporia

known as "treaty ports." In the late nineteenth and early twentieth centuries, foreign trade gradually reduced China's traditional self-sufficiency. For example, kerosene for illumination became a major import. The subject needs overall appraisal in economic terms. But in general China's slowness in modernization still made possible in the 1940s a virtual autarky in Free China's remote inland regions, like Shensi province under the CCP regime at Yenan.

In short, a doctrine of self-sufficiency had been part of the xeno-phobia inherited from the Ming and early Ch'ing. The CCP's penchant for autarky after 1949 expressed deep anti-imperialist sentiments. Deng Hsiao-p'ing's "open door" after 1978 did not represent China's long-term tradition. Not only did it recall the United States Open Door doctrine, which had been our alternative to (or substitute for) imperialism after 1899. It also countered the Soviet model of closed industrial development.

Even in the late 1970s China's investment policy had continued to be a rather simple-minded copying of the Soviets. The basic assumptions were first that the ratio of capital to output was fixed, that is, increase of investment would get an increase of output without any difference year after year. Second, foreign trade was held to be unimportant, and production of consumer goods for export to secure foreign capital was not envisaged. From these assumptions, it followed that the way to industrialize was to invest as much as possible and consume as little as possible. In other words, heavy industry will build a future while consumer goods will delay it. In the 1960s and 1970s the Chinese, on this basis, invested something like 30 percent of the national income. This Chinese attempt at autarky purposely avoided the great opportunity that could have come with the importation of foreign capital.

As time went on, the ratio of capital to output gradually rose, that is, it would take more capital investment to produce a given amount of output. When the national income growth rate fell and the investment rate continued to rise, the amount left for consumption could hardly grow. Production was also held back by the diversion of funds to defense, by a decline in worker incentives, by an increasing difficulty of terrain in railroad building, and the like. Moreover, industrial equipment was old and inefficient, some 60 percent of it in need of replacement. Problems of management included the overrigidity of central planning, and the stress on physical quantities of output,

which often found no market and represented a net loss. For several years after 1976 the Soviet industrial strategy continued, perhaps partly because the industrial planners had been removed from the scene. Of the three hundred top economic officials, at least one hundred were purged and only one-quarter were still in office after the GPCR.

The PRC after 1949 had embarked on a policy of building up heavy industry in the interior provinces, while shutting off foreign trade and investment. The Soviet-type command economy was highly centralized. In each aspect of production the local and provincial producers were in a vertical structure that headed up in the appropriate ministry in Peking, supervised by one of the vice premiers. One can almost feel that the idea was to get back to the Ch'ien-lung period, except that Mao's socialism wanted to achieve a rapid industrial expansion based on collectivized agriculture, central planning, and a stress on heavy industry in interior (more defensible) provincial cities. By the 1970s the triune vested interests of heavy industry, the interior provinces, and the Peking bureaucracy could dominate economic policy even though plagued by the shortages in industrial production and the unconcern for consumer demand that characterize a command economy. The Five-Year Plan proposed in 1978 reminds one of Sun Yat-sen's blueprint for railroad development, unrealistically theoretical. For example, the Ta-ching oil field in the Northeast had become a major producing center, so the plan called for ten more such oil fields to be developed, regardless of whether the oil was there awaiting extraction.

Not until 1979 did the planning strategy make a basic shift to emphasize agriculture and consumer goods for sale abroad. Heavy industry growth would in any case be held down by the comparative lack of energy for it, while light industry was to be helped by foreign investment.

These industrial reforms could not be termed a revival of "capitalism" since the party and the state still called the tune and remained devoted to collectivism, that is "socialism." But the autonomy of enterprises and the more open market, like the responsibility system in agriculture, greatly improved the incentives for production. While a rich peasant economy built up in the countryside, industrial enterprises also forged ahead. Under the responsibility system in industry, authority was given to managers more than committees. State enter-

prises, instead of returning all their profits (and losses) to the government, now kept their own books and, though they paid a high income tax on their profits, they retained the rest for reinvestment in machinery or building up amenities and services for employees.

One evil of the old system had been the cadres' desire to report projects accomplished in the form of new and often excess capacity in quicker-built small plants rather than large ones. The government now met this inefficiency by instituting loans at interest instead of outright one-time grants to finance projects. Repayment of an interest-bearing loan thus became an incentive for cost accounting instead of mere growth in capacity. As the local governments were allowed to retain revenue from their products as an incentive, they were moved to invest in consumer-goods industries with high prospective profits rather than in the less-profitable types of infrastructure investment in transportation and heavy industry. Local governments for a time became the producers of two-fifths of the nation's steel and two-thirds of its cement output. In order to increase production in low-profit industries like mining or telecommunications, the central planners instituted a "key project" system, by which government agencies were mobilized ad hoc to achieve specific results.

The new incentive system of allowing local plants to retain part of their profits also had the effect of taking much of the construction potential out of the central government's budget and leaving it at the disposal of local government agencies. It was found that construction projects could not be handled from the center. Instead of receiving their grants as formerly without regard for the completion of their projects, construction companies were now asked to bid on projects and undertake to secure all the materials required.

Thus the balance of forces after 1978 swung back to (1) the open door for trade and foreign investment, (2) the buildup, therefore, of the coastal cities formerly prominent in foreign trade, and (3) a stress on consumer-goods industries and local initiative rather than complete central control. But serious problems soon confronted this new effort. Once provincial and local governments had the opportunity, they moved rapidly into light-industry production of consumer goods for profitable sales to meet market demand, but the price structure was still controlled from the center and not left to the free play of market forces. Intense competition among local governments and

enterprises produced not only great expansion of light industry but also many undesirable side effects: shortages of basic supplies, bidding up of labor costs, blockading the products of one area to prevent their sale in another, and meantime a reduction of central government revenues needed for building infrastructure in the form of transportation routes, hydropower, and mines. In general this expansion seems to have been accompanied by a great deal of bureaucratic enterprise, both legal and illegal, without necessarily improving cost efficiency or labor productivity.

Current developments in industry are not an historian's province. To pontificate here on China's production and trade in the 1980s could only diminish our credibility, such as it may be. Without competing with the *China Business Review,* let us note here only one index of growth, the decentralization of banking to aid the expansion of credit. China's government finances before 1949 had been generally decentralized. In contrast, when the People's Bank in the 1950s guarded against inflation by tight control of currency and credit, it also limited foreign exchange and international trade and kept savings and commercial funds highly centralized.

When the Deng reforms after 1978 gave some scope for private enterprise and market forces, a great need for credit expansion led to decentralizing the banking system. The People's Bank of China became the central policy maker and overseer for specialized banks dealing with industry and commerce, foreign exchange, international investment, agriculture, and insurance as well as construction. The People's Bank and its subordinate agencies, by making loans instead of grants, were able by setting interest rates to encourage cost efficiency. The effort was to take control of the appointment of personnel and making of decisions out of the hands of local political forces within the bureaucracy. However, the size of these bureaucracies inevitably presented a problem in itself. Thus the specialized bank to finance construction had 2,700 branches employing 46,000 people, whereas the specialized Industrial and Commercial Bank had over 3,000 branches and 300,000 people. The latter bank not only made loans for working capital for commercial and industrial enterprises, it also encouraged technological updating of plants in order to increase output and efficiency. Financing of industries was also assisted by the issuance of stocks, which implied the eventual setting up of a stock market.

THE DENG REFORMS IN HISTORICAL PERSPECTIVE

Oscillations between policy extremes have been a Chinese specialty. For example, in the campaigns of the Maoist era a new line might be taken up so vigorously as to produce excesses, which then might have to be corrected through a new campaign. One can also see an alternation between mobilization for social revolution and consolidation for economic development. In an era of revolutionary growth and change, a swing-back of the pendulum can hardly return simply to its earlier position. But "getting back" to earlier and perhaps happier times has been a constant policy motif.

On this scale where are the Deng reforms positioned? While their substance may seem natural to us, in China they are less a normal middle way than we might suppose. They stand for modernity, to be sure, but China's record of modernization has often been two steps forward, one step back. The PRC's entrance into international life cannot be reversed in general yet may be modified in particular respects.

One issue is that of central control. Is it becoming an impossible task because of the sheer size of China? The Soviets have had their difficulties with a centralized command economy but China has four times the number of people. The Chinese capacity for organization was evident in the late imperial era but generally at a superficial level. With the growth of more penetrating government in the twentieth century, the issue between central control and local initiative has been sharpened. At Peking fifty or so ministries are grouped in half-a-dozen functional systems, each supervised by a vice premier. A vertical structure of subordinate territorial agencies stretches down from the capital to the province and the county, under which (in place of the commune) has been established the *hsiang* (ward or township) about the size of a central market area. This downward penetration of the ministerial structure from the center has produced a great mass of local cadres or managers in charge of production teams and local enterprises on up to higher levels. In other words the bureaucracy of imperial times, which reached down to the village through the lower gentry, has now been enormously inflated to handle the new structure of a command economy as well as mass mobilization and the control system. The suggestion may be offered

that the sheer size of these structures and personnel makes for bureaucratism and delay in administration as well as the deflection of central goals to suit local interests. The result is unwieldy and will no doubt contribute to holding China back.

The center's loss of control over local enterprises has followed from the decentralization of control over material resources. Where the state provides, say, only a third of the raw materials and supplies needed by an enterprise, it can no longer call the tune.

An important side effect of less central control has been the growth of local corruption. "Become an official and get rich" is after all embedded in China's soil, always ready to sprout. Under Maoism the local cadres pushed the people around in a very doctrinaire fashion. But in the era of the responsibility system corruption, profiteering from official position, and working with local connections and conniving managers of other collective enterprises flout the worthy government objectives. Now that units are more on their own in the use of funds, corruption takes the form not only of falsifying records to evade taxes but also of investing funds of the unit to profit illegally in all manner of collusive deals and sub-rosa contracts. Black marketing, real-estate speculation, and overinvestment in redundant productive capacity help to build up self-sufficient kingdoms. Where cadre managers formerly tried to take it out of the people, now they try to take it out of the state economy. It is the old evil of local particularism, but raised to a much higher power because the local managerial class has grown proportionally so much larger than it used to be.

This suggests that the Deng reforms are not bringing Western-style capitalism to China, except for the state capitalism of corporations that make deals with foreigners, but rather they are bringing an expanded form of what might be called "bureaucratic socialism." This is on the analogy of the "bureaucratic capitalism" of the era before 1949. In other words, a modernization that elsewhere has generally produced a new middle class, in China seems likely to produce a local and mid-level leadership that remains essentially bureaucratic. This denies the egalitarian liberation of the common man that was the battle cry of the revolution. It also allows the poor to get poorer as the rich get richer, while hard-won collective institutions like schools and clinics may be allowed to collapse.

Another side effect has been the return of the foreign presence,

which seems bound to rouse xenophobia. The necessary decision to open China to participation in the world economy has revived certain features reminiscent of the nineteenth century, although imperialism has been eliminated. Thus there were soon some fourteen major ports open to foreign investment, a right which the unequal treaties did not secure for foreign industrialists until 1896. The modern hotels, shops, and buses for the tourist trade may be called a form of extraterritoriality because in using them one need not leave home. The foreigner still has special privileges in China, beginning with foreign currency. The growth of emporia like Shanghai and Hong Kong has now been joined by the special economic zones like Shenzhen near Hong Kong, designed to attract foreign investment and set up a joint venture or collaborative economy.

Though anti-foreignism is hardly a serious issue as such, it may contribute along with corruption to the rise of a Mao-type nativist reaction. The expression of "righteous scholarly opinion" *(ch'ing-i* or *qingi)* was an old Confucian specialty. Mao Tse-tung's advocacy of an austere, high-principled egalitarianism harked back to it. It can feed the flame of an anti-materialistic, autarkic righteousness opposed to Deng's open door and local enterprise. One way to counter this atavistic reaction is of course to build new institutions.

THE LAW AND OTHER PROBLEMS

One innovation was to seek a modern legal system. Foreign trade and joint ventures inevitably created an urgent need for lawyers to handle contracts and litigation of commercial disputes. Here was a principal area of innovation worth viewing against its historical background. Chinese administrations had always had law codes—administrative for the bureaucracy, criminal for the populace. Late Ch'ing law reformers, followed by the Nationalist Government in the 1930s, had tried to create more comprehensive modern legal codes. At the same time constitutionalism, which had seemed like a panacea to supplant the imperial despotism, was given formal acknowledgment in a considerable series of documents published by governments and parties. "The Law," however, still played little role in the life of the common people. Litigation before a magistrate remained something to avoid. Local disputes were settled by mediation among all the interested parties, including a public interested in moral jus-

tice and proper, go-along behavior. The PRC in its first years had continued to put forward constitutions and a few laws and decrees, but a "supremacy of law" was hard to find because the supreme power rested in the party and its policies would naturally fluctuate. For a time under Mao, law and morality were amalgamated. Moral behavior, according to party standards, was promoted by the government and immoral behavior was penalized much as under imperial Confucianism. As a result law and policy tended to coincide. Anything contrary to party policy was ipso facto illegal.

By 1981 a new policy was in place, that a genuine legal system should be built up separate from the party. Legal skills were needed not only for foreign trade but also for homeside management. State enterprises having been converted into independent accounting entities, their managers were responsible for profits and losses, the handling of contracts and of investments. One estimate is that these enterprises could use 400,000 legal counsels.

The new state constitution adopted in 1982 specified that the National People's Congress should be the legislative body in which laws should be initiated and by which their enforcement should be pursued. In general the Congress was given much greater authority and prestige, at least on paper. The Ministry of Justice, which had been abolished in 1959, was reinstated in 1979, and People's Courts were set up at four levels—supreme, higher, intermediate and basic. By 1984 there were about 15,000 courts and tribunals, and 70,000 judges. At the same levels were reestablished the People's Procuracies as well as the profession of lawyer. Yet these lawyers were government employees, and when assigned to defend an accused party, they mainly tried to mitigate his sentence. No "presumption of innocence" was established.

In addition to being limited in scope, the new legal system had to start from scratch in personnel. In 1985 a score of higher-education institutions had law departments enrolling some 13,000 students. There were fifteen legal research institutions. Knowledge of law was being spread through the Ministry of Justice and the media. But, since judicial personnel were appointed by the National People's Congress, there was little separation between legislative and judicial functions, and meantime both were overridden by the party dictatorship of which the whole government was a creation. In effect the legal system was not independent from the party and its policies.

In the Deng legal reforms one underlying issue was whether state officials could be protected by administrative procedures from the arbitrary attack of populist movements as in the GPCR. The development of law under the CCP is, we may surmise, aimed first at the limitation of arbitrary power, not at ensuring the human rights of the individual. The one underlying principle is that party control is sacrosanct and law is one of its tools. This certainly is reminiscent of dynastic rule rather than of modern pluralism.

For China to shift to a rule by law from the old rule by ethics was no more urgent or difficult than to reduce population growth. Here the bureaucracy could be of use, in fact was indispensable. The fertility rate in 1984 was about 2.3 per couple. Given a base of over a billion people, preponderantly young (a heritage from Maoism), even this low rate of increase would mean a total of 2.1 billion by the year 2080—this in a land which had only one-quarter to one-third the world per capita average cropland and one-quarter the world per capita average of fresh water. By campaigning for only one child per couple, the PRC hoped to bring the fertility rate down to 1.7 (As with other human enterprises like authors' deadlines, goals have to be set above the desired level of performance.) Whatever the one-child-per-couple campaign might achieve, it would be almost impossible to avoid having a Chinese population of 1.5 billion by 2050.

On the axis between today's modernization and China's inherited culture, one-child-per-family endangers the old family values. If there is no son to look after aged parents and revere the ancestors, the daughter will have to do it. This threatens the patriarchal family.

Overpopulation is, of course, a world problem. Given the uncontrolled spawning of people in Africa, Asia, Latin America, and elsewhere and the new American religion of adoration of the fetus, there may seem to be no peaceful way out. If so, human irrationality may rise to the nuclear level. Individual life we know is only in small part consciously purposed and the life of human society even less so. From this perspective the PRC is leading the world in a necessary effort.

At the same time the Deng regime seems to be avoiding the kind of militarism that overtook Chiang Kai-shek. The military though much more powerful are still in their place subordinate to the party. The People's Liberation Army, which once totaled about 4 million, of whom 3 million or so were ground forces, has now been reduced. Its striking power beyond China's borders remains limited. For ex-

ample, the sizable submarine fleet seems geared to coastal defense; the air force has stressed defensive fighter interceptors more than fighter bombers. Although China exploded an atomic bomb in 1964 and a hydrogen bomb in 1967, its inventory of perhaps 300 missiles is necessarily defensive. The top command eschews Star Wars fantasies and avoids arms races. Modernization is proceeding, but there is little sign of the PRC developing a high seas fleet or sending expeditionary forces far abroad in the imperial Mongol, British, Japanese, or American style. The Han rulers decided long ago that expeditions to chastise barbarians outside the wall must do their job within a few weeks before they ran out of supplies. Foreign adventures were few and generally disesteemed (like the great Ming voyages to India and Africa in 1405–33) because they would reduce the bureaucrats' resources.

However, before we Americans idealize the PRC, let us keep in mind that it remains a party dictatorship. Most of us have difficulty imagining what totalitarian life is really like. Marriage and family, work and play look to the tourist not so different from an open society. The difference comes in interpersonal relations, where a hierarchy of authorities gives some people power over others. Your work unit keeps your secret dossier as a massive kind of report card. In your work unit *(danwei)* or its equivalent, your superiors control your work assignment, housing, rations, education, travel, entertainment, and even marriage and child bearing. Both thought and conduct are under constant scrutiny. Despotism was an old Chinese custom. We may well feel totalitarianism is trying to become a new Chinese custom. But what if we look back at the way the Chinese family used to dominate its members? Isn't today's all-providing, all-controlling work unit an updated form of the old family system? This raises a disturbing question: how from outside a foreign culture can one reach large conclusions without jumping to them?

Finally, the Deng era by reviving intellectual life soon met an old problem: intellectuals demanded freedom of individual expression, necessarily in great variety, but in proper Confucian style the power holders feared moral chaos would result. How could any right-thinking administrator, bearing his inevitable responsibility for social morals and order, not be alarmed by paintings of nude women, novels depicting premarital love-making, disco dancing, or other forms of "spiritual pollution"?

The Anti-Rightist Campaign of 1957 had victimized many of the modern-minded and Western-oriented Chinese intellectuals whom I have described as Sino-liberals, left over from before 1949. They had asserted the autonomy of expert judgment, harking back to the Confucian tradition that the scholar knows the proper principles of government. With this they combined the specialized expertise of the modern professional, who also demands autonomy within his sphere. Once these people had been put out of action in 1957 the Chinese revolution under Mao was ready for a second stage, the GPCR, in which the party and state establishment, most of whom were by definition intellectuals, should also be thrown out of power.

After Mao and his gang were gone, encouragement of intellectuals became a first order of business. The educational trend of the Deng reforms was toward the creation of a Soviet-type intellectual class, suited to bureaucratic behavior, well trained but obedient. For a brief two-year period in 1978–79 the regime allowed personal freedom and true democracy to be advocated in big-character posters on "Democracy Wall" in Peking. But this phase was short-lived. The most prominent advocate of true democracy as a "fifth modernization," a young man named Wei Jing-sheng, was sentenced on flagrantly spurious grounds to fifteen years in jail—the usual tactic of stopping a movement by decapitating it.

While the revival of the Sino-liberal spirit continued in literature and many other lines, the CCP was up against the old KMT dilemma: to let freedom ring might be the death knell of the party dictatorship, but to suppress it too severely would alienate the talented elite whose support was indispensable. There is no quick fix for this problem, as we in America have discovered when we perpetually try to legislate virtue. Once the responsibility system allowed small-scale enterprise in agriculture and industry, contracts were widely made early in 1983 under work units in the arts and literature. But this was soon revoked because it permitted too much uncontrolled expression, not always within the limits set in June 1981 by the Four Basic Principles: namely, Marxism-Leninism-Mao Tse-tung Thought, CCP leadership, the people's democratic dictatorship, and socialism.

A more pervasive problem was that modernization of social style acquired such momentum it verged on Westernization. For example, young Chinese men and women, though unmarried, hold hands in public. Sometimes they even kiss, an activity formerly confined to

the bedroom, because everyone used to know what it might lead to. Moreover, material goods now take precedence over decorous conduct. Where will it all end? The arch-conservative of a century ago (Wo-jen) must be twirling in his grave. No doubt he left many descendants.

The above aspects of Deng Hsiao-p'ing's new "open door" China are offered as examples of changes under way. We cannot even suggest here how the language is changing, literature is finding new forms, norms of conduct are in flux, and the less tangible elements of China's culture are undergoing changes to match the material buildup called Modernization. No attempt can be made here to survey, much less summarize, the growth of China in the 1980s. It is a universe in itself, full of variety, contrasts, unresolved problems, and excess people, who are nevertheless planning to survive in spite of everything.

19

Perspectives

IN CHAPTER 1 we accepted the notion that the largely material effects of scientific and technological development can be usefully distinguished from the deeper and less rapidly changing social structure and values of a society in process of revolution. This metaphor of a superficial material and visible level of change overlying a slower current of social-cultural change no doubt raises as many problems as it solves. It gets us out of the soup but into the fire. It has the utility however of distinguishing between the material evidence of "modernization," such as cities, powered machines, steam transport, roads, and buses on the one hand—in general, things common to all the modern world—and on the other hand the particular values, orientations, and social habits of the Chinese people in their own way of life and culture. (All these words need definition, but in a narrative history we have to use the words available, else nothing will be narrated.)

The above assumption gives Mao the place he claimed in history as a would-be engineer of social-cultural change, even though two of his principal creations collapsed. This implies that China for all its spectacular modernization still faces the problems and perils of the social revolution, in other words the problem of how to bring the peasantry into fuller participation in the national life. The political aim is to obviate rebellion. The cultural aim is to give scope for talent.

The economic aim is to maximize production.

Modernization and social revolution may look for a moment like Marx's forces of production and superstructure, but if so the notion here is topsy-turvy. The slower-changing stratum is the culture, the modern economy may change more quickly. China's tardiness in industrializing (modernizing) has been due to the inertia of the highly developed and sophisticated Chinese culture. In a word, the Chinese upper class up to the 1890s were so cultured and intelligent they didn't *want* to modernize.

Revolutions have met a common fate: At the time they seem like sudden volcanoes of change, unpredictable and uncontrollable. In retrospect they gradually subside into the landscape between foot-hills of causes and effects on both sides of the mountain. This is the *plus ça change* idea. It constitutes one wing of our explanatory meta-phor.

Seeing the enormous improvement under the Deng reforms, we may recall the role of the second-great rulers who consolidated the work of dynastic founders—Emperor T'ai-tsung of the T'ang, Em-peror T'ai-tsung of the Sung, Yung-lo of the Ming, K'ang-hsi of the Ch'ing. In each case the necessary militancy of the founding reign was followed by a triumph of the imperial bureaucracy in a great constructive era. (Terminological note: T'ai-tsung, "grand ancestor," was the name usually bestowed on a second emperor by his succes-sors; Yung-lo and K'ang-hsi were reign titles. Before the Ming an emperor might rule through a whole series of reign periods with various titles.)

If we want to stress macro-continuities, several architectural fea-tures clearly persist: Today China's people are more crowded than ever, unity through a central authority is desired as usual, and so large a mass of people can be governed only through a belief system that is widely accepted, a bureaucracy which must by nature be a trained elite, and local authorities who represent the state in the countryside.

If we compare 1800 with 1985, these features are still in place and varying degrees of continuity and novelty can be seen among them. The terraced mountains, rivers, and flood plains are still there, but water power is harnessed, floods controlled, and soils, crops, and farming methods improved. Similarly, the crowded Chinese people are less worn down by disease and live a good deal longer. Their roles

are more diversified. The unified central government has learned the hard way that many of its functions are best performed decentralized; though modern devices make it possible to convey central commands as never before, to really get results local initiatives must be encouraged; regional differences are too great to be homogenized under a unitary state. The lower gentry of earlier times are gone but a greater number of local cadres and party secretaries still have to collect the peasants' taxes and answer primarily to their superiors. Finally, the persistence of a bureaucratic elite and a set of beliefs shared by it and the people at large is obvious, but Mao Tse-tung Thought is plainly in flux. Gradually it may be expected to harmonize with residual features of Confucianism, such as respect for authority and a sense of duty according to status. Yet Sinified Marxism accepts (perhaps all too readily) the explanatory supremacy of science rather than of Yang and Yin or of principle *(li)* and substance *(ch'i)*.

If we look at the configuration of events during modern times in China, rather than at its present and future, we meet a nagging and neglected question: how far have the years 1800–1985 seen in politics essentially a dynastic cycle in operation, albeit with much modernization of technology and of thought along the way? This question arises because of our Western bias, both liberal and Marxist, in assuming that China must follow the European paradigm of feudalism, capitalism, socialism. Nothing could be less evident. The two Western invasions of Chinese thought, liberal and Marxist, have been the highest stage of our Western intellectual imperialism. They have imposed upon China a saddle that doesn't really fit. We can't ride on it today any more than Mao could. To call China's new order "socialism" is dandy if you prize (or fear) the term, but China's socialism of today is state socialism which is not always distinguishable from state capitalism. "Capitalism" has had such a rich and varied career in recent centuries that the term is now more rhetorical than meaningful. Whether called socialist or state capitalist, it is the modern Chinese government that is leading China's transformation, and it bears many family resemblances to a new dynasty. For all its novelties, it resonates with the dynastic cycle of say the Mongol-Ming transition as well as it does with French, British, or Soviet socialism. It may well be compared with Meiji Japan. But, in the last analysis, China is just being itself, making its own mixture, *sui generis,* as usual. Its "socialism" is so feasible because, in general, daily life is oriented toward the

collective, the group, more than the individual. After 185 years of politics we seem to come out not so very far from where we went in.

Having acknowledged the persistence of the past as an architectonic framework for China's revolution, let us now look at the other side of the coin: the processes of growth and change from 1800 to 1985. Here social history is uncovering momentous changes in Chinese life and institutions. In brief, the rapid growth of population and of commerce led to urbanization and the opening up of village society. City life required a greater division of labor, more various employment, and the growth of recognized professions. Migrants to cities could rise in the world. Small-scale entrepreneurs, brokers, shopmen, specialist artisans catered to upper-class families who had money to spend ostentatiously.

From all this emerged an "elite activism," marked by greater participation of the upper class in local and provincial affairs on a private basis and an attendant concern about government services (or avoidance of exploitative tyranny) and national policies. The tradition of gentry leadership in carrying local responsibilities and meeting local problems sanctioned this trend. It was also called forth by the failure of the Ch'ing government to grow in pace with the society.

The Manchu dynasty's failure after 1860 to lead a modern development such as occurred in Meiji Japan was due to two types of causes, political and institutional. Politically, the dynasty had seen its best days. It was backward-looking and intensely conservative in the effort to sustain its great tradition and its control of China. Here two factors operated: first, the running out of dynastic vitality, a failure of energy, creativity, and leadership. Second, the ill luck of being a non-Chinese dynastic crowd still trying to hold power in an age that called for the rise of Han Chinese nationalism. These two factors hamstrung the Ch'ing effort to Westernize and modernize like Japan.

The second set of causes lay in the inherited institutional structure of the Ch'ing state, in which the imperial power was theoretically and ritually dominant but locally weak and ineffective. The centralized dynastic government was thinly superimposed on a decentralized economy and society. It was systemically incapable of growing, for example in revenue, as the economy and society grew, hence the rise of elite activism largely outside official channels. The

payoff came in the 1900s, when Ch'ing reforms could inspire or even nurture the activities of Han Chinese reformers but could not give them greater opportunity to participate in local and national government.

The Nationalist Government of the Kuomintang inherited both this movement for elite activism, though on a much broader scale, and the movement (under way since the 1850s) for militarization as the chief underpinning of government. In the mid-1920s and especially in Sun's Canton Government and its Northern Expedition, the two movements began to fuse. But the fusion was destroyed on both sides: by Japan's invasion after 1931 and Nationalist militarization to meet it, and by the CCP's spurning elite activism for reform and beginning to militarize China's peasantry for revolution. Japanese invasion and Communist militarization between them gave the Nanking Government's foreign-oriented Sino-liberal establishment only a very few years of opportunity to develop. What it might have accomplished remains of course uncertain.

To put it in political terms, the Ch'ing had ruled China by cooptation of the Chinese upper class. The gentry were incorporated into the official system at the local level. To create new forms for local gentry participation in public life (to say nothing of mass participation) would unbalance the system. After 1911 Yuan Shih-k'ai, the warlords, and Chiang Kai-shek continued to show this incapacity. They felt they were too busy holding on to or seeking central power to open the door to local autonomy or to peasant participation. Thus the CCP was given its opportunity.

After 1949 however, it faced an updated version of the same problem (and still does so today in residual forms). Mao's instinct for mass political mobilization came to be at odds with his colleagues' effort to modernize the economy and state services. He was a peasant hero who lacked the knowledge, humility, and patience to build up the modern institutions that China needed. In particular, Mao was too stuck in his updated tradition of peasant rebellion to realize that China's modernization must begin, as his May Fourth predecessors had known, with hard study both of the outside world and of China. The CCP stress on class struggle was thus a political tactic to break open the old establishment and let the peasantry make their way into it. But class struggle that downgraded intellectuals was populist demagoguery, not rational nation-building. So Mao's great limita-

tions led him into a Great Proletarian Cultural Revolution that turned out to be a great disaster. Mao had contracted the fatal disease of dynastic founders and of revolutionaries, trying to go too fast and regarding people as tools—means, not ends. The militancy with which he led the CCP to power turned into the savagery with which he tried to destroy it. The original compassion that led him toward liberating the Chinese peasantry became in the end a remarkable callousness about their fate. Evidently his early focus on China changed into a focus on his own distorted vision. He was in the great tradition of dynastic unifiers.

If we look for more than vestiges of the dynastic cycle, we face in China since 1800 an unsurpassed record of growth and change at both the levels of material-technological modernization and of the underlying social structure and cultural values. The late imperial Ch'ing despotism was dissipated by the broad growth of the private sector. This was not a Western-liberal free-enterprise sector but, as I would contend, a peculiarly circumscribed and collectivist Sino-liberal sector. From a society split between the muscular masses and the elite intellectuals, China underwent both a potential liberation of the life of the common peasant and also a division between bureaucrats and professionals among the elite.

In slightly different terms, Chapter 3 distinguished between material and intellectual modernization and slower-changing value orientations. In the present era of the Four Modernizations we assume that late imperial China's development was inhibited by her tardiness in welcoming foreign ideas and foreign trade and technology. From this point of view an iconoclast might argue that the trouble with the imperialism of finance capitalism in China was that there was so little of it. This view can be supported by citing the example of Meiji Japan's rapid opening to the West and more recently by the performance of Korea and Taiwan as former victims of Japanese imperialism. By keeping her sovereignty, what was left of it, China failed as Sun Yat-sen noted to become a genuine colony and so suffered the humiliations brought by imperialism without receiving the material benefits, such as they were, of colonialism.

Also, we can assert that China's nineteenth-century failure to open up and develop, but instead to cling to the past, preserved a class structure roughly 80 percent rural, out of politics, and accustomed to being governed by a small elite, which however stayed in

front of its troops partly by maintaining a xenophobic disdain for foreign things. From this perspective the era of American-oriented Sino-liberalism (which now seems to be having a Second Coming) tended to modernize the elite while the era of Mao's Sinification of Marxism began modernization among the masses. But, once the rural masses had begun to participate in politics, they could go in for anti-foreignism and anti-intellectualism as a way of attacking the old elitism.

China's revolution since 1800 has been a struggle to break the grip of the past. While this is true of most revolutions, almost by definition, it has been a major problem in China for the reasons of historical continuity and distinctive culture that have been stressed in preceding chapters. For example, the Cultural Revolution was specifically targeted on the "four olds" (old culture, thought, habits, and customs). These deep-lying cultural traits and values were viewed by Mao as elements that had held China back, in much the fashion we have posited in this book. (One need not support Mao's methods to appreciate his aims.)

Efforts to break the grip of history seem visible also in the vindictive and brutal attacks on members of the establishment—intellectuals and officials, the upper class. This interpretation rests on certain assumptions: first, that insensate peasant hatred of the privileged few had accumulated for centuries. The instinctive egalitarianism visible in the peasant community had been continuously affronted by the Confucian-Mencian class distinction between muscle-workers and brain-workers. The callous beatings, torture, and destruction of upper-class individuals was in the tradition of peasant barbarity in local feuds and risings in the countryside. True, the Red Guards were urban youths, not peasants, but it may be argued that they acted in a climate of opinion with peasant roots that Mao encouraged. The masses' new participation in politics after 1949 had opened the door of an inferno. The GPCR once Mao unleashed it was a "settling of accounts" on a cosmic scale.

Quite aside from such interpretations of the use of violence, the influence of China's long past is ever-present in the environment, the language, the folklore, and the practices of government, business and interpersonal relations. This truism is asserted to stress the severe problems of modernization: Foreign trade and investment required the creation of a legal system including the backbone of litigious

America, the lawyer, but the party remained above the law. The autonomy of specialists in their specialties and of artists and writers in their artistry was acknowledged but kept still subject to government limits. Law, education, and Sino-liberalism necessarily had a great future but hardly in the Western style. In the 1980s Chinese life is exploding with tremendous energy. Yet the hold of the past is evident in each individual's necessary reliance upon personal connections *(kuan-hsi, guanxi)*. These seem like the only way to escape the trammels of bureaucratism, yet connections foster cronyism and corruption, which may hamstring efforts at reform.

Each generation's historians have the task of presenting the past's relevance to our present concerns. Human rights and legal procedure have become great issues in the United States. If we take them as criteria of modernity and find China even more imperfect than ourselves, which is saying a good deal, we may well feel *déjà vu*. We have been here before, sitting in judgment on a largely unknown country from a great distance.

Anti-Bibliographic Note

So why does this book have no notes? The answer is simple: such notes would be misleading, invidious, and inadequate. Misleading because my statements are seldom based on one particular source. To cite one or two references only would therefore not represent the situation; it would leave out all the other possible references. To make great lists of them would create an off-putting mass of gobs of bibliography more appropriate for a Ph.D. thesis. Moreover, to leave out any major works would be invidious, not doing justice to the authors not cited. In short, reference notes would be inadequate for specialists and of no use to nonspecialists.

Finally, one pleasure of putting this story together has been the opportunity to speculate and make perhaps inapt comparisons. I would not like to let such flights of fancy seem attributable to the innocent and careful authors of monographs that an apparatus of notes would cite. Broad works are less accurate the broader they get. Some may recall how Arnold J. Toynbee's *A Study of History* (12 volumes) entranced many readers *except* when he dealt with their specialties.

This personal account of China's long disaster, struggle, and rebirth is my own home brew, but of course the ingredients have been distilled from the work of hundreds of others. I am particularly indebted to the fifty-odd contributors to *The Cambridge History of*

China, volumes 10–15, which concern the period from 1800 to 1980. Having scrutinized the results of so much high-level and sophisticated research, I have tried to benefit from it, but this volume is definitely not an attempt to summarize the 4,500 pages of these six volumes, of which I have been an editor and contributor. On the other hand it has been made possible principally by these scholars' work. Unable myself to consult the sources and master the literature, I have leaned on them at every turn. By way of an acknowledgment, though hardly adequate, I venture simply to append the contents tables of volumes 10–15.

My chief thanks go to the unusually skillful assistance of Joan Hill in the production both of *The Cambridge History of China* and of this volume. For very helpful textual guidance, I am especially indebted to Lloyd Eastman, Albert Feuerwerker, Merle Goldman, Philip A. Kuhn, Roderick MacFarquhar, and Lucian Pye.

One pleasure in writing this book has been to defy the tyranny of romanization. Normally editors require that all transliterations of Chinese words be either in the old Wade-Giles system or in the new *pinyin* system. But who cares? Instead of the old Teng Hsiao-p'ing or the new Deng Xiaoping I have enjoyed writing it Deng Hsiao-p'ing, a hybrid form which seems to me easier to pronounce.

Since 1948 I find I have published more than 1,700 pages of annotated bibliographies. Those interested will find a hundred-page bibliography (disarmingly entitled "Suggested Reading") in my *The United States and China* (Harvard University Press, 4th ed., enlarged, 1983). It is all arranged by topics. Too much is quite enough.

For these reasons I alone can hardly claim to be responsible for all the judgments made in this book, but I can't really tell you who is.

Appendix:

The Cambridge History of China,
Contents, Volumes 10–15

[371]

Chapter 10. *Self-Strengthening: the Pursuit of Western Technology*
by Ting-yee Kuo, late Director of the Institute of Modern History, Academia Sinica, Taipei, and Kwang-Ching Liu

Chapter 11. *Christian Missions and Their Impact to 1900*
by Paul A. Cohen, Professor of History, Wellesley College

Volume 11 *Late Ch'ing 1800–1911, Part 2,* ed. John K. Fairbank and Kwang-Ching Liu

Chapter 1. *Economic Trends in the Late Ch'ing Empire, 1870–1911*
by Albert Feuerwerker, Professor of History, University of Michigan

Chapter 2. *Late Ch'ing Foreign Relations, 1866–1905*
by Immanuel C. Y. Hsu, Professor of History, University of California, Santa Barbara

Chapter 3. *Changing Chinese Views of Western Relations, 1840–95*
by Yen-p'ing Hao, Professor of History, University of Tennessee, and Erh-min Wang, Senior Lecturer, Chinese University of Hong Kong

Chapter 4. *The Military Challenge: the North-West and the Coast*
by Kwang-Ching Liu, Professor of History, University of California, Davis, and Richard J. Smith, Professor of History, Rice University

Chapter 5. *Intellectual Change and the Reform Movement, 1890–98*
by Hao Chang, Professor of History, Ohio State University

Chapter 6. *Japan and the Chinese Revolution of 1911*
by Marius Jansen, Professor of History, Princeton University

Chapter 7. *Political and Institutional Reform, 1901–11*
by Chuzo Ichiko, Professor of History, Center for Modern Chinese Studies, Toyo Bunko, Tokyo

Chapter 8. *Government, Merchants and Industry to 1911*
by Wellington K. K. Chan, Professor of History, Occidental College

Chapter 9. *The Republican Revolutionary Movement*
by Michael Gasster, Professor of History, Rutgers University

Chapter 10. *Currents of Social Change*
by Marianne Bastid-Bruguiere, Maître de Recherche au Centre National de la Recherche Scientifique, Paris

Volume 12 *Republican China 1912–1949, Part 1,* ed. John K. Fairbank

Chapter 1. *Introduction: Maritime and Continental in China's History*
by John K. Fairbank, Professor of History, Emeritus, Harvard University

Chapter 2. *Economic Trends, 1912–49*
by Albert Feuerwerker, Professor of History, University of Michigan, Ann Arbor

Chapter 3. *The Foreign Presence in China*
by Albert Feuerwerker

Volume 14 *The Emergence of Revolutionary China, 1949–1965,* ed. Roderick MacFarquhar and John K. Fairbank

Part I. EMULATING THE SOVIET MODEL, 1949–1957

Part II. THE SEARCH FOR A CHINESE ROAD, 1958–1965

Volume 15 *Revolutions Within the Chinese Revolution, 1966–79,* ed. Roderick MacFarquhar and John K. Fairbank

Part I. THE CULTURAL REVOLUTION: CHINA IN TURMOIL, 1966–69

Part II. THE CULTURAL REVOLUTION:
THE STRUGGLE FOR THE SUCCESSION, 1969–79

Sources of Quotations

1. Susan Naquin, *Millenarian Rebellion in China: the Eight Trigrams ·Uprising of 1813.* Yale University Press, 1976, pp. 176–84.
2. Rev. Charles Gutzlaff, *The Life of Taou-Kwang, Late Emperor of China.* London: Smith Elder, 1852. See p. 43.
3. Jonathan Spence, *K'ang-hsi, Emperor of China.* Knopf, 1974, p. 146.
4. See *China Review,* 2 (1873–74), 309–14.
5. Arthur H. Smith, *Village Life in China.* New York: Fleming H. Revell, 1899. See p. 100.
6. A synoptic view of China's political culture is in Lloyd Eastman, *The Abortive Revolution: China Under Nationalist Rule, 1927–1937.* Harvard University Press, 1974, ch. 7. For a comparative study see Lucian W. Pye with Mary W. Pye, *Asian Power and Politics.* Belknap Press of the Harvard University Press, 1985.
7. William T. Rowe, *Hankow: Commerce and Society in a Chinese City, 1796–1889.* Stanford University Press, 1984. See p. 175. On guilds, see chs. 8, 9 and 10.
8. Howard Levy, *Chinese Footbinding: the History of a Curious Erotic Custom.* New York: Walton Rawls, 1966, p. 47.
9. Fortunato Prandi, ed. and trans., *Memoirs of Father Ripa.* London: John Murray, 1855, p. 58.
10. Ida Pruitt, *A Daughter of Han: the Autobiography of a Chinese Working Woman.* Yale University Press, 1945, p. 22.
11. Thomas Taylor Meadows, *The Chinese and Their Rebellions.* London, 1856, p. 259.
12. Jen Yu-wen, *The Taiping Revolutionary Movement,* p. 425, quoting autobiography of Chu Hung-chang.
13. K'ang-hsi, from *Huang-Ch'ing fan-pu yao-lueh,* comp. for the Ch'ien-lung Emperor by Ch'i Yun-shih, first printed by his son, Ch'i Chün-tsao in 1845. See Che-chiang shu-chü, ed. 1884, chüan 3, p. 10.
14. John K. Fairbank, *The Chinese World Order: Traditional China's Foreign Relations.* Harvard University Press, 1968, p. 264.
15. Fred W. Drake, *China Charts the World: Hsu Chi-yü and His Geography of 1848.* Harvard University Press, 1975, p. 2.
16. See Joseph Fletcher, "The Heyday of the Ch'ing Order in Mongolia, Sinkiang and Tibet," pp. 351–408 in *The Cambridge History of China,* Vol. 10.

17. Peter Ward Fay, *The Opium War 1840–42*. Cambridge University Press, 1978, p. 312.
18. Benjamin Elman, *From Philosophy to Philology: Intellectual and Social Aspects of Change in Late Imperial China*. Council on East Asian Studies, Harvard University, 1984.
19. Ssu-yü Teng, John K. Fairbank, *et al.*, *China's Response to the West: a Documentary Survey 1839–1923*. Harvard University Press, 1954 (hereafter *CRTTW*), Document 6. See also Drake, *China Charts the World*, pp. 135–42.
20. *CRTTW*, Document 12.
21. Journal of Robert Hart (MS), under date of May 11, 1864.
22. Michael H. Hunt, *The Making of a Special Relationship: the United States and China to 1914*. Columbia University Press, 1983, pp. 118–142.
23. *CRTTW*, Document 16.
24. *Ibid.*, Document 19.
25. Fairbank, Bruner and Matheson, eds., *The I. G. in Peking: Letters of Robert Hart, Chinese Maritime Customs, 1868–1907*. Harvard University Press, 1975, 2 vols., letters 947 and 942.
26. *CRTTW*, Document 35.
27. G. E. Morrison, *An Australian in China*. London: Horace Cox, 1895, p. 68.
28. S. W. Barnett and J. K. Fairbank, eds., *Christianity in China: Early Protestant Missionary Writings*. Council on East Asian Studies, Harvard University, 1985. See Frontispiece.
29. Kung-chuan Hsiao, *A Modern China and a New World: K'ang-yu Wei, Reformer and Utopian, 1858–1927*. University of Washington Press, 1975, p. 19.
30. *CRTTW*, Document 41.
31. *Ibid.*, Document 46.
32. *Ibid.*, Document 48, part 3.
33. Fairbank, Bruner and Matheson, eds., *The I. G. in Peking*, letters 1231 and 1232.
34. Mary Clabaugh Wright, *China in Revolution: the First Phase, 1900–1913*. Yale University Press, 1968. Introduction.
35. E. Perry Link, Jr., *Mandarin Ducks and Butterflies: Popular Fiction in Early Twentieth-Century Chinese Cities*. University of California Press, 1981, p. 142.
36. Hao Chang, *Liang Ch'i-ch'ao and Intellectual Transition in China, 1890–1907*. Harvard University Press, 1971, p. 100.
37. *Ibid.*, p. 244.
38. William Ayers, *Chang Chih-tung and Educational Reform in China*. Harvard University Press, 1971, p. 237.
39. Fernando Galbiati, *P'eng P'ai and the Hai-Lu-Feng Soviet*. Stanford University Press, 1985, p. 52.
40. Ernest P. Young, *The Presidency of Yuan Shih-k'ai: Liberalism and Dictatorship in Early Republican China*. University of Michigan Press, 1977, p. 88.
41. Edward Friedman, *Backward Toward Revolution: the Chinese Revolutionary Party 1914–1916*. University of California Press, 1974, p. 43.
42. Young, *Presidency*, p. 204.
43. *Ibid.*, p. 175.
44. Boorman and Howard, eds., *Biographical Dictionary of Republican China*, Vol. I, p. 125.
45. M. C. Wright, *China in Revolution*, Introduction.
46. See Fairbank, Reischauer and Craig, *East Asia: the Modern Transformation*. Houghton Mifflin, 1965, p. 658.

47. *Ibid.,* p. 666.
48. *CRTTW,* Document 57.
49. Chiang Monlin, *Tides from the West.* Yale University Press, 1947, p. 114. On Wang, see Boorman, Vol. III, p. 244.
50. Barry Keenan, *The Dewey Experiment in China: Educational Reform and Political Power in the Early Republic.* Harvard University Press, 1977, pp. 15, 19.
51. *Hu Shih wen-ts'un,* 1.2, 343–46, 357–79, trans. Sally Ch'eng Kuhn.
52. Lu Hsun as quoted in Jonathan Spence, *The Gate of Heavenly Peace: The Chinese and Their Revolution, 1895–1980.* New York: Viking Press, 1981, p. 197.
53. *CRTTW,* Document 65.
54. Eastman, *The Abortive Revolution,* pp. 1, 5.
55. *Ibid.,* p. 11.
56. *Ibid.,* p. 18.
57. Lloyd E. Eastman, *Seeds of Destruction: Nationalist China in War and Revolution, 1937–1949.* Stanford University Press, 1984, p. 56.

Index

Aborigines, 75, 81
Academia Sinica, 189, 192, 198
Agricultural Producers Cooperatives (APCs), 276, 282–283, 298, 299
Agricultural Study Society, 148
Agriculture, 3, 5, 153, 304, 315; commercialization of, 120; under KMT, 219–220; collectivization of, 277, 282–283, 286, 298, 313, 314, 323, 340; family-farm system in, 283, 284; vs. heavy industry, 286, 299; reform of, after 1976, 345–348, 350; responsibility system in, 347, 350, 354, 359
Allen, Young J., 129
American Political Science Association, 175
Amherst, Lord, 37
Amoy (Sha-men), 81, 96
Amur, 333
Analects, 30
Anarchism, 185, 203, 205, 228
Anhwei province, 107, 108, 110
Annam (Vietnam), 36. *See also* Vietnam
Anti-foreignism, 81, 137, 143, 349, 355, 367. *See also* Boxer Rebellion
Anti-intellectualism, 293–295, 305, 331, 367
Anti-Rightist Campaign, 292–295
Anyang (Honan), 3, 199
April Fifth incident, 340
Aquinas, Thomas, 69

Bacon, Francis, 7
Bandits, 66, 76, 81
Banks, 52, 59–61, 278, 352
Bannermen, 20, 27, 65, 84, 322
baogan ("full responsibility to the household") system, 347. *See also* Agriculture
Bentinck, Lord William, 87
Bismarck, Otto von, 111
Board of Revenue, 20, 33, 53, 97
Board of Works, 33, 97
Bohea Hills (Wri-i shan), 54–55
Book of Changes, 22
Book of Documents (Shang-shu), 103
Borodin, Michael, 211, 212, 215, 220
Boxer Indemnity, 97, 138, 187, 192, 197, 198
Boxer Rebellion, 47, 115, 136–138, 143, 144
Brezhnev, Leonid, 332
Bridgman, Elijah, 92
British-American Tobacco Company, 179
British East India Company, 55, 59, 87, 126; and Hong merchants, 95
Bryce, James: *The American Commonwealth,* 175
Buddhism, 75, 128, 131, 152, 157, 185; Maitreya, 22, 64; Sinification of, 82, 89, 250
Bureaucracy, 6, 15, 19, 27, 36, 152, 343; and government, 32–33; and

About the Author

John K. Fairbank and his wife, Wilma Fairbank, got their first impressions of Chinese life by living in Peking for four years in the early 1930s. In 1936 he began to develop instruction and research on Modern China at Harvard University. During World War II he spent the five years 1941 to 1946 in Washington and in China in government service. After he resumed teaching, his first book, *The United States and China,* in 1948 reflected his impressions of the revolutionary ferment among the Chinese people. (The fourth edition of this book, revised and updated, was published by Harvard University Press in 1983.)

Professor Fairbank was one of the small number of Americans whose pioneer work in Modern Chinese History gave necessary shape to the field. Surveys and more specialized courses of lectures, syllabi and bibliographies for use in research seminars, conferences on major topics leading to publication of symposia, all contributed to M.A. and Ph.D. training that launched many of today's professors of Chinese history on their careers.

This development also involved the organization of national committees and conferences to meet the many problems of Chinese studies in America. Professor Fairbank has been president of the Association for Asian Studies and of the American Historical Association and has received numerous honorary degrees. He and his wife live according to the season in New Hampshire and in Cambridge, Mass.